WRITING POEMS
Fifth Edition

ROBERT WALLACE
Late of Case Western Reserve University

MICHELLE BOISSEAU
University of Missouri–Kansas City

 LONGMAN

An imprint of Addison Wesley Longman, Inc.

New York • Reading, Massachusetts • Menlo Park, California • Harlow, England
Don Mills, Ontario • Sydney • Mexico City • Madrid • Amsterdam

Acquisitions Editor: Janice Wiggins Clarke
Sponsoring Development Manager: Arlene Bessenoff
Development Editor: Carol Hollar-Zwick
Marketing Manager: Melanie Goulet
Full Service Production Manager: Valerie Zaborski
Project Coordination, Text Design, and Electronic Composition: Elm Street
 Publishing Services, Inc.
Cover Designer/Manager: Nancy Danahy
Cover Montage: Nancy Danahy
Printer and Binder: The Maple-Vail Book Manufacturing Group
Cover Printer: Coral Graphic Services

For permission to use copyrighted material, grateful acknowledgment is made to the
copyright holders on pp. 349–354, which are hereby made part of this copyright page.

Library of Congress Cataloging-in-Publication Data

Wallace, Robert, 1932–1999
 Writing poems / Robert Wallace, Michelle Boisseau. — 5th ed.
 p. cm.
 Includes bibliographical references and index.
 ISBN 0-321-02688-8
 1. Poetry—Authorship. I. Boisseau, Michelle, 1955– .
II. Title.
PN1059.A9W34 2000
808.1—dc21 99-25484
 CIP

Copyright © 2000 by Robert Wallace and Michelle Boisseau

Please visit our website at http://www.awlonline.com

ISBN 0-321-02688-8

12345678910—MA—02010099

This book is dedicated to Robert Wallace,
who died while it was in production
but who lives on in the many poets
whose work he touched.

CONTENTS

PART I. FORM: THE NECESSARY NOTHING

PART II. CONTENT: A LOCAL HABITATION AND A NAME

PART III. PROCESS: MAKING THE POEM HAPPEN

PREFACE
To the Teacher

Since poetry happens all at once in writing a poem, as it does in reading one, this book's division into parts on form, content, and process, and of these parts into chapters is a structural convenience. We have organized the material, not the course—or, really, the variety of possible courses. We encourage teachers and readers to follow their own direction and priorities, skipping around the text freely.

Chapter 1 ("Starting Out"), new to this edition, lays out a few basics to get students quickly on their feet. From there a course might go on to chapter 2 ("Verse") since understanding that poems are made of *lines* is basic; or to chapter 6 ("Subject Matter") since beginning poets often overlook material for poems that lie, as William Carlos Williams said, "close to the nose." Or to chapter 8 ("Metaphor"). Or to chapter 9 ("Beyond the Rational"), which explores some of poetry's origins in word-magic and dream. Our main advice for using the text is to mix chapters from the three sections, thus raising simultaneous matters more or less simultaneously.

If you allow a little extra time for the condensed technical information in chapter 2 (on lineation) and chapter 3 (on meter), the twelve chapters make a roughly comfortable fit for a semester course. For more advanced courses, you can place more emphasis on form, Part I; for beginning courses you may want to concentrate more on content, Part II. For a shorter course, sections of some chapters may be assigned selectively; for example, the section "Alliteration and Assonance" from chapter 5 ("The Sound [and Look] of Sense") or the section "Exploring" from chapter 11 ("Devising and Revising"). A section may be relevant for a particular student (e.g., "Emotion" in chapter 10, ["Finding the Poem"]) and can be assigned individually and discussed in conference.

In courses built around the workshop, you can put the emphasis on student poems and let the book cover basics like syntax and imagery. In that case, you'll want to spend a few minutes early in the course encouraging students to think of the book as a friendly handbook they can explore on their own. Point out a particularly riveting poem or two among the "Poems to Consider" in a chapter you won't be teaching soon, or an exercise in the "Questions and Suggestions" that might give students a boost when they are searching for ideas for poems. Encourage them to browse and to thumb through "A Brief Glossary of Forms" and "Index of Terms." Students noodling in "Index of Terms" might wonder what for heaven's sake is *stichomythia*, discover Christina Rosetti's "Up-Hill" in "A Brief Glossary of Forms," and be off on a poem of their own.

Students usually arrive in creative writing courses eager and motivated, so the

challenge is less to inspire them than to provide the continuing stimulus of fresh ideas and new information. In workshop courses, especially, when students are reading poems for themselves, they need to be asking W. H. Auden's practical question: "Here is a verbal contraption. How does it work?" as well as, "What can I use?"

Since reading poems stimulates and guides writing poems, this book also acts as a handy anthology of some three hundred poems from the sixteenth century to the present. Rarely are students familiar with much recent poetry—sometimes only with Shel Silverstein and pop lyrics—so our selection leans strongly toward the contemporary. We have also included poems by students (whose names are marked by asterisks) as models of what student poets can accomplish. Usually the poems that appear in the "Poems to Consider" sections following each chapter exemplify matters raised in that chapter, but as every good poem does everything at once, many might appear anywhere in the text. And though in "Questions and Suggestions" we refer to the poems that follow in "Poems to Consider," you may happily want to go further afield. The "Questions and Suggestions" should supplement, not replace, the hands-on instigations of the teacher.

All poets write (and learn from) their own weaker poems, so we have rarely used "bad" examples. Early versions of poems, particularly in the newly concentrated revision chapter (chapter 11), offer instances of the clumsy or wrongheaded—as well as assurance for aspiring poets that problems can be solved. As Ben Johnson urges,

> No more would I tell a green writer all his faults, lest I should make him grieve and faint, and at last despair. For nothing doth more hurt, than to make him so afraid of all things, as he can endeavor nothing. . . . Therefore a master should temper his own powers, and descend to the other's infirmity. If you pour a glut of water upon a bottle, it receives little of it; but with a funnel, and by degrees, you shall fill many of them.

A Note on the Fifth Edition

If you used the fourth edition, you will notice we have condensed our commentary overall and made these substantive changes:

- A new introductory chapter 1, "Starting Out," approaches writing poems through essentials shared with all good writing, through choices in diction and syntax, and through choices a student makes in tinkering with the drafts of a poem.
- The discussion of nonmetrical or free verse (chapter 4, "Measuring the Line, II") now *follows* the discussion of meter (chapter 3, "Measuring the Line, I"), since our ideas about looser meter stem from our understanding of tighter meter. Furthermore, the analysis of meter has been both simplified and fine-tuned.
- The discussions on voice and point of view have been expanded to include general notions about how we tell stories and anecdotes in poems.

- The former two chapters on revision have been concentrated into one chapter, (chapter 11, "Devising and Revising"), so Part III, "Process," now contains a more manageable three chapters. Some of the earlier discussions of revision have been moved to chapter 1 and to chapter 10, encouraging students to see revision as the fundamental process it is.

About one-third of the poems in *Writing Poems*, fifth edition, are new to this edition, including poems by

David Baker	Edward Hirsch	Lucia Perillo
Gerald Barrax	Elizabeth Holmes	Robert Pinsky
Robin Becker	Brooke Horvath	Ezra Pound
Bruce Bennett	Andrew Hudgins	Lynn Powell
William Blake	Mark Irwin	Janet Reno
Louise Bogan	Bonnie Jacobson	Muriel Rukeyser
Marianne Boruch	Robinson Jeffers	Natasha Sajé
Joseph Bruchac	Rodney Jones	William Shakespeare
Sharon Bryan	Allison Joseph	Arthur Smith
Rafael Campo	Donald Justice	Wallace Stevens
Billy Collins	Brigit Pegeen Kelly	Robert Stewart
E. E. Cummings	Carolyn Kizer	Deborah Tall
James Cummins	Peter Klappert	Henry Taylor
Jim Daniels	Ted Kooser	Edward Thomas
Toi Derricotte	Elizabeth Kostova	Jean Toomer
Wayne Dodd	Deborah Kroman*	Ann Townsend
Mark Doty	Maxine Kumin	Gail Tremblay
Christine Dresch*	D. H. Lawrence	William Trowbridge
Nancy Eimers	William Logan	Jean Valentine
Lynn Emanuel	Richard Lyons	Gloria Vando
Alice Friman	Judson Mitcham	Sidney Wade
Robert Frost	Marianne Moore	Ronald Wallace
Michele Glazer	David Mura	Rosanna Warren
Kate Gleason	Marilyn Nelson	Michael Waters
Louise Glück	Michael Nelson*	Susan Whitmore
Sarah Gorham	Sharon Olds	W. C. Williams
Donald Hall	Judith Ortiz Cofer	W. B. Yeats
Robert Hass	Linda Pastan	Al Young
Michael Heffernan	Molly Peacock	

*Poets who wrote their poems as students are marked with an asterisk.

The pleasure of adding poems balances the regret of dropping others. For a loss too painful, we suggest the copier.

Too numerous to acknowledge are the teachers, poets, colleagues, and students—in particular our own teachers and our own students—to whom we owe much

thanks. We are truly grateful for every correction and helpful suggestion, especially to Don Kunz, University of Rhode Island and Michael Cooley, Berry College. Richly deserved thanks also go to two of Michelle Boisseau's graduate assistants who helped in preparing the revision and in handling the indexing: Bridgette Henry and Brandon Graham.

We also wish to thank the formal reviewers for this edition: especially Angela Ball, University of Southern Mississippi; Martin Baum, Jamestown Community College; Michael Collier, University of Maryland; Keith Coplin, Colby Community College; Jim Daniels, Carnegie Mellon University; Vince Gotera, University of Northern Iowa; Angela Green, Lee College; Steve Jaech, Pierce College; Lance Larsen, Brigham Young University; George Looney, Bowling Green State University; Robert Miltner, Kent State University—Stark; Marianne Taylor, Kirkwood Community College; Karen Wallace, West Valley College; and Michael Warren, Maple Woods Community College. And finally we want to acknowledge the sharp eyes and generous help of Carol Hollar-Zwick, developmental editor; Tashia Stone, copyeditor; and Michele Heinz, project editor.

—R. W., M. B.

1

STARTING OUT
An Introduction

Writing poems is nearly as old as humanity itself. Poetry is so interwoven with the human story that we can easily see its origins in the dim regions of prehistory. We can imagine that not long after we began to structure the odd sounds that we could make into language, we began tinkering with that language, making it memorable, making poems. The earliest generations of poets played with poems, made discoveries, and invented new poems, as did the next generation and the next, all the way down to us. People from cultures all over the globe trace their origins through poems. From tundras to rain forests, on rickety tables in apartment complexes, around campfires on windy plains, in the some five thousand human languages, people use poems to express who they are, what they believe, what they have done, what it feels like to be alive.

We always need new poems. Human truth, however enduring, must always be reimagined and revived. "Make it new," Ezra Pound urges, a simple plea, yet an insistent one since what struck one era as innovative and exciting may not strike another in the same way. As Mary Kinzie notes, "pretty soon the surprises do not surprise us any more." At the same time, poets keep in mind the discoveries other poems have brought to light. A poet can only know what remains to be written if, as T. S. Eliot points out, the poet "lives in what is not merely the present, but the present moment of the past, unless [the poet] is conscious, not of what is dead, but of what is already living"—the poems that persist.

Starting to write poems, then, inevitably blends what the beginning poet learns of poetry's craft, its possibilities, and what only each new writer can bring to the adventure—fresh subjects, fresh attitudes, fresh understanding, fresh insights: "the genuine," as Marianne Moore calls it in the opening of her droll poem, "Poetry":

> I, too, dislike it: there are things that are important beyond all this fiddle.
> Reading it, however, with a perfect contempt for it, one discovers in
> it after all, a place for the genuine.
> Hands that can grasp, eyes
> that can dilate, hair that can rise
> if it must

Your teacher, like the authors of this book, can lead you toward writing poems; but expect to follow us only so far. Each poet must learn (and later relearn) how to write his or her own poems. Learning to write poetry means exploring. It means not only recording what you think or feel but investigating those thoughts, sifting your emotions. Howard Nemerov wryly defined writing poems as a spiritual exercise "having for its chief object the discovery or invention of one's character."

Perhaps Creative Writing might better be called "Experimental Writing." Faced with the daunting specter of a blank white page, the poet may feel intimidated by the injunction: *be creative; create*. But: experiment, *try something out*—this sounds more appealing. Even on a bad day, you *can* experiment. Put a few words down, re-order them, find words that are more precise, shape an arresting sentence. Use it as the first line or lines of a poem. What might the poem's *next* sentence say?

The resulting poems may be disappointing, but we expect experiments to be imperfect. Each experiment, though, teaches us how to make the next one work better—how to refine the apparatus, how to pose a problem more acutely, how to comprehend more thoroughly what we are looking for. Writing—trying to dig up one's deepest feelings and to untangle one's most serious view of the world—will always be an intimate, vulnerable activity. You may be hard on your poems, but go easy on yourself.

We learn to write poems from reading (and rereading) poems we like. That's how poets trained themselves before creative writing courses, and that's how they still do. Elizabeth Bishop's advice to an aspiring poet in the 1960s still holds today:

> Read a lot of poetry—all the time. . . . Read Campion, Herbert, Pope, Tennyson, Coleridge—anything at all almost that's any good, from the past—until you find out what you really like, by yourself. Even if you try to imitate it exactly— it will come out quite different. Then the great poets of our own century— Marianne Moore, Auden, Wallace Stevens—and not just 2 or 3 poems, each, in anthologies—read ALL of somebody.

When you meet a poem that truly talks to you, in this book or elsewhere, see what else by the poet you can find in your bookstore, in the library, in *Books in Print*, on the Internet. These poets will help you realize places your own poems might go, new angles of vision, new approaches.

And as you write, always be sure you're having fun. Keep your sense of humor honed, as the poet Sharon Bryan (b.1943) does in this celebration of words:

Sweater Weather: A Love Song to Language

Never better, mad as a hatter,
right as rain, might and main,
hanky-panky, hot toddy,

hoity-toity, cold shoulder,
bowled over, rolling in clover,
low blow, no soap, hope

5

against hope, pay the piper,
liar liar pants on fire,
high and dry, shoo-fly pie,

fiddle-faddle, fit as a fiddle, 10
sultan of swat, muskrat
ramble, fat and sassy,

flimflam, happy as a clam,
cat's pajamas, bee's knees,
peas in a pod, pleased as punch, 15

pretty as a picture, nothing much,
lift the latch, double Dutch,
helter-skelter, hurdy-gurdy,

early bird, feathered friend,
dumb cluck, buck up, 20
shilly-shally, willy-nilly,

roly-poly, holy moly,
loose lips sink ships,
spitting image, nip in the air,

hale and hearty, part and parcel, 25
upsy-daisy, lazy days,
maybe baby, up to snuff,

flibbertigibbet, honky-tonk,
spic and span, handyman,
cool as a cucumber, blue moon, 30

high as a kite, night and moon,
love me or leave me, seventh heaven,
up and about, over and out.

Diction

The joy that painters find in messing around with paint, poets find in words, as Sharon Bryan's "Sweater Weather" demonstrates. You may find it helpful to picture the words of your poems as fluid paint—you can choose them, change them, blend them, layer them. **Diction**, or word choice, is one of the poet's handiest tools. By choosing the *exact* word, not merely something close, the poet convinces and draws a reader into a poem. Through shrewd attention to the **denotative**, or literal, meaning of words, the poet makes explicit the world of the poem. A word used unwittingly, like *liquidate* for *melt*, can quickly confuse and even ruin a poem. Poets take every advantage words offer them; while working on the drafts of his poem "Among School Children," Yeats accidentally substituted "a *mess* of shad-

ows" for "a *mass* of shadows" and immediately recognized the subtler possibilities that accompanied the choice.

As you write, you will find a good dictionary valuable, not only for checking spelling and usage but also for locating a word's etymology (the history of its development). Such etymologies can lead you to a word's **connotative** meanings—its figurative meanings—as well as the overtones and nuances that a word or phrase suggests. For example, as the etymology of *nuance* leads back to *nue*, or cloud, a "nuance" can be likened to the subtle shading, the dip in temperature a cloud gives the landscape of a poem.

Since poems operate in small spaces, the layers that lie beneath the surface— the poems' **implications**—have profound importance. In this poem, notice how the poet's diction shapes the world of the speaker and implies her deeper, unstated concerns:

Cold as Heaven 1995
JUDITH ORTIZ COFER (b. 1952)

Before there is a breeze again
before the cooling days of Lent, she may be gone.
My grandmother asks me to tell her
again about the snow.
We sit on her white bed 5
in this white room, while outside
the Caribbean sun winds up the world
like an old alarm clock. I tell her
about the enveloping blizzard I lived through
that made everything and everyone the same; 10
how we lost ourselves in drifts so tall
we fell through our own footprints;
how wrapped like mummies in layers of wool
that almost immobilized us, we could only
take hesitant steps like toddlers 15
toward food, warmth, shelter.
I talk winter real for her,
as she would once conjure for me to dream
at sweltering siesta time,
cool stone castles in lands far north. 20
Her eyes wander to the window,
to the teeming scene of children
pouring out of a yellow bus, then to the bottle
dripping minutes through a tube
into her veins. When her eyes return to me, 25
I can see she's waiting to hear more
about the purifying nature of ice,
how snow makes way for a body,

how you can make yourself an angel
by just lying down and waving your arms 30
as you do when you say
good-bye.

Ortiz Cofer's *details*—the trudging through snow, the dripping IV bottle, the making of snow angels—bring the scene to life, make it *realized*. We can sense the coldness of the snow, the hot sun outside, the noisy children pouring from the bus, and the speaker's dread. Without explaining her feelings directly (which would seem both unnatural and intrusive), the speaker of the poem shows us how close she feels to her grandmother and thereby allows us to grasp how much she has to lose when her grandmother dies. By drawing on our basic humanity and our interest in our own families, the poem lets us participate in its drama. It doesn't *tell* us to think or feel a thing. And yet we do.

By using the word "conjure" Ortiz Cofer threads into the poem a suggestion that an element of magic lies within the scene. Derived from Latin and meaning "to swear together," *conjure* once meant "to entreat earnestly" and later "to summon supernatural spirits"; through "conjure", the poem implies that the grandmother once wielded a special power through storytelling.

A good thesaurus (the name comes from the Greek word meaning "treasury") can lead to scores of synonyms for a word. Substitutions for the verb *touch* include *feel, caress, massage, twiddle, wield, paw, poke, grope, grapple, run the fingers over, fumble, sift, brush, pinch, prick, stroke, handle, manipulate, contact, rummage, frisk, hit, graze, tickle,* and *goose*. It will also take us to *touch upon, discuss, ventilate, dissertate, go into,* and *critique*. The omnivorousness of English—which has taken in words from many languages—offers us a host of word choices to fit exactly what we mean, or, often more important, to help us to focus, even apprehend, what we do mean.

In making your poems, try to rely on precise nouns and verbs—language's bones—rather than on modifiers. Consider the difference between "I felt the jacket affectionately" and "I stroked the jacket," between "I pawed the jacket" and "I touched the jacket harshly."

In choosing words, balance their meaning and nuance with how they fit the situation or attitude of the poem. If in a love poem the speaker declares, "Let me integrate my life with yours," we will question the speaker's seriousness or wonder why the lover has chosen the remote, formal diction of a job application. A poem's levels of diction (e.g., formal, informal, neutral, colloquial, vulgar) help to establish its **tone**, the poem's attitude toward its subject. Notice how most of Ortiz Cofer's diction is quiet and neutral; it sets a simple stage on which the intense emotions of the poem can play out. A fancy polysyllable might make us doubt the speaker's sincerity and might suggest she is showing off her verbal fireworks rather than showing her concern for her grandmother. Were the speaker to claim she would like "to declaim on frozen rain," she would sound preposterous.

Our pleasure in reading this poem by William Trowbridge (b. 1941) stems from the precision and inventiveness of its diction:

Enter Dark Stranger

In *Shane*, when Jack Palance first appears,
a stray cur takes one look and slinks away
on tiptoes, able, we understand, to recognize
something truly dark. So it seems
when we appear, crunching through the woods. 5
A robin cocks her head, then hops off,
ready to fly like hell and leave us the worm.
A chipmunk, peering out from his hole
beneath a maple root, crash dives
when he hears our step. The alarm spreads in a skittering 10
of squirrels, finches, millipedes. Imagine
a snail picking up the hems of his shell
and hauling ass for cover. He's studied carnivores,
seen the menu, noticed the escargots.

But forget Palance, who would have murdered Alabama 15
just for fun. Think of Karloff's monster,
full of lonely love but too hideous
to bear; or Kong, bereft with Fay Wray
shrieking in his hand: the flies circle our heads
like angry biplanes, and the ants hoist pitchforks 20
to march on our ankles as we watch the burgher's daughter
bob downstream in a ring of daisies.

Trowbridge draws upon images of three figures from classic movies: first the nerveless killer played by Jack Palance in *Shane*, next Frankenstein's monster (in Boris Karloff's portrayal), then King Kong. Notice how the scene's liveliness and comedy spring from Trowbridge's careful choice of active, concrete verbs and verbals and his shifting through levels of diction: *slinks, recognize, crunching, skittering, hauling ass, think, bereft, shrieking, hoist, bob*. The most formal word, *bereft*, lends an air of comic dignity to the huge disconsolate ape.

Sometimes an odd word, like "bereft," provides exactly the sense and surprise the poet is after, as with J. V. Cunningham's "spiritual noise" in "For My Contemporaries" (p. 76), Louise Glück's "coagulate" in "Racer's Widow" (p. 39), and Robert Hayden's (1913–1980) choice of "offices" in the last line of this poem:

Those Winter Sundays

Sundays too my father got up early
and put his clothes on in the blueblack cold,
then with cracked hands that ached
from labor in the weekday weather made
banked fires blaze. No one ever thanked him. 5

I'd wake and hear the cold splintering, breaking.
When the rooms were warm, he'd call,
and slowly I would rise and dress,
fearing the chronic angers of that house,

Speaking indifferently to him, 10
who had driven out the cold
and polished my good shoes as well.
What did I know, what did I know
of love's austere and lonely offices?

In "loves's austere and lonely offices" the denotative meaning of "offices" is "tasks or duties," but the word's connotations remind us of the authority and trust that we associate with fatherhood. The word also carries great psychological weight. In choosing "offices" Hayden registers ambivalence; the son feels strong remorse for belatedly recognizing his father's efforts, and yet the son, despite what he knows, still feels emotionally distant. Some deep pain still haunts him. Notice, also, how much the single word "too" carefully placed in the first line tells us; *every* day, even on the day of rest, his father attended to his family.

As in the example of "offices," the splash of an unexpected word or phrase can inject intensity, and even an appealing note of strangeness: Carolyn Kizer uses "Barbelo" (a female erotic god-figure) and "viridescence" in "Shalimar Gardens" (p. 19); in "Poetry" (p. 1) Moore uses the colloquial "all this fiddle."

In Trowbridge's poem the inventive diction depicts the animals as, once we think of it, movie cartoons. This impression strengthens as we move through the poem: the cur "on tiptoes"; the female robin "ready to fly like hell and leave us the worm"; the submarine-war image when the chipmunk "crash dives" into his burrow. The scene is pure Disney, even to the snail's having "seen the menu, noticed the escargots."

The title, "Enter Dark Stranger," recalls the formulaic stage direction that introduces the bad guy into a plot; by exposing this film cliché, Trowbridge meditates— comically—on how in the eyes of other creatures human beings are the monsters. Generally, however, avoid **clichés**—stale, too familiar words, phrases, and metaphors. The language of poetry pays attention; by its nature a cliché does not. Recently a newspaper carried this sentence: "I think we are enjoying the backlash of the moral decline that peaked in Watergate." To enjoy being lashed seems ridiculous; and the *peak* of a *decline* indicates language that isn't listening to itself at all.

Each age has its own stale formulas; our special curse includes *hard truth, points of light, phenomenal, hard-liner, download, millennial, in denial, meeting one's needs,* and *poetry in motion*. You can test for a cliché by asking yourself whether the word, phrase, or image you're using is particular or generic. If you're writing about a rainbow, do you see a real rainbow with all its translucence, transience, and tenuousness? No rainbow looks exactly like another. Or do you see the graphic artist's generic sentimental symbol: neat little arches lined up according to the spectrum, red to violet, in flat unreal colors?

Another test for a cliché is to ask yourself if you really know what the word, phrase, or image means. What's a doornail? Is it dumber than a roofing nail? Quieter? Smarter than a finishing nail? Also, ask yourself if you get a sensation when you use the phrase, or whether you are only transmitting general impressions. *Hard as nails* doesn't trigger a feeling of hardness and durability. *Cold as ice* doesn't make you shiver while Ortiz Cofer's "Cold as Heaven" intrigues. Does *light as a feather* recall the ticklish, wispy barbs? Be careful not to confuse clichéd and formulaic writing with idiomatic writing. *Idioms* are expressions that have become fixed in a language as constructions deemed natural. English speakers say, "I am going *to* Italy," not, as in other languages, "I am going *in* Italy." Tampering with idiomatic expressions doesn't freshen language; it makes it sound laughable, like the Wild and Crazy Guys in old *Saturday Night Live* routines.

Poetry often generates a kind of cliché all its own, **poetic diction**—fancy, pompous, or contrived language that gets used and reused until it becomes dull and tries a reader's patience. American poets of the 1960s and 1970s had a particular affinity for *stone, dark, alone, dance* and titles that included gerunds like *walking, falling, spinning.* Words like *o'er* for *over, ere* for *before,* or *thou* for *you* were the poetic clichés of an earlier time, as were such eighteenth-century elegant variations as *finny tribe* for fish. As Pound advises, don't use in a poem a word that you wouldn't use in speech—or at least weigh your purpose carefully.

Syntax

Syntax is the structure of phrases, clauses, and sentences. The word *syntax* comes from the Greek *syn* ("together") and *tassein* ("to arrange"): "to arrange together." Also from *tassein* we get the word *tactics,* suggesting the value of syntax to the poet in deploying forces. Syntax is the muscle of poetry. Like all skilled writers, poets express meaning by attending to syntax.

The syntactical qualities of strong writing in general apply to poetry, including these principles: (1) Place main ideas in main clauses and subordinate ideas in subordinate clauses. (2) Use parallel structures for parallel ideas. (3) Put modifiers next to the nouns they modify. (4) Use active voice. (5) Vary sentence structure. (6) Set the most significant part of a sentence at the end. (7) Use unusual syntax only when appropriate to meaning. (8) Break any rule that makes you sound ludicrous.

If you're unsure about syntax, devote some time to paying close attention to it. A writing guide like Strunk and White's classic *The Elements of Style* can help, as well as an ear attuned to the ways the poems you come across marshall meaning and emotion through syntax.

In her elated "Sweater Weather: A Love Song to Language," Sharon Bryan overcomes the rule against using sentence fragments by aligning the celebratory phrases in a parallel list. Her careful coordination of the phrases keeps us from getting tangled in fragments, and her interplaying the poem's sounds help to make it cohere and progress. For example, in the last two lines—"love me or leave me, seventh

heaven, / up and about, over and out" (lines 32–33)—the phrases are balanced, allowing the "o," "e," and "v" sounds to resonate and hold the parts together.

By opening "Cold as Heaven" with the repeated prepositional structure, "Before there is a breeze . . . before the cooling days," Ortiz Cofer suspends—holds off—the main clause ("she may be gone"), making all the more powerful the speaker's realization of how tenuously the grandmother's holds onto life. Ortiz Cofer varies the type (e.g., simple, compound, complex) and length of her sentences to speed and slow the poem's movement, enacting the speaker's train of thought as she considers the substance of what she is telling her grandmother. Following the long parallel clauses of the poem's third sentence (lines 7–13), the simpler fourth sentence ("I talk winter real for her. . . .") seems to erupt, as if the speaker had suddenly grasped why she describes the snow.

Notice in the first stanza of "Those Winter Sundays" how Hayden emphasizes the son's recognition of ingratitude with the short sentence, "No one ever thanked him." Following the four-and-a-half-line opening sentence that lists the father's chores, the short sentence comes as a blow: how little effort—even to express thanks—the other family members took. Trowbridge uses a similar strategy. "Enter Dark Stranger" opens with a dependent (or subordinate) clause ("In *Shane*, when Jack Palance . . ."), which places the emphasis on the creatures in the independent clauses who flee humanity. The interrupted syntax of the third line ("on tiptoes, able, we understand, to recognize") slows down the line and mimics the stray dog's hedging retreat.

As syntax is a poem's muscle, flexing or relaxing those muscles lends the poem its strength and agility. In "Barbed Wire" (p. 82) Henry Taylor manages all twenty-four lines of the poem through one sentence, driving home a sense that nothing can stop the accident. Robert Francis's "Excellence" (p. 57) compresses two sentences into one line: "From poor to good is great. From good to best is small." The terse line seems to register the exactitude we hope for in truth.

The anonymous poet of this little poem uses syntactic patterning to produce, in spite of the nonstandard English, a subtle formal structure:

The Frog

What a wonderful bird the frog are!
When he stand he sit almost;
When he hop he fly almost.
He ain't got no sense hardly;
He ain't got no tail hardly either. 5
When he sit, he sit on what he ain't got almost.

Two sets of parallel sentences ("When . . . almost" in lines 2–3 and "He ain't got . . ." in lines 4–5) prepare for the last line, which gathers both patterns into its climactic syntax.

Robert Frost (1874–1963) was a master of coaxing both music and meaning out of syntax. Listen to the inversions, repetitions, and emphases in this poem:

An Old Man's Winter Night

All out-of-doors looked darkly in at him
Through the thin frost almost in separate stars,
That gathers on the pane in empty rooms.
What kept his eyes from giving back the gaze
Was the lamp tilted near them in his hand. 5
What kept him from remembering what it was
That brought him to that creaking room was age.
He stood with barrels round him—at a loss.
And having scared the cellar under him
In clomping here, he scared it once again 10
In clomping off;—and scared the outer night,
Which has its sounds, familiar, like the roar
Of trees and crack of branches, common things,
But nothing so like beating on a box.
A light he was to no one but himself 15
Where now he sat, concerned with he knew what,
A quiet light, and then not even that.
He consigned to the moon, such as she was,
So late-arising, to the broken moon
As better than the sun in any case 20
For such a charge, his snow upon the roof,
His icicles along the wall to keep;
And slept. The log that shifted with a jolt
Once in the stove, disturbed him and he shifted,
And eased his heavy breathing, but still slept. 25
One aged man—one man—can't keep a house,
A farm, a countryside, or if he can,
It's thus he does it of a winter night.

Through frequent inversions, as when he places the complement before the verb ("A light he was to no one but himself," line 15), Frost presents the old man's world as slightly off-kilter; he is losing touch. The second sentence, which begins on line 4 with "What kept his eyes . . . ," leads us through a long series of the results of his uncertainty before we get the cause in line 7, "age." Lines 6–9, which repeat "him" four times, work to a minor climax within the turning and returning syntax that creates a rhythm to the old man's wandering through the house.

A few words on grammar and mechanics: Sometimes inexperienced writers labor under the delusion that knowing grammar might dry up their creative juices. As a carpenter knows when to use which screwdriver and a cook when to use which spice, good writers know the tools at their disposal, and don't, for instance, use a semicolon in place of a colon. Similarly, though correct spelling hardly impresses a reader, a poem blotched with a misspelling distracts and destroys the illusion of the

poet's control. When a lecturer steps on stage with an unzipped fly, whatever the speech, the audience won't be paying much attention to the words.

Pruning and Weeding

Like a coiled spring, much of a poem's power comes from its compression. We don't mean that all poems should be epigrams; nor that at the expense of clarity or grace, a poem should be clogged, cramped, or written in robot-speak. But the poet should follow the principle of not using two words when the poem calls for one. Everything need not be said. As Ernest Hemingway notes:

> If a writer . . . knows enough about what he is writing about, he may omit things that he knows and the reader, if the writer is writing truly enough, will have a feeling of these things as strongly as though the writer had stated them. The dignity of movement of an iceberg is due to only one-eighth of it being above water.

Poetry has been defined as an art of revision. By constantly sifting the words and gauging each sentence, the poet allows what lies beneath the surface—the implications—to propel the poem. Often a poem goes wrong when the poet overlooks what a word or a sentence pattern implies. Getting words down on the page, like poking seeds into the ground, is just the first step. The seeds may sprout, but unless the gardener thins them and later weeds them, the garden will become a choked mess.

As you play around with a poem, look for redundancies, for what you can clear out of the way, for what can go without saying. Cynthia Macdonald advises students to think of what she calls the "Small Elephant Principle." We don't need to state an elephant is big; largeness naturally accompanies our sense of that creature. If the elephant is small, however, that's worth mentioning. Apply this principle as you weigh choices like "dark night," "wide grin," or "beautiful flower."

Cutting and rearranging the elements of a poem can awaken you to new ways of seeing it and allow you more room to include new discoveries. Consider this draft by a student, D. A. Fantauzzi:

Moorings

A collection of white, yellow, red
hulks of sailboats—
bugs with wings
folded down their backs,
tucked out of the wind, 5
sitting still.
Through the heart
a tall pin
sticks each to the blue-green mat.

This keenly observed poem presents a colorful scene that might be invigorated if pruned. Here is the text again, with possible omissions shown by brackets:

> [A collection of] white, yellow, red
> [hulks of] sailboats—
> bugs with wings
> folded down their backs,
> [tucked out of the wind,] 5
> [sitting still.]
> [Through the heart]
> a tall pin
> sticks each to the blue-green mat.

The plural "sailboats" might be sufficient without "A collection of." The analogy between sailboats and a display of pinned insects makes "collection" relevant, but since the phrase comes first, it has little force. In line 2 "hulks of" seems unnecessary and misleading (did he mean "hulls"?); "hulks" feels too large and clumsy for sailboats. The comparison of sails to wings seems accurate (both are means of propulsion by air) and necessary, and the sails are "folded down their backs," as insects' wings might be.

Yet "tucked out of the wind" explains too much and makes the action sound too volitional since in the metaphor the insects are dead. In line 6 "sitting" appears too flat and motionless for sailboats moored on the water. Though the drama of "Through the heart" seems right, neither sailboats nor insects have hearts, so the line becomes imprecise, sentimental, clichéd.

Each of these potential deletions raises a question the poet should mull over. How necessary is this word or detail to the poem I am trying to write? What happens if I move this phrase? Here is the poem as the poet might rearrange and condense it:

> White, yellow, red sailboats—
> bugs with wings
> folded down their backs.
> A tall pin
> sticks each to the blue-green mat. 5

The form above has the added benefit of suggesting—through its unbalanced, low, flat shapes—the folded-down sails of the boats. At this stage other phrases and details may occur to the poet. Might the word "collection" now go in somehow? Might "away from the wind"—an alteration of "tucked out of the wind"—work somewhere? What about the rhythm? Working through such questions, the poet writes the poem. Here is the poet's revision:

> A collection of white, yellow, red
> sailboats—bugs with wings
> folded down their backs.

in rows.
A tall pin 5
sticks each to the blue-green mat.

This version adds a detail—"in rows"—that both focuses the picture and helps
support the metaphor. The poet decided to keep the phrase "A collection of," which
sets up the metaphor and prevents a reader from imagining the sailboats as dispersed.

Slackness (wasted words, wasted motions) goes against Anton Chekhov's belief
that "when a person expends the least possible movement on a certain act, that is
grace." Not all poems should be short, of course, nor as short as this poem by Ezra
Pound (1885–1972) which from a thirty-five-line draft became a two-line poem!
But every poem should be as short as possible.

In a Station of the Metro

The apparition of these faces in the crowd;
Petals on a wet, black bough.

Tightening the poem, seeing what can be dropped, what can be rearranged, often
leads the poet to depict more dramatically the elements in a poem. Take a look at
this poem which Wilfred Owen (1893–1918) wrote from the trenches of World War
I. Owen was killed in France just before the armistice:

Dulce et Decorum Est

Bent double, like old beggars under sacks,
Knock-kneed, coughing like hags, we cursed through sludge,
Till on the haunting flares we turned our backs
And towards our distant rest began to trudge.
Men marched asleep. Many had lost their boots 5
But limped on, blood-shod. All went lame; all blind;
Drunk with fatigue; deaf even to the hoots
Of tired, outstripped Five-Nines° that dropped behind.

Gas! Gas! Quick, boys!—An ecstasy of fumbling,
Fitting the clumsy helmets just in time; 10
But someone still was yelling out and stumbling,
And flound'ring like a man in fire or lime . . .
Dim, through the misty panes° and thick green light,
As under a green sea, I saw him drowning.

In all my dreams, before my helpless sight, 15
He plunges at me, guttering, choking, drowning.

If in some smothering dreams you too could pace
Behind the wagon that we flung him in,
And watch the white eyes writhing in his face,

His hanging face, like a devil's sick of sin; 20
If you could hear, at every jolt, the blood
Come gargling from the froth-corrupted lungs,
Obscene as cancer, bitter as the cud
Of vile, incurable sores on innocent tongues,—
My friend, you would not tell with such high zest 25
To children ardent for some desperate glory,
The old Lie: Dulce et decorum est
Pro patria mori.

8 *Five-Nines:* 5.9-inch caliber shells; 13 *misty panes:* of the gas mask

The horrors that the poem holds out to us form an argument against the glorification of war. The soldier's death by mustard gas makes a compelling case against the motto from the Roman poet Horace, which was popular during World War I: "Dulce et decorum est pro patria mori." This motto can be translated as "Sweet and fitting it is to die for one's country."

If we looked at Owen's drafts of this poem (the originals are held in the British Museum) we can see how Owen coaxed this vivid picture from his material. In early drafts, he labored over these lines that appeared just before the startling second stanza:

Then somewhere near in front: Whew . . . fup, fup, fup,

Gas shells? Or duds? We loosened masks in case,—

And listened. ~~Nothing~~. Far rumouring of Krupp.
 ~~crawling~~ swoosh stung
Then ~~sudden~~ poison[s] ~~hit~~ us in the face.

The anxious soldiers listen for sounds that might indicate gas shells detonating and the poisonous gas descending on them. After fiddling with the lines for a while, Owen crossed all of them out; obviously he saw that beginning the stanza abruptly with "Gas! Gas! Quick, boys!" made the menace fiercer. The soldiers are suddenly engulfed.

Clarity, Obscurity, and Ambiguity

Nobody really champions **obscurity**. "It is not difficult to be difficult," Robert Francis quipped. If what you are saying is worth saying, nothing can be gained (and everything can be lost) by obscuring it. Yes, poems that handle complicated issues may be demanding. All the more reason to be as scrupulously clear as you can. However, if what you are saying turns out to be not really worth saying, readers will not find the poem more compelling if they have to slosh though a swamp. You may feel

what you have to say just seems too obvious to state directly, but don't confuse clarity with the underdeveloped, the simplistic, the unexamined.

In this poem Wallace Stevens (1879–1955) pokes fun at naysayers who simplistically insist "The world is ugly, and the people are sad," and blind themselves to the universe's marvels.

Gubbinal

That strange flower, the sun,
Is just what you say.
Have it your way.

The world is ugly
And the people are sad. 5

That tuft of jungle feathers,
That animal eye,
Is just what you say.

That savage of fire,
That seed, 10
Have it your way.

The world is ugly
And the people are sad.

Through each new metaphor for the sun—"Strange flower," "tuft of jungle feathers," "animal eye," "savage of fire," "seed"—Stevens demonstrates how potent and dazzling the ordinary is. You won't find "gubbinal" in a lot of dictionaries (Stevens loved odd words); a "gubbin" is a small fragment. Ironically, through sentence fragments such as the phrase "That seed," Stevens makes a full case against clichéd thinking, easy notions about the state of the world and its people.

Don't confuse obscurity with **ambiguity,** a poem's ability to offer more than one plausible reading at a time. The connotations of its words, its syntax, the implications of its images, the strength of its metaphors, its use of allusion, its shape and sounds—every aspect of a poem enriches and creates poetry's depth and resonance so we return to a poem again and again, drawing more from it each time.

The beginning poet will find that being clear can be demanding, for what may seem obvious to the poet may be anything but obvious to the reader standing on the outside. We have often watched student poets squirm as class discussions about their poems lead to goofy conclusions about what they meant.

The fault lies sometimes with readers who don't pay close enough attention and so miss a signal. A poem of multiple layers lends itself to multiple readings. Responsible readers try to make sure that their reading of a poem accounts for, or at least does not contradict, each of the poem's features. It's unfair to ignore signals a poem gives about how it should be read in order to make another reading work. In the

poem above, we do a rotten job as readers if we ignore the vigor of images like "tuft of jungle feathers" and take Stevens *literally* to mean that "the world is ugly and the people are sad."

Sometimes obscurity enters a poem accidentally, through a confusing sentence fragment or an infelicity of wording that escaped editing and proofing—for example, a pronoun that doesn't refer to what the poet thinks it does. When readings of a poem cancel each other out—or just lead in totally opposite directions—obscurity rears up. Given several mutually exclusive choices, a reader can become like the proverbial donkey between two piles of hay. It couldn't make up its mind which to eat and so starved to death.

But often the inexperienced poet, in a state of ingenious solitude, has so tangled and hidden the signals in the underbrush that no one can spot them. In this little essay "The Indecipherable Poem," from 1965, Robert Francis describes a situation still common today among men and women poets:

I have no love for the indecipherable poem, but for the indecipherable poet I have often a warm friendly feeling. He is usually a bright chap, perhaps brilliant, a good talker, someone worth knowing and worth watching. He is also often a college undergraduate majoring in English and in love with writing.

In his literature and writing courses it is taken for granted that the significant poets are the difficult ones. So, what less can an undergraduate poet do than be difficult himself?

Difficulty, of course, is not the only virtue of great poets. They give us passion, vision, originality. None of these the undergraduate poet probably has, but he can be difficult. He can be as difficult as he wants to be. He can be as difficult as anybody else. He need only give the words he uses a private set of meanings. It is not difficult to be difficult.

What I mean is, a poem that is very difficult to read may not have been at all difficult to write.

One poem sufficiently difficult can keep a creative writing class busy a whole hour. If its young author feels pleased with himself, can we blame him? He is human. He has produced something as difficult as anything by Ezra Pound. Why shouldn't he be pleased?

If he wants to, he can let his classmates pick away at his poem indefinitely and never set them straight. If his teacher ventures to criticize a phrase or a line, the author can say that the passage is exactly as he wants it. Is it awkward? Well, he intended it to be awkward since awkwardness was needed at that point. This would be clear, he murmurs, to anyone who understood the poem.

Nobody can touch him. Nobody at all. He is safe. In an ever-threatening world full of old perils and new, such security is to be envied. To be able to sit tight and pretty on top of your poem, impregnable like a little castle perched on a steep rock.

Although you may well feel pangs listening to others read your poem in ways you never imagined, try to listen intently. Such readings can show you better how to di-

rect your poem and may lead you to just the insight your poem needs. As you reconsider and revise, avoid "analyzing" your own work; you can't spin around the dance floor if you're staring at your feet.

Bear in mind that readers read in a poem things you did not intend, as well as things you did. With any poem that touches readers, readers will recall their own experiences and tie in their own associations and feelings. These will never be exactly like the poet's, just as one person can never hope to convey to another person the *exact* mental picture of a particular place. (Even pointing out a particular star to someone is hard.) So long as the reader's "poem" doesn't violate or undermine the clues to the poet's "poem," the transaction works. When readers bring themselves to a poem and make it truly their own, they are doing precisely what any poet hopes they will, making the poem come alive.

Questions and Suggestions

1. Write a poem that uses at least five words from side "A" and at least one word from side "B." Make the diction choices appropriate to the context. What happens to your poem when the more formal diction from side B enters the poem?

A		**B**
horsefly	simmer	shriven
shrug	blast	distinction
crumble	maple	articulate
jacket	smudge	codify
oxygen	salt	abduction
rake	oil	warranty
bungle	blunt	numinous
shrink	brake	inscrutable
wire	smelt	bombast
wrangle	strict	alacrity
temper	battery	surly
vine	chalk	epoch

2. Examine carefully how pacing is controlled by the syntax of these poems in the text and in "Poems to Consider," noting the kind, the length, and the deployment of syntactic features like suspension, parallelism, inversion, repetition: Robert Hayden, "Those Winter Sundays" (p. 6); Wilfred Owen, "Dulce et Decorum Est" (p. 13); Czeslaw Milosz, "Realism" (p. 18); Carolyn Kizer, "Shalimar Gardens" (p. 19); Naomi Shihab Nye, "Famous" (p. 20); Mark Doty, "No" (p. 23); Rafael Campo, "*El Día de los Muertos*" (p. 25).

3. Write a poem that begins with one or more long subordinate clauses and ends with a short declarative clause. For instance, "If you could know how nervous . . . , you would not ask me to. . ."

4. Take the poem you wrote in exercise 1 or any other poem you have written, and tighten it. Cut out all of its adjectives and adverbs. Try to cut out one-fourth of the poem. Examine what you have left. What adjectives and adverbs were necessary? Reorder the sentences; refine the diction, rearrange the lines. Can you cut out a fourth more?

5. In a poem everything happens for a reason, even if the "reason" can't be put into words. Examine "Realism" below and consider what the poem would be like if the final line were missing. Then, consider it without the final five lines. What would happen to the poem if the last five lines came first? Take a careful look at "Shalimar Gardens" (p.19) and "Famous" (p. 20). Why do the poems begin and end with the lines that they do? What would happen in "Shalimar Gardens" if the second stanza appeared before the first, or the fourth before the third, or even earlier? In "Famous" what if the fourth stanza ("The tear") appeared where the first now does? What if the sixth ("The bent photograph") line opened the poem? You might want to copy the poems, cut their stanzas apart, and see if you can discover the "logic" of their order.

6. With your notebook open to a clean page, think back to where you lived ten years ago. Look out your favorite window there. What do you see? Make it the first day of summer; it's raining. What does it smell like? What do you hear? Are you wearing shoes? Close your eyes and for five minutes look out that window. When you're finished, jot down what you saw. Now look out another window, twenty years or two years ago. It hasn't rained for weeks. Close your eyes, look, write it down. Then climb out the window and go for a walk. (And take notes.)

Poems to Consider

Realism 1994

CZESLAW MILOSZ (b. 1911)

We are not so badly off if we can
Admire Dutch painting. For that means
We shrug off what we have been told
For a hundred, two hundred years. Though we lost
Much of our previous confidence. Now we agree 5
That those trees outside the window, which probably exist,
Only pretend to greenness and treeness
And that the language loses when it tries to cope
With clusters of molecules. And yet this here:
A jar, a tin plate, a half-peeled lemon, 10

Walnuts, a loaf of bread—last, and so strongly
It is hard not to believe in their lastingness.
And thus abstract art is brought to shame,
Even if we do not deserve any other.
Therefore I enter those landscapes 15
Under a cloudy sky from which a ray
Shoots out, and in the middle of dark plains
A spot of brightness glows. Or the shore
With huts, boats, and, on yellowish ice,
Tiny figures skating. All this 20
Is here eternally, just because once it was.
Splendor (certainly incomprehensible)
Touches a cracked wall, a refuse heap,
The floor of an inn, jerkins of the rustics,
A broom, and two fish bleeding on a board. 25
Rejoice! Give thanks! I raised my voice
To join them in their choral singing,
Amid their ruffles, collets, and silk skirts,
One of them already, who vanished long ago.
And our song soared up like smoke from a censer. 30

Translated from the Polish by the author and Robert Hass.

Shalimar Gardens 1998

CAROLYN KIZER (b. 1925)

In the garden of earth a square of water;
In the garden of waters a spirit stone.

Here music rises: Barbelo! Barbelo!
Marble pavilions border the water.

Marble petals of lotus bevel 5
The edge of the pool.

All about us a green benediction!
God's breath a germination, a viridescence.

From you the heavens move, the clouds rain,
The stones sweat dew, the earth gives greenness. 10

We shiver like peacock's tails
In the mist of a thousand colored fountains

Miraculous water, God's emissary,
Lighting our spring once more!

Here spirit is married to matter. 15
We are the holy hunger of matter for form.

Kizer, you enter the dark world forever
To die again, into the living stone.

Famous 1982

NAOMI SHIHAB NYE (b. 1952)

The river is famous to the fish.

The loud voice is famous to silence,
which knew it would inherit the earth
before anybody said so.

The cat sleeping on the fence is famous to the birds 5
watching him from the birdhouse.

The tear is famous, briefly, to the cheek.

The idea you carry close to your bosom
is famous to your bosom.

The boot is famous to the earth, 10
more famous than the dress shoe,
which is famous only to floors.

The bent photograph is famous to the one who carries it
and not at all famous to the one who is pictured.

I want to be famous to shuffling men 15
who smile while crossing streets,
sticky children in grocery lines,
famous as the one who smiled back.

I want to be famous in the way a pulley is famous,
or a buttonhole, not because it did anything spectacular, 20
but because it never forgot what it could do.

Tahoe in August 1990

ROBERT HASS (b. 1941)

What summer proposes is simply happiness:
heat early in the morning, jays
raucous in the pines. Frank and Ellen have a tennis game
at nine, Bill and Cheryl sleep on the deck
to watch a shower of summer stars. Nick and Sharon 5
stayed in, sat and talked the dark on,
drinking tea, and Jeanne walked into the meadow
in a white smock to write in her journal
by a grazing horse who seemed to want the company.
Some of them will swim in the afternoon. 10

Someone will drive to the hardware store to fetch
new latches for the kitchen door. Four o'clock;
the joggers jogging—it is one of them who sees
down the flowering slope the woman with her notebook
in her hand beside the white horse, gesturing, her hair 15
from a distance the copper color of the hummingbirds
the slant light catches on the slope; the hikers
switchback down the canyon from the waterfall;
the readers are reading, Anna is about to meet Vronsky,
that nice M. Swann is dining in Combray 20
with the aunts, and Carrie has come to Chicago.
What they want is happiness: someone to love them,
children, a summer by the lake. The woman who sets aside
her book blinks against the fuzzy dark,
re-entering the house. Her daughter drifts downstairs; 25
out late the night before, she has been napping,
and she's cross. Her mother tells her David telephoned.
"He's such a dear," the mother says, "I think
I make him nervous." The girl tosses her head as the horse
had done in the meadow while Jeanne read it her dream. 30
"You can call him now, if you want," the mother says,
"I've got to get the chicken started,
I won't listen." "Did I say you would?"
the girl says quickly. The mother who has been slapped
this way before and done the same herself another summer 35
on a different lake says, "Ouch." The girl shrugs
sulkily. "I'm sorry." Looking down: "Something
about the way you said that pissed me off."
"Hannibal has wandered off," the mother says,
wryness in her voice, she is thinking it is August, 40
"why don't you see if he's at the Finleys' house
again." The girl says, "God." The mother: "He loves
small children. It's livelier for him there."
The daughter, awake now, flounces out the door,
which slams. It is for all of them the sound of summer. 45
The mother she looks like stands at the counter snapping beans.

Laws 1984

STEPHEN DUNN (b. 1939)

A black cat wanders out into
an open field. How vulnerable it is,
how even its own shadow
causes it to stop and hunch.
Mice come, hundreds of them, 5

forming a circle around the cat.
They've been waiting for months
to catch the cat like this.
But the cat is suddenly unafraid.
Though the mice have their plans, 10
have worked on tactics and tricks,
none of them moves.
The cat thinks: all I have to do
is be who I am. And it's right.
One quick move 15
and the mice scatter, go home.

After humiliation, home is a hole
where no one speaks. Mouse things
get done, and then there is
the impossibility of sleep. 20
They curse nature, they curse
their small legs and hearts.
We all know stories of how, after
great defeat, the powerless rise up.
But not if they're mice. 25
The cat waits for them in the tall grass.
The mice are constantly surprised.

A Poem of Attrition 1986

ETHERIDGE KNIGHT (1931–1991)

I do not know if the color of the day
Was blue, pink, green, or August red.
I only know it was summer, a Thursday,
And the trestle above our heads
Sliced the sun into black and gold bars 5
That fell across our shiny backs
And shimmered like flat snakes on the water,
Worried by the swans, shrieks, jackknives,
And timid gainers—made bolder
As the day grew older. 10
Then Pooky Dee, naked chieftain, poised,
Feet gripping the black ribs of wood,
Knees bent, butt out, long arms
Looping the air, challenged
The great "two 'n' a half" gainer . . . 15
I have forgotten the sound of his capped
Skull as it struck the block . . .
The plop of a book dropped? The tear of a sheer blouse?

I do not know if the color of the day
Was blue, pink, green, or August red. 20
I only know the blood slithered, and
Our silence rolled like oil
Across the wide green water.

No 1993

MARK DOTY (b. 1953)

The children have brought their wood turtle
into the dining hall
because they want us to feel

the power they have
when they hold a house 5
in their own hands, want us to feel

alien lacquer and the little thrill
that he might, like God, show his face.
He's the color of ruined wallpaper,

of cognac, and he's closed, 10
pulled in as though he'll never come out;
nothing shows but the plummy leather

of the legs, his claws resembling clusters
of diminutive raspberries.
They know he makes night 15

anytime he wants, so perhaps
he feels at the center of everything,
as they do. His age,

greater than that of anyone
around the table, is a room 20
from which they are excluded,

though they don't mind,
since they can carry this perfect
building anywhere. They love

that he might poke out 25
his old, old face, but doesn't.
I think the children smell unopened,

like unlit candles, as they heft him
around the table, praise his secrecy,
holding to each adult face 30

his prayer,
the single word of the shell,
which is no.

The Long Marriage 1997

MAXINE KUMIN (b. 1925)

The sweet jazz
of their college days
spools over them
where they lie
on the dark lake 5
of night growing
old unevenly:
the sexual thrill
of PeeWee Russell's
clarinet; Jack 10
Teagarden's trombone
half syrup, half
sobbing slide;
Erroll Garner's
rusty hum-along 15
over the ivories;
and Glenn Miller's
plane going down
again before sleep
repossess them . . . 20

Türschlusspanik.
Of course
the Germans have
a word for it,
the shutting of 25
the door,
the bowels' terror
that one will go
before
the other as 30
the clattering horse-
hooves near.

El Día de los Muertos 1996

RAFAEL CAMPO (b. 1964)

In Mexico, I met myself one day
Along the side of someone's private road.
I recognized the longing in my face.
I felt the heavy burden of the load
I carried. Mexico, I thought, was strange 5
And very dry. The private road belonged
To friends more powerful than I, enraged
But noble people who like me sang songs
In honor of the dead. In Mexico,
Tradition is as heavy as the sun. 10
I stared into my eyes. Some years ago,
I told myself, I met a handsome man
Who thought that I was Mexican. The weight
Of some enormous pain, unspeakable
Yet plain, was in his eyes; his shirt was white, 15
So white it blinded me. After it all
Became more clear, and we were making love
Beneath the cool sheet of the moon, I knew
We were alive. The tiny stars above
Seemed strange and very far. A dry wind blew. 20
I gave myself to him, and then I asked
Respectfully if I might touch his face.
I did not want to die. His love unmasked,
I saw that I had slept not with disgrace
But with desire. Along the desert road, 25
A cactus bloomed. As water filled my eyes,
I sang a song in honor of the dead.
They came for me. My grief was like a vise,
And in my blood I felt the virus teem.
My noble friends abandoned me beside 30
The road. The sun, awakened from its dream,
Rose suddenly. I watched it as I died,
And felt the heaviness of all its gold.
I listened for the singing in the distance.
A man walked toward me. The story he told 35
Seemed so familiar, pained, and so insistent,
I wished I would live long enough to hear
Its end. This man was very kind to me.
He kissed me, gave me water, held me near.
In Mexico, they sing so beautifully. 40

Dearest, 1969

JEAN VALENTINE (b. 1934)

 this day broke
at ten degrees. I swim
in bed over some dream sentence lost
at a child's crying: the giant on her wall
tips the room over, back: 5
I tell her all I know,
the walls will settle, he'll go.

Holding her fingers, I watch the sky rise, white.
The frost makes about the same lines
on the same window as last winter, 10
quicker, quieter. . I think how nothing's happened,

how to know
to touch a face to make a line
to break the ice to come in time
into this world, unlikely, small, 15
bloody, shiny, is all, is God's good will
I think, I turn to you,
and fail, and turn,

as the day widens
and we don't know what to do. 20

FORM
The Necessary Nothing

Glass

Words of a poem should be glass
But glass so simple-subtle its shape
Is nothing but the shape of what it holds.

A glass spun for itself is empty,
Brittle, at best Venetian trinket.
Embossed glass hides the poem or its absence.

Words should be looked through, should be windows.
The best words were invisible.
The poem is the thing the poet thinks.

If the impossible were not
And if the glass, only the glass,
Could be removed, the poem would remain.

ROBERT FRANCIS

2

VERSE

When we want to write poems, we usually set out by writing verse. But why does that help? What is *verse?*

When you open a book, you know at once whether you are looking at prose or verse. Prose is rectangular and comes in blocks. Prose fills the page from the left margin to a straight right margin set arbitrarily, *externally*, by the printer, not by the writer. The printer determines when a new line begins, and the wider the page, the longer the line. Prose trains readers to pay no attention to the movement from line to line.

Poetry, however, pays attention to that movement. **Verse** is a system of writing in which the right margin, the line turn, is set *internally*, by something in the line itself. Thus, no matter how wide the page, the line remains as the poet intended. The poet, not the printer, determines the line.

The Greek word for measure is *meter* (as in *thermometer,* "heat measure"). In poetry the word *meter* traditionally refers to the conventions of verse by which poets measure their lines (for instance, iambic pentameter). *All* verse, though, even what is called "free" verse, has measure—some rationale or system by which the poet breaks lines. The choices may be intuitive or trained, but the nature of verse calls poets to use a perception of the identity of each line, even if they cannot articulate the reasons.

This vital aspect of verse appears in the etymology of the word itself. *Verse* comes from the Latin *versus,* which derives from the verb *versare,* meaning "to turn." (The root also appears in words like *reverse,* "to turn back," or *anniversary,* "year turn.") Originally the past participle *versus* literally meant *"having turned."* As a noun it came to mean *the turning of the plough,* hence *furrow,* and ultimately *row* or *line.* Thus, the English word *verse* refers to the *deliberate turning from line to line* that distinguishes verse from prose. In this age-old image, like the farmer driving ox and plough, the poet plants the seeds of sound and meaning row by row, guided by the line just done, aware of the line to come, and so enabling the cross-pollination that enriches the poem for a reader's harvesting.

The deliberate turning of lines adds an essential element to verse. The rhythm of prose is simply the linear cadence of the voice, a flow patterned only by the phrases and clauses that are the units of sentences. In verse, however, the cadence of sen-

tences also plays over the additional, relatively fixed unit of **line.** Reading verse, the voice also pauses ever so slightly at line ends, as if acknowledging the slight muscular shifting of the eye back to the left margin. (Words that end lines receive relatively more emphasis than words in the middle of the line.) The element of line thus empowers the poet with a fresh way to pattern and vary the flow of language.

Line breaks may coincide with grammatical or syntactical units. Such breaks reinforce regularity and emphasize normal speech pauses.

> and eddieandbill
> come running
> from marbles and piracies
> and it's spring

Line breaks also may occur within grammatical or syntactical units, creating pauses and introducing unexpected emphases.

> and eddieandbill come
> running from marbles and
> piracies and it's
> spring

When the end of a line coincides with a normal speech pause (usually at punctuation), the line is called **end-stopped,** as in these lines by Wallace Stevens (1879–1955) from "Sunday Morning":

> We live in an old chaos of the sun,
> Or old dependency of day and night,
> Or island solitude, unsponsored, free,
> Of that wide water, inescapable.

Lines that end without any parallel to a normal speech pause are called **enjambed** (noun: **enjambment),** as between each of these pairs of lines:

> Deer walk upon our mountain, ‖ and the quail
> Whistle about us their spontaneous cries . . .

> At evening, ‖ casual flocks of pigeons make
> Ambiguous undulations as they sink . . .

A **caesura** (‖), a normal speech pause that occurs within a line, produces further variations of rhythm and counterpoint not possible in prose.

By varying end-stop, enjambment, and caesura and by playing sense, grammar, and syntax against them, the poet may produce fresh rhythms. Note how, in this passage from *Paradise Lost,* John Milton (1608–1674) creates an effect of free-falling with these devices:

> Men called him Mulciber: and how he fell
> From Heaven they fabled, thrown by angry Jove
> Sheer o'er the crystal battlements: from morn
> To noon he fell, from noon to dewy eve,
> A summer's day, and with the setting sun 5
> Dropt from the zenith, like a falling star,
> On Lemnos, th' Aegean isle.

The syntactical pauses, or divisions of the action, occur within the lines; and the line ends primarily enjamb.

Line

The poet's sensitivity to line is a large part of what makes poetry, as Paul Valery puts it, "a language within a language." Consider this quatrain written by an anonymous, sixteenth-century poet and now called "Western Wind."

> Western wind, when wilt thou blow,
> The small rain down can rain?
> Christ, if my love were in my arms
> And I in my bed again!

In love and away from home, the speaker longs for spring when he and his lover will be reunited. Speaking *to* the wind suggests isolation and distance as well as loneliness. Both wind and the "small rain" are personified. (**Personification** means treating something inanimate as if it had the qualities of a person, such as gender—or here—volition.) So "can rain" implies that the rain shares the speaker's impatience. Direct address to the wind also suggests that the exclamatory "Christ" in line 3 is, in part, a prayer. The speaker's world is a world of forces—wind, rain, Christ—and his passion makes the human also a force among forces. The incomplete conditional of lines 3–4 conveys more by implication than something explicit but passive like "we will be in bed together." The speaker's singular "I in my bed again" makes him seem at once vigorous and, because the phrase is witty understatement, unintimidated by circumstance.

The compression of verse calls for staying alert—word by word, line by line—for attention that we rarely give to prose, which is habitually discursive and given to adding yet something further, drawing us onward to what is next and then next and next again. Prose, like a straight line, extends to the horizon. Verse draws us spiraling into itself.

This reflexiveness of verse causes us to *feel* a poem's rhythm as we seldom do with prose. All but two syllables in lines 1–2 (the second syllable of "Western" and "The") are heavy. The lines are slow, dense, and clogged, expressing the ponderousness of waiting. By contrast, lines 3–4 offer light syllables; only "Christ," "love," "arms," "I," and "bed" have real weight. The lines leap forward, expressing the speaker's eagerness. The poet's measuring of lines helps to measure feeling. Rhythm

is meaning. The "equal" lines of verse differ tellingly from one another in a way that the looser elements of prose cannot imitate. The lover's desire carries its own music with it.

The following poem shows how verse invites our attention line by line, adding a spatial dimension that prose cannot imitate. One of a number of "chansons inno-centes," this poem is by the indefatigable experimenter who elsewhere brilliantly wrote "mOOn," E. E. Cummings (1894–1962).

in Just

in Just-
spring when the world is mud-
luscious the little
lame balloonman

whistles far and wee 5

and eddieandbill come
running from marbles and
piracies and it's
spring

when the world is puddle-wonderful 10

the queer
old balloonman whistles
far and wee
and bettyandisbel come dancing

from hop-scotch and jump-rope and 15

it's
spring
and
 the

 goat-footed 20

balloonMan whistles
far
and
wee

Cummings uses line and word spacing to choreograph the rhythms visually. Most obvious is the speeding of words run together, "eddieandbill," "bettyandisbel," as the children "come running" or "come dancing"; and the slowing (and so distancing) of words open-spaced, like "whistles far and wee" in line 5. This adverbial phrase is repeated twice, spaced differently for increasing emphasis:

> far and wee

then, with a line for each word at poem's end:

> far
> and
> wee

This repetition-with-variation seems appropriate for a poem about the cycle of sea-
sons and return of spring. We notice also that "in Just- / spring"—where the strong,
hyphenated enjambment (and then extra space in line 2) suggests how it is *barely*
spring yet—is picked up in lines 8–9 by

> and it's
> spring

and again in lines 15–18 by

> and
> it's
> spring
> and

The poem establishes its own conventions and, once established, can vary them. For
example, the poem alternates four- and one-line stanzas, suggesting a slower-faster-
slower pace. The identations and stanza breaks of lines 18–21—

> and
> the
>
> goat-footed
>
> balloonMan whistles

—suggest a slow, almost dragging gait.

The poem's lack of punctuation (except for apostrophes and hyphens) lets it end
without the finality a period might imply. And the convention of using lowercase
throughout is significantly varied in "Just-" and "balloonMan." The first perhaps
seemed only for added emphasis. At line 21, however, the capitalized words seem
intentionally linked to mean that the seller of balloons is *just* a *man*—not, as we sud-
denly realize that the poem has been quietly suggesting, the goat-footed and licen-
tious god Pan.

"in Just-" is an extreme instance, but the inimitable effect of any poem derives
from the *lines* of its verse. Cutting across the sentences, the lines give to every poem
its essential difference.

Form

The idea of form takes us deep into the mystery of every art. Symmetry pleases us, as children delight in colored blocks of wood; and rhythm lets us remember, as with the little verse about which months have thirty days. Form preserves content. At its best, form somehow *expresses* content. Ideally, it is the necessary nothing, the pressure, that transforms the ordinary carbon into diamond.

We may think of poetic form as being of two kinds, metrical and nonmetrical. Both make good poems. As Robert Lowell remarked, "I can't understand how any poet, who has written both metered and unmetered poems, would be willing to settle for one and give up the other." The two turn out to be far more alike than different, despite the oppositional, loaded terms sometimes used to refer to them: "closed" and "open," "fixed" and "free," "solid" and "fluid" or "organic." Such terms tend to misrepresent the way poems are actually written. The process, in which scattered thoughts, phrases, images, insights, and so on, gradually come together into a poem, is always open, free, and fluid at the beginning and becomes, as the poem finds its form, finally closed, fixed, and solid. Cummings's "in Just-" is ultimately no more organic, no less artificial, than "Western Wind." As Paul Lake points out in a fine essay, "The Shape of Poetry," even "the rules of formal poetry generate not static objects like vases, but the same kind of bottom-up, self-organizing processes seen in complex natural systems such as flocking birds, shifting sand dunes, and living trees." As Lake notes, the process is also top-down since the poet's ideas of what a poem is or might be—the poems he or she admires—enter the loop of self-adjustment and feedback. Acorns grow into oaks, not dogwoods. The poet inevitably borrows and varies, and so re-creates, formal elements that occur in earlier poems, as Cummings does, for instance, with the devices of enjambment, stanza, and refrain. In every successful poem, the poet actively *achieves* the final form.

In writing Sonnet 73, William Shakespeare (1564–1616) is as much shaping the quatrains and couplet of the form as using them to find the shape of his material, in the way that a good interviewer's questions draw a coherent account from a witness.

> That time of year thou mayst in me behold
> When yellow leaves, or none, or few, do hang
> Upon those boughs which shake against the cold,
> Bare ruined choirs° where late the sweet birds sang.
> In me thou see'st the twilight of such day 5
> As after sunset fadeth in the west,
> Which by-and-by black night doth take away,
> Death's second self that seals up all in rest.
> In me thou see'st the glowing of such fire
> That on the ashes of his youth doth lie, 10
> As the deathbed whereon it must expire,
> Consumed with that which it was nourished by.

> This thou perceiv'st, which makes thy love more strong,
> To love that well which thou must leave ere long.

4 *choirs*: choir lofts

The theme is the speaker's aging. He compares his age to three things: autumn, the dying of the year; twilight, the dying of the day; and glowing ashes, the dying of the fire. The three quatrains emphasize the threefold comparison. The couplet at the end, with its difference in tone, presents a resolution of the problem offered in the quatrains. Form and content support each other.

Note that the order of the comparisons corresponds to a mounting anguish. The poem moves, first, from a bare winter-daylight scene to a twilight scene, and then to a night scene, the time when a fire is allowed to die. The progression from day to dusk to night emphasizes the image of night as "Death's second self" and possibly suggests night as the time one most fears dying.

Another progression works through the three images: Each of the *dyings* is shorter and more constricted than the last, as though the speaker were aware of the quickening of death's approach. The first comparison is to a dying season, the second to a dying day, and the third to a dying fire. In its preoccupation with time, the first quatrain looks backward to summer, when "late the sweet birds sang." The second looks forward to "Death" explicitly and inevitably ("by-and-by"). The third imagines the coming night/death, when death is no longer a prospect but a reality: "deathbed." The images echo a story of an aging man's death during the night after a cold winter day.

The constraint of the sonnet form dramatically matches that of the speaker. He addresses the trouble of aging only indirectly, through inanimate images, as if to hold its personal implications at a distance. The apparent composure is, however, deceptive. Each of the three images begins with a more positive tone than it ends with. The increasingly self-diminishing revisions in line 2 offer a clear example: "yellow leaves, or none, or few." The yellow leaves, like the "twilight" and the "glowing" of the fire, attempt an optimism that the speaker cannot maintain. In each of the images he is compelled to say what he originally seems to have wanted to withhold, even from his own consciousness.

Intended as a compliment to the person addressed, the couplet begins on a positive note: "This thou perceiv'st, which makes thy love more strong." But the next line betrays the speaker's fears because he does not say, as we might expect, "To love that well which thou must *lose* ere long"; rather, "To love that well which thou must *leave* ere long." He sees his death as his friend leaving him, not the other way around. Throughout the poem, the speaker has expressed, not his self-image, but what he imagines to be his friend's image of him: "thou mayst in me behold," "In me thou see'st," and "This thou perceiv'st." By "leave" in line 14 he need not mean more than "leave behind," but the bitter taste of jealousy is on the word. He does not say, "To love *me* well *whom*," nor even "To love *him* well *whom*," but "To love *that* well *which*." The poet refers to himself as a thing, as though time had robbed

him, in his friend's eyes, of selfhood. The compliment remains, of course, but we feel a swirl of dramatic currents beneath its surface. Note the rigidity of rhythm in the couplet when we mark the pattern of accents:

> Thís thóu percéiv'st, ‖ which mákes thy lóve more stróng,

> To lóve that wéll ‖ which thóu must léave ere lóng.

Both lines pause at the same place, after the fourth syllable, and in both there are three accents before and three accents after the caesuras. The sense of unrelieved feeling resounds in that grim exactitude.

Delicate precision of content can also occur in a nonmetrical poem:

A Noiseless Patient Spider
WALT WHITMAN (1819–1892)

A noiseless patient spider,
I marked where on a little promontory it stood isolated,
Marked how to explore the vacant vast surrounding,
It launched forth filament, filament, filament, out of itself,
Ever unreeling them, ever tirelessly speeding them. 5

And you O my soul where you stand,
Surrounded, detached, in measureless oceans of space,
Ceaselessly musing, venturing, throwing, seeking the spheres to connect them,
Till the bridge you will need be formed, till the ductile anchor hold,
Till the gossamer thread you fling catch somewhere, O my soul. 10

The spacious lines, unreeling loosely out across the page, correspond to the long filaments the spider strings out into the wind when it is preparing to construct a web. The two stanzas, like paragraphs, one for the spider, one for the soul's "musing, venturing, throwing, seeking," shape the poem's central comparison.

Each stanza has five lines. Notably, the first line in each is shorter than the other four, as if to suggest the outward flinging and lengthening of the spider's filaments and of the soul's "gossamer thread." Each of the first lines has three accents: "Ă nóiseless pátient spíder," "Ănd yóu Ŏ mў sóul whĕre yŏu stánd." Perhaps the *extra* unstressed syllables between the stresses of line 6 imply a greater urgency or importance in the soul's daring. The lines of stanza 2 are also, we see, generally longer than the lines of stanza 1.

The poem does not present the comparison mechanically, however. The spider's activities, described in stanza 1, are neither explained nor resolved until the last line of stanza 2. The success of the soul's "gossamer thread," catching and anchoring, implies a similar success for the spider. Notice the verbal echoes between various words in the two stanzas: "stood"/"stand," "surrounding"/"Surrounded," "tirelessly"/"Ceaselessly." Similar links bridge the images, as in the contrast of small to grand scale with

"on a little promontory," followed in stanza 2 by "measureless oceans of space." After "promontory" (a headland or cliff jutting out into the ocean), the images of "oceans of space," "bridge," and "anchor" lend unity to the comparison. Like the spider's action, the poem's apparent randomness is in fact careful and purposeful.

Alliteration and assonance give some of the lines a unity of sound and emphasize their filamentlike linearity: the alliteration of *l*'s and *f*'s in line 4, for instance, or the assonance of long *e*'s in "unreeling" and "speeding" in line 5, or the almost-rhyme of "*Cea*selessly" and "*see*king" in line 8. Rhythm completes the effect. In lines 7–10 the *progression* of the caesuras toward the line ends gives an almost tactile impression of the filaments' lengthening toward ultimate contact.

> Surroúnded, ‖ detáched, ‖ in meásureless óceans of spáce,
>
> Ceáselessly músing, ‖ vénturing, ‖ thrówing, ‖ seéking the sphéres to connéct them,
>
> Till the brídge you will neéd be fórmed, ‖ till the dúctile ánchor hóld,
>
> Till the góssamer threád you flíng cátch sómewhere, ‖ O my soúl.

If we count stresses per phrase, we may show the rhythm this way:

> 1/1/3
> 2/1/1/3
> 3/3
> 5/1

At the ends of lines 7–8, the longer three-stress phrases suggest the soul's thread reaching outward; and the two three-stress phrases of line 9 repeat and extend this action, as does the significantly longer five-stress phrase that begins line 10. So the short, one-stress phrase ending line 10 indicates or implies success—the catching, the making contact—in the triple partial-rhyme *hold-O-soul*. In short, lines 7–8 establish a local rhythmic norm which Whitman varies in lines 9 and 10 to surprising effect.

Excellence depends less on a choice between metrical and nonmetrical than on the poet's skill in using either sort of form.

Balance, Imbalance

Form is a poem's—a poet's—way of letting us notice things. The rhythm of packed, heavy syllables in lines 1–2 of "Western Wind," for instance, contrasts with the quick, lighter rhythm of lines 3–4, showing different tones in the speaker's complex feelings (delay, expectation). The *b*'s, hard *c*'s, and long *a*'s in Shakespeare's "boughs which sh*a*ke against the cold, / Bared ruined choirs where late the sweet birds sang"

subtly link important ideas. The imbalances and enjambments in Milton's lines about Mulciber give the illusion of falling in space.

A line, as the basic unit of verse, has its own structure, a vital element of which is balance or imbalance; and, as in the ending of "A Noiseless Patient Spider," several lines may develop a complex pattern in which rhythm becomes meaning. One feels, for example, the antitheses and strict balancing of parts in these lines from a comic poem about a lover's snipping a lock of the heroine's hair, "The Rape of the Lock" by Alexander Pope (1688–1744):

> Whether the nymph shall break Diana's Law,
> Or some frail *China* Jar receive a Flaw,
> Or stain her Honour, or her new Brocade,
> Forget her Pray'rs, or miss a Masquerade,
> Or lose her Heart, or Necklace, at a Ball . . .

The irony of course lies in treating the important and the trivial with equal significance: to lose her chastity or to chip a China jar, to stain her honor or a mere brocade, and so on. The first contrast balances in two lines, but then the madness of misplaced values escalates and each line contains its own pithy contrast. The rigidly repeated number of accented syllables on each side of the caesuras underlines the balance rhythmically:

Or stáin her Hónour, ‖ (́) or her néw Brocáde, 2/3

Forgét her Práy'rs, ‖ or míss a Másquerá(́)de, 2/3

Or lóse her Héart, ‖ or Nécklace, (́)at a Báll . . . 2/3

The balance or imbalance may be—and usually is—a good deal subtler than in Pope's amusing lines, and it may function equally in metrical or nonmetrical poems. In an elegant essay, "Listening and Making," Robert Hass points out the rhythmical imbalance in these lines from Whitman's "Song of Myself":

I lóaf and invíte my sóul, 3

I léan and lóaf at my éase ‖ obsérving a spéar of súmmer gráss. 3/4

The rhythm of the first line (three accents) is essentially repeated by the first part of the second line (three accents); but the second part not only extends the line but does so by *four* accents. Commenting on his stresses-per-phrase scansion, Hass adds, "Had Whitman written *observing a spear of grass*, all three phrases would be nearly equivalent . . . ; instead he adds *summer*, the leaning and loafing season, and an-

nounces both at the level of sound and of content that this poem is going to be free and easy."

As a further example Hass offers this little poem by Whitman:

A Farm Picture

Through the ample open door of the peaceful country barn,	3/3
A sunlit pasture field with cattle and horses feeding.	3/3
And haze and vista, and the far horizon fading away.	2/4

Each line has six accents, divided (by a light phrasal pause or caesura in lines 1 and 2) as indicated. The asymmetry of line 3 (2/4) effectively resolves the pattern (as a 3/3 version of the line might not), releasing the tension, letting the rhythm come to rest in the longer, four-accent phrase, "and the far horizon fading away."

We may take the point further. Lines 1–2, linked by more than their parallel, balancing rhythms, make up one of the poem's two sentences; and together they present the speaker's place—the frame of the open barn doorway, "the cattle and horses feeding" seen at a middle distance. The appearance is of order and plenty; the barn is "ample," "peaceful," the pasture sunny. However, if we can intuit the speaker's feelings in the symmetric rhythms of the verbless, actionless sentence, the scene seems also static and unsatisfying.

The asymmetry of rhythm in line 3 suggests what troubles him as his eyes rise to glimpse it: "haze and vista, and the far horizon fading away." He is drawn to the uncertain and far-off, because it represents possibilities either longed for or unrealized ("fading"). Perhaps he pauses from his work. His vantage point, within the shade of the barn, suggests an unexpected melancholy, a sense of incompleteness, as the poem ends with a lingering attention to what is both distant and vanishing.

In the previous examples, lines are end-stopped. In this poem by Louise Glück (b. 1943), however, a number of lines break very forcefully. Observe how the enjambment interacts with the lines' often striking imbalance:

The Racer's Widow

The elements have merged into solicitude.	
Spasms of violets rise above the mud	
And weed and soon the birds and ancients	
Will be starting to arrive, bereaving points	
South. But never mind. It is not painful to discuss	5
His death. I have been primed for this,	
For separation, for so long. But still his face assaults	
Me, I can hear that car careen again, the crowd coagulate on asphalt	
In my sleep. And watching him, I feel my legs like snow	
That let him finally let him go	10
As he lies draining there. And see	
How even he did not get to keep that lovely body.	

Enjambments that flow to caesuras very near beginnings of lines (like "But still his face assaults / Me,") produce abrupt stops, giving the rhythm an extreme effect of jerking forward and then dead-ending, of careening around corners, like a car almost out of control. The device also appears monosyllabically in "bereaving points / South." And it occurs less sharply in ". . . above the mud / And weed," ". . . discuss / His death," ". . . on asphalt / In my sleep," and—going the other way, from a caesura near line end—in "And see / How even he . . ." The poem's rhythm seems quite off-balance, especially in

For separation, ‖ for so long. ‖ But still his face assaults 2/2/3

Me, ‖ I can hear that car careen again, ‖ the crowd coagulate on asphalt 1/4/5

In my sleep. ‖ And watching him, ‖ I feel my legs like snow 1/2/3

That let him finally let him go 4

The repetition in line 10—"That let him finally let him go"—needs, but has no, punctuation, and so appears syntactically incoherent. The "snow-go" rhyme makes us notice, suddenly, that the poem is meant to rhyme in couplets throughout, but does so only inexactly—"solicitude-mud," "ancients-points," and so on.

The widow contradicts her assertion that "It is not painful to discuss / His death" not only through the lurching rhythm, but also through her imagery that suggests how distraught she really is ("Spasms of violets"), through her almost compulsive alliteration ("I can hear the car careen again, the crowd coagulate . . ."), and through her internal rhyming that culminates in "And *see* / How *even* he did not get to *keep* that lovely body." Everything in the poem works to convey the widow's repressed but ill-concealed emotional turmoil.

A quite different impression emerges in the rhythm of the following poem by Elizabeth Spires (b. 1952). The speaker, three months pregnant, meditates languorously.

Letter in July

My life slows and deepens.
I am thirty-eight, neither here nor there.
It is a morning in July, hot and clear.
Out in the field, a bird repeats its quaternary call,
four notes insisting, *I'm here, I'm here.* 5
The field is unmowed, summer's wreckage everywhere.
Even this early, all is expectancy.

It is as if I float on a still pond,
drowsing in the bottom of a rowboat,

curled like a leaf into myself. 10
The water laps at its old wooden sides
as the sun beats down on my body,
a wand, an enchantment, shaping it
into something languid and new.

A year ago, two, I dreamed I held 15
a mirror to your unborn face and saw you,
in the warped watery glass, not as a child
but as you will be twenty years from now.
I woke, a light breeze lifting the curtain,
as if touched by a ghost's thin hand, 20
light filling the room, coming from nowhere.

I know the time, the place of our meeting.
It will be January, the coldest night
of the year. You will be carrying a lantern
as you enter the world crying, 25
and I cry to hear you cry.
A moment that, even now,
I carry in my body.

The sense of stasis in Spires's poem is very strong. Most of the lines are end-stopped; five of the seven lines in stanza 1 are complete sentences. Scanning lines 1 and 2 shows:

My lĭfe slŏws and dĕepens. 3

Í ăm thírtў-éight, ‖ néithĕr hére nŏr thére. 3/3

Not only do the two phrases of line 2 repeat the three-stress pattern of line 1, but, as the breves (˘) indicating unaccented syllables show, the pacing of the three stresses in each phrase is the same. The poem ends with a similar balance:

A móment thát, ‖ éven nów, 2/2

Ĭ cárrў ĭn mў́ bódў. 2

The pattern of stressed and unstressed syllables in line 28 is entirely symmetrical.

Enjambments tend to be mild, like the one linking lines 11 and 12, which connects full clauses. Caesuras usually occur midline, suggesting balance. One exception, line 13—"a wand, an enchantment, shaping it"—evokes balance in a different way by framing the central phrase; and the enjambment of "shaping it / into something languid and new" seems quietly expressive, implying transformation. So, too, with the early caesura in line 19, where the imbalance suggests the suddenness of waking, then the mild disturbance of the breeze-lifted curtain; and in any case, the

imbalance is quickly absorbed by the ensuing end-stops and by the symmetrical, mirror-rhythm phrases of line 21:

light filling the room, ‖ coming from nowhere.

The informal stresses-per-phrase scansion we have been using helps to describe the rhythmic structure of lines long enough to have two or more phrases or clauses (and so one or more caesuras). It can tell us little about shorter lines without caesura, like Spires's "I carry in my body." In noting that this line is symmetrical, we are already using another informal method of scansion—*for short lines*—in which we mark both accented and unaccented syllables. We then look for what may be called *drag, advance,* or *balance* of each line—the pacing of the stresses, in effect, or how the weight of syllables is distributed. (Drag has also been called a *falling line;* advance, a *rising line.*) **Drag** is the backward leaning or tilt of a line's weight (accented running to unaccented syllables); we mark it by an arrow pointing left (←). **Advance** is the forward leaning of a line (unaccented running to accented syllables); the arrow points right (→). In a drag line, accented syllables predominate in the first half; in an advance line, they predominate in the second half. And **balance** is a symmetrical pattern of accented and unaccented syllables, that is, leaning neither backward nor forward; the arrow points left and right (↔). Spires's last line, for instance, being symmetrical, shows balance and so would be marked:

I carry in my body. ↔

Scanning two other lines shows:

drowsing in the bottom of a rowboat, →

curled like a leaf into myself. ↔

In the first of these, the weight leans forward, showing advance. In the second, the symmetrical distribution registers as balance. The repeated looping of three unstressed syllables between stresses gives the first line a leisurely rhythm, which slows in the two stresses of "rowboat," where the assonance of long *o*'s emphasizes the pause of the end-stop. The rhythm of the second line seems equally appropriate—the paired accents at midline suggesting a folding in or protectiveness.

Consider, finally, this little poem by William Carlos Williams (1883–1963):

Complete Destruction

It was an icy day.
We buried the cat,

then took her box
and set match to it

in the back yard.
Those fleas that escaped
earth and fire
died by the cold.

Properly, short sentences and terse, end-stopped phrases evoke the bleak scene. In shape, the first quatrain is rigid, boxlike; and the just slightly longer line 6—with the word "escaped"—only for a moment breaks the spatial frame.

We would mark the poem this way:

Ĭt wăs ăn ícў dáy. →

Wĕ búrĭed thĕ cát, →

thĕn tóok hĕr bóx →

ănd sét mátch tŏ ít →

ĭn thĕ báck yárd. →

Thóse fléas thăt ĕscáped ←

éarth ănd fíre ↔

díed bў thĕ cóld. ↔

After five lines showing advance, line 6 decisively shifts to showing drag; and—notably—lines 7–8 show balance, bringing the pattern of line rhythms to a complete standstill. The poem's everyday diction and usage are, as Williams might say, in the American idiom. His quiet art of line and stanza, of verse, lets us listen to a subtle music normally hidden in our plain speech.

◈ ◈ ◈

Questions and Suggestions

1. Here are two poems printed as prose. Experiment with turning them into verse by dividing the lines in different ways. What different effects can you create? The originals, as well as all further notes to the Questions and Suggestions, can be found in Appendix II (pp. 337–343).

a) Theology

There is a heaven, for ever, day by day, the upward longing of my soul doth tell me so. There is a hell, I'm quite as sure; for pray, if there were not, where would my neighbors go?

b) Liu Ch'e

The rustling of the silk is discontinued, dust drifts over the court-yard, there is no sound of foot-fall, and the leaves scurry into heaps and lie still, and she the rejoicer of the heart is beneath them: a wet leaf that clings to the threshold.

2. In his *Autobiography*, Benjamin Franklin reports how he trained as a writer by reading carefully several times, but not memorizing, a passage of prose he admired; then, after putting it aside for a time, *writing it himself in his own words*. Comparing his version with the original was often instructive—and occasionally he thought he had improve it! Try this experiment with a *poem* you like but don't know very well.

3. Choose a poem of your own that you aren't really satisfied with and experiment with its form. Rearrange the sentences into lines either much shorter or much longer than in the original version. Try breaking the poem into stanzas of two, then three lines, and so on. If something *feels right*, you may have found a way to start the poem going again.

4. Write a poem either (a) in strictly alternating lines of seven and five *words* in length, or (b) in stanzas progressively one line shorter or one line longer than the first one. What difficulties do you find? What opportunities? Such merely arbitrary, mechanical patterns (to work with or against) can often be a helpful control in composition.

5. Browse in an encyclopedia to find an item that interests you, and write a poem using the information. Maybe: brown recluse spider, Sarajevo, griffin, or Charles, 2nd Earl Grey (after whom a tea was named).

6. In a library, see if you can find a reproduction of Gustav Klimt's famous painting *The Kiss*. Is Marta Tomes's poem (p. 53) faithful to it? Might a painting give you a good subject for a poem? (*Voices in the Gallery*, Dannie and Joan Abse, eds., The Tate Gallery, 1986, is a lively collection of poems and the works of art on which they are based.)

7. Consider formal choices the poets have made in several of the poems in Poems to Consider (pp. 45–53)—line and stanza, caesura, end-stopping or enjambing, balance or imbalance. For instance, note the differing uses of indenting lines in Richard Wilbur's "Hamlen Brook," Ann Townsend's "Day's End," and Peggy Shumaker's "Chinese Print: No Translation." Study William Wordsworth's use (or lack of) caesuras in the lines of "Composed upon Westminster Bridge, September 3, 1802," and Conrad Hilberry's use of balance and imbalance in "Storm Window." At the end of a poem in cou-

plets, "The Kiss," what does Marta Tomes's final one-line stanza imply or suggest?

Several of the poems are also linked in subject matter, theme, or characters, and comparing them may help discover the poet's strategy in each. For instance, Wordsworth's sonnet and Gerald Costanzo's "The Sacred Cows of Los Angeles" are both cityscapes (London, L.A.). To what different purposes do spiders appear prominently in Elizabeth Kirschner's "These Heady Flowers," as well as in Whitman's "A Noiseless Patient Spider" (p. 36)? How do these poems' tones differ? How might Housman's "Loveliest of Trees" and Deborah Allbery's "Outings" be similar, not to mention Peter Klappert's "Scattering Carl"? How might the characters in Ann Townsend's "Day's End," Wallace Stevens's "Two Figures in Dense Violet Light," Peggy Shumaker's "Chinese Print: No Translation," and Marta Tomes's "The Kiss" be compared?

Poems to Consider

Loveliest of Trees 1896

A. E. HOUSMAN (1859–1936)

> Loveliest of trees, the cherry now
> Is hung with bloom along the bough,
> And stands about the woodland ride
> Wearing white for Eastertide.
>
> Now, of my threescore years and ten, 5
> Twenty will not come again,
> And take from seventy springs a score,
> It only leaves me fifty more.
>
> And since to look at things in bloom
> Fifty springs are little room, 10
> About the woodlands I will go
> To see the cherry hung with snow.

Outings 1991

DEBRA ALLBERY (b. 1957)

> I remember asking *Why go*
> *for a ride just for a ride? Why walk*
> *through cemeteries reading the stones?*
> I was five. We had driven out past their old farm,
> then left our cars along the main road— 5
> my aunt, uncle, grandfather, cousins,
> my parents. We chewed sassafras roots

My grandfather pulled up and peeled
as we shuffled the hot chalk of the road.
Then we came to two private gardens 10
of graves, mowed, shaded. Our parents
nodded at some of the names
while we children murmured how pretty
the marble, how long ago the years,
as we edged between where the bodies were buried. 15

I found my own name and age, a girl
dead in the spring of 1860.
Read her marker aloud in my new-reader voice:
Deborah, 5 years, She hath done what she could.

When I got older I would stay 20
in the car on our visits to Greenlawn,
where an uncle and cousin had since been taken.
Winter, my sister would sit in my lap.
I remember her asking *Why*
do we have to go to this place? 25
I said *Because*, our breaths frosting the windows.
And when we drove away she and I drew pictures
on the glass. With gloved fingers
we wrote our autographs and watched
what was passing beyond the spaces 30
our names had cleared.

Scattering Carl 1999

PETER KLAPPERT (b. 1942)

The lid to the metal box has slipped
off the fallen tree and into the weeds.
The half-filled box of Carl sits
open to the air.
 As the ashes fell,
you could see fragments of bone—femur 5
or thigh, perhaps—delicate
shell-like curves, none larger
than a coin or an end of kindling,
and all grey-white.

 Open to the air and light.

 Now each of us takes a turn 10
watering the tree again, and Bill says
Let's sit here a moment,

as he eases himself heavily
down to the sloping ground, among the small flowers.
I've finally remembered their name 15
—common speedwell.

Composed upon Westminster Bridge, September 3, 1802

WILLIAM WORDSWORTH (1770–1850)

Earth has not anything to show more fair;
Dull would he be of soul who could pass by
A sight so touching in its majesty:
This City now doth, like a garment, wear
The beauty of the morning; silent, bare, 5
Ships, towers, domes, theatres, and temples lie
Open unto the fields, and to the sky;
All bright and glittering in the smokeless air.
Never did sun more beautifully steep
In his first splendour, valley, rock, or hill; 10
Ne'er saw I, never felt, a calm so deep!
The river glideth at his own sweet will:
Dear God! the very houses seem asleep;
And all that mighty heart is lying still!

The Sacred Cows of Los Angeles 1982

GERALD COSTANZO (b. 1945)

As if it had never happened
an old Angeleno will remember
the coming of the word *smog*.

How in 1948 a meteorologist
predicted the end of the past 5
in four letters. How the sacred

cows brought with them traffic
lights and street signs, cross-
walks and the dotted line,

which after a while they began 10
to ignore. Pausing at corners,
they'd drool a pool of oil

and maybe etch a rubber patch,
leaving. They were fed
whatever it took. They were washed 15

and shined. At night they'd idle
through La Cienega or watch
from a lovers' lane over

the cool Pacific. They'd snooze 20
beneath the flickering face
of the Escondido Drive-In

or sleep in garages, nestled
in the waning fumes—safe,
a few hours, from the future, safe

from the sight of the full moon, 25
a pomegranate resting
on the hazy lip of Los Angeles.

Poem for a New Cat 1988

ED OCHESTER (b. 1939)

Watching her stand on the first
joints of her hind legs like a kangaroo
peering over the edge of the bathtub
at my privates floating like a fungoid lilypad,
or her bouncy joy in pouncing on a crumpled 5
Pall Mall pack, or the way she wobbles walking
the back of the couch, I think when
was it we grew tired of everything?
Imagine the cat jogging, terrified
that her ass might droop, or studying 10
the effective annual interest paid
by the First Variable Rate Fund, the cat
feeling obliged to read those poems that
concentrate the sweetness of life like prunes.
O.K., that's ridiculous—though the cat 15
also kills for pleasure—but I find
myself in the middle of the way,
half the minutes of my sentient life
told out for greed and fear.
The cat's whiskers are covered with lint 20
from the back of the dryer.
 Friend,
how it is with you I don't know
but I'm too old to die.

Hamlen Brook 1982

RICHARD WILBUR (b. 1921)

At the alder-darkened brink
Where the stream slows to a lucid jet
I lean to the water, dinting its top with sweat,
And see, before I can drink,

A startled inchling trout
Of spotted near-transparency, 5
Trawling a shadow solider than he.
He swerves now, darting out

To where, in a flicked slew
Of sparks and glittering silt, he weaves 10
Through stream-bed rocks, disturbing foundered leaves,
And butts then out of view

Beneath a sliding glass
Crazed by the skimming of a brace
Of burnished dragon-flies across its face, 15
In which deep cloudlets pass

And a white precipice
Of mirrored birch-trees plunges down
Toward where the azures of the zenith drown.
How shall I drink all this? 20

Joy's trick is to supply
Dry lips with what can cool and slake,
Leaving them dumbstruck also with an ache
Nothing can satisfy.

Quake Theory 1980

SHARON OLDS (b. 1942)

When two plates of earth scrape along each other
like a mother and daughter
it is called a fault.

There are faults that slip smoothly past each other
an inch a year, with just a faint rasp 5
like a man running his hand over his chin,
that man between us,

and there are faults that get stuck at a bend for twenty years.
The ridge bulges up like a father's sarcastic forehead 10
and the whole thing freezes in place, the man between us.

When this happens, there will be heavy damage
to industrial areas and leisure residence
when the deep plates
finally jerk past
the terrible pressure of their contact. 15

 The earth cracks
and innocent people slip gently in like swimmers.

These Heady Flowers 1992

ELIZABETH KIRSCHNER (b. 1955)

I am living deeply now
like the white spider I spy
among the wild roses. She lifts her legs,
moves her small ghostly body across each flower
like moonlight in a house. She is the snowflake 5
vanishing. Her fall from the dark sky
matters. It is quick and bright.
Her web is a beautiful hope
easily undone, a fabric transient as tears.
She lays it all upon these heady flowers 10
which for her are the world: flushed,
falling, gorgeous and doomed.

Storm Window 1980

CONRAD HILBERRY (b. 1928)

At the top of the ladder, a gust catches the glass
and he is falling. He and the window topple
backwards like a piece of deception slowly
coming undone. After the instant of terror,
he feels easy, as though he were a boy 5
falling back on his own bed. For years,
he has clamped his hands to railings, balanced
against the pitch of balconies and cliffs
and fire towers. For years, he has feared falling.
At last, he falls. Still holding the frame, 10
he sees the sky and trees come clear
in the wavering glass. In another second
the pane will shatter over his whole length,
But now, he lies back on air, falling.

Does Joanna Exist? 1998

BONNIE JACOBSON (b. 1933)

Of course she exists, everyone says so.
There is a certificate with a seal.
You've seen her jog by, she is blond and slim.
Who would sit down in a chair where she sits?
Look her up, ring the doorbell and ask— 5
her husband and her children will tell you
Joanna is upstairs in her sitting room,
happily stitching twelve birds into twelve
dining room chairseats, thinking of all those
who will sit upon her birds, and would gladly 10
pop down if you think otherwise.
But why should you think otherwise?
What sort of world would this be if you
(or anyone, surely Joanna herself)
were to find after a lifetime lived 15
otherwise that Joanna is not the creature
all had assumed, but is in reality
some weird emanation from eternity
sealed up in a mind that *thinks* it's Joanna,
a body that lives in Joanna's house? 20
To whose advantage if everything known
is wrong? Joanna might have to resign
from her club, her charity boards—her friends
forced to dine elsewhere, her family regroup—
Of course she exists, everyone sighs. 25
And you exist too, Joanna replies.

Day's End 1998

ANN TOWNSEND (b. 1962)

Once again
 I wipe the bedspread
down with a sponge,
 damp to catch the cat's hairs
where he lounges 5
 all afternoon, though had
I caught him
 I would have banished him
before you come home
 to sit near the pillows, 10
remove your shoes,
 and notice the minute

hairs where your head
 will rest and say *Jesus*,
will you look at this. 15
 It's in that kind of hurry
that I finish and vow
 to do better,
that I sweep the smudge
 of black and white hair 20
into the trash, that I pass
 quickly through two rooms
and sit at my desk
 as the door swings
open and you see me 25
 lingering, turning the pages
of the latest novel.

Two Figures in Dense Violet Light 1923

WALLACE STEVENS (1879–1955)

I had as lief be embraced by the porter at the hotel
As to get no more from the moonlight
Than your moist hand.

Be the voice of night and Florida in my ear.
Use dusky words and dusky images. 5
Darken your speech.

Speak, even, as if I did not hear you speaking,
But spoke for you perfectly in my thoughts,
Conceiving words,

As the night conceives the sea-sounds in silence, 10
And out of their droning sibilants makes
A serenade.

Say, puerile, that the buzzards crouch on the ridge-pole
And sleep with one eye watching the stars fall
Below Key West. 15

Say that the palms are clear in a total blue,
Are clear and are obscure; that it is night;
That the moon shines.

Chinese Print: No Translation 1985

PEGGY SHUMAKER (b. 1952)

Without warning, the woman says,
 Our marriage has become a business.
How can you say that, when you know I love you, etc., etc.,
 her husband cries. He serves her pirouettes and Earl Grey
 on porcelain dishes, but it's not enough. 5
What can I give you? What do you want?
 But secretly, so far I'm the only man brave enough
 to take you on, and you know it. Still,
What can I give you? What do you want?
 But if he has to ask, it doesn't count. 10
As in, if he can't swim naked at midnight
 on a deserted beach
 without worrying about phosphorescent plankton
 and our traveler's checks, forget it.
At dawn, she washes up on the beach, 15
 fire-coral dreams searing her thighs.
Brown UPS trucks search for her husband, each one
 delivering what has to be signed for.

The Kiss 1995

MARTA TOMES*

—a painting by Gustav Klimt

He knows he is irresistible. No doubt he has
looked in the mirror wearing his stained glass robe

and seen the cropped curls and stately shoulders
of Marc Antony. He cups my head like an infant

and lifts my chin toward him. He thinks I am shy; 5
my eyes are closed, my face turned away. He thinks

that this arm slung about his neck is my embrace,
that I've shrunken my shoulders forward so the dress

slides down my white arms just for him. This swirling
pekoe aura around me, he believes, exudes 10

my great excitement. I am trapped on my knees
on a cliff of flowers, and I've braced myself.

My bare toes tense forward, stiff as triggers.

3

MEASURING THE LINE (I)

Meter means "measure." To determine a line's meter we use some recurring element of the language as the unit of line measurement. Languages differ and thus each has its own distinctive basis for meter. Latin verse, for example, uses the duration of vowels, long or short, as the measuring element. Chinese, in which all words are monosyllabic, counts syllables.

The traditional way of measuring lines of verse in English is called **accentual-syllabic meter.** Dominant from Shakespeare in the sixteenth century to Yeats and Frost early in the twentieth century, the tradition remains lively in the work of many younger poets such as Henry Taylor, Marilyn Hacker, Wendy Cope, Marilyn Nelson, and Rafael Campo. But, roughly since Whitman, other ways of conceiving of the line have sprung up; and since what unites them is that they *aren't* accentual-syllabic meter, they are usually summed up rather vaguely as "free" verse. We have looked at several poems in these measures in chapter 2, and we will turn to others in Chapter 4. First, though, what is this meter they are "free" from?

Accentual-Syllabic Meter

As the name implies, both the number of accents and the number of syllables are counted; and the *pattern* of unaccented and accented syllables forms the meter. The elementary pattern or unit is called a **foot.** The basic foot is the iambic, or **iamb,** which is an unaccented syllable followed by an accented syllable: tĕ TÚM, as in "wĭll blóom" or "ălóng" or "thĕ chérrў nów." Note that, as in the third example, a word may be part of two separate feet. Several iambs strung together produce the pattern or meter of a line:

Ĭs húng | wĭth blóom | ălóng | thĕ bóugh,

which you will recall from Housman's "Loveliest of Trees" (p. 45); or this line from Francis's "Glass" (p. 27):

54

Thĕ pŏ|ĕm ís | thĕ thíng | thĕ pŏ|ĕt thínks,

or these lines from Shakespeare's Sonnet 73 (p. 34):

Thăt tíme | ŏf yéar | thŏu máyst | ĭn mé | bĕhóld

Whĕn yél|lŏw léaves, | ŏr nóne, | ŏr féw, | dŏ háng

Ŭpón | thŏse bóughs | thăt sháke | ăgáinst | thĕ cóld . . .

The rhythm is a natural one in English:

Thĕ rhýth|m ís | ă nát|ŭral óne | ĭn Éng|lĭsh.

Iambs are the most usual (and thus most neutral) foot, so iambic serves as the norm in metrical verse. Other feet may substitute for iambs, as you may have noticed in the fourth foot of the last example. We might in speech elide the second and third syllables of "natural," or enunciate them clearly, but the metrical character of the line would scarcely alter.

Before we consider substitution and other variations in the system, let's look at some passages that exemplify the different line lengths which our meter measures, each of which has a name. Take it slowly. Study the passages carefully and perhaps read the poems from which they are taken. Don't worry about the occasional feet that aren't iambs—we'll explain them in a moment.

Monometer, a line consisting of one foot: ˘´ , rarely occurs except in stanzaic poems of mixed line lengths like George Herbert's "Easter Wings" (p. 118). In stanza 1 we find:

Tĭll hé | bĕcáme

Mŏ̆st póor;

Wĭth thée

Ŏ lét | mĕ ríse

Ăs lárks, | hărmó|nĭŏuslý . . .

Note: Parentheses indicate syllables that could be interpreted equally the other way, as here we are aware that some readers might hear "Most" as accented or stressed. Parentheses also show "promotions"—see following.

Dimeter, also rare, is a line of two feet: ˘ ´ | ˘ ´ . The example is a stanza of "For My Contemporaries" by J. V. Cunningham. The poem appears on p. 76.

How tíme | rĕvér|sĕs

Thĕ próud | ĭn héart!

Ĭ nów | măke vér|sĕs

Whŏ aímed | ăt árt.

Note: A final unaccented syllable at the end of a line—an extra-syllable (or e-s) ending—is not counted and does not change the meter.

Trimeter is a line of three feet: ˘ ´ | ˘ ´ | ˘ ´ , as in the last stanza of "First Death in Nova Scotia" by Elizabeth Bishop. The poem appears on p. 152.

Thĕ grá|cĭoŭs róy|ăl cóu|plĕs

wĕre wárm | ĭn réd | ănd ér|mĭne;

thĕir féet | wĕre wéll | wrápped úp

ĭn thĕ lá|dĭes' ér|mĭne tráins.

Thĕy ĭnvít|ĕd Ár|thŭr tŏ bé

thĕ smáll|ĕst páge | ăt cóurt.

Bŭt hów | cŏuld Ár|thŭr gó,

clútchĭng | hĭs tí|nў líl|lў,

wĭth hĭs éyes | shŭt úp | sŏ tíght

ănd thĕ | róads déep | ĭn snów?

Tetrameter, a very common and serviceable meter, uses a line of four feet: ˘ ´ | ˘ ´ | ˘ ´ | ˘ ´ . Here are the last stanzas of "The Snowfall" by Donald Justice. The poem appears on p. 76.

Thĕ lándmárks | ăre góne. | Névĕr|thĕléss

Thĕre ĭs sóme | thĭng fámí|lĭar ăbóut | thĭs cóun|trў.

ˣSlow|lў nów | wĕ bĕgín | tŏ rĕcáll

Thĕ tér|rĭblĕ whĭs|pĕrs ŏf | ŏur éld|ĕrs

Fálling | sóftlў | ăbóut | ŏur eárs

Ĭn chíld|hŏod, név|ĕr bĕliévĕd | tĭll nów.

Note: In line 3, the unaccented syllable of the first foot is omitted—its place is marked by the superscript x. This convention is called anacrusis—see following.

Pentameter is a line of five feet: ˘ ´ | ˘ ´ | ˘ ´ | ˘ ´ | ˘ ´ . Iambic pentameter has been the standard line of verse in English from Shakespeare to the present. Unrhymed, it may be called **blank verse;** but here are the opening lines of Shakespeare's Sonnet 29 (p. 77):

Whén, ĭn | dĭsgráce | wĭth fór|tŭne ănd | mén's éyes,

Ĭ áll | ălóne | bĕwéep | mў óut|căst státe,

Ănd tróu|blĕ deáf heáv|ĕn wĭth | mў bóot|lĕss críes,

Ănd lóok | ŭpón | mўsélf, | ănd cúrse | mў fáte,

Wíshĭng | mĕ líke | tŏ óne | mórĕ rích | ĭn hópe,

Feátŭred | lĭke hím, | lĭke hím | wĭth friénds | pŏsséssed,

Dĕsír|ĭng thís | mán's árt | ănd thát | mán's scópe,

Wĭth whát | Ĭ móst | ĕnjóy | cŏntént|ĕd leást . . .

Hexameter (or **Alexandrine**) is a line of six feet: ˘ ´ | ˘ ´ | ˘ ´ | ˘ ´ | ˘ ´ | ˘ ´ . Although hexameter is not used frequently, Robert Francis (1901–1987) makes it serve brilliantly in "Excellence":

ˣÉx|cĕllénce | ĭs míl|lĭmét|ĕrs ănd | nŏt míles.

Frŏm póor | tŏ góod | ĭs greát. | Frŏm góod | tŏ bést | ĭs smáll.

Frŏm ál|mŏst bést | tŏ bést | sŏmetímes | nŏt meá|sŭráb|lĕ.

Thĕ mán | whŏ leáps | thĕ hígh|ĕst leáps | pĕrháps | ăn ínch

Ăbóve | thĕ rún|nĕr-úp. | Hŏw glŏr|íoŭs | thăt ínch

Ănd thăt | splít-séc|ŏnd lóng|ĕr ĭn | thĕ áir | bĕfóre | thĕ fáll.

Heptameter, a line of seven feet, is rare, as are octameter and so on. Only two lines of this stanza from "The Love Song of J. Alfred Prufrock" by T. S. Eliot (1888–1965) are heptameters:

Thĕ yél|lŏw fóg | thăt rúbs | ĭts báck | ŭpón | thĕ wín|dŏw pánes,

Thĕ yél|lŏw smóke | thăt rúbs | ĭts múz|zlĕ ón | thĕ wín|dŏw pánes,

Licked its tongue into the corners of the evening,

Lingered upon the pools that stand in drains,

Let fall upon its back the soot that falls from chimneys,

Slipped by the terrace, made a sudden leap,

And seeing that it was a soft October night,

Curled once about the house, and fell asleep.

The other lines of the stanza are pentameters and hexameters. Can you figure out which are which? Perhaps, using a sheet of scratch paper, see if you can work out scansions for each line before we discuss some of them later in the chapter.

If you are inexperienced at meter, this might be a good point to try out the basics. Take a sheet of paper and mark on it, with breve (˘) and ictus (´), blanks for four lines of iambic tetrameter, thus:

˘ ´ ˘ ´ ˘ ´ ˘ ´

˘ ´ ˘ ´ ˘ ´ ˘ ´

˘ ´ ˘ ´ ˘ ´ ˘ ´

˘ ´ ˘ ´ ˘ ´ ˘ ´

Then fit short sentences to the pattern, not worrying much about what they say. Be sure the unaccented and accented syllables are quite obvious. (Your dictionary marks accents if you are in doubt.) Perhaps rhyme lines 2 and 4 for the fun of it. You will get something like:

Thĕ róad ĭs góĭng úp thĕ híll.

Thĕ róad ĭs álsŏ cómĭng dówn.

Thĕ wáy ŏne thínks ĭt gŏes depénds.

Thĕ bóy ĭs wálkĭng hóme frŏm tówn.

A variation, as you grow confident, is then to make each line *one* foot longer, as "The road is going up the *woodĕd* hill, / The road, *of course*, is also coming down," and so on. Harder, but worth a try, is making each line shorter by one foot, as:

The road goes up the hill.

It's also coming down.

The way it goes depends.

The boy is leaving town.

A further variation might be to make one line run-on, as:

Going up the hill, the road

Is also coming down.

Don't be afraid to tinker with your draft. Save it, as we will return to it later.

Substitution and Variations

Writing in meter for the first time may feel stiff but, like learning to drive a stick shift, one soon gets the hang of it and prefers the sports car. Fear that meter must be mechanical also quickly vanishes.

One simple way to create flexibility in rhythm is to vary line lengths, as Eliot does quite modestly in the stanza describing fog through cat images and as do Matthew Arnold in "Dover Beach" (p. 273), where lines range from dimeter to pentameter, and Frost in "After Apple-Picking" (p. 125), where lines range from monometer to hexameter. Herbert in "Easter Wings" (p. 118) and Wilbur in "Hamlen Brook" (p. 49) invent stanzas. Notice how Wilbur's use of shorter lines before and after the stanza's single pentameter suggests his theme of parallel (and sometimes reflecting) worlds above and below the surface of the water.

The richest source of rhythmic flexibility in the metrical line is, of course, **substitution.** As we noted, the iamb (te TUM) is the basic foot. And the convention of substitution simply means that any of five other feet may freely replace one or more of the iambs in a line. You will have noticed a number of substitutions in the passages we scanned previously to illustrate line lengths. The other feet are:

Trochee (trochaic): accented syllable followed by unaccented syllable: TÚM tĕ.

ónlў clútchĭng ców ănd Névĕr|theless

Spondee (spondaic): two accented syllables together: TÚM TÚM.

bréad bóx whose big | línes swéll stróng fóot

Anapest (anapestic): two unaccented syllables followed by an accented syllable: tĕ tĕ TÚM.

ĭntĕrvéne fŏr ă whíle nev|ĕr bĕlíeved

Bacchic: unaccented syllable followed by two accented syllables: tĕ TÚM TÚM.

ă lóng tíme trou|blĕ déaf héav|en

Pyrrhic: two unaccented syllables: tĕ tĕ.

ănd thĕ | roads deep ĭn ă | green shade

Because it contains no accent and so is hard to hear as a unit of rhythm in an accentual language, the pyrrhic foot is properly considered with (or as joining) the foot that follows it—often a spondee as in the two previous examples, or in line 1 of Shakespeare's Sonnet 30 (p. 214):

Whĕn tŏ | thĕ sés|sĭons ŏf | swéet sí|lĕnt thóught

Pyrrhics are otherwise rare in more formal verse.

Any of these feet—trochees, spondees, anapests, bacchics, or pyrrhics—may be *substituted* for iambs in the norm line. "Clutching" is a trochee substituted as the first foot in Bishop's

clútchĭng | hĭs tín|ў líl|ў,

perhaps suggesting the tightness or awkwardness of the dead boy's grip, as the similarly substituted trochee in Eliot's pentameter,

Slĭpped bў | thĕ ter|răce, máde | ă sŭd|dĕn leáp,

may suggest catlike quickness or stealth. (Such interpretations of rhythm are subjective and obviously depend on context more than on any quality in the trochaic foot itself.) An anapest, spondee, pyrrhic, and spondee are substituted in Bishop's final lines:

wĭth hĭs éyes | shút úp | sŏ tíght

ănd thĕ | róads déep | ĭn snów?

We said at the outset that accentual-syllabic meter counts both accents and syllables. But, you quickly recognize, it counts them less than it perhaps seemed. A pentameter with two substituted spondees, like Shakespeare's

Dĕsír|ĭng thís | mán's árt | ănd thát | mán's scópe,

will have seven stresses, rather than five. A tetrameter with three anapests and an extra-syllable ending will have twelve syllables, not the expected eight, like Justice's

Thĕre ĭs sóme|thĭng fămíl|iăr ăboút | ĭ thĭs cóun|trў.

Although meter counts accents and syllables, the genius of it is that it may vary either, or even both at once, and still work. Substitution allows an almost infinite rhythmical variety, and it serves frequently to introduce imitative or expressive effects. Used deftly, it offers the freedom of the formal poem.

Beyond substitution, three further conventions of accentual-syllabic meter remain to note: extra-syllable ending, anacrusis, and promotion.

Extra-syllable ending refers to a final unaccented syllable at the end of a line, as in Bishop's "clutching a tiny lily" or Justice's "There is something familiar about this coun*try*." E-s endings are *not* counted metrically, though they are marked in scansion. So Bishop's line remains iambic trimeter, Justice's iambic tetrameter—a happy simplification, which merely takes note of the fact that some words end in stressed syllables, some in unstressed syllables. So the second of these further lines of Sonnet 29 remains iambic pentameter:

Háplў | Ĭ thínk | ŏn thée—|ănd thén | mў státe,

Líke tŏ | thĕ lárk | ăt bréak | ŏf dáy | ărís|ĭng

From súl|lĕn eárth, | síngs hýmns | ăt héav|ĕn's gáte

Although not counted in assessing meter, extra-syllable endings often contribute significantly to rhythm—as, here, the extra light syllable adds to the speed or sweep of Shakespeare's enjambment, after which the sentence finds its main verb in the emphatic spondee "sings hymns . . ." The rhythmic *lift* of the lines is extraordinary.

Anacrusis* is simply the absence or omission of the unaccented syllable of an iamb at the beginning of a line. It is marked in scansion by a superscript *x*, as in Eliot's

 ˣLícked | ĭts tóngue | ʲíntŏ | thĕ cór|nĕrs óf | thĕ éve|nĭng,

 Língerĕd | úpŏn | thĕ póols | thăt stánd | ĭn dráins

Anacrusis should be distinguished from substitution of an initial trochee, as in the second line, although the effects are similar—starting a line on a stressed syllable. Counted like regular iambs, anacruses are heard as minor variations and, like extra-syllable endings, do not change the metrical count. When an e-s ending precedes anacrusis, as in these lines of Milton's "L'Allegro":

 Ănd át | mў wín|dŏw bíd | góod mór|rŏw

 ˣThróugh | thĕ swéet-|bríar, ŏr | thĕ víne,

the result is in effect an iamb, "-row / Through," that turns the corner and is sometimes called a "dovetail" foot.

 Anacrusis may help in rhythm to suggest force, abruptness, speed, and so on. Consider its repetition in the tetrameters of this little elegy by Robert Herrick (1591–1674), "Upon a Child That Died":

 ˣHére | shĕ líes, | ă prét|tў búd,

 ˣLátelў máde | ŏf flésh | ănd blóod:

 ˣWhó, | ăs sóon, | fell fást | ăsléep,

*We follow George Saintsbury in *A History of English Prosody,* who allows the term in this sense on occasion (volume 1, pp. 64, 78, 170). *Anacrusis* (Greek: "striking up a tune") seems preferable to the sometimes-used term *acephalous line,* meaning "headless," or to *decapitation,* as that metaphor inaccurately implies that the variation is major in rhythmical effect. The term *initial truncation* is similarly unpleasant, deriving from a Latin verb that means "to shorten by cutting off, as limbs from trunk or torso; to maim or mutilate."

ˣÁs | hĕr lít|tlĕ éyes | dĭd péep.

ˣGíve | hĕr stréw|ĭngs; bŭt | nót stír

Thĕ éarth, | thăt líght|lў cóv|ĕrs hér.

The anacruses perhaps suggest, in rhythm, the speaker's restraint or emotional taut-
ness, which relaxes only in the regular iambs of line 6 and in the consoling image
of the child as napping, lightly covered, whom "strewings" of flowers would not
disturb.

Promotion means that we may credit as accented, when they appear in a metrical
stress position, syllables that would normally be unaccented in speech. (Crediting
them doesn't imply that we fully stress or emphasize them woodenly in reading verse
aloud, only that we count them as if they were accented.) Consider "on" and "of" in
this line you will recall from Sonnet 73 (p. 34):

Thăt ŏn⁽́⁾ | thĕ ásh|ĕs ŏf⁽́⁾ | hĭs yóuth | dŏth líe

In speech these prepositions would receive little or no stress. For the purposes of
scansion, however, both count as stressed and are marked in parentheses to indicate
the promotion. So lines of iambic pentameter may easily have as few as three speech
stresses or, as we saw, as many as seven in "Desiring this man's art and that man's
scope."

Promotion depends on the fact that the iambic norm creates an expectation. So
with very little (if any) differential in stress, we are able to sense the meter ticking
along regularly within the speech rhythm and to credit "on" and "of" as accented
syllables in the line from Sonnet 73; hence, the rarity of pyrrhics in metrical verse
except when they precede spondees, as in Bishop's

ănd thĕ | róads déep | ĭn snów

Two lines of Ezra Pound's "The Return" (p. 101) are especially interesting because
they show both promotions and a genuine pyrrhic:

Thĕ tróu|blĕ ĭn⁽́⁾ | thĕ páce | ănd thĕ | ŭncér|tăin

Wáv|ĕrĭng⁽́⁾!

Exclamation ends the short second line (and the sentence) with an abruptness that
leaves the third syllable of "Wavering" in a metrical stress position, echoing. Scan-
ning a promotion seems accurate. But in the first line, perhaps since the word *the* has

already appeared twice without stress, once in parallel syntax, it doesn't seem natural to hear "and the" as a promotion.

Because meter has only two values (unaccented and accented), it simplifies the many levels of accent we hear in speech. This simplification is the key, however, as it lets us perceive the common pattern in rhythms that vary but are similar. We count syllables as unaccented or accented only *relatively*, that is, by listening and comparing adjacent syllables, not by some absolute measurement. Thus, meter trains us to be aware of subtleties. We sort and weigh, as we usually do not when reading or writing prose. The taut web responds to the slightest touch.

Return now to the draft of your quatrain. Try a few substitutions and perhaps an e-s ending or anacrusis. You will notice now that, in our last version, anacrusis appeared in line 1:

> ˣGó|ǐng úp | thĕ híll, | thĕ róad . . .

To make the line shorter by a foot, we might substitute a trochee and what is probably a spondee, thus:

> Góǐng | (ʹ)úphíll, | thĕ róad . . .

The trimeter has the same four accented syllables as the tetrameter, but counts out as one foot less.

We might combine lines 1–2 into one pentameter line, and then do the same with lines 3–4, producing a couplet:

> Góǐng | (ʹ)úphíll, | thĕ róad | (ʹ)cómes dówn | ǎs wéll.

> Ĭt góes | thĕ wáy | yŏu gó. | Thăt's hów | tŏ téll.

Or substituting anapests:

> Góǐng | (ʹ)úphíll, | thĕ róad | ĭs dĕscénd|ǐng ǎs wéll.

This version, with only one iamb (and a trochee, a spondee, and two anapests), remains iambic pentameter because it essentially keeps the beat and in a longer passage would seem quite normal. The rhythm may even be expressive as we perhaps feel resistance (as in walking uphill) in the first two feet, and then ease

or speed (as in walking downhill) in the longer, quicker strides of the extra syllables of the second part of the line. Or, rather than a couplet, we might arrange it as a quatrain mixing trimeter and dimeter lines:

> Going uphill, the road
> > Is descending as well.
> It goes the way you go.
> > That's how to tell.

Here is another made up quatrain, tetrameters and trimeters, rhyming *a b a b*. Play around with it by changing line lengths, reordering the rhyme-words and meaning (try *a a b b*, for instance), and so on, before you look at a couple of versions in Appendix II (p. 337). Perhaps, adding a stanza or two, make a story about the box.

> There is a big, old wooden box,
> > Without a thing inside.
> It therefore needs, and has, no locks.
> > The top is open wide.

Or for fresh possibilities, write another quatrain of your own and tinker with substitution, line length, and so forth. The discipline of adding and subtracting feet, rearranging phrases, and trying out different words will sometimes discover new directions. Because it encourages us to look closely at our words and their relationships, poets value meter. Often we have choices we were not aware of. As Pope says,

> True ease in writing comes from art, not chance,
> As those move easiest who have learned to dance.

Rhythm

Meter is a pattern of unaccented and accented syllables: te TUM te TUM te TUM, mechanical and abstract. But something happens when the words of a poem flow through the pattern. The result is never precisely regular or mechanical. The usual stresses of words, their varying importance or placement in the sentences, their sounds, as well as the pauses and syntactical links among them, all work to give each line an individual movement and flavor. This we call rhythm: the play of the words over the metrical pattern.

Meter measures speech, the varied flow of a voice. Poetic rhythm is the result of blending the fixed (meter) and the flexible (speech). It isn't exactly the te TUM te TUM of meter nor a reproduction of idiomatic speech. A poem is read always as something between the two. We may show the relationship this way:

$$\frac{\text{speech}}{\text{meter (line)}} \ = \ \text{poetic rhythm}$$

The flow of speech slows, becoming more distinct, as we listen to the binary values (stressed, unstressed) into which the variety of speech is measured. Subtleties we may be unaware of, in the hurry of speech, become magnified and we then perceive them. Conversely, the rigidity of meter (an iamb is an iamb) becomes flexible—and may stretch through substitution. Even a line of iambs may reveal a rhythmic character of its own, if we listen.

Consider a simple example, the sentence which is part of the first line of a poem by Richard Wilbur ("Juggler"): "A ball will bounce, but less and less." We would be as inaccurate to read the line mechanically by the meter ("a BALL will BOUNCE, but LESS and LESS") as we would be to read it as we might speak it ("a ball will BOUNCE, but less and less"). In speech, we usually dash off everything but the most emphatic part. In fact, depending on the intention, we might place the primary accent on *any* of the eight words in the sentence. If we are distinguishing a ball from a glass bottle, for instance, we might say, "a BALL will bounce, but less and less." In distinguishing a single ball from a box of balls, we might say, "A ball will bounce, but less and less." Similarly, in speech, we might find a perfectly good reason for saying "a ball WILL bounce, but less and less" or "a ball will bounce, BUT less and less," and so on, depending on what we are trying to stress in a particular context.

We read this sentence in the poem, however, neither according to the rigid meter nor according to any of those wholly fluid speech emphases. In the poem the meter changes the speech-run a little, giving the sentence a more measured movement; and the speech-run of the sentence loosens the march-step of the meter. The result is distinctive—rhythm. *Speech flowing over meter produces rhythm.*

Typically, the unique qualities of rhythm occur where substitutions occur. But Wilbur's four perfectly regular iambs, te TUM te TUM te TUM te TUM, create their own deliciously distinctive rhythm. Within regularity or, rather, because of it, small differences in stress give the effect of less and less force and so seem to imitate the way a ball slows to a stop in smaller and smaller hops. The rise in stress from "A" to "ball" is relatively great, that from "will" to "bounce" somewhat less great, and so on through the line. The *difference* between each unaccented syllable and the following accented syllable diminishes in succession. An iamb, it turns out, is never the same iamb. If we draw the difference of stress in each foot, it will look something like this:

A ball will bounce, but less and less.

Meter makes possible such rhythmic control because it tunes the ear to careful measurements. Often enough, it provides the unnoticed magic by which the poet gets the rabbit *into* the hat.

Tight metrical structures let us perceive the slightest variation as significant. Tuned to that expectation—te TUM te TUM—we can respond sensitively to the subtleties or counterpoint. Alexander Pope's famous "sound of sense" passage from *An Essay on Criticism* (p. 79) is a treasury of metrical effects. Here, for instance, is the couplet about the Greek hero in the Trojan War, Ajax:

> When Ájax stríves sóme róck's vást wéight tŏ thrów,
>
> Thĕ líne tóo lábŏrs, ănd thĕ wórds móve slów

Pope uses several spondaic substitutions to produce the feeling of weight and then of effort. In the second line, in addition to the two spondees—"too lab-" and "move slow"—the third foot is broken by the caesura—"-ors, ‖ and"—so that the somewhat forced accent on "and" seems itself slow and laborious. In the first line the two spondees (or spondee and near spondee) put five heavy syllables together and so weight the center of the line, as Ajax lifts the boulder he means to hurl. The secret of the line, however, isn't merely adding spondees. The craft lies in the placement of the regular iamb in the fifth foot, "to throw." It is in that small te TUM gesture that we *feel* Ajax's effort. After five nearly even strong syllables, the contrast in weight between "to" and "throw" rhythmically mimics Ajax's gesture.

Pope's skill shows in his having varied slightly the normal word order of the sentence. If we undo the inversion and restore "to throw" to its normal place, the effect disappears, and Ajax is left standing there with the rock sagging in his hands:

> When Ájax stríves tŏ thrów sóme róck's vást wéight

Read the two versions of the line aloud. The little fillip of a perfectly regular foot makes us feel the actual attempt to heave the rock. The embodiment of content in form is exquisite.

Look back to our scansion of Francis's "Excellence" (p. 57). The norm meter, iambic hexameter, may appear an odd choice for a poem about the legerity of a high jumper. But Francis is less interested in the athlete's lightness or ease than in his difficulty—the extra push or effort that earns excellence, that buys the additional "inch / And that split-second longer in the air." Because hexameter goes on a little beyond the more usual pentameter—and seems to have to push its way up to its end—it was a fine choice. Note how dogged line 2 seems! Unrelenting monosyllables in rigidly even iambs, made by the caesura into two sentences, may suggest that the distance from "poor" to "best" can only be traversed by the sort of stubborn labor or practice this rhythm embodies. And notice, in line 3, how the last foot is itself *not measur-*

able! In speech, the word has no secondary accent. We can't really say "MEAS-ur-AB-le," and "MEAS-ur-ab-UL" would be worse, though we may be tempted by the half-rhyme with "small" in line 2. Sometimes, the rhythm says "almost best" and "best" are so nearly the same, we can't tell. It is a masterful touch.

Notice, too, the difference in rhythm between lines 2 and 5, although each is divided exactly midline by a full-stop caesura. The rhythm of line 5 is softened somewhat by the di- and trisyllabic words "runner" and "glorious" as well as by the promotion of the last syllable of the latter. Moreover, enjambments flowing from lines 4 and 5 have a fluidity quite different from the fully end-stopped sentences of lines 1–3. And the enjambments, describing the jumping, lead to the *heptameter* "And that split-second longer in the air before the fall." We won't see the line's extra length, but we hear it, even when we don't count feet. The line itself lasts in the ear just a split-second longer than the others.

Rhythm is meaning that we *hear.*

When poets write in meter, they usually do so not to be calculating, but, as John Ciardi remarked, by working from "a reminiscence of the pentameter." They have internalized the feel of regular meter and, in writing, listen for the unique rhythm rather than for a mechanical count. Correctness is not the point.

A Note on Scanning

Scansion has two purposes. The simpler one is just to determine a poem or passage's metrical norm or to check a line. The other, more important purpose, is to find those *divergences* from the norm (variations, substitutions, anomalies) that reveal the singularity of the poem's rhythm, which of course includes such other elements as rhyme and phrasing. It doesn't matter, indeed it may be valuable for insights, if we hear or interpret a passage somewhat differently.

In scanning, listen to the poem. Don't impose a metrical pattern on it. Read each line aloud slowly, naturally, more than once. Perhaps scan several lines tentatively before marking any, to determine the norm. (This may help resolve difficult or ambiguous spots elsewhere in the poem.) Mark ambiguous syllables (those you can imagine counting two ways) with your preferred interpretation in parentheses. Like substitutions, such feet often provide a key to the subtleties in the rhythm. In general, scan to find the lowest common denominator: that is, what is closest to the iambic base, with the fewest or least complicated variations.

And don't just begin by marking off feet from the beginning of lines—you'll quickly run into difficulties.

Let's scan two brief passages from this poem by Robert Frost (1874–1963). Its title appears in quotation marks because it is an **allusion** to a famous soliloquy in Shakespeare's *Macbeth*—"Out, out, brief candle" (p. 200). As you read, notice a line or two that seem easily regular, to find the norm.

"Out, Out—"

The buzz saw snarled and rattled in the yard
And made dust and dropped stove-length sticks of wood,
Sweet-scented stuff when the breeze drew across it.
And from there those that lifted eyes could count
Five mountain ranges one behind the other 5
Under the sunset far into Vermont.
And the saw snarled and rattle, snarled and rattled,
As it ran light, or had to bear a load.
And nothing happened: day was all but done.
Call it a day, I wish they might have said 10
To please the boy by giving him the half hour
That a boy counts so much when saved from work.
His sister stood beside them in her apron
To tell them "Supper." At the word, the saw,
As if to prove saws knew what supper meant, 15
Leaped out at the boy's hand, or seemed to leap—
He must have given the hand. However it was,
Neither refused the meeting. But the hand!
The boy's first outcry was a rueful laugh,
As he swung toward them holding up the hand, 20
Half in appeal, but half as if to keep
The life from spilling. Then the boy was all—
Since he was old enough to know, big boy
Doing a man's work, though a child at heart—
He saw all spoiled. "Don't let him cut my hand off— 25
The doctor, when he comes. Don't let him, sister!"
So. But the hand was gone already.
The doctor put him in the dark of ether.
He lay and puffed his lips out with his breath.
And then—the watcher at his pulse took fright. 30
No one believed. They listened at his heart.
Little—less—nothing!—and that ended it.
No more to build on there. And they, since they
Were not the one dead, turned to their affairs.

Taking the first passage:

> And the saw snarled and rattled, snarled and rattled,
> As it ran light, or had to bear a load.

we begin by marking the main (often the root) syllables of each noun, verb, and adjective. (If you are in doubt, a dictionary will show both main and secondary accents for polysyllabic words, both of which are speech stresses and usually marked in scan-

ning.) Also, *always* set off an extra-syllable ending, since a line's meter anchors on its final accented syllable. So we have:

> And the sáw snárled and ráttled, snárled and rát|tlĕd,

> As it rán líght, or hád to béar a lóad.

A safe procedure is to work backward through the line. Here, with single-syllable, not very important, words between the marked accents, it is pretty clear that both lines end in three iambs. So we mark:

> And the sáw snárled | ănd rát|tlĕd, snárled | ănd rát|tlĕd,

> As it rán líght, | ŏr hád | tŏ béar | ă lóad.

The second foot of each line, having two accented syllables, will probably count as spondees. In line 1, if so, we would be left with "And the" as a foot. It won't be an iamb, since an accent on "the" is a totally implausible emphasis. So we may consider marking either a trochee or a pyrrhic—

> Ánd thĕ | sáw snárled Ănd thĕ | sáw snárled

Either scansion seems plausible. But since "And" here carries no particular implication in the narrative (of link or consequence), we would probably conclude, weighing the line's first four syllables, to mark a pyrrhic:

> Ănd thĕ | sáw snárled | ănd rát|tlĕd, snárled | ănd rát|tlĕd.

In line 2, similarly, "As it" might be read with some emphasis on "As" as a trochee— "Ás ĭt | rán líght"—but simultaneity isn't particularly the point. Similarly, there is no rhetorical emphasis on "it" (as in *it* as opposed to something else), though stress on the word may seem a little heavier than on "As," but still distinctly less than on the also-adjacent "ran." So scanning *either* a muted iamb or a pyrrhic will be accurate:

> Ăs ĭt | rán líght, | ŏr hád | tŏ béar | ă lóad.

> Ăs ĭt | rán líght, | ŏr hád | tŏ béar | ă lóad.

Notice that snarling and rattling describe two phases of the buzz saw in operation. It *snarls* as wood to be cut is pressed into the whirling teeth of the blade, producing

intense noise. Then, idling, the saw *rattles*—engine and the loosely turning belt and blade run slack. The repetition in the first line—"snarled and rattled, snarled and rattled"—expresses the repetitiousness of the job the boy is doing as he cuts firewood. And the rhythm of the second line perhaps suggested the two actions of the saw: first, in "As it ran light," the speeding up when the blade spins freely; then, in the reengaged iambs of "or had to bear a load," the snarling as wood is again fed against the blade. The slight rhythmic difference in the two parts of the line matches this difference in denotation. So scanning a pyrrhic for "As it" may be somewhat preferable, as well as simpler.

Before going on to the second passage, we may look at a faulty scansion that results from just marking off feet from the beginning of a line. The first foot will *seem* an anapest, and then we would get four trochees in the first line, three trochees and a problem in the second:

Ănd thĕ sáw | snárled ănd | ráttlĕd, | snárled ănd |ráttlĕd,

Ăs ĭt rán | líght, or | hád tŏ | béar ă | lóad.

The value of first setting off an e-s ending and then keying scansion to the line's final accent is real.

Here is the second passage:

He saw all spoiled. "Don't let him cut my hand off—

The doctor, when he comes. Don't let him, sister!"

So. But the hand was gone already.

The doctor put him in the dark of ether.

He lay and puffed his lips out with his breath.

Except for a point or two, this passage is simpler. So you may want to try marking, lightly in pencil, your own scansion before reading on. Note that in "my hand off" the adverb as well as the noun would be stressed in speech—an idiom—as it would be in "my finger off." Of course "my" does not need or get a rhetorical stress, as there is no question of anyone else's hand.

Once it is clear, working backward, that the last foot in line 1 must be a bacchic, not a spondee, inserting accents and then the breves (˘) for unaccented syllables is straightforward. Spondees appear in "all spoiled," a natural emphasis, and in "So. But," and in a usual promotion in line 4—leaving only the fourth foot in line 5 undecided:

Hĕ sáw | áll spóiled. | "Dŏn't lét | hĭm cút | mў hánd óff—

Thĕ dócltŏr, whén | hĕ cómes. | Dŏn't lét | hĭm, sísltĕr!"

Só. But | thĕ hánd | wăs góne | ălréadly̆.

Thĕ dóc|tŏr pút | hĭm ĭn | thĕ dárk | ŏf é|thĕr.

Hĕ láy | ănd púffed | hĭs líps | out with | hĭs bréath.

In line 5, "out" should accented because in speech we would properly say "puffed óut his lips." The foot seems interpreted better as a trochee than as an iamb—a lazy scansion? So now we have:

Hĕ láy | ănd púffed | hĭs líps | óut wĭth | hĭs bréath.

Frost's minor, colloquial displacement in the phrase (and the trochaic substitution this causes) helps suggest the difficulty the boy has breathing. And we might notice, moments before he dies, the symbolism of the puffed-out candle alluded to in the poem's title.

Careful scansion takes us deep into understanding a poem. Too casual a reader will not notice that line 3 here, significantly, is a *tetrameter*, one vital beat short in the poem's pentameter norm. Frost knows of course. It is a little message sent through the years to his best readers.

Questions and Suggestions

1. Scan the following poems and consider the significance of rhythmical variations. (For comparison, scansions appear in Appendix II, pp. 337–343).

 a) ***Death of the Day***
 WALTER SAVAGE LANDOR (1775–1864)

 My pictures blacken in their frames
 As night comes on,
 And youthful maids and wrinkled dames
 Are now all one.

 Death of the day! a sterner Death 5
 Did worse before;
 The fairest form, the sweetest breath,
 Away he bore.

b) *Riches*
WILLIAM BLAKE (1757–1827)

The countless gold of a merry heart,
The rubies and pearls of a loving eye,
The indolent never can bring to the mart,
Nor the secret° hoard up in his treasury.

4 *the secret:* i.e., a miser

c) *Anecdote of the Jar*
WALLACE STEVENS (1879–1955)

I placed a jar in Tennessee,
And round it was, upon a hill.
It made the slovenly wilderness
Surround that hill.

The wilderness rose up to it, 5
And sprawled around, no longer wild.
The jar was round upon the ground
And tall and of a port in air.

It took dominion everywhere.
The jar was gray and bare. 10
It did not give of bird or bush,
Like nothing else in Tennessee.

d) *If I should learn, in some quite casual way*
EDNA ST. VINCENT MILLAY (1892–1950)

If I should learn, in some quite casual way,
That you were gone, not to return again—
Read from the back-page of a paper, say,
Held by a neighbor in a subway train,
How at the corner of this avenue 5
And such a street (so are the papers filled)
A hurrying man, who happened to be you,
At noon today had happened to be killed—
I should not cry aloud—I could not cry
Aloud, or wring my hands in such a place— 10
I should but watch the station lights rush by

With a more careful interest on my face;
Or raise my eyes and read with greater care
Where to store furs and how to treat the hair.

e) **A Bird came down the Walk**
EMILY DICKINSON (1830–1886)

A Bird came down the Walk—
He did not know I saw—

He bit an Angleworm in halves
And ate the fellow, raw,

And then he drank a Dew 5
From a convenient Grass—
And then hopped sidewise to the Wall
To let a Beetle pass—

He glanced with rapid eyes
That hurried all around— 10
They looked like frightened Beads, I thought—
He stirred his Velvet Head

Like one in danger, Cautious,
I offered him a Crumb
And he unrolled his feathers 15
And rowed him softer home—

Than Oars divide the Ocean,
Too silver for a seam—
Or Butterflies, off Banks of Noon
Leap, plashless as they swim

2. Find a paragraph or two of interesting prose and *translate* the passage into blank verse (unrhymed iambic pentameter) or, if several rhyme-words show up and you feel daring, into rhymed couplets. Stick with the language of the original as much as you can, but don't be afraid to rephrase, to stretch and compress, to rearrange, and even to add your own touches to help the meaning fit the form.

3. *For a group.* To write a "poem" together, pick a simple subject—a familiar but unusual animal works well, for instance. Then, using the edges of a large blackboard as a "mind," think of and group as many details, ideas, and metaphors, especially metaphors, as you can. Start with whatever easy metrical

form comes to hand, perhaps trimeter and tetrameter quatrains rhyming
a b c b; and let possible rhymes suggest a scene or scenario. Begin the poem
in the center of the blackboard *and keep going.*

One group's "poem" came up with the image of a skunk "waddling like a
tanker / that trails a plume of black smoke." Another group's began, "A
snake's slow flowing stopped / Suddenly in the grass . . .," and ended:

> Like a tiny pitchfork or lightning,
> Its tongue sparked in the socket.
> It looked as slim and mean
> As a hissing, countdown rocket.
>
> Eyes glowing like a switchboard
> That showed all systems on,
> It scared me—and I scared it,
> For suddenly it was gone.

The fun is usually in the metaphors, but there's a lesson in the way form
can coax a poem forward.

4. Try your hand at a limerick. (See Appendix I, p. 335, for examples and a de-
 scription of the technicalities.)

5. Several sonnets appear among the Poems to Consider (p. 76–83): Shake-
 speare's Sonnet 29, Wendy Cope's "Strugnell's Bargain," Marilyn Nelson's
 "Balance," and sonnet-like poems such as Donald Justice's "The Snowfall,"
 Gerald Barrax's "The Guilt," and Molly Peacock's "Afraid." Cope satirizes
 the usual love-sonnet stuff, but others have found ways of renewing even
 that traditional subject matter—including Edna St. Vincent Millay in "If I
 should learn, in some quite casual way" (p. 73) and T. R. Hummer in "The
 Rural Carrier Discovers That Love Is Everywhere" (p. 190). Poets have al-
 ways been fascinated by the form, varying it, using it for all sorts of other
 purposes. Have a look at Elizabeth Barrett Browning's "Grief" and the tech-
 nical description in Appendix I (p. 333), and also at William Wordsworth's
 "Composed upon Westminster Bridge, September 3, 1802" (p. 47) and
 Ronald Wallace's "The Bad Snorkler" (p. 328). Why not have a go at a son-
 net yourself?

6. Alexander Pope plays a variety of delightful tricks in the meter of the pas-
 sage from "An Essay on Criticism." These will reward patient attention. But
 not all the poems in Poems to Consider *seem* obviously metrical, and the
 ways in which poets avoid that also deserve study. Look particularly at James
 Cummins's "Games," Howard Nemerov's "Learning by Doing," Paul Lake's
 "Blue Jay," and Mark Irwin's "Buffalo." Notice how Henry Taylor makes
 "Barbed Wire" out of *one* long sentence.

Poems to Consider

For My Contemporaries

<div align="right">1942</div>

J. V. CUNNINGHAM (1911–1985)

How time reverses
The proud in heart!
I now make verses
Who aimed at art.

But I sleep well. 5
Ambitious boys
Whose big lines swell
With spiritual noise,

Despise me not!
And be not queasy 10
To praise somewhat:
Verse is not easy.

But rage who will.
Time that procured me
Good sense and skill 15
Of madness cured me.

The Snowfall

<div align="right">1960</div>

DONALD JUSTICE (b. 1925)

The classic landscapes of dreams are not
More pathless, though footprints leading nowhere
Would seem to prove that a people once
Survived for a little even here.

Fragments of a pathetic culture 5
Remain, the lost mittens of children,
And a single, bright, detasseled snow-cap,
Evidence of some frantic migration.

The landmarks are gone. Nevertheless
There is something familiar about this country. 10
Slowly now we begin to recall

The terrible whispers of our elders
Falling softly about our ears
In childhood, never believed till now.

Sonnet 29 1609

WILLIAM SHAKESPEARE (1564–1616)

When, in disgrace with fortune and men's eyes,
I all alone beweep my outcast state,
And trouble deaf heaven with my bootless cries,
And look upon myself, and curse my fate,
Wishing me like to one more rich in hope, 5
Featured like him, like him with friends possessed,
Desiring this man's art and that man's scope,
With what I most enjoy contented least;
Yet in these thoughts myself almost despising,
Haply I think on thee—and then my state, 10
Like to the lark at break of day arising
From sullen earth, sings hymns at heaven's gate;
For thy sweet love remembered such wealth brings
That then I scorn to change my state with kings.

Strugnell's Bargain 1984

WENDY COPE (b. 1945)

My true love hath my heart and I have hers:
We swapped last Tuesday and we felt elated
But now, whenever one of us refers
To "my heart," things get rather complicated.
Just now, when she complained, "My heart is racing," 5
"You mean *my* heart is racing," I replied.
"That's what I said." "You mean the heart replacing
Your heart my love." "Oh piss off, Jake!" she cried.
I ask you, do you think Sir Philip Sidney°
Got spoken to like that? And I suspect 10
If I threw in my liver and a kidney
She'd still address me with as scant respect.
Therefore do I revoke my opening line:
My love can keep her heart and I'll have mine.

9 *Sidney:* Elizabethan sonneteer (1554–1586). Strugnell, a fictitious twentieth-
century poet, writes love sonnets in Sidney's style.

Balance 1990

MARILYN NELSON (b. 1946)

He watch her like a coonhound watch a tree.
What might explain the metamorphosis
he underwent when she paraded by
with tea-cakes, in her fresh and shabby dress?
(As one would carry water from a well— 5

straight-backed, high-headed, like a diadem,
with careful grace so that no drop will spill—
she balanced, almost brimming, her one name.)

She think she something, stuck-up island bitch.
Chopping wood, hanging laundry on the line, 10
And tantalizingly within his reach,
she honed his body's yearning to a keen,
sharp point. And on that point she balanced life.
That hoe Diverne think she Marse Tyler's wife.

The Guilt 1996

GERALD BARRAX (b. 1933)

He made himself her compost heap and hoped
Something old or something new would grow
Where he kept the guilt always in the best light
For her tending, fertilized with bile and bone meal
Ashes shaken through the grate in her heart. 5
She used her privilege of a good woman done wrong
And opened him up at will to nurse and prune
It, until the habit of their make-do lives
One day lulled them off guard into a casual quarrel,
And she turned at bay with her *cri de coeur,* 10
"I will never forgive you, never." He set his face
To muffle its shout of deliverance
When his seahorse womb aborted the misshapen thing
And, midwife to himself, he became a something new.

Afraid 1984

MOLLY PEACOCK (b. 1947)

Hell, I'm afraid I'll be afraid of your voice,
that's why I don't call (and because I'd like
to be grown-up about my phone bill, choice
being a signal of adulthood)! Like
something papery, but stiff, I think 5
your voice will sound, like the end of a tablet
or paper, no more whiteness or lines set
in sheer availability. My heart will sink
when I see the gray cardboard backing staring
at me, unblinking, the way I think your voice 10
will stare, if voices stared, gray and uncaring.
I wish you were here. I'd ask your advice
about whether to call. You'd put your arm
around me and we'd talk, our voices warm,
about whether it would do us any harm.

Games 1997

JAMES CUMMINS (b. 1948)

A good athlete moves slowly after defeat,
or sits in the dugout staring at the field,
as it gets taken back by the ones who tend it,
who have nothing on their minds but the field,
they love it so. Some lights will blink out, 5
before he can enter the locker room again,
each face there reminding him of his loss,
his weakness, their weakness, at last exposed
when the final tally only mocked their ardor.
He is like a neophyte lover, exposed, chagrined, 10
standing outside the locked bathroom door,
wearing only a pair of dark blue rayon socks.
And it's a small leap of the mind to imagine
that blue-socked naked bum wondering
if what's coming up behind him isn't what 15
he desires most, after all: such are the signs
defeat puts on your body, in your mind.
And if he should conquer the wife that night,
it will be strange threesome in their bed:
this sore-assed loser, his bottom in the air; 20
the sneer of defeat, riding his butt hard;
and the little screaming woman they drive crazy.

Epitaph 1979

TIMOTHY STEELE (b. 1948)

Here lies Sir Tact, a diplomatic fellow
Whose silence was not golden, but just yellow.

from An Essay on Criticism 1711

ALEXANDER POPE (1688–1744)

But most by numbers judge a poet's song;
And smooth or rough, with them, is right or wrong:
In the bright muse though thousand charms conspire,
Her voice is all these tuneful fools admire;
Who haunt Parnassus° but to please their ear, 5
Not mend their minds; as some to church repair,
Not for the doctrine, but the music there.
These equal syllables alone require,
Though oft the ear the open vowels tire;
While expletives their feeble aid do join; 10

And ten low words oft creep in one dull line:
While they ring round the same unvaried chimes,
With sure returns of still expected rhymes;
Where'er you find "the cooling western breeze,"
In the next line, it "whispers through the trees": 15
If crystal streams "with pleasing murmurs creep,"
The reader's threatened (not in vain) with "sleep":
Then, at the last and only couplet fraught
With some unmeaning thing they call a thought,
A needless Alexandrine ends the song, 20
That, like a wounded snake, drags its slow length along.
Leave such to tune their own dull rhymes, and know
What's roundly smooth, or languishingly slow;
And praise the easy vigor of a line,
Where Denham's° strength, and Waller's° sweetness join. 25
True ease in writing comes from art, not chance,
As those move easiest who have learned to dance.
'Tis not enough no harshness gives offense,
The sound must seem an echo to the sense:
Soft is the strain when Zephyr° gently blows, 30
And the smooth stream in smoother numbers flows;
But when loud surges lash the sounding shore,
The hoarse, rough verse should like the torrent roar:
When Ajax° strives some rock's vast weight to throw,
The line too labors, and the words move slow; 35
Not so, when swift Camilla° scours the plain,
Flies o'er th' unbending corn, and skims along the main.

5 *Parnassus*: Greek mountain, sacred to the Muses; 25 *Denham*: poet Sir John
Denham (1615–1669); *Waller*: poet Edmund Waller (1601–1687); 30 *Zephyr*: the
west wind; 34 *Ajax*: Greek warrior in *The Illiad*; 36 *Camilla*: ancient Roman queen,
reputed to run so swiftly that she could skim over a field of grain without bending the
stalks, over the sea without wetting her feet.

The Tropics in New York 1920

CLAUDE MCKAY (1890–1948)

Bananas ripe and green, and ginger-root,
 Cocoa in pods and alligator pears,
And tangerines and mangoes and grape fruit,
 Fit for the highest prize at parish fairs,

Set in the window, bringing memories 5
 Of fruit-trees laden by low-singing rills,
And dewy dawns, and mystical blue skies
 In benediction over nun-like hills.

My eyes grew dim, and I could no more gaze;
 A wave of longing through my body swept, 10
And, hungry for the old, familiar ways,
 I turned aside and bowed my head and wept.

Learning by Doing 1967

HOWARD NEMEROV (1920–1991)

They're taking down a tree at the front door,
The power saw is snarling at some nerves,
Whining at others. Now and then it grunts,
And sawdust falls like snow or a drift of seeds.
Rotten, they tell us, at the fork, and one 5
Big wind would bring it down. So what they do
They do, as usual, to do us good.
Whatever cannot carry its own weight
Has got to go, and so on; you expect
To hear them talking next about survival 10
And the values of a free society.
For in the explanations people give
On these occasions there is generally some
Mean-spirited moral point, and everyone
Privately wonders if his neighbors plan 15
To saw him up before he falls on them.

Maybe a hundred years in sun and shower
Dismantled in a morning and let down
Out of itself a finger at a time
And then an arm, and so down to the trunk, 20
Until there's nothing left to hold on to
Or snub the splintery holding rope around,
And where those big green divagations were
So loftily with shadows interleaved
The absent-minded blue rains in on us. 25

Now that they've got it sectioned on the ground
It looks as though somebody made a plain
Error in diagnosis, for the wood
Looks sweet and sound throughout. You couldn't know,
Of course, until you took it down. That's what 30
Experts are for, and these experts stand round
The giant pieces of tree as though expecting
An instruction booklet from the factory
Before they try to put it back together.

Anyhow, there it isn't, on the ground. 35
Next come the tractor and the crowbar crew
To extirpate what's left and fill the grave.
Maybe tomorrow grass seed will be sown.
There's some mean-spirited moral point in that
As well: you learn to buy your mistakes, 40
Though for a while at dusk the darkening air
Will be with many shadows interleaved,
And pierced with a bewilderment of birds.

Blue Jay 1986

PAUL LAKE (b. 1951)

A sound like a rusty pump beneath our window
Woke us at dawn. Drawing the curtains back,
We saw—through milky light, above the doghouse—
A blue jay lecturing a neighbor's cat
So fiercely that, at first, it seemed to wonder 5
When birds forgot the diplomacy of flight
And met, instead, each charge with a wild swoop,
Metallic cry, and angry thrust of beak.

Later, we found the reason. Near the fence
Among the flowerless stalks of daffodils, 10
A weak piping of feathers. Too late now to go back
To nest again among the sheltering leaves.
And so, harrying the dog, routing the cat,
And taking sole possession of the yard,
The mother swooped all morning. 15

 I found her there
Still fluttering round my head, still scattering
The troops of blackbirds, head cocked toward my car
As if it were some lurid animal,
When I returned from work. Still keeping faith. 20
As if what I had found by afternoon
Silent and still and hidden in tall grass
Might rise again above the fallen world;
As if the dead were not past mothering.

Barbed Wire 1985

HENRY TAYLOR (b. 1942)

One summer afternoon when nothing much
was happening, they were standing around

a tractor beside the barn while a horse
in the field poked his head between two strands
of the barbed-wire fence to get at the grass 5
along the lane, when it happened—something

they passed around the wood stove late at night
for years, but never could explain—someone
may have dropped a wrench into the toolbox
or made a sudden move, or merely thought 10
what might happen if the horse got scared, and
then he did get scared, jumped sideways and ran

down the fence line, leaving chunks of his throat
skin and hair on every barb for ten feet
before he pulled free and ran a short way 15
into the field, stopped and planted his hoofs
wide apart like a sawhorse, hung his head
down as if to watch his blood running out,

almost as if he were about to speak
to them, who almost thought he could regret 20
that he no longer had the strength to stand,
then shuddered to his knees, fell on his side,
and gave up breathing while the dripping wire
hummed like a bowstring in the splintered air.

◈ Buffalo 1997

MARK IRWIN (b. 1953)

They are the earth we have forgotten.
And the great continents of the head knows this
and will look right through you from the brown stones
of the eyes. And I would know them as a child knows
the brown-humped land that listens 5
for the prairie wind that is the bellows of their lungs.
Nolan and I once stopped, astonished by the mile long
herd, and by the slow train of the hooves
drumming up an expiring music like wind like God like sun.
Still I marvel as the late Nebraska light gilds the horns 10
and the ponderous mass of fur, while the foothills blue
recalling the cold declining length of the rifle's bore.
They are the color of the earth thrust up, and history
still roams in the matted rags of hair, in the bleached litter
of bones, and in the chalky cliffs of the skull. 15

4

MEASURING THE LINE (II)

Following Walt Whitman's example, poets have experimented significantly with measuring the verse line in fresh, that is, *nonmetrical*, ways. Although it takes many forms, nonmetrical verse has had only the catchall name **free verse.** Borrowed from the French *vers libre*, the term is attractive since everyone approves of freedom; but it is also uninformative—telling us only what such verse is *not* (metrical) and nothing at all about what it is.

T. S. Eliot said, "No *vers* is *libre* for the poet who wants to do a good job." And the great American innovator in free verse, William Carlos Williams, was always quite certain: ". . . to my mind, there is no such thing as free verse. It's a contradiction in terms. The verse is measured. No measure can be free." Since the nature of verse itself means that we pay attention to the way lines cut across and so measure the flowing phrases and sentences of speech, Williams is correct: Free verse measures. Lines are *measured*, although not *metered*.

There is, however, little practical theory of free verse. It remains largely a white area on the maps. Poets writing successfully have done so mostly by intuition. A well-tuned ear—a delicate sensitivity to idiom—finds the unique form, the unique rhythm, which in Ezra Pound's words "corresponds exactly to the emotion or shade of emotion to be expressed." Denise Levertov puts the aim this way: "there is a form in all things (and in our experience) which the poet can discover and reveal." Much free verse falls short, she notes, because "the attention of the writer has been switched off too soon, before the intrinsic form of the experience has been revealed." The riskiest temptation of the poet writing in free verse, then, may be in settling for the spontaneity or ease the term seems to promise.

Until there is an adequate theory of nonmetrical verse, rough distinctions will help. We may notice, for instance, that we usually associate nonmetrical verse with poems written in *very long* lines (like Whitman's), in *very short* lines (like William Carlos Williams's), or in lines of *greatly varying* or uneven lengths. So we may see these as three of the basic types of free verse. They offer the poet differing opportunities, and, since by nature or definition lines cannot be established by meter, each creates somewhat different ways of organizing or using the unit of line.

These three types of nonmetrical verse developed, logically enough, to exploit

the possibilities in areas where metrical verse operates minimally. At the center of the metrical spectrum are poems in lines of four and five feet (tetrameters, pentameters); poems in lines of three or six feet (trimeters, hexameters) occur much less frequently, but are common. Lines shorter or longer than these seldom show up. Moreover, poems in meter often keep to one line length throughout, or vary only a little. Thus, in these areas where verse in meter is least effective or stable, poets experimenting with nonmetrical verse have found openings for new forms of the poetic line.

In this chapter, we will discuss these three fairly open-ended types, as well as syllabics and the prose poem, which perhaps should count as other types or variants.

Nonmetrical Verse: Longer Lines

The great original in longer lines is Walt Whitman, although there are antecedents in the "verse" of Psalms and Ecclesiastes in the King James Bible (1611), and in Christopher Smart's *Rejoice in the Lamb* and William Blake's prophetic poems in the eighteenth century. Whitman's "A Noiseless Patient Spider," discussed in chapter 2 (pp. 36–37), exemplifies free verse in longer lines. Lines as long as Whitman's are usually end-stopped; that is, line breaks occur at syntactical or grammatical pauses or intervals. Structured by these pauses, the rhythm may then be modulated by caesural pauses within the lines. The cadence of such verse derives from the tension between these two kinds of pauses.

It is worth noticing that short lines of end-stopped verse diminish the possibility of modulation. In the extreme—where every syntactical unit is given a line—the tension disappears and all that remains is chopped prose. Suppose lines of "A Noiseless Patient Spider" were rearranged:

> Surrounded,
> Detached,
> In measureless oceans of space,
> Ceaselessly musing,
> Venturing,
> Throwing,
> Seeking the spheres to connect them . . .

Line now merely repeats the phrasal pauses of prose. Beginners sometimes divide lines this way, and the effect isn't very interesting. Line in verse, however one measures or defines it, must somehow cut across the flow of sentences, at least often enough to create a new rhythm.

Let's look at another example of nonmetrical verse in longer lines, also by Whitman:

When I heard the Learn'd Astronomer

When I heard the learn'd astronomer,
When the proofs, the figures, were ranged in columns before me,

When I was shown the charts and diagrams, to add, divide, and measure them,
When I sitting heard the astronomer where he lectured with much applause
 in the lecture-room,
How soon unaccountable I became tired and sick, 5
Till rising and gliding out I wander'd off by myself,
In the mystical moist night-air, and from time to time,
Look'd up in perfect silence at the stars. ·

All one sentence, the poem gets its rhythmic force, especially that of the chillingly beautiful last line, by Whitman's manipulation of syntax. Lines 1–4, describing the lecture, have no main clause, and so seem indecisive as well as repetitious and clogged with details—no doubt like the lecture. (The device of organizing lines or sentences by repeating a word or phrase at the beginning of each, as with "When . . ." here, is called **anaphora.**) The verbs in lines 2 and 3 are passive; and "*When I* sitting *heard*" in line 4 repeats the structure of line 1. We almost feel, in that awkward syntax, the speaker's fidgeting on a hard seat and his boredom in the redundant thump of "*lectured* . . . in the *lecture*-room." The rhythm enacts his discomfort, as it does again in line 5. The adverb "unaccount*ably*" would make sense, but we get instead the displaced adjective "unaccount*able* I." Meaning doubles: Bored by the lecture, the speaker feels that he himself is no more countable in figures and columns than are the infinite stars.

 Here is a stresses-per-phrase scansion:

When I heard the learn'd astronomer, 3

When the proofs, ‖ the figures were ranged in columns before me, 1/4

When I was shown the charts and diagrams, ‖ to add, ‖ divide, ‖ and
 measure them, 5/1/1/2

When I sitting heard the astronomer ‖ where he lectured with
 much applause in the lecture-room, 4/5

How soon unaccountable I became tired and sick, 6

Till rising and gliding out ‖ I wander'd off by myself, 3/3

In the mystical moist night-air, ‖ and from time to time, 4/2

Look'd up in perfect silence at the stars. 5

The complexity of the lecture is reflected in the repetitions and elaborations of lines 2–4. The syntax of line 2 (short clause followed by a long one) is reversed in line 3

(long clause followed by short ones); and *two* long clauses in line 4 make plain the lecturer's pomposity.

After the four lines devoted to the lecture, both syntax and rhythm begin to clarify—even in line 5 where, despite the awkward construction, the single clause shows the speaker recognizing the cause of his distress. Shorter lines express unity. The adjectives "rising" and "gliding" are familiar terms for heavenly motion; and "wander'd" repeats the literal meaning (*wanderer*) of the Greek root of the English word *planet*. The balancing rhythm in line 6 parallels the speaker's becoming confidently aware of himself as part of the universal whole. The poem's sentence flows into the phrasal unity of line 8—which also happens to be clearly iambic pentameter:

$$\text{Look'd úp | ĭn pérlféct sĭ|lénce ắt | thĕ stárs.}$$

The line's familiar music evokes, paradoxically, what is natural and lacking in artifice, the unmediated experience of standing beneath the stars themselves.

Nonmetrical Verse: Lines of Mixed Length

Since this type falls inevitably between nonmetrical verse in longer and in shorter lines, we can look at it here. Consider this straightforward example by Robinson Jeffers (1887–1962):

People and a Heron

A desert of weed and water-darkened stone under my western windows
The ebb lasted all afternoon,
And many pieces of humanity, men, women, and children,
 gathering shellfish,
Swarmed with voices of gulls the sea-breach.
At twilight they went off together, the verge was left vacant,
 an evening heron 5
Bent broad wings over the black ebb,
And left me wondering why a lone bird was dearer to me than many people.
Well: rare is dear: but also I suppose
Well reconciled with the world but not with our own natures we grudge
 to see them
Reflected on the world for a mirror. 10

Overlooking a pebbly beach as the tide ebbs, the speaker muses on why he prefers, to the families "gathering shellfish," the later lone heron. He describes the people rather coolly as "pieces of humanity" and characterizes them in the insect image of swarming, so we experience at least the tone of his misanthropy. He offers two reasons for this response. The first—"rare is dear"—implies an objectivity that can't be very plausible for a human observer, as the speaker knows; so he goes on to a second

reason. We may be "well reconciled with"—can be brought to accept—the physical world, but not "our own natures," he says, though he doesn't explain that deep dissatisfaction. We might guess that their seeking food suggests the people's dependence or perhaps their cruelty. But the heron is undoubtedly also feeding and so is little different in that regard. Ironically, the speaker tries to generalize, shifting from "dearer to *me*" and "*I* suppose" to "*we* grudge" and "*our* own natures," as if to include the rest of us. And of course it is precisely that communal impulse—his desire to share his perception, perhaps his wish to write (and ours to read) the poem—that is the quality he finds mirrored in the group on the beach.

Scanning the poem will show that the five distinctly longer lines range from eight to ten stresses, and the five distinctly shorter lines from three (line 10) to five or six stresses. But it is the *regular alternation* of longer and shorter lines that reflects the poem's crucial oppositions: tidal flow and ebb, many and one, nature and human nature, self and mirror. The poem is about two states of mind, the solitary and the communal—*and* is of two minds about them. Lines 5 and 6 demonstrate this:

> At twilight they went off together, ‖ the verge was left vacant, ‖
> an evening heron 5/3/2
>
> Bent broad wings over the black ebb, 6

The phrasal unity of line 6 clearly characterizes, in the expressive enjambment, the lone heron as it sails down to replace people on the beach. Alliteration, *v*'s in line 5 and *b*'s in line 6, suggest in sound the fittingness of the lone bird's arrival. Except for line 8, the shorter lines have phrasal unity. By contrast, the longer lines (with caesuras) suggest multiplicity, activity. Line 3, describing people, is syntactically the busiest in the poem: 3/1/1/1/3.

Few poems demonstrate the mixing of longer and shorter lines so evenly, though in "The Letter" (p. 103) Amy Lowell's regularly alternating longer and shorter lines comes close. Sometimes only a line or two will be much longer, or much shorter, than a poem's norm; as, for instance, in "My Grandmother's Love Letters" (p. 208) Hart Crane gives her name, "Elizabeth," the emphasis of a line to itself. Readers interested in poems mixing line lengths may want to look at Robert Frost's "After Apple-Picking" (p. 125), D. H. Lawrence's "Snake" (p. 110), and Louise Bogan's "Medusa" (p. 191). Since length is always relative, the type presumably also includes Liz Rosenberg's "The Silence of Women" (p. 115), Katharyn Howd Machan's "Hazel Tells Laverne" (p. 106), and James Tate's "A Guide to the Stone Age" (p. 228).

The shorter lines, and indeed the shorter second stanza, of the following poem by a student, Sheila Heinrich, appropriately suggest the poem's theme:

disappearances

was a man of many disguises
was a man of few words and

one day when they looked where he had been
they found

and no one said 5
so no one ever

The omitted name or pronoun at the beginning of line 1 and the omitted comma at
its end signal what is coming. The man seems already elusive or mysterious before
the significantly missing clauses of lines 4–6. The poem's form makes its statement.

Or consider this amusing poem by Jim Daniels (b. 1956):

Short-Order Cook

An average joe comes in
and orders thirty cheeseburgers and thirty fries.

I wait for him to pay before I start cooking.
He pays.
He ain't no average joe. 5

The grill is just big enough for ten rows of three.
I slap the burgers down
throw two buckets of fries in the deep frier
and they pop pop spit spit . . .
psss . . .
The counter girls laugh. 10
I concentrate.
It is the crucial point—
they are ready for the cheese:
my fingers shake as I tear off slices 15
toss them on the burgers/fries done/dump/
refill buckets/burgers ready/flip into buns/
beat that melting cheese/wrap burgers in plastic/
into paper bags/fries done/dump/fill thirty bags/
bring them to the counter/ wipe sweat on sleeve 20
and smile at the counter girls.
I puff my chest out and bellow:
"Thirty cheeseburgers, thirty fries!"
They look at me funny.
I grab a handful of ice, toss it in my mouth 25
do a little dance and walk back to the grill.
Pressure, responsibility, success,
thirty cheeseburgers, thirty fries.

Lines range from one stressed syllable ("psss . . .") to twelve syllables with nine stresses:

ínto páper bágs/fríes dóne/dúmp/fíll thírty bágs/

Daniels organizes the poem by a series of repetitions in which an earlier line is answered by a later line: "I wait for him to pay . . . / He pays." Line 1, "An average joe comes in," is answered by the same rhythm in line 5, "He ain't no average joe." This device also focuses the little personal drama. Line 11, "The counter girls laugh," is answered by line 21, "and smile at the counter girls," and that in turn by line 24, "They look at me funny." Like a refrain, the noun phrase of line 2, "and orders thirty cheeseburgers and thirty fries," recurs proudly in line 23, then with reflective satisfaction in line 28. The cook understands his triumph, whether the counter girls accept it or not.

The first half of the poem mixes short, medium, and long lines about equally, and randomly, in what we may take as an easygoing norm. But the slight tightening at the moment of challenge—

> The counter girls laugh.

> I concentrate.

is followed by a steady lengthening of line into the crisis (lines 16–20), when spatula-like slashes replace commas and the action is recounted in telegraphic rapidity. The poem then relaxes into lines of mostly medium length with "and smile at the counter girls." Despite "They look at me funny"—the shortest line in the poem's second half—the cook will not be swayed from savoring the episode. Except for the action lines with slashes, few lines in the poem have caesuras until the last four:

> I grab a handful of ice, ‖ toss it in my mouth 3/2

> do a little dance ‖ and walk back to the grill. 3/3

> Pressure, ‖ responsibility, ‖ success, 1/2/1

> thirty cheeseburgers, ‖ thirty fries. 3/2

We feel in rhythm the cook's sense of balancing and weighing, and ultimately of self-assurance. We may also be hearing the muted, metrical pentameter and tetrameter concealed in his rhythm:

> Pressure, | respon|sibil|ity, | success,

> thirty | cheesburg|ers, thir|ty fries.

Since iambic is a natural rhythm in English, the surprise would be its *not* occurring fairly often in poems in what we think of as free verse. Robert Lowell preferred

the term "unscanned verse" because he was aware, after writing, that lines sometimes scan metrically. Thom Gunn notes in a recent interview: "If you look at most of my contemporaries and most new poems, they write something that's not quite free verse and not quite meter." Though frustrating, such ambiguity seems inevitable in nonmetrical verse. If we don't expect it and so aren't listening, the rhythm may nonetheless appear even in longer lines like Whitman's

> When Í | wăs shównd | thĕ chárts | ănd díǐagrăms, | tŏ ádd, | dĭvíde, | ănd
> méas|ŭre thém

We may happily leave the logical problem to prosodists. The poet, though, writing free verse, may be usefully aware that metrical cadences are one of the resources.

Nonmetrical Verse: Shorter Lines

It is helpful to think of verse in shorter lines as being, loosely, of two kinds. The simpler may be called *phrasal verse*, because the poet divides lines at phrase or clause boundaries. Most of what was thought of as "free verse" early in the twentieth century was of this kind—following almost literally Pound's injunction "to compose in the sequence of the musical phrase, not in sequence of a metronome." A poem by William Carlos Williams is exemplary:

Pastoral

When I was younger
it was plain to me
I must make something of myself.
Older now
I walk back streets 5
admiring the houses
of the very poor:
roof out of line with sides
the yards cluttered
with old chicken wire, ashes, 10
furniture gone wrong;
the fences and outhouses
built of barrel-staves
and parts of boxes, all,
if I am fortunate, 15
smeared a bluish green
that properly weathered
pleases me best

 of all colors.

 No one

will believe this 20

of vast import to the nation.

Phrase being a fairly elastic concept, the lines might have been broken somewhat differently: "admiring / the houses of the very poor," for instance, or "admiring / the houses / of the very poor." But poets writing phrasal verse have relatively limited options. Caesuras will inevitably be rare. In the scansion below, caesuras appear only in lines 10, 14, and 19. In the last, the dropped-line sets off and emphasizes the last sentence, very much as a stanza break would.

Though three lines have four stresses (lines 8, 10, and 19), the norm is two or three stresses; there are nine lines of each. In general, nothing fancy—plain vanilla, in keeping with Williams's belief in "the American idiom." We also note drag/ balance/advance.

When I was younger ↔

it was plain to me →

I must make something of myself. →

Older now ↔

I walk back streets →

admiring the houses ↔

of the very poor: →

roof out of line with sides ←

the yards cluttered ↔

with old chicken wire, ‖ ashes, ↔

furniture gone wrong; →

the fences and outhouses →

built of barrel-staves ↔

and parts of boxes, ‖ all, →

if I am fortunate, ←

smeared a bluish green ↔

that properly weathered ↔

pleases me best ↔

of all colors.‖

 No one ⌐⌐↳

will believe this →

of vast import to the nation. ←

Two-stress lines occur mostly in the poem's first and last thirds; there is only one in lines 8–14, so the rhythm is appropriately heavier in presenting the detail of clutter. Nine lines showing advance and nine showing balance spread fairly evenly through the poem. Only three lines show drag—registering perhaps awkwardness in line 8, doubt in line 15, and at poem's end the laconic irony of the speaker's belief that others will not recognize the importance of this urban scene, which despite its poverty evokes in him admiration (line 6) and aesthetic pleasure (line 18). These values oppose the more typically American ambition recalled in line 3; and, though the speaker does not argue his preference, the title "Pastoral" implies an idealization of moral values similar to that of the tradition of pastoral poetry that began with Theocritus in the third century B.C. We may find meaning and beauty now, Williams implies, not among happy shepherds in a bucolic countryside, but in such everyday scenes as the poem shows us.

Other poems in phrasal verse include Williams's "Complete Destruction" (p. 42), Bruce Bennett's "Smart" (p. 115), and Tricia Stuckey's "In the Mirror" (p. 196).

The second kind of nonmetrical verse in shorter lines may be called *radically enjambed*. The poet breaks some or many of the lines at emphatic or sometimes arbitrary points *within* phrases—between adjective and noun, for example, or even between preposition and article, article and noun, and so on. Ezra Pound pioneered the device in "The Return" (p. 101) in which these lines appear:

> See, they return; ah, see the tentative
> > Movements, and the slow feet,
> > The trouble in the pace and the uncertain
> > Wavering!

The rhythmic character of the passage derives from the very strong run-on lines broken between adjectives and nouns: "The tentative / Movements" and "the uncer-

tain / Wavering!" Both force a slightly abnormal pause, and this extra hesitation rhythmically evokes the tentative, uncertain feeling. Given a line by itself, "Wavering!" unexpectedly ends the stanza's flow, leaving it on an appropriately awkward diminuendo. Lines 3–4 are scanned in chapter 3 (p. 63).

Pause or delay is only part of the effect, however. In addition, paradoxically, we feel a slight *speeding up* as the momentum of the interrupted phrase and sentence reasserts itself and seems to pull the voice around the corner into the next line. Read Pound's lines aloud several times, and listen carefully. You should feel, first, a slight pause or hesitation as voice and eye reach the unexpected break in the sentence's flow; then, second, as if to catch up, a slight hurrying as the voice curves into the new line and continues. In the last line break we feel a frustration of that hurrying as the voice jams up in "Wavering!" because the sentence ends.

The double nature of such enjambment—pause, hurry—gives it the power of seeming to imitate or express in rhythm quite opposite effects. In Cumming's lines, for instance, it creates first haste:

> and eddieandbill come
> running from marbles and
> piracies and it's
> spring

—and then, in "and it's / spring," delay for climax or emphasis. Throughout the poem (p. 32) Cummings plays on *both* impressions, now pause, now hurry.

Radical enjambment often occurs with more force than do the enjambments in traditional verse. Look back at Milton's lines about Mulciber (p. 31); enjambments occur at phrase boundaries and so are relatively mild. By contrast, radical enjambment releases a lot of energy, and the device can easily seem to become a mannerism.

Robert Hass suggests a further consideration:

A lot of William Carlos Williams's individual perceptions are a form of iambic music, but he has arranged them so that the eye breaks the iambic habit. The phrase—"a dust of snow in the wheeltracks"—becomes

> a dust of
> snow in
> the wheeltracks

and people must have felt: "yes, that is what it is like; not one-TWO, one-TWO. A dust of / snow in / the wheeltracks. That is how perception is. It is that light and quick." The effect depends largely on traditional expectation. The reader had to be able to hear what he was not hearing.

Presumably Williams is aware of, and counts on his readers hearing, the iambs which the enjambments mute.

Especially when enjambment impels a sentence forward, shorter lines often pro-
duce rhythmic speed, as they do in Bruce Bennett's "Smart" (p. 115) or Cornelius
Eady's "The Wrong Street" (p. 108). But this isn't always so. The cat in Williams's
"Poem," in spite of radical enjambments, moves in slow motion:

Poem

As the cat
climbed over
the top of

the jamcloset
first the right 5
forefoot

carefully
then the hind
stepped down

into the pit of 10
the empty
flowerpot

One interesting detail: The poem is unpunctuated. This omission of the little logical
cogs of commas and periods frees the sentence in the white space of the page. When
end-stopping occurs, it is muted or softened, as with line 4, where we would expect a
comma, or as with line 12, where (without a period) the almost seamless motion
seems poised to continue. Williams can omit the punctuation because he manages
his sentence deftly.

 Scansion shows a norm of one or two stresses per line:

Ăs thĕ cát →

clímbed óvĕr ←

thĕ tóp ŏf ↔

thĕ jámclósĕt ↔

fírst thĕ ríght ↔

fórefóot ↔

cárefŭllў ←

then the hind ↔

stepped down ↔

into the pit of ←

the empty ↔

flowerpot ↔

The drag-advance notation is especially revealing. *Only* line 1 shows advance. Lines 2, 7, and 10 show drag, and the rest—*eight* of the poem's twelve lines—show balance. This preponderance of lines in balance, these symmetrical rhythms, produce a feeling of stasis that even the momentum of radical enjambments can scarcely overcome.

Poems, of course, aren't written by means of calculation or complicated analysis. No doubt Williams, a doctor, wrote "Poem" rapidly, on the back of a prescription pad. But he knew how to listen, had trained himself to listen, for the rhythm he needed among the words that were suggesting themselves.

Other poems using radical enjambment include Gwendolyn Brooks's "We Real Cool" (p. 106), William Greenway's "Pit Pony" (p. 173), and Katharyn Howd Machan's "Hazel Tells Laverne" (p. 106).

Syllabics and Prose Poems

Syllabics, a form in which the number of syllables in each line is counted, is usually a variant of radically enjambed verse. As developed with great success by Marianne Moore (1887–1972), syllable count links corresponding lines of often complex stanzas. Here is Moore's

To a Steam Roller

The illustration
is nothing to you without the application.
 You lack half wit. You crush all the particles down
 into close conformity, and then walk back and forth on them.

Sparkling chips of rock 5
are crushed down to the level of the parent block.
 Were not "impersonal judgment in aesthetic
 matters, a metaphysical impossibility," you

might fairly achieve
it. As for butterflies, I can hardly conceive 10
 of one's attending upon you, but no question
 the congruence of the complement is vain, if it exists.

Each first line has five syllables; each second line, twelve; each third line, twelve; and each fourth line, fifteen. Especially in stanzas 1 and 3, the longer last lines mimic, both visually and rhythmically, the effect of something rolled and flattened by a steamroller. And the rhyme in each stanza's lines 1–2 (on top, like the too-methodical steamroller) is followed by the *lack* of rhyme in lines 3–4, as if the last two lines had been squashed. Even the chopped off "achieve / it" seems something the steamroller would do.

Moore's real subject, behind the symbolical steamroller, is probably the pompous critic quoted in lines 7–8, but the poem applies to any person who behaves intellectually like a steamroller—dotting every *i*, crossing every *t*, insisting on spelling out in relentless detail the entire and complete meaning ("application") of any example or illustration. As Moore said elsewhere, "I myself . . . would rather be told too little than too much."

Another example of Moore's delightful syllabics, "The Fish," appears in Chapter 11 (p. 290).

Prose poems, as one might infer, aren't verse at all, but short compositions in prose that ask for (and reward) the concentrated attention usually given to poetry. An example by Robert Bly (b. 1926):

Looking at a Dead Wren in My Hand

Forgive the hours spent listening to radios, and the words of gratitude I did not say to teachers. I love your tiny rice-like legs, that are bars of music played in an empty church, and the feminine tail, where no worms of Empire have ever slept, and the intense yellow chest that makes tears come. Your tail feathers open like a picket fence, and your bill is brown, with the sorrow of an old Jew whose daughter has married an athlete. The black spot on your head is your own mourning cap.

In subject, tone, and imagery—as well as in length—"Looking at a Dead Wren in My Hand" differs considerably from what we expect in short story or essay or, for that matter, natural history. Bly begins with emotion, with the shock of personal seriousness the dead wren in his hand prompts, and even in that his approach is oblique: "Forgive the hours spent listening to radios, and the words of gratitude I did not say to teachers." Only gradually and indirectly can he come to an empathy that properly expresses his grief—for the bird, and no longer for the realization of his own inevitable death.

Other prose poems are Jay Meek's "Swimmers" (p. 110) and Elizabeth Kostova's "Suddenly I Realized I Was Sitting" (p. 218).

Questions and Suggestions

1. To test the integrity and possible effects of lines, try out as many free-versed versions of a prose sentence as you can think of. Consider the sentence: "Bob and Sarah, my friends of many years, have come back in time for tea." Literally, of course, there are dozens of possibilities. The range is from phrasal units (omitting internal punctuation):

 > Bob and Sarah
 > my friends of many years
 > have come back
 > in time for tea.

 —to off-the-wall arrangements (mechanically, two words per line):

 > Bob and
 > Sarah my
 > friends of
 > many years
 > have come
 > back in
 > time for
 > tea.

 —or to indented versions, like:

 > Bob and Sarah
 > my
 > friends of many
 > years
 > have come back
 > in time for tea.

 Play around further with this sentence, then make up an interesting sentence or two. Type the versions to see how they would look in print. Observe especially how the variations bring out emphases or hidden potential in the sentence. In the indented version above, for instance, the subsentence "years have come back," buried in the original, appears and perhaps suggests some of the meaning of the event to the speaker. Are there other buried subsentences or subphrases?

2. Experiment with rearranging a short poem (or a stanza) into lines of very different lengths from the original. What effects can you produce? Or work with an old poem of your own.

3. Choose a simple object—a stone, a twig, a leaf, a wristwatch, for example— and study it slowly and carefully with each of your five senses (sight, hear-

ing, smell, taste, touch) in turn. Don't be shy about tasting a watch or listening to a twig! Then write a sentence or two of description for each sense. Comparisons are fine. ("It feels like a flat, closed bowl or box. Heavy. There's a little button on the side that probably opens the lid.")

Any surprises? Might there be a poem in it? Have a look at Linda Hogan's "Potholes" (p. 109).

4. Write a poem in syllabics. Or try an **acrostic,** that is, a poem in which the first letters of each line spell a name or perhaps a brief, hidden message. "Of Astrea" by Sir John Davies (1569–1626) is one of his twenty-six acrostics praising Queen Elizabeth I:

> E arly before the day doth spring
> L et us awake, my muse, and sing,
> I t is no time to slumber;
> S o many joys this time doth bring
> A s time will fail to number. 5
>
> B ut whereto shall we bend our lays?
> E ven up to heaven, again to raise
> T he maid which thence descended,
> H ath brought again the golden days
> A nd all the world amended. 10
>
> R udeness itself she doth refine,
> E ven like an alchemist divine,
> G ross times of iron turning
> I nto the purest form of gold,
> N ot to corrupt till heaven wax old, 15
> A nd be refined with burning.

The longest acrostic ever is George Starbuck's "A Tapestry for Bayeaux." The poem's subject is the Allied landings in Normandy in 1944, but the first letters of its 156 lines spell out this epigram about a well-known anthologist: "Oscar Williams fills a need, but a Monkey Ward catalog is softer and gives you something to read. We treasure his Treasuries, most every pominem. Our remarks are uncouth or unjust or ad hominem."

5. Here is the first draft of a poem called "In One Place." If it were your poem, how would you revise it? (The poet's final version appears in Appendix II, p. 341.)

In One Place

The tree grows in one place.

A seed goes down, and something
holds up two or three leaves
the first year.

> Then the spindling 5
> goes on climbing, branching,
> up, up, up
> until birds
> live in it and no one can
> remember it wasn't there. 10
>
> The tree stands always here.

6. Among the Poems to Consider, read Katharyn Howd Machan's "Hazel Tells Laverne." Imagine several ways Laverne might react, whether replying to Hazel or gossiping to someone else about the incident; and then, developing one, write "What *Laverne* Says." Or write a poem in the voice of one of the pool players in Gwendolyn Brooks's "We Real Cool," or perhaps in the voice of the son, Francis, in Christine Dresch's "Holy Water." (Why does the mother sprinkle the backseat of the old Thunderbird? The bedpillows?) Extending the possibilities, imagine (and write?) a poem in the voice of the daughter in Jane Flanders's "Shopping in Tuckahoe" (p. 160) or in that of the envoy (to whom the Duke speaks) in Robert Browning's "My Last Duchess" (p. 176).

7. The selections in Poems to Consider reflect a variety of nonmetrical forms and offer a variety of themes and tones from Ezra Pound's classical subject in "The Return" to the road rage in Jim Daniels's "The Day After," from the saucy satire of E. E. Cummings's anti-war poem, "my sweet old etcetera," to the pondering and ponderous narrative of D. H. Lawrence's "Snake." Study two or three of the poems minutely, watching the use of line and stanza, of caesura, of enjambment, and so on. In what ways do the *verse* and the theme or tone match one another? Note, for instance, which poems opt for the little formality of capitalizing the first letters of lines and which don't.

 First-person speakers often describe (or imply pretty clearly) a place and circumstances in which the poem is spoken or where its narrative occurs. In "my sweet old etcetera," for example, Cummings evokes a glimpse of "the deep mud et / cetera" of the trenches and battles of World War I. The speaker in Christine Dresch's "Holy Water" gives us a fairly thorough account of the household (and of its values and social class). What might we ascertain, from the sparse details Amy Lowell provides in "The Letter," of the place and the circumstances of her speaker? Do the speaker's own diction and syntax add to the portrait—as do those of the speaker in Jim Daniels's "The Day After"? Where do we imagine the speaker, and what is she doing as she listens to the little frogs, in Margaret Holley's "Peepers"? What are we led to imagine of the couple, of the place and of their circumstances, in Claudia Rankine's "The Man. His Bowl. His Raspberries."?

Poems to Consider

The Return 1912

EZRA POUND (1885–1972)

> See, they return; ah, see the tentative
> Movements, and the slow feet,
> The trouble in the pace and the uncertain
> Wavering!
>
> See, they return, one, and by one, 5
> With fear, as half-awakened;
> As if the snow should hesitate
> And murmur in the wind,
> and half turn back;
> These were the 'Wing'd-with-Awe', 10
> Inviolable.
>
> Gods of the wingèd shoe!
> With them the silver hounds,
> sniffing the trace of air!
>
> Haie! Haie! 15
> These were the swift to harry;
> These the keen-scented;
> These were the souls of blood.
>
> Slow on the leash,
> pallid the leash-men! 20

The Man. His Bowl. His Raspberries. 1994

CLAUDIA RANKINE (b. 1963)

> The bowl he starts with
> is too large. It will never be filled.
>
> Nonetheless, in the cool dawn,
> reaching underneath the leaf, he frees
> each raspberry from its stem 5
> and white nipples remain suspended.
>
> He is being gentle, so does not think
> *I must be gentle* as he doubles back
> through the plants
> seeking what he might have missed. 10

At breakfast she will be pleased
to eat the raspberries and put her pleasure
to his lips.

Placing his fingers beneath a leaf
for one he had not seen, he does not idle. 15
He feels for the raspberry. Securing, pulling
gently, taking, he gets what he needs.

Peepers 1992

MARGARET HOLLEY (b. 1944)

One amber inch
of blinking berry-eyed
amphibian,

four fetal fingers
on each hand, 5
a honey and mud-brown

pulse of appetite
surprised into stillness,
folded in a momentary lump

of flying bat-fish 10
ready to jump
full-tilt into anything

—the whole strength
of its struggling length
you can hold in your hand. 15

Its poetry, a raucous
refrain of pleasure
in the April-warm pools

of rain, the insistent
chorus of whistles 20
jingles through night woods,

Females! It's time!
that confident come-on
to a whole wet population

of embraces, eggs, tadpoles 25
—all head and tail,
mind darting in every direction

until the articulating torso,
Ovidian bag of bones,
results in the "mature adult": 30

a rumpled face in the mirror
still sleeping through Basho's°
awakening plop,

re-enchanted daily
by the comforting slop 35
of burgeoning spring woods

and all this sexual chatter,
doing its best to make
the wet and silky season

last forever. Yet 40
as you lie dreaming mid-leap,
splayed in the sheets,

the future as a kind
but relentless scientist
feels around in your flesh 45

for the nerve of surprise;
he just loves
the look of wonder on your face,

the word on your open lips
for the immensity 50
that grips you,

Oh.

32 For Basho's poem, see p. 335.

The Letter 1919

AMY LOWELL (1874–1925)

Little cramped words scrawling all over the paper
Like draggled fly's legs,
What can you tell of the flaring moon
Through the oak leaves?
Or of my uncurtained window and the bare floor 5
Spattered with moonlight?
Your silly quirks and twists have nothing in them
Of blossoming hawthorns,

And this paper is dull, crisp, smooth, virgin of loveliness
Beneath my hand. 10

I am tired, Beloved, of chafing my heart against
The want of you;
Of squeezing it into little inkdrops,
And posting it.
And I scald alone, here, under the fire 15
Of the great moon.

my sweet old etcetera 1922

E. E. CUMMINGS (1894–1962)

my sweet old etcetera
aunt lucy during the recent

war could and what
is more did tell you just
what everybody was fighting 5

for,
my sister

isabel created hundreds
(and
hundreds) of socks not to 10
mention shirts fleaproof earwarmers

etcetera wristers etcetera, my
mother hoped that

i would die etcetera
bravely of course my father used 15
to become hoarse talking about how it was
a privilege and if only he
could meanwhile my

self etcetera lay quietly
in the deep mud et 20

cetera
(dreaming,
et
 cetera, of
Your smile 25
eyes knees and of your Etcetera)

Holy Water 1999

CHRISTINE DRESCH*

It was still sitting in the upstairs closet,
behind the Har-Tex flea dip for Reilly,
the long-dead purebred Pekinese
they'd had before the kids.
It stunk like wet pennies 5
and it was very nearly gone,
but she swished around
the split palm and sprinkled the mailbox
to keep the bills away, then the good china,
nestled (since her goddamn sister-in-law 10
had stalked out during last Thanksgiving's feast,
twins in tow) in the German cherrywood cabinet,
and yesterday's leftovers,
tucked in Tupperware, since she thought
the Miracle-Whip had tasted suspiciously pungent. 15
She went into the garage and daubed
the fading phoenix on the old Thunderbird,
praying the strangely palpitating acceleration
on the way to Dairy Queen last night was only
a momentary pang of advanced motor age, 20
since Francis had set his heart
on driving it to Prom next week.
She sprinkled the backseat.
Upstairs, she dragged out the big moldy box
with all the uncashed pension checks and tax returns 25
she'd taken from Mother's apartment in the hopes
her sister (toting trays of Brandy Cobblers
and Vodka Martinis somewhere in Vegas)
would reconnect her long distance
and sign over power of attorney so they could 30
get State Farm Nursing Home insurance
with whatever was left. She also sprinkled
the cheerfully fluffed, lavender-scented bedpillows,
because her husband's paperwork
seemed to pile up more with each passing day. 35
The rest she scattered over the living room furniture,
since she never could find time to dust.
In the silence before the garage door opened
she caught her breath,
squinting so the setting sun seemed to ignite 40
the waterdrops into glowing, knowing fingerprints,
clutching the empty Mason jar to her chest.

Promised Land 1995

LYNN POWELL (b. 1955)

The Lord wrinkles up His nose and admits she's right:
He *had* forgotten her.
Well, damn, she says. She knew it.
Why else would He let her live till her hands warped,
her nails thickened and yellowed like the dead's? 5
Why else would He let her legs, which she had always
considered one of His finest accomplishments,
shrink to knobby rails?

Not used to being blind, she lifts up her head
to eye Him and change the subject: 10
So what's in bloom out there?
Forsythia, dogwood, redbud, He replies,
a touch of arbutus, the beginning of bloodroot—

she feels a rabbit run over her grave, and she startles.

Well, now she knows He won't invite 15
her over Jordan till she gets to its headwaters—
a trickle of snowmelt she'll walk over without notice,
bound for a bed of white trillium.

We Real Cool 1959

GWENDOLYN BROOKS (b. 1917)

> *The Pool Players.*
> *Seven at the Golden Shovel.*

We real cool. We
Left School. We

Lurk late. We
Strike straight. We

Sing sin. We 5
Thin gin. We

Jazz June. We
Die soon.

Hazel Tells Laverne 1981

KATHARYN HOWD MACHAN (b. 1952)

last night
im cleanin out my

howard johnsons ladies room
when all of a sudden
up pops this frog 5
musta come from the sewer
swimmin aroun an tryin ta
climb up the sida the bowl
so i goes ta flushm down
but sohelpmegod he starts talkin 10
bout a golden ball
an how i can be a princess
me a princess
well my mouth drops
all the way to the floor 15
an he says
kiss me just kiss me
once on the nose
well i screams
ya little green pervert 20
an i hitsm with my mop
an has ta flush
the toilet down three times
me
a princess 25

Saviour (Mississippi 1957) 1995

OMOTEJI ADEYEMON*

Christ was white this morning,
when I went to church
to hear the good news of
his coming and
the resurrection of my soul. 5
Christ was white this morning
and displayed up high.
Then they came and burnt the church down.
Now Christ is black,
with a crown of charcoal thorns. 10
Now Christ is black,
like me,
and lying on the ground.

The Wrong Street 1991

CORNELIUS EADY (b. 1954)

If you could shuck your skin and watch
The action from a safe vantage point,
You might find a weird beauty in this,
An egoless moment, but for
These young white men at your back. 5
Your dilemma is how to stay away from
That three to five second shot
On the evening news of the place
Where you stumble, or they catch
Their second wind, or you run up 10
To the fence, discover that
You are not breeze, or light,
Or a dream that might argue
Itself through the links. Your responsibility
Is not to fall bankrupt, a 15
Chalk-marked silhouette faintly
Replaying its amazement to
The folks tuning in, fist to
Back, bullet to mid-section.
Your car breaks down 20
And gives you up. A friend's
Lazy directions miss
The restaurant by two
Important blocks. All of this
Happened. None of this 25
Happened. Part of this
Happened. (You dream it
After an ordinary day.) Something
Different happened, but now
You run in an 30
Old story, now you learn
Your name.

The Day After 1997

JIM DANIELS (b. 1956)

the worst snowstorm in years,
a horn blares—a stuck cab
blocks the street, the guy
in the car behind leans on his horn
then stomps out and starts pounding 5
on the cabbie's door shouting move it

move your fucking car and the cabbie's
saying I'm stuck and the guy's screaming
try it you're not stuck and the cabbie opens
his door and the guy hits him in the face 10
and throws snow at him and the cabbie says
he's gonna call the cops and the guy says
call the cops fucking call the cops
and the cabbie says I'm gonna get my gun
and he goes around to his back door 15
and the other guy starts running
back to his car until it occurs to him
that the cabbie's bluffing because he's stopped
with his hand on his back door
so the guy charges back saying 20
get your gun get your fucking gun
but the cabbie don't move
because he ain't got a gun so the guy starts
throwing snow at him again and shouting
move, motherfucker, let's see your gun 25
but he ain't got no gun
so the guy keeps taunting him
let's see your fucking gun
and punches the cabbie in the face
then gets in his car and rear ends 30
the cab till it's out of his way
and speeds off and the cabbie's alone
in the street shouting next time
I'll have a gun
next time I'll have a fucking gun. 35

◈ Potholes 1988

LINDA HOGAN (b. 1947)

The streets we live by fall away.
Even the asphalt is tired
of this going and coming to work,
the chatter in cars,
and passengers crying on bad days. 5

Trucks with frail drivers
carry dangerous loads. Have care,
these holes are not just holes
but a million years of history
opening up, all our beautiful failures 10

and gains. The earth is breathing
through the streets.

Rain falls.
The lamps of earth switch on.
The potholes are full 15
of light and stars, the moon's many faces.

Mice drink there in the streets.
The skunks of night drift by.
They swallow the moon.
When morning comes, 20
workers pass this way again,
cars with lovely merchandise. Drivers,
take care, a hundred suns look out of earth
beneath circling tires.

Swimmers 1994

JAY MEEK (b. 1937)

Coming out of the theater, in the light of the marquee, I can see there is
something on my clothing and my hands. When I look back I can see it on
the others too, like light off the screen on their faces during the film, or the
grey illuminations made at night by summer lightning. It doesn't go away.
We are covered with it, like grease, and when by accident we touch each
other, we feel it on our bodies. It is not sensual, not exciting. It is slippery,
this film over our lives, so that when we come up against one another and
slide away, it is as if nothing has happened: we go on, as though swimming
the channel at night, lights on the water, hundreds of us rising up on the
beach on the far side.

Snake 1921

D. H. LAWRENCE (1885–1930)

A snake came to my water-trough
On a hot, hot day, and I in pyjamas for the heat,
To drink there.

In the deep, strange-scented shade of the great dark carobtree
I came down the steps with my pitcher 5
And must wait, must stand and wait, for there he was at the trough
 before me.

He reached down from a fissure in the earth-wall in the gloom
And trailed his yellow-brown slackness soft-bellied down,
 over the edge of the trough

And rested his throat upon the stone bottom,
And where the water had dripped from the tap, in a small clearness, 10
He sipped with his straight mouth,
Softly drank through his straight gums, into his slack long body,
Silently.

Someone was before me at my water-trough,
And I, like a second comer, waiting. 15

He lifted his head from his drinking, as cattle do,
And looked at me vaguely, as drinking cattle do,
And flickered his two-forked tongue from his lips, and mused a moment,
And stooped and drank a little more,
Being earth-brown, earth-golden from the burning bowels of the earth 20
On the day of Sicilian July, with Etna smoking.

The voice of my education said to me
He must be killed,
For in Sicily the black, black snakes are innocent, the gold are venomous.

And voices in me said, If you were a man 25
You would take a stick and break him now, and finish him off.

But must I confess how I liked him,
How glad I was he had come like a guest in quiet, to drink
 at my water-trough
And depart peaceful, pacified, and thankless,
Into the burning bowels of this earth? 30

Was it cowardice, that I dared not kill him?
Was it perversity, that I longed to talk to him?
Was it humility, to feel so honoured?
I felt so honoured.

And yet those voices: 35
If you were not afraid, you would kill him!

And truly I was afraid, I was most afraid,
But even so, honoured still more
That he should seek my hospitality
From out the dark door of the secret earth. 40

He drank enough
And lifted his head, dreamily, as one who has drunken,
And flickered his tongue like a forked night on the air, so black;
Seeming to lick his lips,
And looked around like a god, unseeing, into the air, 45
And slowly turned his head,
And slowly, very slowly, as if thrice adream,

Proceeded to draw his slow length curving round
And climb again the broken bank of my wall-face.

And as he put his head into that dreadful hole, 50
And as he slowly drew up, snake-easing his shoulders, and entered
 farther,
A sort of horror, a sort of protest against his withdrawing into that
 horrid black hole,
Deliberately going into the blackness, and slowly drawing himself after,
Overcame me now his back was turned.

I looked round, I put down my pitcher, 55
I picked up a clumsy log
And threw it at the water-trough with a clatter.

I think it did not hit him,
But suddenly that part of him that was left behind convulsed
 in undignified haste,
Writhed like lightning, and was gone 60
Into the black hole, the earth-lipped fissure in the wallfront,
At which, in the intense still noon, I stared with fascination.

And immediately I regretted it.
I thought how paltry, how vulgar, what a mean act!
I despised myself and the voices of my accursed human education. 65

And I thought of the albatross,
And I wished he would come back, my snake.

For he seemed to me again like a king,
Like a king in exile, uncrowned in the underworld,
Now due to be crowned again. 70

And so, I missed my chance with one of the lords
Of life.
And I have something to expiate;
A pettiness.

Taormina.

5

THE SOUND (AND LOOK) OF SENSE

Before the invention of printing in the fifteenth century, poetry was primarily an oral art. It was heard, rather than seen, in songs, ballads, recited epics, or tales. Formal meters, clearly accented and countable, allowed a poem's form to be followed by its hearers, just as rhyme, apart from its musical qualities, signaled lines like a typewriter bell. Since the sixteenth century, and especially after the rise of general literacy in the nineteenth century, poetry has come to have an increasingly visual dimension as well, through an almost imperceptible evolution. Today we are more accustomed to seeing a poem than to hearing it, and students must be reminded to read poems aloud lest they miss the essential music.

Pope is having fun with that music in the "sound of sense" passage (p. 79), showing some of the tricks verse can perform. When he mentions the gluey effect of open vowels, he provides a line of them: "Though oft the ear the open vowel tire." He illustrates how filler words like "do" make awkward lines: "While expletives their feeble aid do join." Or how monotonously monosyllables can move: "And ten low words oft creep on one dull line." He makes an illustrative hexameter sinuously sluggish:

> A needless Alexandrine ends the song,
> That, like a wounded snake, drags its slow length along.

The fun has a serious point: "The sound must seem an echo to the sense." The echo will rarely be as obvious as in the examples Pope has contrived. What, after all, is the sound of a particular emotion—of, say, looking at the stars outside a lecture hall or holding a dead wren, or of regarding a man who picks raspberries for a woman's breakfast? Yet poets who write successful poems must be listening carefully for the sound that seems an echo to the sense.

And now, too, poets are probably watching carefully for the look that seems a mirror to the meaning.

In this chapter we will consider some of the elements both of the sound and of

the look of sense: *visible form, repetition, onomatopoeia, alliteration, assonance,* and *rhyme*.

Visible Form

The rise of nonmetrical verse in the twentieth century has no doubt increased our reliance on the visual dimension of poetry. With such verse, we *see* line breaks; the measure shapes itself on the page, to the eye. The visual of course does not replace the oral (poetry always draws on speech for its vigor) but complements it, opening new formal possibilities, visual forms, as well as (since the sixteenth century) enriching the resources of more traditional verse.

Every poem has a visible form when we see it on the page, a shape that invites at least a subliminal predisposition as to tone or theme, heft or airiness, difficulty or informality, quiet or agitation, and so on. Appearance conveys a message. Is the poem slender, bony, quick? Solid, heavy, full? Are the lines even, orderly, smooth? Or raggedy, jumpy, excited, mixing long and short? Or perhaps lines get gradually longer, or shorter, as the poem goes along?

Are some lines indented? Irregularly or in a pattern?

Does the poem use stanzas? Of the same or of a varying number of lines? Narrow stanzas, like couplets? Plumper ones? Do the stanzas have a distinctive shape, like those of Wilbur's "Hamlen Brook" (p. 49) or Moore's "To a Steam Roller" (p. 96)?

In short, will the visible form give readers an accurate first impression of the poem? Like a good title, appearance can be informative, as well as attractive and enticing. Further, does the visible form help readers in responding to the poem?

Stanzas, for instance, can express a poem's organization. They may be "closed," ending with a completed sentence, or "open," continuing a sentence across the stanza break. Like paragraphs in prose, closed stanzas may correspond to segments of an idea or argument, as in Whitman's "A Noiseless Patient Spider" (p. 36) where they present the comparison of venturing spider and venturing soul, or to scenes or parts of a narrative, as in Paul Lake's "Blue Jay" (p. 82). Open stanzas help Williams express the cat's poise or hesitancy in "Poem" (p. 95) as, albeit differently, they help Moore express the fluid under-seascape of "The Fish" (p. 290). In writing, the careful poet will be alert to seize the opportunities of visible form. Fixed stanzas of a certain number of lines can often help, like a trellis over which the poem can play. In Margaret Holley's "Peepers" (p. 102), for example, the triplets provide a pattern she can vary subtly by occasional rhyming or by the sensual emphasis of the final, one-line stanza: "Oh." Equally, shifting and natural stanzas that show themselves to the poet as a poem develops will often be subtle in a different way.

The following poem by Liz Rosenberg (b. 1955) uses both closed and open stanzas, though it is their length and shape that make the poem exciting:

The Silence of Women

Old men, as time goes on, grow softer, sweeter,
while their wives get angrier.
you see them hauling the men across the mall
or pushing them down on chairs,
"Sit there! and don't you move!" 5
A lifetime of *yes* has left them
hissing bent as snakes.
It seems even their bones will turn
against them, once the fruitful years are gone.
Something snaps off the houselights, 10
and the cells go dim;
the chicken hatching back into the egg.

Oh lifetime of silence!
words scattered like a sybil's leaves.
Voice thrown into a baritone storm— 15
whose shrilling is a soulful wind
blown through an instrument
that cannot beat time

but must make music
any way it can. 20

The point is less silence than being silenced. Women have words, but their words
have been scattered; they have a voice, but it has been drowned out by the "baritone
storm" of men's voices and so turned into a "shrilling"—perhaps like the stridency of
line 5. It is "a soulful wind" expressing itself through an instrument that "must make
music / any way it can."

This suppression, this diminishing, shows visually in the dwindling of stanzas
from twelve lines to six, then to two, as well as in the generally shorter lines of stan-
zas 2 and 3—which after line 15 decrease unrelentingly. The poem's shape is some-
thing like an emblem of its meaning.

Or consider how stanzas create the gestures that Bruce Bennett (b. 1940) uses in
this poem:

Smart

like the fox
who grabs a stick
and wades
into the water

deep 5
and deeper
till only his muzzle's

above it
his fleas

leap 10
up and up
onto his head
out onto the stick

which he lets go

off it floats 15
as he swims back
and shakes himself dry

Part of the effect depends on Bennett's eschewing capitalization and punctuation, thus partially disguising the poem's three sentences. (The second would normally begin, "His fleas . . . ," in line 9; the third, "Off it floats . . . ," in line 15.) The first stanza break, stretching the sentence over it, perhaps helps to suggest the "deep / and deeper" of the water; and the second, how "his fleas // leap / up and up . . ." Best, though, is the way the third and fourth stanza breaks isolate "which he lets go," so that the one-line stanza floats on the page, visually like the horizontal stick adrift on the water.

Other sorts of visual choreographing use typography and spacing on the page, including indentation or dropped-line. E. E. Cummings's "in Just-" (p. 32) is a good example, as is "my sweet old etcetera" (p. 104), based on his experience in World War I. In "Jump Cabling" (p. 129) Linda Pastan amusingly arranges the last words of lines for symbolic—note, not for pictorial—effect.

Dropped-line is a convention that probably originated in dramatic usage. In printing Shakespeare's plays for instance, when a single pentameter line is divided between two speakers, the second part of the line is shown as "dropped":

Brutus: What means this shouting? I do fear, the people
 Choose Caesar for their king.
Cassius: Ay, do you fear it?
 Then must I think you would not have it so.

The Tragedy of Julius Caesar, I, ii, 79–81

Dropped-line creates rhythmical variation or emphasis, as Richard Wilbur does in "Love Calls Us to the Things of This World" (p. 303):

And the heaviest nuns walk in a pure floating
Of dark habit,
 keeping their difficult balance.

In this poem Nancy Eimers (b. 1954) uses dropped-line or indentation to indicate rhythmic subordination, guiding both eye and voice.

A Night Without Stars

And the lake was a dark spot
 on a lung.
Some part of its peace was dead; the rest was temporary. Sleeping ducks
 and geese,
goose shit underfoot 5
 and wet gray blades of grass.
The fingerlings like sleeping bullets
 hung deep in the troughs of the hatchery
and cold traveled each one end to end,
such cold, 10
 such distances.

We lay down in the grass on our backs—
beyond the hatchery the streetlights were mired in fog and so
there were no stars,
 or stars would say there was no earth. 15

Just a single homesick firefly lit on a grass blade.
Just our fingers
 curled and clutching grass,
this dark our outmost hide, and under it
 true skin. 20

The speaker and a companion go on a summer evening to a fish hatchery that apparently also serves as a park. Fog, however, eerie, disappointing, seems a lung on which the lake is like a threatening spot. The tiny fish are "like sleeping bullets" and the speaker interprets the lone firefly as "homesick." The outing is a failure. They can't lie romantically on the grass and watch stars.

In a general way, the device of dropped-line registers this disjunction between expectation and event. We read, for instance,

 such cold,
 such distances,

somewhat differently than we would if the second phrase appeared either on the same line with the first or as a completely separate line flush left. The device suggests a remoteness, a dropping of the voice, that we wouldn't feel in either of those other ways of presenting the phrase. Each of the eight dropped-lines or indentations has its own singular tone or effect. The combined length of lines 7–8, for instance, suggests the long rectangular pools or troughs in which the young fish are raised, and the dropping of line 8 the depth of the fingerlings beneath the surface of the water. Facing the current that runs from end to end of the troughs, the fingerlings seem in touch with distances as well as the chill, fresh water. The brevity of the dropped-line

20—"true skin"— perhaps registers the vulnerability the speaker feels beneath the foggy darkness that seems so close as to be "our outmost hide."

In a very small but interesting class of poems, the visual or spatial element dominates, becoming explicitly pictorial. "Easter Wings" by George Herbert (1593–1633), written in meter, is an early example of this tradition:

Lord, who createdst man in wealth and store,
Though foolishly he lost the same,
Decaying more and more
Till he became
Most poore;
With thee
O let me rise
As larks, harmoniously,
And sing this day thy victories;
Then shall the fall further the flight of me.

My tender age in sorrow did beginne;
And still with sicknesses and shame
Thou didst so punish sinne,
That I became
Most thinne.
With thee
Let me combine,
And feel this day thy victorie;
For if I imp° my wing on thine,
Affliction shall advance the flight in me.

19 *imp:* to graft. Alludes to a term in falconry.

Decreasing and then increasing the lines of each stanza by one foot, Herbert not only makes the poem look like two pairs of angels' wings but also embodies in rhythm its theme of diminution and regrowth. Twentieth-century poets have used the shapes of a Coca-Cola bottle, key, fireplug, umbrella, lightbulb, New York State, and even a swan and its reflection.

William Carlos Williams offers a famous, contemporary picture poem:

The Red Wheelbarrow

so much depends
upon

a red wheel
barrow

glazed with rain
water

beside the white
chickens

5

Each stanza seems to show a miniature wheelbarrow in side view, with the longer first line suggesting the handle. If so, the radically enjambed line-turn may give us an oral image of the wheel:

Visual and rhythmic forms combine. This tiny still life catches energy in stasis, a colorful vitality only momentarily at rest.

Repetition

Simply repeating a word or phrase, perhaps with variations, can give a tune to a passage, as in Howard Nemerov's "Learning by Doing" (p. 81): "So what they do / They do, as usual, to do us good"; or as in Robert Hayden's "Those Winter Sundays" (p. 6), we hear emotion in the doubled phrase: "What did I know, what did I know / of love's austere and lonely offices?" Look again at "The Wrong Street" (p. 108), in which Cornelius Eady suddenly breaks the flow of the speculative narrative and ends the poem:

> . . . All of this
> Happened. None of this
> Happened. Part of this
> Happened. (You dream it
> After an ordinary day.) Something
> Different happened, but now
> You run in an
> Old story, now you learn
> Your name.

"Something / Different happened" and since the day was ordinary, whatever it was wasn't overtly dangerous, but nonetheless can precipitate—"now . . . now . . ."—the very real fear and the identity that the "Old story" holds for the speaker. Repetition brings the poem into startling focus.

Simpler but no less effective is the relentless repetition in this poem by Richard Lattimore (1906–1983):

Catania to Rome

> The later the train was at every station,
> the more people were waiting to get on,
> and the fuller the train got, the more time it lost,

and the slower it went, all night, station to station,
the more people were on it, and the more people 5
were on it, the more people wanted to get on it,

waiting at every twilight midnight and half-daylight
station, crouched like runners, with a big suitcase
in each hand, and the corridor was all elbows armpits

knees and hams, permessos and per favores, and a suitcase 10
always blocking half the corridor, and the next station
nobody got off but a great many came aboard.

When we came to our station we had to fight to get off.

The ever-branching, delaying, crowded sentence of lines 1–12 captures the frustra-
tion of the long train journey in repeating and repeating: *station, more people, more,
waiting, get* (and *got*), *on, all* and *always, suitcase, corridor, came,* and ultimately *off,*
not to mention eight *and*'s. It is a sentence crowded with commas—and, equally,
crowded because it does not include commas where we expect them: "twilight mid-
night and half-daylight" as well as "all elbows armpits // knees and hams."

Line 13 is a relief—although, missing its needed comma after "station," the sen-
tence has to push its way to its end.

Repetition may serve as a structural device, as it does in different ways in E. E.
Cummings's "my sweet old etcetera" (p. 104), Langston Hughes's "Aunt Sue's Sto-
ries" (p. 131), and Robin Becker's "When Someone Dies Young" (p. 179). More for-
mally, repetition becomes the **refrain** of song or song-like poems. A refrain is a line
or lines regularly repeated from stanza to stanza, usually at the end, as in Shake-
speare's "When Icicles Hang by the Wall" (p. 130) and Maura Stanton's contempo-
rary "Song (After Shakespeare)" (p. 130). In "Recuerdo" (Spanish for *recollection* or
memory), Edna St. Vincent Millay (1892–1950) organizes the poem by beginning
the stanzas with a refrain:

Recuerdo

We were very tired, we were very merry—
We had gone back and forth all night on the ferry.
It was bare and bright, and smelled like a stable—
But we looked into a fire, we leaned across a table,
We lay on a hill-top underneath the moon; 5
And the whistles kept blowing, and the dawn came soon.

We were very tired, we were very merry—
We had gone back and forth all night on the ferry;
And you ate an apple, and I ate a pear,
From a dozen of each we had bought somewhere; 10
And the sky went wan, and the wind came cold,
And the sun rose dripping, a bucketful of gold.

We were very tired, we were very merry,
We had gone back and forth all night on the ferry.
We hailed, "Good morrow, mother!" to a shawl-covered head, 15
And bought a morning paper, which neither of us read;
And she wept, "God bless you!" for the apples and pears,
And we gave her all our money but our subway fares.

Repetition of words or of whole lines underlies the complex whole-poem forms of sestina, villanelle, and pantoum. Familiar and difficult, sestina and villanelle remain popular among poets; and there has been a resurgence of interest in the challenging pantoum, a Malayan form. Descriptions and contemporary examples may be found in Appendix I (pp. 331–336). Edward Hirsch's "At Sixteen" (p. 132) is a somewhat relaxed adaptation of the pantoum.

Onomatopoeia

Some words have sound effects built in: *hiss, buzz, snarl, rattle, snap, crunch, swish, whirr, whisper, murmur, hum, roar*. Such words, called onomatopoetic (noun: **onomatopoeia**), imitate their meaning. Keep your ear tuned for them. Often they will imitate sounds, like those just listed; but words expressive of size, motion, touch, and other qualities are nearly as frequent. Notice *thin, skinny, slim, slender, squirrelly, spindly*; or *fat, plump, rotund, gross, humongous, pudge-pot, stout, brawny*. Notice how lightly *delicate* hits its syllables, how heavily *ponderous* does. Feel how your mouth says *pinched, shut, open, round, hard, soft, smooth*. Try *up, down; quick, slow*; or *sweet, tart, bitter, sour*.

It isn't only that particular sounds have meanings as such; many words don't sound at all like their meanings: *cat, suddenly, pigeon*. Sometimes it may be association as much as sound we respond to, as in *tip* and *top* or *slip* and *slide*—though there are also *slice, slick, slight, slim, slime, sling, slink, slit, slither, sliver*. As Dr. Johnson put it, "on many occasions we make the music we imagine ourselves to hear."

The most familiar example of onomatopoeia is Tennyson's

The moan of doves in immemorial elms
And murmuring of innumerable bees

Equally unmistakable, in Jim Daniels's "Short-Order Cook" (p. 89) is

and they pop pop spit spit . . .
psss . . .

where even the dots of the ellipses may suggest the spitting grease of the deep fryer. Such effects are best used sparingly, lest they become obtrusive and overwhelm meaning. Nevertheless overdoing it is the fun of this poem by John Updike (b. 1932):

Player Piano

My stick fingers click with a snicker
And, chuckling, they knuckle the keys;
Light-footed, my steel feelers flicker
And pluck from these keys melodies.

My paper can caper; abandon 5
Is broadcast by dint of my din,
And no man or band has a hand in
The tones I turn on from within.

At times I'm a jumble of rumbles,
At others I'm light like the moon, 10
But never my numb plunker fumbles,
Misstrums me, or tries a new tune.

The interplay of onomatopoetic diction and other sound effects—alliteration, assonance, rhyme, and even rhythm—may be as complex as in these familiar lines by Pope:

And the smooth stream | in smoother numbers flows;

But when | loud surges lash | the sounding shore,

The hoarse, | rough verse | should like | the torrent roar.

Smooth and *smoother, loud, lash, hoarse, rough,* and *roar* are clearly onomatopoetic, and perhaps *stream, flows, surges,* and *torrent* as well. But the alliterating *s*'s and *m*'s in the first line, and the speed of the pyrrhic/spondee and then the evenness of the iambs, also contribute. In the second and third lines, the spondees and trochee (which bring runs of stresses together) add to the tumult of alliterating *r*'s and rhymes or near-rhymes—*shore, hoarse, torrent, roar,* along with *surges, verse.* And, in this seemingly uncontrolled release of energy, don't overlook the assonance of *loud* and *sounding.*

Alliteration and Assonance

Alliteration is the repetition of consonant sounds in several words in a passage; **assonance,** the repetition of vowel sounds. Initial alliteration usually jumps out at us. In Pope's line "But when loud surges lash the sounding shore," the *l*'s of "*l*oud" and "*l*ash" and the *s*'s of the "*s*urges" and "*s*ounding" are unmistakable. Harder to notice is the alliteration of "la*sh*" and "*sh*ore," since the first of the pair doesn't start the syllable's sound. For a similar reason, assonance may also be subtle, as in "l*ou*d" and

"sounding," where it links the noise of breakers and the resulting noise of the shore on which they fall—echoing, too, in the *d*'s following the vowel sounds.

Consider another line in Pope's passage:

> Thĕ líne | tóo lá|bŏrs, ănd | thĕ wórds | móve slów.

An impression of dragging stems from the two spondees and from the promoted stress on "and," which (after the caesura) makes it awkward for the voice to regain momentum. Long vowels and alliterating *l*'s in "line," "too," "labors," "move," and "slow" increase the effect, though probably the assonance in "too" and "move" most impedes the sentence's progress.

With the same devices Howard Nemerov creates a very different music in these lines from "The Fourth of July" (p. 136)

> Ĭt ís, | ĭndéed, splén|dĭd:
>
> Shówĕrs | ŏf rós|ĕs ín | thĕ ský, fóun|tains
>
> Ŏf ém|ĕrálds, | ănd thóse | prŏfúse|lў scát|tĕred zír|cŏns
>
> Fállĭng, | ănd fáll|ĭng, flów|ĕrĭng ás | thĕy fáll
>
> Ănd fól|lŏwed dís|tăntlў | bў ă nóise | ŏf thún|dĕr.
>
> Mў éyes | ăre hálf-|ăflóat | ĭn háp|pў téars.

We notice at once the showy alliteration of *f*'s that center on the repetitions of "Falling and falling, flowering as they fall," and that are almost always accompanied by *l*'s, even in "profusely." The assonance in "Sh*ow*ers" and "f*ou*ntains," which frames the first full line, shows up two lines below as internal rhyme in "fl*ow*ering"—which also picks up the *or* sound in "emeralds," "scattered," "zircons," and then in "thunder." Assonance and internal rhyme also link "roses," "those," and "profusely." Both alliteration and assonance link "*half-*" and "*happy*" in the last line, with a thematic relevance that leads to the heavy irony in the speaker's admiration for the grand fireworks and for "the careful and secure officials / Who celebrate our independence now" (alliteration in "careful" and "secure," assonance in "*-ful*" and "offici*al*"). Readers may not notice that the line about the profusion of zircons has six feet, but poets will who want to know how effects happen.

Alliterative pairing can emphasize either comparison, as in "The *s*ound must *s*eem an echo to the *s*ense," or contrast, as in Francis's "Excellence is *m*illimeters and not *m*iles." Like rhyme, alliteration or assonance may serve both as a musical and as an organizing device. Howard Nemerov gets the last word:

Power to the People

Why are the stamps adorned with kings and presidents?
That we may lick their hinder parts and thump their heads.

Alliteration precisely links "hinder parts" and "heads"; and is it assonance in "presidents" and "heads" that makes the couplet seem formally complete, nearly rhyming?

Rhyme

By definition, **rhyme** is an identity in two or more words of vowel sound and of any following consonants. Exact rhymes: *gate-late*; *own-bone*; *aware-hair*; *applause-gauze*; *go-throw*. Rhymes normally fall on accented syllables. Double (or extra-syllable) rhymes normally fall on an accented and unaccented syllable: *going-throwing*; *merry-cherry*; but they may fall on two accented syllables, as in *ping-pong, sing-song*. Triple rhymes are *merrily-warily*; *admonish you-astonish you*. There are a few natural four-syllable rhymes, like *criticism-witticism*.

English is not an easy language to rhyme. Many familiar words have no natural rhymes, like "circle" or "month." For some words there is only one natural rhyme: "strength-length," "fountain-mountain." A word as much used as "love" offers meager possibilities: *above, dove, glove, shove, of*. Despite a poet's best effort, it is hard to make such rhymes fresh; consequently, *unrhymed* verse is equally standard, as the **blank verse** (unrhymed iambic pentameter) of Shakespeare's plays and of many of Frost's dramatic monologues—and of Nemerov's "The Fourth of July."

The difficulty of rhyme in English has opened up a variety of inexact rhyme—off- or slant-rhymes—that the poet may use with considerable freshness—terminal alliteration, for instance, as in *love- move, ban-gone, both-truth, chill-full*; or **consonance** (identity of consonants with different main vowels), as in *bad-bed, full-fool, fine-faun*, or *summer-simmer*; or near consonance as in *firm-room, past-pressed*, or *shadow-meadow*. There is assonance, of course, as in *bean-sweet* or *how-cloud*; and Emily Dickinson has even made length of vowel work, as in "be-fly" or the fainter "day-eternity."

Rhyming accented with unaccented (or secondarily accented) syllables is also a common method of off-rhyme, as in "*see-pretty*," "*though-fellow*," "*full-eagle*," "*fish-polish*," "*them-solemn*," "*under-stir*." There is no need to be systematic about the varieties of off-rhyme. Depending upon the effect you want, anything will do—look ahead to the inventiveness of Marianne Moore's "The Fish" (p. 290). In this World War I poem by Wilfred Owen (1893–1918), off-rhyme becomes nearly as formal as exact rhyme. The persistent refusal to rhyme gives the poem an off-key sound in keeping with its ironic theme

Arms and the Boy

Let the boy try along this bayonet-blade
How cold steel is, and keen with hunger of blood;

Blue with all malice, like a madman's flash;
And thinly drawn with famishing for flesh.

Lend him to stroke these blind, blunt bullet-leads 5
Which long to nuzzle in the hearts of lads,
Or give him cartridges of fine zinc teeth,
Sharp with the sharpness of grief and death.

For his teeth seem for laughing round an apple.
There lurk no claws behind his fingers supple; 10
And God will grow no talons at his heels,
Nor antlers through the thickness of his curls.

Nor need rhyme always fit a rigid pattern. In Robert Frost's "After Apple-Picking," the line length varies; so does the occurrence of the rhymes:

After Apple-Picking

My long two-pointed ladder's sticking through a tree
Toward heaven still,
And there's a barrel that I didn't fill
Beside it, and there may be two or three
Apples I didn't pick upon some bough. 5
But I am done with apple-picking now.
Essence of winter sleep is on the night,
The scent of apples: I am drowsing off.
I cannot rub the strangeness from my sight
I got from looking through a pane of glass 10
I skimmed this morning from the drinking trough
And held against the world of hoary grass.
It melted, and I let it fall and break.
But I was well
Upon my way to sleep before it fell, 15
And I could tell
What form my dreaming was about to take.
Magnified apples appear and disappear,
Stem end and blossom end.
And every fleck of russet showing clear. 20
My instep arch not only keeps the ache,
It keeps the pressure of a ladder-round.
I feel the ladder sway as the boughs bend.
And I keep hearing from the cellar bin
The rumbling sound 25
Of load on load of apples coming in.
For I have had too much
Of apple-picking: I am overtired

Of the great harvest I myself desired.
There were ten thousand thousand fruit to touch, 30
Cherish in hand, lift down, and not let fall.
For all
That struck the earth,
No matter if not bruised or spiked with stubble,
Went surely to the cider-apple heap 35
As of no worth.
One can see what will trouble
This sleep of mine, whatever sleep it is.
Were he not gone,
The woodchuck could say whether it's like his 40
Long sleep, as I describe its coming on,
Or just some human sleep.

Sometimes rhymes occur in adjacent lines, but they may be separated by as many as three other lines, as are "break-take" in line 13–17 and "end-bend" in lines 19–23. The triple-rhyme "well-fell-tell" in the quickly turning lines 14–16 appropriately helps to convey the indefinable transition from waking to dreaming. Near the end of the poem, in a masterful touch, "heap" in line 35 doesn't find its line-end rhyme until, after seven lines, "sleep" appears in line 42, although the word teasingly occurs three times *within* intervening lines.

This is a good example of **internal rhyme**. Unlike end-rhyme, which occurs at line ends as part of the formal organization of a poem, internal rhyme may occur anywhere within lines and is musically "accidental," though it may be wonderfully expressive:

> And I keep hearing from the cellar bin
> The rumbling sound
> Of load on load of apples coming in.

Internal rhyme may be as overt and corny as in the old popular song's "the lazy, hazy, crazy days of summer" or as subtle as in these lines of Richard Wilbur's "Year's End":

> I've known the wind by water banks to shake
> The late leaves down, which frozen where they fell
> And held in ice as dancers in a spell
> Fluttered all winter long into a lake . . .

The lovely whirling sound within the "which" clause mainly results from the internal rhyme of "held," which attaches to the end-rhyme "fell" and unexpectedly spins the voice toward the end-rhyme "spell." The quick movement is intensified by the only technically accented "in" of "as dancers in a spell," with three essentially unac-

cented syllables speeding the line. Although hardly noticeable, the "rhyme" of two *in*'s—one unaccented, the other technically accented, "*in* ice as dancers in a spell"—also contributes to the magical feeling of whirling, as does the light, hidden rhyme in "A*nd*" and "dance*rs*."

Part of the effect, too, comes from syntactical suspension. We wait a line and a half for the clause's subject, "which," to find its verb, "Fluttered." This suspension mirrors the suspended motion of the leaves (dancers) as, in ice, they *seem* to be still turning but are not. The alliterated *f*'s of "*f*rozen," "*f*ell," and "*F*luttered" help mark off this suspension within the continuing *l*'s that begin with "*l*ate *l*eaves in line 2 and culminate with "*l*ong into a *l*ake" in line 4. The trochaic substitution "Fluttered" signals the resumption of reality. Motion in stasis—leaves on ice, dancers in a spell.

Too much rhyme is like too much lipstick. Robert Frost's test for rhymes was to see if he could detect which had occurred to the poet first. Both rhyme-words had to seem equally natural, equally called for by what was being said. If one or the other seemed dragged in more for rhyme than sense, the rhyming was a failure. This is a hard but useful test. If you sometimes have to settle for a slightly weak rhyme, put the weaker of the pair *first*; then, when the rhyme bell sounds in the ear with the second, it will be calling attention to the more suitable and natural word.

Ars celare artem, as Horace said. The art is to hide the art.

❖ ❖ ❖

Questions and Suggestions

1. Transcribe the lyrics of a popular song you enjoy. What formal devices do you find?

2. The fact that there are words for which no natural rhymes exist, like "scarce," "circle," "census," and "broccoli," has tempted poets to invent comic rhymes for them. Ogden Nash (1902–1971) reported, for instance, that kids eat spinach "inach by inach" and remarked that a man who teases a cobra will soon be "a sadder he, and sobra." Anonymous worked around "rhinoceros" this way:

> If ever, outside a zoo,
> You meet a rhinoceros
> And you *cross her, fuss*
> Is exactly what she'll do.

 Have a try at "umbrella" or "lionesses" before looking in Appendix II (p. 341) to see what poets did with them; and if you find the game amusing, go on to some puzzlers of your own.

3. Recalling "Easter Wings," use shape as the form of a picture poem of your own, working with an ice cream cone, a tree, a hat, a fireplug, a state with a recognizable shape, or the like.

4. After checking the technicalities of the sestina in Appendix I (p. 334), consider Michael Heffernan's "Famous Last Words" (p. 133), making sure you infer something remarkable about the speaker. If you try your hand at a sestina, what problems and opportunities might you expect to encounter in this round-and-round, spiraling-in form?

 An in-class variant suggested by poet Susan Thornton: Using six randomly chosen words, everyone (including the teacher) writes a sestina before the period ends and reads the result aloud. One class used: *raining, chalkboard, watermelon, ordeal, zoo, needle*.

5. Study the following passages from John Donne's "Satire III" and Alexander Pope's "Second Pastoral" in which the poets use both repetition and carefully arranged syntax to get startling and lovely effects. Among other things, note the bacchic foot ("the hill's sud-") and the spondee ("win so") in Donne's fourth line. Don't overlook the fact that all four of Pope's lines have similar subordinate clauses, though deployed in cleverly different relations to the main clauses, as he describes the beautiful woman's walk in a wood and emergence into a more open garden.

 > On a huge hill,
 > Cragged, and steep, Truth stands, and he that will
 > Reach her, about must, and about must go;
 > And what the hill's suddenness resists, win so . . .

 > Where-e'er you walk, cool Gales shall fan the Glade,
 > Trees, where you sit, shall crowd into a Shade,
 > Where-e'er you tread, the blushing Flow'rs shall rise,
 > And all things flourish where you turn your Eyes.

6. As you go through the poems in Poems to Consider, do a lot of reading aloud in order not to miss the sound effects of repetition, rhyme, alliteration, and assonance. In W.B. Yeats's "Two Songs of a Fool," for instance, in addition to the refrain-like line "The horn's sweet note and the tooth of the hound" (with its balanced alliteration of *h*'s and *t*'s), don't miss the emotionally charged repetitions by which he sets up the line's second appearance: ". . . she had heard, / *It may be*, and had not stirred, / That now, *it may be*, has found . . ." Repetition is also structural in Langston Hughes's "Aunt Sue's Stories" and, of course, in Edward Hirsch's "At Sixteen," about which he comments:

 > I was hoping that the obsessiveness of a sixteen-year-old's experiences would be enacted through the form of the pantoum. I like the obsessive recurrences of the pantoum, the way it keeps unfolding and curving back on itself. It creates a quality of being stuck, of going forward, of repetitive motion . . .

 He notes, too, that he means for the poem's subject to echo, "as a historical backdrop, a vague historical memory," the notorious Triangle Shirtwaist Factory fire.

Jean Toomer's "Reapers" and John Keats's "To Autumn" offer plentiful examples of deliciously patterned sound. In the former, you'll notice the alliteration of "*Black*," "*bleeds*," "*blade*," and "*Blood*" in lines 5–8, but don't stop with that. "To Autumn" is the most charming of Keats's great odes, with its subtle texturing of diction, syntax, sound, and indentation. For instance, what do you make of the phrase "full-grown lambs"? What word does Keats avoid? How does this choice help to set up the tone of the ending?

Poems to Consider

Jump Cabling 1984

LINDA PASTAN (b. 1932)

When our cars	touched
When you lifted the hood	of mine
To see the intimate workings	underneath,
When we were bound	together
By a pulse of pure	energy,
When my car like the	princess
In the tale woke with a	start,

I thought why not ride the rest of the way together?

5

Song 1998

WILLIAM LOGAN (b. 1950)

Her nose is like a satellite,
her face a map of France,
her eyebrows like the Pyrenees
crossed by an ambulance.

Her shoulders are like mussel shells, 5
her breasts nouvelle cuisine,
but underneath her dress she moves
her ass like a stretch limousine.

Her heart is like a cordless phone,
her mouth a microwave, 10
her voice is like a coat of paint
or a sign by Burma Shave.

Her feet are like the income tax,
her legs a fire escape,
her eyes are like a videogame, 15
her breath like videotape.

True love is like a physics test
or a novel by Nabokov.

My love is like ward politics
or drinks by Molotov. 20

When Icicles Hang by the Wall 1598

WILLIAM SHAKESPEARE (1564–1616)

When icicles hang by the wall,
 And Dick the shepherd blows his nail,
And Tom bears logs into the hall,
 And milk comes frozen home in pail;
When blood is nipped, and ways be foul, 5
Then nightly sings the staring owl,
'Tu-whit, tu-who!'—a merry note,
While greasy Joan doth keel the pot.

When all aloud the wind doth blow,
 And coughing drowns the parson's saw, 10
And birds sit brooding in the snow,
 And Marian's nose looks red and raw,
When roasted crabs hiss in the bowl,
Then nightly sings the staring owl,
'Tu-whit, tu-who!'—a merry note, 15
While greasy Joan doth keel the pot.

Song (After Shakespeare) 1984

MAURA STANTON (b. 1946)

When mist advances on the mountain
 And Dick the postman shields his mail
And Tom adjusts the furnace fan
 And the cat mews with lowered tail
When the umbrella is our domain 5
Then softly calls the solemn rain,
 Oh-blue,
All blue, Oh-blue: a dreary sound,
While lazy Joan creeps back to bed.

When leaves fall on the boulevard 10
 And quarrels begin among good men
And snails crisscross the sodden yard
 And Marian broods over maps again
When globed drops run down the pane
Then softly calls the solemn rain, 15
 Oh-blue,
All-blue, Oh-blue: a dreary sound,
While lazy Jack creeps in with Joan.

Two Songs of a Fool
1919

WILLIAM BUTLER YEATS (1865–1939)

I

A speckled cat and a tame hare
Eat at my hearthstone
And sleep there;
And both look up to me alone
For learning and defence 5
As I look up to Providence.

I start out of my sleep to think
Some day I may forget
Their food and drink;
Or, the house door left unshut, 10
The hare may run till it's found
The horn's sweet note and the tooth of the hound.

I bear a burden that might well try
Men that do all by rule,
And what can I 15
That am a wandering-witted fool
But pray to God that He ease
My great responsibilities?

II

I slept on my three-legged stool by the fire,
The speckled cat slept on my knee; 20
We never thought to enquire
Where the brown hare might be,
And whether the door were shut.
Who knows how she drank the wind
Stretched up on two legs from the mat, 25
Before she had settled her mind
To drum with her heel and to leap?
Had I but awakened from sleep
And called her name, she had heard,
It may be, and had not stirred, 30
That now, it may be, has found
The horn's sweet note and the tooth of the hound.

Aunt Sue's Stories
1921

LANGSTON HUGHES (1902–1967)

Aunt Sue has a head full of stories.
Aunt Sue has a whole heart full of stories.

Summer nights on the front porch
Aunt Sue cuddles a brown-faced child to her bosom
And tells him stories. 5

Black slaves
Working in the hot sun,
And black slaves
Walking in the dewy night,
And black slaves 10
Singing sorrow songs on the banks of a mighty river
Mingle themselves softly
In the flow of old Aunt Sue's voice,
Mingle themselves softly
In the dark shadows that cross and recross 15
Aunt Sue's stories.

And the dark-haired child, listening,
Knows that Aunt Sue's stories are real stories.
He knows that Aunt Sue never got her stories
Out of any book at all, 20
But that they came
Right out of her own life.

The dark-faced child is quiet
Of a summer night
Listening to Aunt Sue's stories. 25

Reapers 1923

JEAN TOOMER (1894–1967)

Black reapers with the sound of steel on stones
Are sharpening scythes. I see them place the hones
In their hip-pocket as a thing that's done,
And start their silent swinging, one by one.
Black horses drive a mower through the weeds, 5
And there, a field rat, startled, squealing bleeds,
His belly close to ground. I see the blade,
Blood-stained, continue cutting weeds and shade.

At Sixteen 1997

EDWARD HIRSCH (b. 1950)

I walked under a fire escape splashed with gasoline.
 I walked past a sweatshop buried in a warehouse
where dozens of women were sewing garments.
 I got a job as a waiter in a downtown restaurant.

I walked past a sweatshop buried in a warehouse. 5
 My father lent me the car on Saturday nights.
I waited on tables in a downtown restaurant
 and ate in the kitchen with the other waiters.

My father lent me the car on Saturday nights.
 I took my girlfriend to the beach for parties. 10
I ate in the kitchen with the other waiters.
 Everyone laughed at my enormous appetite.

I took my girlfriend to the beach for parties.
 She wanted to get married, get pregnant.
Everyone laughed at my enormous appetite. 15
 I wanted her so much I thought I'd die of it.

She wanted to get pregnant, get married.
 I wrote a poem about a closing steel door.
I wanted her so much I thought I'd die of it.
 I got a job in a warehouse next to a factory. 20

I wrote a poem about a steel door closing.
 I walked under a fire escape splashed with gasoline.
I took orders in a warehouse next to a factory
 where dozens of women were feeding machines.

Famous Last Words 1979

MICHAEL HEFFERNAN (b. 1942)

Is it a question, then, of getting up
the will to move from one place to the next?
I'm undecided, largely, at the start,
as always, though I guess I'm apt to see
a good bit better once I've had a drink. 5
It's still too soon for that yet. I can wait.

Sometimes I have to laugh: the more you wait,
the more you end up wishing you could up
and have a look at what will happen next.
Where did it ever get you, from the start, 10
the time or two you said you'd wait and see,
when all you really wanted was to drink

it all in, all of it, in one long drink
that would relieve you of the need to wait
for the Right Moment? A man's time is up 15
too soon in this quick world. As for the next,
I think I have a theory: first you start
to notice how you can't move, think, or see,

and this alarms you, so you try to see
what a person has to do to get a drink 20
in this place. No one drinks here, so you wait
a long time trying to figure out what's up—
a very long time, well into the next
two or three thousand years, until you start

to feel more lonely than you were to start 25
with, and you stay this way forever. See,
I'm realistic. And I need a drink.
The will to move is only the will to wait
in different terms: moving is when you're up
and ready for whatever happens next; 30

waiting is what you do when you're the next
in line and several others got the start
on up ahead of you and you can see
their dust rise off them. If I had a drink
instead of breakfast, I could stand the wait. 35
They'd probably like to know what held me up.

Maybe they'll send a man up here to see
what keeps me waiting. Maybe he'll say I'm next.
Maybe he'd like a drink before we start.

The Art of Vanishing 1997

WILLIAM TROWBRIDGE (b. 1941)

> I just don't put all my weight down.
> —Minnie Pearl on airplane safety

Who's never studied it? doesn't recognize
the jittery clerk in the cartoon, who,
when the CEO rounds the corner, becomes
in rapid-fire succession a water fountain,
fax machine, filing cabinet; the kid who just 5
put a crack in the stained-glass window, flapping
his arms, slowly spinning, hoping maybe
to auger straight underground, tunnel off
among the gophers; the speeder who spots
the plainclothes car behind him, 10
and tries to slip inside absolute 55,
where, as on any such Platonic back street,
phenomenon turns noumenon and disappears?
If we get it right, it's Presto—now they see us,
now they don't, not even a sleeve 15

for nothing to be up as we slide into
our back-row desks, staring down
when whatever teacher's deciding who
to call on, whatever doctor's scanning
for intrigue on the x-rays. When work 20
numbs our face and knots our jaws, we'd
trade places with the Invisible Man, shuffling
off his clothes and bandages, free at last
to sail plates at their heads, prance and cackle
while he gooses the barkeep; or Glenn Ford 25
in *The Fastest Gun Alive*, beatific
as they plant his old self deep in Boot Hill.
But we're more kin to that sad Coyote, concealed
with "vanishing" cream, scotched when the beer
truck driver doesn't see us, or the proverbial 30
ostrich, sand in our mouths and asses up
for another proctoscope.
 "Shim-shala-bim!"
cried Harry Blackstone, Jr.; "Oh," we exclaimed,
as his spangly assistant dematerialized, 35
transmigrated to the dusty nether world
beneath the trap door. "Dust to dust," says the preacher,
and—one, two, three—to our amazement and dismay,
an amateur, someone we actually knew,
does it lying down, without the mirrors. 40

◈ For the Women of Ancient Greece 1995

MEGGAN WATTERSON*

> *We come, then, to this strange paradox: man,*
> *wishing to find nature in woman, but nature*
> *transfigured, dooms woman to artifice.*
> —Simone de Beauvoir

I had not meant to pick up the scissors.
I was searching for something
I've now forgotten.
So it was by chance
That my skin touched steel 5
Sending chills into me.
I pulled them from deep within the drawer
Hidden beneath screwdrivers and batteries.
I slid fingers into place,
Taking control of the blades. 10
A glimmer of light reflecting from them

Invited me to crisscross
Swish . . . Swish . . . Swish . . .
The lopping, the not layering.
Here at last was my liberty. 15
We had finally met,
The shaking of hands had taken place
On my porch in the winter of my 20th year.

The Fourth of July 1973

HOWARD NEMEROV (1920–1991)

Because I am drunk, this Independence Night,
I watch the fireworks from far away,
From a high hill, across the moony green
Of lakes and other hills to the town harbor,
Where stately illuminations are flung aloft, 5
One light shattering in a hundred lights
Minute by minute. The reason I am crying,
Aside from only being country drunk,
That is, may be that I have just remembered
The sparklers, rockets, roman candles, and 10
So on, we used to be allowed to buy
When I was a boy, and set off by ourselves
At some peril to life and property.
Our freedom to abuse our freedom thus
Has since, I understand, been remedied 15
By legislation. Now the authorities
Arrange a perfectly safe public display
To be watched at a distance; and now also
The contribution of all the taxpayers
Together makes a more spectacular 20
Result than any could achieve alone
(A few pale pinwheels, or a firecracker
Fused at the dog's tail). It is, indeed, splendid:
Showers of roses in the sky, fountains
Of emeralds, and those profusely scattered zircons 25
Falling and falling, flowering as they fall
And followed distantly by a noise of thunder.
My eyes are half-afloat in happy tears.
God bless our Nation on a night like this,
And bless the careful and secure officials 30
Who celebrate our independence now.

To Autumn

1819

JOHN KEATS (1795–1821)

Season of mists and mellow fruitfulness,
　　Close bosom-friend of the maturing sun;
Conspiring with him how to load and bless
　　With fruit the vines that round the thatch-eves run;
To bend with apples the moss'd cottage-trees,　　　　　　　　5
　　And fill all fruit with ripeness to the core;
　　　　To swell the gourd, and plump the hazel shells
With a sweet kernel; to set budding more,
And still more, later flowers for the bees,
Until they think warm days will never cease,　　　　　　　　10
　　　　For summer has o'er-brimm'd their clammy cells.

Who hath not seen thee oft amid thy store?
　　Sometimes whoever seeks abroad may find
Thee sitting careless on a granary floor,
　　Thy hair soft-lifted by the winnowing wind;　　　　　　15
Or on a half-reap'd furrow sound asleep,
　　Drows'd with the fume of poppies, while thy hook
　　　　Spares the next swath and all its twinèd flowers:
And sometimes like a gleaner thou dost keep
　　Steady thy laden head across a brook;　　　　　　　　20
　　Or by a cider-press, with patient look,
　　　　Thou watchest the last oozings hours by hours.

Where are the songs of spring? Ay, where are they?
　　Think not of them, thou hast thy music too,—
While barred clouds bloom the soft-dying day,　　　　　　25
　　And touch the stubble-plains with rosy hue;
Then in a wailful choir the small gnats mourn
　　Among the river sallows, borne aloft
　　　　Or sinking as the light wind lives or dies;
And full-grown lambs loud bleat from hilly bourn;　　　　30
　　Hedge-crickets sing; and now with treble soft
　　The red-breast whistles from a garden-croft;
　　　　And gathering swallows twitter in the skies.

CONTENT
A Local Habitation and a Name

And as imagination bodies forth
The forms of things unknown, the poet's pen
Turns them to shapes and gives to airy nothing
A local habitation and a name.
Such tricks hath strong imagination,
That, if it would but apprehend some joy,
It comprehends some bringer of that joy;
Or in the night, imagining some fear,
How easy is a bush supposed a bear!

WILLIAM SHAKESPEARE
from *A Midsummer Night's Dream* (V, i)

6

SUBJECT MATTER

Content, the other half of the indivisible equation, is harder to describe systematically than form. Once certain subjects were deemed acceptable for poems, and others were not. Though almost no subject today is off-limits to the poet, several misconceptions can blind the beginning poet to the freedom of subject matter; for instance, the notion that poems should be about certain traditional subjects like the seasons, love (especially a lost love), and "the meaning of life"; or the notion that poems should be, somehow, *grand*—high flown, solving the world's problems, full of important pronouncements; or the corollary notion that the ordinary, everyday things that we experience—things close to the nose, as William Carlos Williams says—aren't proper subjects.

Writing under these assumptions, one might feel compelled to write about "poetic" subjects, like the nightingale—that familiar figure of British poetry—without realizing that the nightingale isn't indigenous to the Americas and you may have never seen the bird, much less heard its song. Pay attention to the everyday world we usually ignore, and you will find ripe subjects for poems. The common sparrows in the backyard, a construction site at night, a reclusive neighbor, or a cat stepping carefully into and out of a pot can offer you as much raw material as any fancy subject can. Make the ordinary extraordinary. An editor of *Outside* magazine has said that he'd rather publish a piece about a backyard picnic made exotic than a routine travel piece to an exotic location.

Equally blinding for the beginning poet is the assumption that poetry is mainly direct self-expression: what happened to *me*, what *I feel*. Poets risk psychobabble— endlessly reporting their own feelings, their own experience (only because it's their experience), unaware that they are boring a reader. Looking only inward can keep poets from looking outward. If they notice the cat, the construction site, or the neighbor, they only rush on to how such things affect them personally. The poem that begins, "I see the ugly machines," will likely end with an overblown pronouncement about "the world as I see it." Such poems put the poet's feelings, rather than evocative elements of the construction site, at the center. This poet won't likely notice how the streetlight makes the cement look soft, won't wonder about the ladder of the crane, or the alien alphabet left by truck tires.

We're all tempted to write poems that spill out our feelings. And poets, of course, do express themselves, though rarely as directly as it may seem. In the following poem, notice how William Matthews (1942–1997) begins by deflecting attention away from himself, thereby taking in the scene's deeper significance:

Men at My Father's Funeral

The ones his age who shook my hand
on their way out sent fear along
my arm like heroin. These weren't
men mute about their feelings,
or what's a body language for? 5

and I, the glib one, who'd stood
with my back to my father's body
and praised the heart that attacked him?
I'd made my stab at elegy,
the flesh made word: the very spit 10

in my mouth was sour with ruth
and eloquence. What could be worse?
Silence, the anthem of my father's
new country. And thus this babble,
like a dial tone, from our bodies. 15

By decentering the son's grief (which nevertheless lies at the heart of this poem), Matthews can foreground the small gestures that reveal the mourners' hidden feelings: a mixture of generosity and selfishness. The dead father's peers lament the loss of their friend and at the same time fear for their own lives. Naturally the men wouldn't admit or acknowledge, perhaps even to themselves, that they have such feelings, but their fear is palpable. The awkward handshake between them and the son jolts his arm "like heroin"—powerful, strange, dangerous, forbidden. Whereas the unobservant might see only the son standing before his father's coffin to eulogize him, this poet says he stood with his *back* to his father's body, suggesting that he, too, wanted to shun the dead, perhaps because his father reminded him of the precariousness of his own life. The son, "the glib one," speaks the appropriate words of praise for his father, though they turn sour in his mouth for all that remains unsaid. All this noise—body language and spoken language, a babble meaningless as a "dial tone"—speaks of the survivors' desire to drown out the silence they feel hovering behind them. Matthews's poem shows how small commonplace actions speak more powerfully than grand pronouncements.

Subjects and Objects

Poems compete with everything else in the world for our attention. As E. E. Cummings says, "It is with roses and locomotives (not to mention acrobats Spring electricity Coney Island the 4th of July the eyes of mice and Niagara Falls) that my 'poems' are competing. They are also competing with each other, with elephants, and with El Greco." Poems must be interesting, or we'll leave them half-read. And *subject matter* can grab our attention like nothing else. Especially for the beginning poet, an arresting subject, well-handled, can make up for any number of technical blunders. If you have special knowledge of a subject (Indonesia, fossils, sugar cane farming, bow hunting, your messy car), exploit it and fascinate a reader.

New poets sometimes despair that everything has already been written. Love, loss, death, birth—the great universal themes of humanity have been written many times over. But the poets of each generation must explore them from their unique perspective in their own idiom and voice. The world is much the same place it has always been. We have wars and famine, peace and bounty; we are brave and noble, selfish and narrow. We love, we work, we try to make sense of life. But we experience all these things somewhat differently from other ages. Our relationship with the natural world, for instance, has changed since the environment has changed, and few of us now subsist through hunting or harvesting. And slightly changed are the relationships between men and women, children and parents, and the haves and have-nots. We live with day-care centers, cell phones, oil spills, heart transplants, twelve-step groups, suburban blight, and megasupermarkets selling lemongrass and CDs. Find what is close to your nose. Venture into parts of your neighborhood you have always passed up. Step into the bingo hall, a feed store, or the local pawn shop. Hang out in the barbershop and listen to the banter, or start up a conversation at a yard sale.

Explore what makes you unique—your point of view, your particular upbringing, your heritage. Family stories may open out into vivid landscapes as they did for Rita Dove (b. 1952) in her Pulitzer-Prize-winning sequence about her grandparents, *Thomas and Beulah* (1986). Dove began with a story her grandmother told about her grandfather "when he was young, coming up on a riverboat to Akron, Ohio, my hometown." And her curiosity led, poem by poem, to a re-creation of the African-American experience in the industrial Midwest. "Because I ran out of real fact, in order to keep going, I made up facts . . ." Like old photographs coming to life, poems such as this show the potential of a good subject. Notice how the Depression of the 1930s provides background:

A Hill of Beans

One spring the circus gave
free passes and there was music,
the screens unlatched
to let in starlight. At the well,
a monkey tipped her his fine red hat 5
and drank from a china cup.

By mid-morning her cobblers
were cooling on the sill.
Then the tents folded and the grass

grew back with a path 10
torn waist-high to the railroad
where the hoboes jumped the slow curve
just outside Union Station.
She fed them while they talked,
easy in their rags. *Any two points* 15
make a line, they'd say,
and we're gonna ride them all.

Cat hairs
came up with the dipper;
Thomas tossed on his pillow 20
as if at sea. When money failed
for peaches, she pulled
rhubarb at the edge of the field.
Then another man showed up
in her kitchen and she smelled 25
fear in his grimy overalls,
the pale eyes bright as salt.

There wasn't even pork
for the navy beans. But he ate
straight down to the blue 30
bottom of the pot and rested
there a moment, hardly breathing.
That night she made Thomas
board up the well.
Beyond the tracks, the city blazed 35
as if looks were everything.

Like anyone, these people live among things. The objects in the poem—the screen door, the monkey with the red cap, the waist-high grass, the cat hairs, overalls, and navy beans—make it feel authentic. We see people who ask for little else than the chance to make do. When they can't afford peaches for cobblers, the wife gathers rhubarb at the edge of the field. They enjoy the brief wonder of the circus, then return to their routines of eking out a living and helping out those worse off than themselves. Someone always is. Unlike the hoboes Beulah feeds—who at least take pleasure in their freedom—the man who eats the entire pot of unseasoned beans without stopping reeks of fear, suggesting he's on the run. She doesn't pry into his secret. His presence reminds Beulah that hidden danger lurks beyond their neighborhood, that the well may be poisoned, and that looks aren't everything.

Occasionally a poet will stumble upon a lucky subject, as Miller Williams did for

"The Curator" (p. 164). In 1991, visiting the Hermitage Museum in St. Petersburg, he heard the story the poem tells from the curator himself, then a man in his eighties. The story concerned events fifty years earlier when the city, then called Leningrad, was under siege by the Germans in World War II. Unable to use a tape recorder or take notes, Williams rushed back to the bus and jotted down three or four pages of vivid recollections. The poem, he remarks, though it went through many revisions, "is as literally true as told to me as any other poem I ever wrote."

Sometimes the subject of a poem will come to a poet gradually. In 1965 Philip Levine (b. 1928) made his first visit to Orihuela, Spain, the village that had been home to the poet Miguel Hernández. Like many other artists and intellectuals in the Spanish Civil War of the 1930s, Hernández sympathized with the Republican forces that opposed the fascist Francisco Franco, and like many others he paid direly for his beliefs. Following the defeat of the Republicans, Hernández tried to escape into Portugal but was imprisoned and, owing in part to the prison's deplorable conditions, died in 1942 at the age of thirty-one. When Levine first visited the region of Hernández's birth, Hernández's wife and son were still living there. Levine reports he never forgot that first visit, and some thirty years later he wrote the following poem. In it, Levine says, he imagines how Hernández would feel coming home from exile "had exile been possible," returning to that world Levine saw on his first visit. The poem explores the question *What if . . . ?*

The Return: Orihuela, 1965
for Miguel Hernández

You come over a slight rise
in the narrow winding road
and the white village broods
in the valley below. A breeze
silvers the cold leaves 5
of the olives, just as you knew
it would or as you saw
it in dreams. How many days
have you waited for this day?
Soon you must face a son grown 10
to manhood, a wife to old age,
the tiny, sealed house of memory.
A lone crow flies into the sun,
the fields whisper their courage.

You can make anything into a good subject, if you dig into it. As William Matthews says in his essay "Dull Subjects" (*Curiosities*, University of Michigan Press, 1989), "It is not, of course, the subject that is or isn't dull, but the quality of attention that we do or do not pay to it. . . . Dull subjects are those we have failed." Cathy Song (b. 1955) puts a spotlight on young mothers taking their babies out in strollers and makes the familiar seem wonderfully strange:

Primary Colors

They come out in warm weather
like termites
crawling out of the woodwork.
The young mothers chauffeuring
these bright bundles in toy carriages. 5
Bundles shaped like pumpkin seeds.

All last winter,
the world was grown up,
gray figures hurrying along
as lean as umbrellas; 10
empty of infants,
though I heard them at night
whimpering through a succession
of rooms and walls;
felt the tired, awakened hand 15
grope out from the dark
to clamp over the cries.

For a while, even the animals vanished,
the cats stayed close to the kitchens.
Their pincushion paws left padded tracks 20
around the perimeters of houses
locked in heat.
Yet, there were hints of children
hiding somewhere,
threatening to break loose. 25
Displaced tricycles and pubescent dolls
with flaxen hair and limbs askew
were abandoned dangerously on sidewalks.
The difficult walk of pregnant mothers.
Basketfuls of plastic eggs 30
nestled in cellophane grass
appeared one day at the grocer's
above the lettuce and the carrot bins.

When the first crocuses
pushed their purple tongues 35
through the skin of the earth,
it was the striking of a match.
the grass lit up, quickly,
spreading the fire.
The flowers yelled out 40
yellow, red, and green.
All the clanging colors of crayolas

lined like candles in a box.
Then the babies stormed the streets,
sailing by in their runaway carriages, 45
having yanked the wind
out from under their mothers.
Diapers drooped on laundry lines.
The petals of their tiny lungs
burgeoning with reinvented air. 50

Putting aside what we take for granted—that people and animals kept indoors by cold weather come outside to relish the first warm days of spring—Song turns inside out a commonplace subject and makes it riveting. Images normally suggestive of fruitfulness take on a menacing attitude. Babies, young mothers, spring flowers, the sudden growth of grass—the speaker turns a keen eye to these typical sights of spring and connects them with termites, clanging crayons, and fire, suggesting that behind the most familiar world lurks something powerful, even threatening. The poem's speaker seems alien to, even repulsed by, the scene and so can notice what we normally ignore. For instance, she says, "plastic eggs / nestled in cellophane grass / appeared one day at the grocer's" as if she had never seen Easter decorations before. The hidden children of stanza 3 were "*threatening* to break loose"; in stanza 4 the "flowers *yelled out* / yellow, red, and green"; "the babies *stormed* the streets." Such sharp observations create an insidious undercurrent in the poem that suggests the speaker feels a mixture of repulsion and attraction to children and to spring.

Discovering a good subject may be partly luck, but luck comes to poets who are alert, who keep their antennae out. In the words of that accidental wit Yogi Berra, "You can observe a lot just by watching." As other poets' poems remind us, the subjects for poetry are boundless, especially when one allows poems to sprout from the ordinary—a noticed detail, a stray connection, something forgotten. Pay attention. Look at things. Examine the lunar surface of a slice of bread, for instance; really see it and then write about what you notice. Free yourself of assumptions about the staff of life and shimmering fields of golden grain. Look at the bread. Like the purloined letter in Edgar Allan Poe's story, the secret is hidden in the open.

It is easy to notice only what everybody does. The result is cliché—not only clichés of language, but clichés of observation, of thought, and even of feeling. We all fall victim to them, and the result is a dead subject. Retelling the story of Romeo and Juliet or the assassination of JFK, if the poem only reports what we already know, won't interest a reader. The poem must see the subject from a unique perspective. What about Juliet's mother at a niece's wedding? What about the autoshop in Dallas that towed the blood-stained car?

Trying to see something fresh stands at the center of making good poems. Insights don't have to be large. Indeed, most of the original ones are small. In "Primary Colors" Cathy Song describes the bundled babies as "shaped like pumpkin seeds." Rita Dove gives us "pale eyes bright as salt." Matthews calls the "babble" of mourners a "dial tone." Accurate perception is not just an aesthetic choice; we might also say we have a moral obligation to see what is there, not just what we would like

to see. The speaker of this poem by Adrienne Rich (b. 1929) makes clear this responsibility:

The Slides

Three dozen squares of light-inflicted glass
lie in a quarter-century's dust
under the skylight. I can show you this:
also a sprung couch spewing
dessicated mouse-havens, a revolving bookstand 5
rusted on its pivot, leaning
with books of an era: *Roosevelt vs Recovery*
The Mystery & Lure of Perfume My Brother Was Mozart
I've had this attic in mind for years
 Now you 10
who keep a lookout for
places like this, make your living
off things like this: You see, the books are rotting,
sunbleached, unfashionable
the furniture neglected past waste 15
but the lantern-slides—their story
could be sold, they could be a prize
 I want to see
your face when you start to sort them. You want
cloched hats of the Thirties, engagement portraits 20
with marcelled hair, maillots daring the waves,
my family album:
 This is the razing of the spinal cord
by the polio virus
this, the lung-tissue kissed by the tubercle bacillus 25
this with the hooked shape is
the cell that leaks anemia to the next generation
enlarged on a screen
they won't be quaint; they go on working; they still kill.

The speaker addresses an antiques collector who yearns for images of the mythic good old days: charming young ladies sporting elaborate clothes and hairstyles. Such a view of the past is sentimental. Most of us succumb to it now and then. But among the musty books and ruined furniture, the dealer will find images of the past we often overlook. Instead of romance the person Rich addresses will find the physician's medical slides. Polio, tuberculosis, sickle-cell anemia: "they won't be quaint; they go on working; they still kill." The point is not that we must always look on the dark side of existence, but that we mustn't ignore the complete picture by blinding ourselves with clichéd perspectives, clichéd images. Rich's details strengthen her point.

The "sprung couch spewing / dessicated mouse-havens," the "quarter-century's dust" and "rotting books" prompt our senses of sight, smell, and touch. Our noses crinkle. We want to recoil.

Presenting

Emotions, in themselves, are not subject matter. Being in love, or sad, or lonely, or feeling good because it is spring are common experiences. Poems that merely state these emotions won't be very interesting. We respect such statements, but we can't be moved by them. Therefore, to present the complex emotional world of a poem, poets rely on the **image,** a representation of a sense impression. While we often think of imagery as visual, as Rich's poem shows, images can register any sense; they can also be aural (sound), tactile (touch), gustatory (taste), and olfactory (smell). Poems that excite many of our senses draw us in and convince us. We can live inside them. In this poem, Theodore Roethke (1908–1963) brings many kinds of images into play to create an intense memory.

My Papa's Waltz

The whiskey on your breath
Could make a small boy dizzy;
But I hung on like death:
Such waltzing was not easy.

We romped until the pans 5
Slid from the kitchen shelf;
My mother's countenance
Could not unfrown itself.

The hand that held my wrist
Was battered on one knuckle; 10
At every step you missed
My right ear scraped a buckle.

You beat time on my head
With a palm caked hard by dirt,
Then waltzed me off to bed 15
Still clinging to your shirt.

We see the pans slide from the shelves and hear them bang on the floor. We feel the rollicking dance of the father, hear and feel him beating time. We can even smell the whiskey. Roethke doesn't state his feeling about his father in "My Papa's Waltz"; he doesn't need to. He lets us feel it for ourselves by presenting us with the particular scene out of which the feeling came. While emotions in general aren't subject matter, the *circumstances* of a particular emotion, the scene or events out of which it

comes, however, are subject matter. Don't tell the emotion; show the context. Presented vividly, it will not only convince us of its truth but will also make us dramatically *feel* it.

In "A Hill of Beans," Dove doesn't tell us the circus felt magical. She says "the screens unlatched / to let in starlight." In "The Slides," Rich presents her theme— romanticizing the past—by counterpointing the "marcelled hair" with the hook-shaped cell "that leaks anemia." Presenting the facts, showing the scene, will often be the only way of adequately making your point or describing the emotion. What word or list of words that describes the emotions of love, fear, pain, mischief, panic, delight, and helplessness could begin to sum up what the boy (and the grown man) feel in (and about) the little scene in "My Papa's Waltz"?

The key is *presenting;* not to *tell* about, but to *show*. Put the spring day with mothers and their children in strollers *into* the poem. Put the circus monkey *into* the poem. Put the handshake between mourners *into* the poem.

And present the subject accurately. Accuracy of information, of detail, of terminology makes the presentation convincing. As a good liar knows, if you're going to say you were late because you had a flat tire, you'd better give a vivid description of your struggling with the jack, lug bolts, and traffic whizzing by, and have a good explanation for your clean hands. Whether writing about cellular biology, rocking chairs, leopards, the Barenaked Ladies, quasars, Yemen, or the physiology of the grasshopper, the poet should know enough, or find out enough, to be reasonably authoritative. Tulips originated in Turkey. Whales aren't fish. Jackie Joyner-Kersee was a track-and-field Olympic gold medalist. Common knowledge and careful observation are usually enough. Good reference books and field guides help, too. Rich knows the cell shape of sickle-cell anemia. Though Song sees the spring day from a fresh angle, she is still accurate about when termites come out and crocuses bloom and what Easter displays look like. Sometimes poets come upon a subject that sends them to the library and requires their becoming something of a specialist.

In presenting subject matter, *particulars* offer overtones of thought and emotion to a poem, giving it depth and substance. We don't need (or want) *every* detail to make a poem vivid and moving. We need details that are significant and resonant. A poem will bore us with inconsequence if it places us at 51 degrees latitude and 4 degrees longitude on January 17th at 2:28 P.M. beside a 118-year-old willow near a farm pond owned by Mr. John Johnson. The right detail in the right place moves us. Thomas Hardy (1840–1928) deftly handles details to create an atmosphere of loss:

Neutral Tones

We stood by a pond that winter day,
And the sun was white, as though chidden of God,
And a few leaves lay on the starving sod;
 —They had fallen from an ash, and were gray.

Your eyes on me were as eyes that rove 5
Over tedious riddles of years ago;

And some words played between us to and fro
　　On which lost the more by our love.

The smile on your mouth was the deadest thing
Alive enough to have strength to die; 10
And a grin of bitterness swept thereby
　　Like an ominous bird a-wing. . . .

Since then, keen lessons that love deceives,
And wrings with wrong, have shaped to me
Your face, and the God-curst sun, and a tree, 15
　　And a pond edged with grayish leaves.

The white sun, the ash tree, the unspecified words that "played" between the lovers, the grayish leaves—Hardy's discrimination, his careful selection of which details to include and which to ignore, presents the bleak memory, the neutral tones of the last moment of a love affair. Consider the difference between saying "a pale sky" and saying "the sun was white," between saying "tree" and saying "ash," or "oak," or "blossoming pear," or "hemlock." Suppose in "The Slides" Adrienne Rich hadn't given us the titles of the books (*Roosevelt vs Recovery, The Mystery & Lure of Perfume, My Brother Was Mozart*). The poem would lose more than a sense of vividness and accuracy; it would lose the ironic contrast set up between the titles and the diseases "that go on working." The concerns of the books may be dated, even silly; illness isn't. In Roethke's "My Papa's Waltz" the detail about the "pans" sliding from the "kitchen shelf" does more than indicate the rowdiness of the drunken father's dancing. It tells us something about the working-class family—a kitchen neither large nor elegant. More importantly, it sets the scene in the kitchen. Suggestions abound. The father (affectionately "Papa" in the title) who works with his hands ("a palm caked hard by dirt") has come home late from work, having stopped off for whiskey. He has come in by the back door, into the kitchen. Dinner is over and the pans back on the shelf, but the boy and his mother are still in the kitchen. That they have not held dinner for the father, or waited longer, measures the mother's stored-up anger, as does the word "countenance," which suggests how formidably she has prepared herself. She is "mother" not "mama." The incongruity of the father's merriment is all the stronger because the waltzing begins, so inappropriately, in the kitchen.

Descriptive Implication

Particulars may give a poem its richly colored surface, evoking vividly for the reader the subject or the setting in which an action occurs. They may also, implicitly, provide a sort of running commentary on the subject or action—and on the speaker's attitude about either. Consider the selection of detail in this poem by Elizabeth Bishop (1911–1979):

First Death in Nova Scotia

In the cold, cold parlor
my mother laid out Arthur
beneath the chromographs:
Edward, Prince of Wales,
with Princess Alexandra, 5
and King George with Queen Mary.
Below them on the table
stood a stuffed loon
shot and stuffed by Uncle
Arthur, Arthur's father. 10

Since Uncle Arthur fired
a bullet into him,
he hadn't said a word.
He kept his own counsel
on his white, frozen lake, 15
the marble-topped table.
His breast was deep and white,
cold and caressable;
his eyes were red glass,
much to be desired. 20

"Come," said my mother,
"Come and say good-bye
to your little cousin Arthur."
I was lifted up and given
one lily of the valley 25
to put in Arthur's hand.
Arthur's coffin was
a little frosted cake,
and the red-eyed loon eyed it
from his white, frozen lake. 30

Arthur was very small.
He was all white, like a doll
that hadn't been painted yet.
Jack Frost had started to paint him
the way he always painted 35
the Maple Leaf (Forever).
He had just begun on his hair,
a few red strokes, and then
Jack Frost had dropped the brush
and left him white, forever. 40

The gracious royal couples
were warm in red and ermine;

their feet were well wrapped up
in the ladies' ermine trains.
They invited Arthur to be 45
the smallest page at court.
But how could Arthur go,
clutching his tiny lily,
with his eyes shut up so tight
and the roads deep in snow? 50

While we hear the voice of the little girl, behind it we also sense the poet's voice, se-
lecting and controlling the scene. Indicating just how caught up she is in her first
experience of death, the speaker mentions almost nothing outside the "cold, cold
parlor," nor anything before or after the one event, seeing little Arthur in his coffin.
The poem refers to only a few details of the parlor, the color lithographs of the royal
family and the stuffed loon on its marble-topped table. No other furnishings appear
in the poem, and yet from these we can draw the impression of an ornate and rather
formal room, as well as a sense that the household values patriotism, family loyalty,
and propriety.

The pattern of Bishop's imagery links the poem's details. Like Arthur himself and
his coffin ("a little frosted cake"), the loon and the chromographs of the royal family
are studies in white and red. The loon's breast and the "frozen lake" of the marble-
topped table are white; his glass eyes red. Similarly the "gracious royal couples" are
"warm in red and ermine." Arthur is "white, forever," except for the "few red
strokes" of his hair. Very likely the red and white of the loon and the chromographs
make the little girl notice them and associate them with her dead cousin. And both
are connected with death. "Uncle / Arthur, Arthur's father" had killed the loon and
had it stuffed. The white ermine of the royal family similarly comes from animals
killed to provide decorative fur. These connections give the poem its icy, rich unity:
red and white; warm (royal family) and cold (loon). The funeral reminds the little
girl of a birthday, the "little frosted cake" of the coffin.

The particulars suggest beautifully the little girl's incomprehension of what she is
witnessing. The loon is not so much dead as silenced: "Since Uncle Arthur fired / a
bullet into him, / he hadn't said a word." Like the girl the loon is cautious; he "kept
his own counsel" and only "eyed" little Arthur's coffin. Struggling for comfort in the
scene, she shifts her attention from Arthur's corpse to the familiar loon and chromo-
graphs. The girl's fantasy that the royal family had "invited Arthur to be / the small-
est page at court" shows her translating her cousin's death into her experience.
("Jack Frost" suggests the storybook dimensions of that experience.) Her mother's
well-meaning but too careful "'Come and say good-bye / to your little cousin
Arthur'" invites the fantasy. Although the girl doesn't understand, she senses that
the confusion between life (red) and death (white) will resolve itself ominously.
"But how could Arthur go, / clutching his tiny lily, / with his eyes shut up so tight /
and the roads deep in snow?" (Lily and snow emphasize more white.) This question,
which ends the poem, demonstrates the fragility of her defense against the grim
truth. The final lines shift from the close-up view of Arthur, eyes shut, "clutching his

tiny lily," to the wide-angle shot of "roads deep in snow"; the distance puts the small boy against a large cold landscape; both children are up against great strange forces.

Thinking of visual detail as *cinematography* can remind you of your options as you explore a scene; think of camera angle or location, close-up or distant shot, fade-in or fade-out, panning, montage, and so on. Working with only the squiggles of words on a page, the poet somehow controls what readers see with the mind's eye. Bishop first makes us see a white, frozen lake and then the marble-topped table when she says that the stuffed loon

> kept his own counsel
> on his white, frozen lake,
> the marble-topped table.

The two objects, in effect, become one; lake turns into table. The metaphor is simple enough and, in reading, the transformation happens so fast that we scarcely notice. But for a moment we glimpse an iced-over lake, like a superimposition of two shots in a film. The poet no doubt manages such things intuitively, absorbed by the scene in the inner eye, but nonetheless picking angle, distance, and focus. In "My Papa's Waltz" we never glimpse the father's face. We see his *hand* twice, however: close-ups of the hand on the boy's wrist, the battered knuckle; and of the "palm caked hard by dirt." We see close-ups of the buckle and the shirt. The camera is *at the boy's eye-level*, sees what he sees; and the man now speaking sees again what he saw as a boy. Note, incidentally, that he says "My right ear scraped a buckle," not the expected reverse: "His buckle scraped my right ear." How perfectly we see that he cannot blame the father for anything!

As another instance of camera work, consider again Shakespeare's quatrain from Sonnet 73 (p. 34):

> That time of year thou mayst in me behold
> When yellow leaves, or none, or few, do hang
> Upon those boughs which shake against the cold,
> Bare ruined choirs, where late the sweet birds sang.

Line 2 shows us first the yellow leaves of fall, then the later absence of leaves. We're given a distant shot; we don't see a particular tree, simply yellow leaves in the aggregate. But notice how, as the camera seems to pan from "yellow leaves" to "none," it suddenly stops and moves in for a close-up shot: "or few." So close are we to a few leaves, we are probably seeing a single tree. The sense of loss is intensified, and the desolation of the few surviving leaves is greater than that produced by "none." "Boughs" in line 3 seems a close-up still, but we are now looking *up* into the branches. In line 4 the branches are compared to "Bare ruined choirs"; that is, choir lofts of a ruined and roofless church. For a moment we have the impression of standing inside such a church, looking upward through its buttresses (like the branches) at the sky. The film word for the effect might be a "dissolve." It is only momentary,

however; and in the last half of line 4 we are looking at the early winter boughs again, but this time with a superimposed shot of the same boughs in summer, with birds in them. The musical association between the songbirds and the choir lofts supports the shift. Good description is not only a matter of choosing effective details but also of visualizing them effectively, from the right angle and the right distance.

Details—like the props on the stage and the characters' costumes—bring a scene to life. They can carry with them a psychological or dramatic undercurrent, like Bishop's dead loon and Hardy's "ominous bird a-wing." Notice, however, that none, if any, of the poems we have been discussing is wholly or mainly descriptive. Purely descriptive poems, though we are tempted to write them, are likely to be tedious, like slides of someone's Disney World vacation. As everything in a poem needs to do more than one job, description needs some dramatic or thematic thrust to carry it. Philip Levine in "The Return" renders the village of Orihuela through the eyes of a political exile who has longed for home; the description does emotional work—it *doesn't decorate*. In trying to render a scene's authenticity, poets often go wrong by overdecorating. Particularly when a poem grows out of a strong memory, you may feel inclined to include *everything* you can remember, from every bit of clothing you were wearing to every piece of furniture in the room, every relative who patted you on the head. As you're better off hiring a few good workers than a whole team who just hang around getting in the way, it's better if you choose details that do many things at once—as the minimal furnishings of Bishop's parlor suggest the entire psychological realm of the little girl.

While the right detail can convince a reader, careless use of abstractions can undermine the reader's confidence in the poet. In the work of many beginning poets, words like *love, hate, peace, happiness, innocence,* and *evil* ring as hollow and sound as pretentious as political speeches. Trust William Carlos Williams's famous dictum, "No ideas but in things." He does not mean *no* ideas, but rather ideas arrived at through particulars. Not the one nor the other, but the inductive relationship of the two. How would one sort out the gestures of the mourners from the ideas about loss and fear in William Matthews's "Men at My Father's Funeral" without robbing both of their significance? Or Elizabeth Bishop's understanding of the child's experience in "First Death in Nova Scotia" from the objects that exemplify the girl's confusion?

The difference between statement and implication is crucial. Abstractions state a meaning, whereas particulars may *imply* a meaning. Abstractions fail when they draw conclusions unwarranted by example. Abstractions that are earned, distilled from details, convince readers. The details of Hardy's scene in "Neutral Tones" prepare us for the haunting paradox in the middle of the poem: "The smile on your mouth was the deadest thing / Alive enough to have strength to die." (**Paradox:** a seemingly self-contradictory statement which nonetheless expresses some truth.) The speaker abstracts the "keen lessons that love deceives / And wrings with wrong" from his exploration of the particulars of the lovers' last moments together. Rich arrives at the declaration that the diseases "go on working; they still kill" after taking us through the dessicated attic and its ruined contents.

Questions and Suggestions

1. After studying a pine cone or a sliced-open orange (or some other common object) for twenty minutes or so, write a description of it. Concentrate on what you see, but include smell, touch, taste, and sound if you can.

2. Write a poem about one of the following, or a similarly odd or unique subject. Flesh it out with carefully chosen details.

the backstroke	a courthouse wedding	hammers
Parcheesi	climbing a phone pole	amethysts
mitosis	carousel horses	avocado skin

3. Write a poem in which someone encounters a creature or creatures, and through the encounter arrives at some evocative/moving/troublesome—but in any case interesting—conclusions. Of course, a poem's "conclusions" can be mainly implicit. In Poems to Consider, you'll find these poems that might work as models: William Olsen, "The Dead Monkey," (p. 159), Donald Hall, "Names of Horses," (p. 162), and William Stafford, "Traveling through the Dark," (p. 163). Elsewhere, you might find these poems helpful: Mark Doty, "No" (p. 23), Enid Shomer, "Among the Cows" (p. 175), Andrew Hudgins, "Goat" (p. 244), and C. Lynn Shaffer, "A Butterfly Lands on the Grave of My Friend" (p. 313).

4. Following is a poem that has been rewritten so that abstractions and clichés replace imagery, detail, and implication. Freely revise it (including the title), keeping with the same narrative, but inventing images and details you feel might be evocative. Compare your poem with those by others in your writing group (and with the original in Appendix II, p. 342). How similar do the poems seem?

Our Parents' Wedding

With the silk of her groom's parachute
from World War II, she made her dress.
She felt so vulnerable and exposed
as she stood ready to march

down the aisle with everyone watching, 5
to march into a future spread before her,
a future when we would be born.
She was wide-eyed as a baby deer

and wanted a marriage like in old movies,
her hero a loving husband. 10
They were both so young and innocent.
Her hands shook so hard her bouquet

trembled. She felt she might faint.
Things had been so different
during the war—all the young men 15
were gone,

but now they had returned, the church
overflowing with handsome men
turning to see her coming down
the aisle like a queen. She thought 20

about the reception when the men
would swirl her around the dance floor.
She loved their sexy military haircuts.
Her mother's warnings rang in her ears.

The men looked at her wearing the parachute 25
and remembered the horrible dangers
they had survived.

5. Among the pleasures of David Wojahn's sonnet "The Assassination of John
 Lennon as Depicted by the Madame Tussaud Wax Museum, Niagara Falls,
 Ontario, 1987" (p. 161) and Alice Friman's "Diapers for My Father"
 (p. 160) are their contemporary subject matters. How does the precision
 of the poets' details help evoke the ambivalence both poems express?

6. As Judson Mitcham's "An Introduction" below makes poignantly clear, we
 get to know the people in poems by where and how we we find them. Read
 the Poems to Consider with an eye to how the poems characterize the
 people in them. What does the setting of New Orleans contribute to "The
 Dead Monkey"? What does the weedy lot suggest in "Shopping in Tucka-
 hoe"? How do the chores function in "What She Could Do"? What does the
 stepmother's money-making scheme in "Ronda" tell us about her? And the
 speaker's "hesitating" in "Traveling Through the Dark"?

Poems to Consider

An Introduction 1996

JUDSON MITCHAM (b. 1949)

You who break the dark all night, whisper and shout,
who travel in and out of all the rooms,
who come with pill or needle, vial or chart,
with bedding, mop and bucket, tray of food;
who turn, clean, pull, read, record, pat, and go; 5
who see her hair matted by the pillow, greasy white
wild short hair that will shock
anyone from home who hasn't seen her for a while—

shocking like her bones, showing now,
like the plum-colored bruises on her arms, like her face 10
when she first comes to and what it says, like her mouth
and the anything it says: *Call the bird dogs*, or
I've got to go to school, or *Tonight y'all roll
that wagon wheel all the way to Mexico*; you
who have seen three children—unbelieving, unresigned— 15
in all these rooms, full of anger and of prayer;
you who change her diaper, empty pans
of green and gold bile she has puked up; you
who cannot help breathing her decay,

I would like to introduce you to our mother, 20
who was beautiful, her eyes like nightshade,
her wavy brown hair with a trace of gold. Myrtle,
whose alto flowed through the smooth
baritone our father used to sing;
our mother, who would make us cut a switch, 25
but who rocked us and who held us and who kissed us;
Myrtle, wizard typist, sharp with figures,
masterful with roses and with roast beef;
who worked for the New Deal Seed Loan Program,
for the school, local paper, county agent, and the church; 30

who cared long years for her own failing mother
(whom she worries for now—you may have heard her);
who was tender to a fault, maybe gullible,
as the truly good and trusting often are; and even so,
who could move beyond fools, though foolishness itself 35
delighted her—a double take, words turned around,
a silly dance—and when our mother laughed
(I tell you this because you haven't heard it),
the world could change, as though the sun could shine
inside our very bones. 40
 And where it's written in Isaiah
that the briar won't rise, but the myrtle tree,
there's a promise unfulfilled:
she will not go out with joy.
Still, if you had known her, you yourselves, 45
like Isaiah's hills, would sing. You'd understand
why it says that *all the trees
of the field shall clap their hands*.

The Dead Monkey 1988

WILLIAM OLSEN (b. 1954)

A face framed in a pink lace baby's hood was youth and age
collapsed to a wizened black walnut. It had no idea
that we were there, New Orleans, 1981, or that we were
growing envious of its owner, an unshaven but rich-looking Mexican
who hoisted it from the ground, not altogether modest 5
about the attention he and it were getting from all of us,
eating our beignets, watching this binary configuration,
man and monkey, kiss, kiss again, patching up
some make-believe quarrel between lovers.
Suddenly it leapt up a trellis of morning glory vines, 10
swung from a brass chandelier over the human circus of breakfasters
and scrambled across the street into a moving bus,
arms and legs toppling one over the other
as it tried to keep up with its death.
The man walked out to the ridiculous end to his happiness, 15
stealing the delight from us, like surreptitious newlyweds,
poor enough in spirit to be amazed by fact.
Taking it in his arms, crying to make himself alone,
this Mexican was living proof that suffering
is not all that crazy about company. 20
When the crowd dispersed, he seemed relieved,
as if too much had already been suffered
without us adding our thimbleful.
That night we saw the Mexican without his monkey in a bar,
buying everyone drinks and laughing hysterically 25
about the whole thing, saying *death is my life*.
If that sounds a bit dramatic, blame it
on sweet bourbon, this is just what he said,
being just lucid enough to mix up life and death
and stupid enough to want to share in their confusion. 30
We toasted with him to stupidity because
there's not always enough stupidity around to celebrate,
and when we were good and drunk we turned ourselves out into the night,
between more bars we saw more bars,
windows like photographs fleshed out with 35
bodies that destroyed their secrets,
we took the journey across the dangerous street,
entranced by the idea of getting somewhere,
sick for everything but home.

Shopping in Tuckahoe 1988

JANE FLANDERS (b. 1940)

One could spend years in this parking lot
waiting for a daughter to find just the right
pair of jeans. From time to time I slip the meter
its nickel fix. Across the street in Epstein's
basement, shoppers pick their way through bins 5
of clothes made tempting by the words "marked down."
We have replaced making things with looking for them.

My mood is such I almost miss what's happening next door,
where a weedy lot is conducting its own
January clearance with giveaways galore— 10
millions of seeds, husks, vines, bare sepals
glinting like cruisewear in the cold sun.
"Come in," says the wind. "We love your pale hair
and skin, the fine lines on your brow."

The shades of choice are bone and dust, everything 15
starched, rustling like taffeta, brushing against me
with offers of free samples—thorns, burrs, fluff,
twigs stripped of fussy flowers.
Greedy as any bargain hunter, I gather them in,
till my arms are filled with the residue of plenty. 20

By the time my daughter reappears, trailing her scarves
of pink and green, she will be old enough
to drive home alone. I have left the keys for her.
She'll never spot me standing here like a winter bouquet
with my straw shield, my helmet of seeds and sparrows. 25

Diapers for My Father 1998

ALICE FRIMAN (b. 1933)

Pads or pull-ons—*that*
is the question. Whether to buy
pads dangled from straps
fastened with buttons or Velcro—
pads rising like a bully's cup 5
stiff as pommel with stickum backs
to stick in briefs. Or, dear God,
the whole thing rubberized,
size 38 in apple green, with
or without elastic leg. Or the kind, 10

I swear, with an inside pocket
to tuck a penis in—little resume
in a folder. Old mole, weeping
his one eye out at the tunnel's end.

The clerk is nothing but patience 15
practiced with sympathy.
Her eyes soak up everything.
In ten minutes she's my cotton batting,
my triple panel, triple shield—my Depends
against the hour of the mop: skeleton 20
with a sponge mouth dry as a grinning brick
waiting in the closet.

She carries my choices to the register,
sighing the floor with each step.
I follow, absorbed away to nothing. 25

How could Hamlet know what flesh is heir to?
Ask Claudius, panicky in his theft,
hiding in the garden where it all began
or behind the arras, stuffing furbelows
from Gertrude's old court dress into his codpiece. 30
Or better, ask Ophelia, daughter too
of a foolish, mean-mouthed father,
who launched herself like a boat of blotters
only to be pulled babbling under the runaway stream.

The Assassination of John Lennon as Depicted by the Madame Tussaud Wax Museum, Niagara Falls, Ontario, 1987 1990

DAVID WOJAHN (b. 1953)

Smuggled human hair from Mexico
Falls radiant around the waxy O

Of her scream. Shades on, leather coat and pants, Yoko
On her knees—like the famous Kent State photo

Where the girl can't shriek her boyfriend alive, her arms 5
Windmilling Ohio sky.
 A pump in John's chest heaves

To mimic death-throes. The blood is made of latex.
His glasses: broken on the plastic sidewalk.

A scowling David Chapman, his arms outstretched,
His pistol barrel spiraling fake smoke 10

In a siren's red wash, completes the composition,
And somewhere background music plays "Imagine"

Before the tableau darkens. We push a button
To renew the scream.
 The chest starts up again.

Names of Horses 1977

DONALD HALL (b. 1928)

All winter your brute shoulders strained against collars, padding
and steerhide over the ash hames, to haul
sledges of cordwood for drying through spring and summer,
for the Glenwood stove next winter, and for the simmering range.

In April you pulled cartloads of manure to spread on the fields, 5
dark manure of Holsteins, and knobs of your own clustered with oats.
All summer you mowed the grass in meadow and hayfield,
 the mowing machine
clacketing beside you, while the sun walked high in the morning;

and after noon's heat, you pulled a clawed rake through the same acres,
gathering stacks, and dragged the wagon from stack to stack, 10
and the built hayrack back, uphill to the chaffy barn,
three loads of hay a day from standing grass in the morning.

Sundays you trotted the two miles to church with the light load
of a leather quartertop buggy, and grazed in the sound of hymns.
Generation on generation, your neck rubbed the windowsill 15
of the stall, smoothing the wood as the sea smooths glass.

When you were old and lame, when your shoulders hurt bending
 to graze,
one October the man, who fed you and kept you, and harnessed you
 every morning,
led you through corn stubble to sandy ground above Eagle Pond,
and dug a hole beside you where you stood shuddering in your skin, 20

and lay the shotgun's muzzle in the boneless hollow behind your ear,
and fired the slug into your brain, and felled you into your grave,
shoveling sand to cover you, setting goldenrod upright above you,
where by next summer a dent in the ground made your monument.

For a hundred and fifty years, in the pasture of dead horses, 25
roots of pine trees pushed through the pale curves of your ribs,
yellow blossoms flourished above you in autumn, and in winter
frost heaved your bones in the ground—old toilers, soil makers:

O Roger, Mackerel, Riley, Ned, Nellie, Chester, Lady Ghost.

Ronda

1997

GLORIA VANDO (b. 1935)

On Tuesday they moved my father's
body from its temporary quarters
run by the state to a private plot
on the outskirts of San Juan. "Not

too far away," my sister assures me. 5
"When you come this summer we'll
visit. I think you'll like it better."
My stepmother spent the year

making *coquito* out of coconut
milk and rum. She sold enough bottles 10
at Christmas to raise the $350 it cost
to move my father's body across

town. I marvel at her zeal,
but think, too, of his impending ordeal,
of his bones having to make fresh 15
indentations in the soil, his flesh

having to warm the land around him.
Even in death he seems condemned
to suffer life's transgressions—
forced to break in a final mattress, 20

to take in a final mistress.

Traveling Through the Dark

1960

WILLIAM STAFFORD (1914–1993)

Traveling through the dark I found a deer
dead on the edge of the Wilson River road.
It is usually best to roll them into the canyon:
that road is narrow; to swerve might make more dead.

By glow of the tail-light I stumbled back of the car 5
and stood by the heap, a doe, a recent killing;
she had stiffened already, almost cold.
I dragged her off; she was large in the belly.

My fingers touching her side brought me the reason—
her side was warm; her fawn lay there waiting, 10
alive, still, never to be born.
Beside that mountain road I hesitated.

The car aimed ahead its lowered parking lights;
under the hood purred the steady engine.
I stood in the glare of the warm exhaust turning red; 15
around our group I could hear the wilderness listen.

I thought hard for us all—my only swerving—,
then pushed her over the edge into the river.

What She Could Do 1997

ELIZABETH HOLMES (b. 1957)

Swing some good licks
with a hoe or an axe.
Scatter sheep manure, doom
dandelions. Mulch
with bark and batting. 5
Name lilies in Latin.

Render pot liquor, turkey-
neck broth, enormous
grape-juice fruitcakes—batter
dripping from fingers. 10

Get her mouth around hymns,
young Lochinvar, tintinnabulation
of bells. Be the eensy spider,
or voice of God. Walk
blunt. Laugh big. Pinch 15
with her long white toes.

The Curator 1992

MILLER WILLIAMS (b. 1930)

We thought it would come, we thought the Germans would come,
were almost certain they would. I was thirty-two,
the youngest assistant curator in the country.
I had some good ideas in those days.

Well, what we did was this. We had boxes 5
precisely built to every size of canvas.
We put the boxes in the basement and waited.

When word came that the Germans were coming in,
we got each painting put in the proper box
and out of Leningrad in less than a week. 10
They were stored somewhere in southern Russia.

But what we did, you see, besides the boxes
waiting in the basement, which was fine,
a grand idea, you'll agree, and it saved the art—
but what we did was leave the frames hanging, 15
so after the war it would be a simple thing
to put the paintings back where they belonged.

Nothing will seem surprised or sad again
compared to those imperious, vacant frames.

Well, the staff stayed on to clean the rubble 20
after the daily bombardments. We didn't dream—
You know it lasted nine hundred days.
Much of the roof was lost and snow would lie
sometimes a foot deep on this very floor,
but the walls stood firm and hardly a frame fell. 25

Here is the story, now, that I want to tell you.
Early one day, a dark December morning,
we came on three young soldiers waiting outside,
pacing and swinging their arms against the cold.
They told us this: in three homes far from here 30
all dreamed of one day coming to Leningrad
to see the Hermitage, as they supposed
every Soviet citizen dreamed of doing.
Now they had been sent to defend the city,
a turn of fortune the three could hardly believe. 35

I had to tell them there was nothing to see
but hundreds and hundreds of frames where the paintings had hung.

"Please, sir," one of them said, "let us see them."

And so we did. It didn't seem any stranger
than all of us being here in the first place, 40
inside such a building, strolling in snow.

We led them around most of the major rooms,
what they could take the time for, wall by wall.
Now and then we stopped and tried to tell them
part of what they would see if they saw the paintings. 45
I told them how those colors would come together,
described a brushstroke here, a dollop there,
mentioned a model and why she seemed to pout
and why this painter got the roses wrong.

The next day a dozen waited for us, 50
then thirty or more, gathered in twos and threes.

Each of us took a group in a different direction:
Castagno, Caravaggio, Brueghel, Cezanne, Matisse,
Orozco, Manet, DaVinci, Goya, Vermeer,
Picasso, Uccello, your Whistler, Wood, and Gropper. 55
We pointed to more details about the paintings,
I venture to say, than if we had had them there,
some unexpected use of line or light,
balance or movement, facing the cluster of faces
the same way we'd done it every morning 60
before the war, but then we didn't pay
so much attention to what we talked about.
People could see for themselves. As a matter of fact
we'd sometimes said our lines as if they were learned
out of a book, with hardly a look at the paintings. 65

But now the guide and the listeners paid attention
to everything—the simple differences
between the first and post impressionists,
romantic and heroic, shade and shadow.

Maybe this was a way to forget the war 70
a little while. Maybe more than that.
Whatever it was, the people continued to come.
It came to be called The Unseen Collection.

Here. Here is the story I want to tell you.

Slowly, blind people began to come. 75
A few at first then more of them every morning,
some led and some alone, some swaying a little.
They leaned and listened hard, they screwed their faces,
they seemed to shift their eyes, those that had them,
to see better what was being said. 80
And a cock of the head. My God, they paid attention.

After the siege was lifted and the Germans left
and the roof was fixed and the paintings were in their places,
the blind never came again. Not like before.
This seems strange, but what I think it was, 85
they couldn't see the paintings anymore.
They could still have listened, but the lectures became
a little matter-of-fact. What can I say?
Confluences come when they will and they go away.

7

TALE, TELLER, AND TONE

Every poem begins with a voice, a **speaker,** the person who tells us whatever we hear or read. Usually the poet speaks, but often someone else does. Just as anything can serve as the subject of a poem, so too can anyone, indeed any*thing,* serve as the speaker. In this poem Amy Gerstler, (b. 1956) speaks through the voice of a mermaid whose song seduced sailors into shipwreck:

Siren

I have a fish's tail, so I'm not qualified to love you.
But I do. Pale as an August sky, pale as flour milled
a thousand times, pale as the icebergs I have never seen,
and twice as numb—my skin is such a contrast to the rough
rocks I lie on, that from far away it looks like I'm a baby 5
riding a dinosaur. The turn of centuries or the turn
of a page means the same to me, little or nothing.
I have teeth in places you'd never suspect. Come. Kiss me
and die soon. I slap my tail in the shallows—which is to say
I appreciate nature. You see my sisters and me perched 10
on rocks and tiny islands here and there for miles:
untangling our hair with our fingers, eating seaweed.

As the speaker talks, she begins to characterize herself and to present the scene where we find her, stretched out on a rock in the sea, munching on seaweed. Her cool diction ("not qualified," "I appreciate nature") supports her cool temperament—and temperature. Her skin is "pale as icebergs." She says, matter of factly, "Kiss me / and die soon." She fits our general notion of a mermaid/siren, but the details of her portrait—her phrasing, her tail slapping the water, her disinterest in passing time, her diet—sharpen and complicate that portrait.

In a sense many poems are small plays. The speaker steps out and begins to talk, creating a person and circumstances, a context, a *scene,* where we find that person. Sometimes a poem's circumstances are complex, as in Miller Williams's "The Curator,"

(p. 164) where the curator tells the story of the Hermitage Museum in Leningrad during World War II: his story takes many turns and unreels over many lines. Or the circumstances may be simpler as those of "Siren." But for the circumstances to matter to us, something must be at stake in them; they must be dynamic. In "The Curator," artistic masterpieces and the spirit of a people are at stake. In "Siren," what's at stake is implicit—the lives of the sailors.

Look at the simple, yet dynamic, circumstances of this poem:

Adlestrop
EDWARD THOMAS (1878–1917)

Yes, I remember Adlestrop—
The name, because one afternoon
Of heat the express-train drew up there
Unwontedly. It was late June.

The steam hissed. Someone cleared his throat. 5
No one left and no one came
On the bare platform. What I saw
Was Adlestrop—only the name

And willows, willow-herb, and grass,
And meadowsweet, and haycocks dry, 10
No whit less still and lonely fair
Than the high cloudlets in the sky.

And for that minute a blackbird sang
Close by, and round him, mistier,
Farther and farther, all the birds 15
Of Oxfordshire and Gloucestershire.

No one would liken this to a Hollywood action flick, but notice the poem opens dynamically, with a motivating incident, something that prompts the poem: Apparently the speaker has just been asked if he has ever heard of the town Adlestrop, and he responds with this memory. Look how the circumstances change and how much is at stake though nothing dramatic *happens*. We're presented with a little mystery—why the express halts at an unlikely place for no apparent reason. The train "hissed," as if impatient. Someone almost speaks, but doesn't. After the first sentence, running three and a half lines, we get three short sentences expressing stasis as we anticipate something happening. Then, although the *train* doesn't move, the *sentences* begin to. The bluster and rush of the express train is overwhelmed by the quiet confidence of the wildflowers and then, gradually, the birds' singing. For the moment of quiet, the speaker seems to *hear* "Farther and farther," until this spot of nowhere, with no town visible, centers a birdsong-filled stillness that spreads out across two counties. Of course he remembers Adlestrop.

Narrative

Many poems are **narratives:** They tell (or imply) stories. Books of poetry can be novel-like: Robert Browning's crime thriller *The Ring and the Book* (1868–1869), Vikram Seth's *The Golden Gate* (1986), Andrew Hudgins's *After the Lost War* (1988), Mark Jarman's *Lucy* (1991), Margaret Gibson's *The Vigil* (1993), or Anne Carson's *The Autobiography of Red* (1998). And striking short stories can be written in verse, from Chaucer's tales to Christina Rossetti's "Goblin Market" to Frost's "The Witch of Coös."

Any story, not just a work of fiction, can deploy narrative techniques to render an arresting tale. Consider this poem by Marilyn Nelson (b. 1946):

Minor Miracle

Which reminds me of another knock-on-wood
memory. I was cycling with a male friend,
through a small midwestern town. We came to a 4-way
stop and stopped, chatting. As we started again,
a rusty old pick-up truck, ignoring the stop sign, 5
hurricaned past scant inches from our front wheels.
My partner called, "Hey, that was a 4-way stop!"
The truck driver, stringy blond hair a long fringe
under his brand-name beer cap, looked back and yelled,
 "You fucking niggers!" 10
And sped off.
My friend and I looked at each other and shook our heads.
We remounted our bikes and headed out of town.
We were pedaling through a clear blue afternoon
between two fields of almost-ripened wheat 15
bordered by cornflowers and Queen Anne's lace
when we heard an unmuffled motor, a honk-honking.
We stopped, closed ranks, made fists.
It was the same truck. It pulled over.
A tall, very much in shape young white guy slid out: 20
greasy jeans, homemade finger tattoos, probably
a Marine Corps boot-camp footlockerful
of martial arts techniques.

"What did you say back there!" he shouted.
My friend said, "I said it was a 4-way stop. 25
You went through it."
"And what did I say?" the white guy asked.
"You said: 'You fucking niggers.'"
The afternoon froze.

"Well," said the white guy, 30
shoving his hands into his pocket
and pushing dirt around with the pointed toe of his boot,
"I just want to say I'm sorry."
He climbed back into his truck
and drove away. 35

Paying attention to the fundamentals of good narrative allows a poet to choose what to include and what to leave out, when to summarize details and when to depict the action moment by moment; that is, to control the poem's *pacing.* Nelson's deft handling of the narrative derives from her pacing, her control of the poem's sense of *time.* She starts her story very close to the center of the action, not with the beginning of the bike ride but with the confrontation with the man. First the poem's conversational tone draws us in. Next she depicts the crucial circumstances of the story: cycling, small Midwestern town, 4-way stop. When the driver "hurricanes" past, the action speeds up, the details grow menacing, then erupt.

After the driver hurls the racial slur at them, Nelson slows the action down again by describing the countryside, building suspense. In sketching the lush natural world around them, in "writing off the subject" as Richard Hugo called the technique, Nelson sharpens the scene's contrast with the threatening man and his loud machine. When the driver looms up again, he intrudes upon the peaceful meadows which (we come to realize) anticipate the amazing turnaround we later see in the driver's character. Through stanza breaks and by focusing in on details like the pointed toes of the man's boots, Nelson holds off this final revelation and so intensifies its payoff.

A seemingly unimportant feature, *verb form,* helps control this action. Most of "Minor Miracle" takes place in the simple past tense, also called the *narrative past:* "stopped," "started," "yelled," "slid out," "shouted," "climbed back," "drove away." But the past progressive marks crucial moments; the central story begins with "I was cycling," signaling that the action will soon shift. Look at the point after they remount their bikes: "We were pedaling through a clear blue afternoon . . . when we heard an unmuffled motor . . ." (lines 14–17). This past progressive indicates something is about to happen. Similarly at the end, before the man makes his apology, we see him "shoving his hands in his pockets / and pushing dirt." Furthermore, did you notice that the entire poem is framed within the present tense, within the phrase, "Which reminds me . . ."? Such a frame helps supply the poem's **motivating incident,** the reason the speaker recounts the story.

For telling a story or even relating a short anecdote, careful manipulation of verb form is crucial; as we can see in Nelson's poem, the verbs help us keep track of where the action is going, where it has been, and where it's headed. Use of the past tense signals that the action of the poem is completed, that the speaker, therefore, has had time to think it over, as Wordsworth says, *to recollect in tranquility,* to weigh the significance of and reflect on the events. Marilyn Nelson's title suggests such reflection: The man's sudden apology was, indeed, a "Minor Miracle."

The present tense can give the impression of immediacy and intensity. It also controls the realm of eternal truths, as in Whitman's "A Noiseless, Patient Spider" (p. 36) and that of discovered truths, like those of Liz Rosenberg's "The Silence of Women" (p. 115). Gerstler's siren lives in an eternal present tense in which she feels no remorse.

As we might expect, the future tense belongs to the realm of the imagined; it controls prophecy poems like Nina Cassian's "Ordeal" (p. 236) and Donald Justice's "Variations on a Text by Vallejo" (p. 256).

Carefully handled, verbless fragments can be effective "sentences." Sharon Bryan's "Sweater Weather" strings such fragments into a "Love Song to Language" (p. 2). The first stanza of Keats's "To Autumn" (p. 137) contains only *verbals*, like "maturing" or "to bend." The stanza itself acts as a long address to the season, helping Keats personify it as a beautiful woman. But use verbless sentences with care. A passage without verbs surrenders a significant marker. As you work on your poems, carefully weigh your decisions about verb form; try out different tenses to see what effect they have on your subject. Consider how "Adlestrop" cast entirely in the present tense would lose its poignancy, as would "Siren" cast in the past tense. The skilled writer minds a poem's verbs as a shrewd gambler keeps track of the betting around the table. This sly poem about storytelling makes the point clear:

Understanding Fiction
HENRY TAYLOR (b. 1942)

What brings it to mind this time? The decal
from East Stroudsburg State in the window
ahead of me as traffic winds to the airport?

Maybe we pass the Stroudwater Landing apartments.
Whatever it is, you who are with me get to hear it 5
all over again: how once, just out of college

or maybe a year or two later, into the first
teaching job, some circumstance found me
in the home of an old friend, one of the mentors

to whom I owe what I am, on one of those days 10
when the airwaves are filled with football.
We remember it now as four games, and swear

to one another, and to others, that this
is what happened. In the second game,
as men unpiled from a crowded scramble, 15

a calm voice remarked that Mike Stroud
had been in on the tackle, and we told
ourselves that we had heard the same thing

in the first game. Odd. So we listened,
or claimed to be listening, and drank, 20
and took what we were pleased to call notice.

Never an isolating or identifying shot,
just these brief observation of crowds:
Mike Stroud was in all four games.

An astonishing trick, a terrific story— 25
some plot of the color commentators,
a tribute to a friend with a birthday,

or maybe just a joke on the world.
I tell it at least four times a year,
and each time it is longer ago. 30

Mike Stroud, if he ever played football,
does not do so now, but he might
even have played only one game

that late fall day in—oh, 1967, let's say.
We were drinking. God knows what we heard. 35
But I tell it again, and see how

to help you believe it, so I make
some adjustment of voice or detail,
and the story strides into the future.

Persona

The poet's ability to imagine and to project underlies what Keats called **negative capability.** In a letter he described this "quality . . . which Shakespeare possessed so enormously—I mean *Negative Capability*," the capability "of being in uncertainties, Mysteries, doubts, without any irritable reaching after fact & reason." Later Keats wrote of

> the chameleon poet . . . the most unpoetical of anything in existence, because he has no Identity—he is continually in for [informing] and filling some other Body—The Sun, the Moon, the Sea and Men and Women.

Through negative capability poets can empty the self, suspend judgments, and so imagine others from the inside: "if a sparrow come before my window, I take part in its existence and pick about the gravel," Keats wrote. A friend reported that Keats said that he could conceive that "a billiard Ball . . . may have a sense of delight from its own roundness, smoothness volubility & the rapidity of its motion."

The following poem demonstrates such poetic *empathy*—how the poet can get inside the existence of others and manifest their inner reality. While touring an aban-

doned coal mine in Wales, the speaker imagines the strange sunless world of the ponies his guide describes.

Pit Pony
WILLIAM GREENWAY (b. 1947)

There are only a few left, he says,
kept by old Welsh miners, souvenirs, like
gallstones or gold teeth, torn
from this "pit," so cold and wet my
breath comes out a soul up 5
into my helmet's lantern
beam, anthracite walls running,
gleaming, and the floors iron-rutted
with tram tracks, the almost pure
rust that grows and waves like 10
orange moss in the gutters of water
that used to rise and drown.
He makes us turn all lights off, almost
a mile down. While children scream
I try to see anything, my hand touching 15
my nose, my wife beside me—darkness palpable,
velvet sack over our heads, even the glow
of watches left behind. This is where
they were born, into this nothing, felt
first with their cold noses for the shaggy 20
side and warm bag of black
milk, pulled their trams for twenty
years through pitch, past birds
that didn't sing, through doors
opened by five-year-olds who sat 25
in the cheap, complete blackness listening
for steps, a knock. And they
died down here, generation after
generation. The last one, when it
dies in the hills, not quite blind, the mines 30
closed forever, will it die strangely? Will it
wonder dimly why it was exiled from the rest
of its race, from the dark flanks of the soft
mother, what these timbers are that hold up
nothing but blue? If this is the beginning 35
of death, this wind, these stars?

The poem's control of time helps the speaker imagine the ponies' inner lives; the speaker moves us from the present, to the past, then—as he explores the weird world

of creatures exiled from the open air—to the future. By moving us through these three time periods, Greenway gives the impression of having made a wide swoop through time, projecting a sad dignity to the forgotten ponies and overcoming the limited vision that a poem set solely in the present tense might risk.

When a poem's speaker is clearly someone other than the poet, we often refer to it as a **persona poem**: a poem in which a fictional, mythic, historic, or other type of figure speaks. When the character's speech creates a dramatic scene, we often call the poem a **dramatic monologue.** In either case, as if dressing up for a costume party, the poet becomes another character. In Amy Gersler's poem a siren speaks; Robert Browning uses the voice of a ruthless Italian Renaissance Duke (p. 176); Allison Joseph invents a black Mary Poppins (p. 192); and T.R. Hummer becomes a rural letter carrier (p. 190). The speaker need not be famous, nor even human.

Daisies
LOUISE GLÜCK (b. 1943)

Go ahead: say what you're thinking. The garden
is not the real world. Machines
are the real world. Say frankly what any fool
could read in your face: it makes sense
to avoid us, to resist 5
nostalgia. It is
not modern enough, the sound the wind makes
stirring a meadow of daisies: the mind
cannot shine following it. And the mind
wants to shine, plainly, as 10
machines shine, and not
grow deep, as, for example, roots. It is very touching,
all the same, to see you cautiously
approaching the meadow's border in early morning,
when no one could possibly 15
be watching you. The longer you stand at the edge,
the more nervous you seem. No one wants to hear
impressions of the natural world: you will be
laughed at again; scorn will be piled on you.
As for what you're actually 20
hearing this morning: think twice
before you tell anyone what was said in this field
and by whom.

These bright, articulate, and witty daisies see through the poet's nervousness and seem to mock her internal struggle: "It is very touching," they say. They apparently have recognized that the poet resists them as poetic subject—even though she is drawn to them—because the daisies are "not modern enough." The poet feels she "will be / laughed at again; scorn will be piled on" her if she offers "impressions

of the natural world." The daisies act as the vehicle that identifies the poet's misgivings and exposes the tangle of voices inside a poet when writing a poem: "think twice," the daisies advise, "before you tell anyone what was said in this field / and by whom." *Think twice*, the voice is more complex than it seems—as are the daisies.

We might say a persona operates in most, if not all, poems. After all, for readers who don't know the poet personally, any poem involves the perception of a presented character, real or otherwise. Thus, even the poet writing or trying to write in his or her own voice creates a self, by presenting a *particular* tone, stance, circumstance, and theme; otherwise, the poem drifts in the generic. As in life we show different faces to different people and in different situations (at the beach, in church), so in writing, often without realizing it, we change or adjust the voice we use, naturally adopting somewhat different *personae*. Yeats called such versions of the self the poet's *masks*. In writing a poem the poet puts on a mask—adopts a *persona*—who speaks the poem. This process of taking on a mask, when the issues are serious, may even amount to exploring one's identity, ethnicity, gender, or heritage; that is, to self-discovery. Through looking at a version of the self, one's narrow assumptions can be challenged and enlarged. The imagination of this poem leads the speaker through a spiritual exercise.

Among the Cows
ENID SHOMER (b. 1944)

Advised to breathe with the Holsteins
 as a form of meditation,
I open a window in my
 mind and let their vast humid breath,
sticky flanks, the mantric switching 5
 of their tails drift through. I lie down
with them while they crop the weedy
 mansions, my breasts muffled like the
snouts of foxes run to ground. I
 need to comfort the cows, the way 10
heart patients stroke cats and the grief
 of childhood is shed for dogs. I
offer them fans of grass under
 a sky whose grey may be the hide
of some huge browser with sun and 15
 moon for wayward eyes. It begins

to rain. How they sway, their heavy
 necks lift and strain. Then, like patches
of night glimpsed through a bank of clouds,
 they move toward four o'clock, the dark 20
fragrant stalls where dawn will break first
 as the curved pink rim of their lips.

> I want to believe I could live
> > this close to the earth, could move with
> a languor so resolute it 25
> > passes for will, my heart riding
> low in my body, not this flag
> > in my chest snapped by the lightest
> breeze. Now my breath escapes with theirs
> > like doused flames or a prayer made 30
> visible: May our gender bear
> > us gracefully through in these cumbrous frames.

Choosing cows for a poem about contemplation makes fine sense. Cows are classified with other cud-chewers as "ruminants," related to the word "ruminate": When we ponder something we're said to chew on it. The langorous cows show her a way to be "close to the earth." Imagining the cows' "vast humid breath, / sticky flanks, the mantric switching / of their tails," she arrives at a delicately comic intuition that to the cows the cosmos resembles them. The gray sky may be "the hide of some huge browser with sun and / moon for wayward eyes." Similarly the dawn breaks like the "curved pink rim of their lips." Gradually she seems to understand that if the world resembles our selves, then by finding peace within, the world outside will become peaceful. The speaker finds that breath itself, in the simple act of breathing, becomes a prayer that she is praying, too. "May our gender bear / us gracefully through in these cumbrous frames."

Point of View

The angle from which the poem comes to us is the poem's **point of view.** In *first-person* point of view the "I" or "we" reports what happens; in *second* person the "you" is the focus; in *third* person "he," "she," or "they" is the focus. Although readers talk in general terms about these three points of view, point of view involves very fine gradations. Listening in on a devious speaker can show us some of the intricacies of point of view:

My Last Duchess
ROBERT BROWNING (1812–1889)

> That's my last duchess painted on the wall,
> Looking as if she were alive. I call
> That piece a wonder, now: Frà° Pandolf's hands
> Worked busily a day, and there she stands.
> Will't please you sit and look at her? I said 5
> "Frà Pandolf" by design, for never read
> Strangers like you that pictured countenance,
> The depth and passion of its earnest glance,
> But to myself they turned (since none puts by

The curtain I have drawn for you, but I) 10
And seemed as they would ask me, if they durst,
How such a glance came there; so, not the first
Are you to turn and ask thus. Sir, 'twas not
Her husband's presence only, called that spot
Of joy into the Duchess' cheek: perhaps 15
Frà Pandolf chanced to say "Her mantle laps
Over my lady's wrist too much," or "Paint
Must never hope to reproduce the faint
Half-flush that dies along her throat": such stuff
Was courtesy, she thought, and cause enough 20
For calling up that spot of joy. She had
A heart—how shall I say?—too soon made glad,
Too easily impressed; she liked whate'er
She looked on, and her looks went everywhere.
Sir, 'twas all one! My favor at her breast, 25
The dropping of the daylight in the West,
The bough of cherries some officious fool
Broke in the orchard for her, the white mule
She rode with round the terrace—all and each
Would draw from her alike the approving speech, 30
Or blush, at least. She thanked men—good! but thanked
Somehow—I know not how—as if she ranked
My gift of a nine-hundred-years-old name
With anybody's gift. Who'd stoop to blame
This sort of trifling? Even had you skill 35
In speech—which I have not—to make your will
Quite clear to such an one, and say, "Just this
Or that in you disgusts me; here you miss,
Or there exceed the mark"—and if she let
Herself be lessoned so, nor plainly set 40
Her wits to yours, forsooth, and made excuse,
—E'en then would be some stooping; and I choose
Never to stoop. Oh sir, she smiled, no doubt,
Whene'er I passed her; but who passed without
Much the same smile? This grew; I gave commands; 45
Then all smiles stopped together. There she stands
As if alive. Will't please you rise? We'll meet
The company below, then. I repeat,
The Count your master's known munificence
Is ample warrant that no just pretense 50
Of mine for dowry will be disallowed;
Though his fair daughter's self, as I avowed
At starting, is my object. Nay, we'll go
Together down, sir. Notice Neptune, though,

Taming a sea-horse, thought a rarity, 55
Which Claus of Innsbruck cast in bronze for me!

3 *Frà*: Friar, a monk; Browning has invented a Renaissance painter-monk, like Frà
Angelico, for this poem. The sculptor of the last line (Claus of Innsbruck) is also
Browning's invention.

By allowing this Renaissance duke to speak for himself, Browning reveals that
within this eloquent, intelligent, cultivated man lurks greed, arrogance, cunning,
and ruthlessness. The Duke of Ferrara is addressing a subordinate, an envoy from a
count; they are negotiating the terms for the count's daughter to become the next
duchess. Created by his dramatic monologue, he appears as vividly as a character on
a stage. Besides monologues, poems can take the forms of letters, diary entries,
prayers, internal meditations, definitions—any form human utterance can take.
Frost's "The Witch of Coös" (p. 185) combines two forms: A first person narrates a
dialogue between a mother and son.

Just as he controls who will now look at his last duchess, the duke controls his
words, all the while modestly claiming he has no "skill / In speech." With prevari-
cating smoothness, he reveals that he had her murdered ("I gave commands; / Then
all smiles stopped together," lines 45–46) because he felt, among other things, that
she did not demonstrate a high enough regard for him and his title ("as if she
ranked / My gift of a nine-hundred-years-old name / With anybody's gift," lines 32–
34). He puts quite a spin on his account of her.

As he delicately brings up the subject of the new dowry, look at how abstract his
diction and how convoluted his syntax become ("no just pretense / Of mine for
dowry will be disallowed," lines 50–51). The duke doesn't specify how much a dowry
he expects; instead he compliments the count's generosity and notes the expecta-
tions that munificence generates.

The first-person point of view has the advantages of creating immediacy, inten-
sity, and sympathy. Call to mind how the speaker's innocence in "First Death in
Nova Scotia" (p. 152) convincingly demonstrates how bizarre death and its rituals
appear to a child, suggesting death's ultimate strangeness in a way a more experi-
enced speaker couldn't. Hearing the duke's story from his own mouth makes him a
compelling, even perversely attractive, figure; we hear what he wants the envoy to
hear although we perhaps end up knowing more about his ruthlessness than he may
like. Perhaps. The duke's self-disclosure may be a tactic; perhaps he wants the envoy
to advise the count's daughter what the duke will demand of her—and the conse-
quences if she doesn't measure up. Or perhaps the duke doesn't care how much he
reveals; perhaps he is merely relishing his domination over others.

Like many first person narrators, the duke is unreliable; the reader is responsible
for trying to figure him out. First-person narrators may have intellectual, psychologi-
cal, emotional, experiential, or even moral limits which color the picture they pre-
sent. The duke's arrogance skews his description of his duchess who we nonetheless
understand is guilty only of having had an easy and open nature. Typically, the closer
a narrator is to the poem's central character or situation, the less psychic distance he

or she will have and the less reliable the narrator will be. The closer we are to an event—temporally or psychologically—the less objective we tend to be. Writers often create a minor character to act as a narrator and lend credibility, especially when the action is unusual, or to provide a voice for commentary, as the nephew does in T. S. Eliot's "Aunt Helen" (p. 184).

The second-person point of view appears infrequently in narration, but more often in poetry than in prose fiction. The second person finds its most common home in the direct address of love poems and in imperatives—directions and directives—like Muriel Rukeyser's "A Simple Experiment" (p. 189), which tells someone how to unmake and remake a magnet. In American English we often use "you," when the British would use "one," to describe habitual or typical action, and such is the case with poems like Cornelius Eady's "The Wrong Street" (p. 108) and Natasha Sajé's "Reading the Late Henry James (p. 253)." At times "you" may signify "I," as when you mutter to yourself, "You're going to be late for work." When speakers address themselves—advising, blaming, warning, motivating, reminding themselves—we glimpse their inner dynamics, and the address can subtly pull both speaker and reader into a common sympathy:

When Someone Dies Young
ROBIN BECKER (b. 1951)

<div style="padding-left: 2em;">

When someone dies young
a glass of water lives
in your grasp like a stream.
The stem of a flower
is a neck you could kiss. 5
When someone dies young
and you work steadily
at the kitchen table
in a house calmed by music
and animals' breath, 10
you falter at the future,
preferring the reliable past,
films you see over and over
to feel the inevitable
turning to parable, characters 15
marching with each viewing
to their doom.
When someone dies young
you want to make love furiously
and forgive yourself. 20
When someone dies young
the great religions welcome you,
a supplicant begging with your bowl.
When someone dies young

</div>

the mystery of your own 25
good luck finds a voice
in the bird at the feeder.
The strict moral lesson
of that life's suffering
takes your hand, like a ghost, 30
and vows companionship
when someone dies young.

The sharp details of the poem, like the working at the kitchen table "in a house calmed by music / and animals' breath," suggest that the speaker is addressing herself, and yet the poem's entire attitude includes the reader. In a sense the "you" calls us by name and includes us, helping us remember—or imagine—our own feelings "when someone dies young." The repetition of this subordinate clause forms a rhythm of suspension and release which further involves the reader.

The third-person point of view covers a wide spectrum, from narrow to wide angles of vision—from limited points of view that focus on a single character to wider, all-knowing points of view which may display god-like powers. Such *omniscient third-person* points of view may jump around in time and space, move from inside one character's mind to another's, and understand events, motives, and circumstances a single character would not.

Let's look at a poem that takes a narrow point of view—a girl who is trying to avoid thinking or feeling. Notice how the point of view remains detached from the scene as it focuses what we can know about the girl.

Kitten
FLEDA BROWN JACKSON (b. 1944)

She is thirteen. Her cat, Sneakers,
has just had another litter of kittens
to be chloroformed by her father
in the large cooking pot. "Keep whichever
you want," he says, "mother or kitten, 5
just one." She is sitting on her bed
petting the male kitten with thick
tan fur. She sits close to her Silvertone
radio, moves her mouth to the music.
A rifle cracks in the back yard, 10
then a scuffle like a rat
under the house. Sneakers has gotten
away, not quite dead, is crouched
in a far corner wailing a low
steady wail. She watches the square 15
knob on her dresser, lit with sun,
the back hairs of her kitten ablaze

in the sunlight like little spines.
Under her is the live crawlspace.
She holds the little paws of her kitten, 20
pushes her thumbs gently into the center
of the pads with almost divine
tenderness, watches the claws extend
involuntarily, translucent little hooks.
She has a vision of pushing until they fly 25
outward like darts, or rays of sun,
leaving the kitten with buff-
colored buttons of feet. She names it
Buffy, imagines buffing the DeSoto
with the kitten, rubbing him flat 30
as her grandmother's fox stole,
popping in little marbles for eyes
that would catch the light,
hard. Her father is calling kitty, here
kitty, his flashlight in the cat's 35
eyes. It is Jungle-Cat, leaping out
of a 3-D screen among arrows, flying
at the audience. She stretches out on
the bed and brushes her face across
her smooth animal. A dark creature passes 40
through the back chambers of her thought
like a shadow, enters a kingdom
of shadows, stirring and stirring.

The girl sprawls on her bed, fantasizing while she plays with the kitten and listens to her father hunt down the cat. The objective point of view puts the girl in close-up, but it also has the flexibility to know the father's conditions for keeping a cat and to see him under the house with the flashlight. Having set up the scene, the point of view shifts to the girl, registering the violent fantasies she entertains. It reveals her as passive, floating in a wordless realm without deeply reflecting on what is happening around her. The images of hardness and sharpness suggest that her passivity may be an armor of self-protection which she wears against her father's cruelty. The poem's omniscient narrator keeps a distance, talking to the reader, cooly reporting what happens in the room. The girl's actions suggest the cruelty with which the girl will repay the father as she grows fully into her sexuality.

Tone

When we attempt to describe the **tone** of a poem, we are trying to identify a complex of attitudes toward its subject, including the attitudes of the speaker and the poet, which, as Jackson's "Kitten" and Browning's "My Last Duchess" suggest, may be quite different. Poetry can range through all human attitudes and so register

many tones—anger, elation, curiosity, hysteria, bliss, indifference, sorrow, terror, tenderness, skepticism, joy, anticipation, scorn, silliness. Since poems often trace moments of heightened awareness and of intense emotions, the poet may take a reader on a roller-coaster ride of feelings. As long as the context supports the tone— or tones—a poet can express any attitude, even contradictory attitudes, in the course of a poem.

Consider the interplay of tones in this poem:

Lunch by the Grand Canal
RICHARD LYONS (b. 1951)

Harry Donaghy, an ex-priest, is telling us
that, after ten rounds, the welterweight was still panting
from a literal hole in his heart.
The fish the waiter lays before me on a white plate
is hissing through its eye, I swear it. 5
Harry spills out a carton of old photos
between the bread & the vials of vinegar.
The people in the pictures are friends of his aunt, whose body

he's signed for & released, now on a jet lifting from Rome.
He says he's always preferred Venice, 10
here a Bridge of Sighs separates this life from the next.
One of the photos, he thinks, is of his aunt,
she's no longer young having dropped a cotton dress at her feet

so the artist at arm's length might see her beauty
as if it had already slipped away. Across from me, 15
Paige Bloodworth is wearing a red hat, which looks good on her,
but she hasn't said a word, so pissed we missed the launch
to San Michele where Pound is buried.

For her, Harry's unidentified relatives
posing on the steps down to the Grand Canal 20
are lifting stones from their pockets
and pelting the poet's coffin as it eases out
on a black boat, chrysanthemums hoarding their perfumes.

I'm stroking the curved prow of a boat as if it were
the neck of a wild stallion rearing close 25
for a hidden cube of sugar or a slice of apple.
Miss Bloodworth's hat becomes a figure in memory's contract
as it lifts over water the color of tourmaline.
Harry's big hands trap all the photos, spilling the wine.
It's the winter of 1980, just warm enough 30
to sit outside as I remember. The rest of that year
no doubt is a lie.

The heterogeneous mix of people, motives, details, and time frames makes for a darkly funny poem and an ironic tone. The speaker seems to feel simultaneously intrigued by the strangeness and appalled at the meaninglessness of the circumstances he delineates. This aimless trio of Harry, Paige, and the narrator, who have apparently met while traveling, sit around a common table, but have little in common, except perhaps a shared annoyance with things which might interrupt their diversions.

Quirky juxtapositions intensify the scene's incongruence. A welterweight boxer with a hole in his heart is set against a fish hissing through its eye. An ex-priest, apparently the surviving relative of an expatriate model, casually flips through what's left of her life at an outdoor café. A woman whose surname is Bloodworth wears a red hat that "looks good on her" even though she is sulking because they missed a boat to see a famous poet's grave.

At the end the rootlessness of the people and the discordance of other elements seem to be cosmically dismissed when the wind comes up to scatter the photographs and lift the hat over the canal. Although Lyons writes the poem in present tense, the scene remains distant; that is, he establishes an ironic distance between himself and the poem's subject.

One feature of tone that deserves elaboration is **irony,** which generally indicates a discrepancy between the author's attitude and the attitude(s) expressed within the poem. The incongruous elements which Lyons assembles sets up a disapproval of the self-centered, dislocated lives we glimpse in the poem. The poem's entire tone is ironic, and in the poem's closing the speaker levels that irony at himself, "The rest of that year / no doubt is a lie." In the last line Lyons shows his hand. He reports to us that he made the entire poem up. He had been encouraging his students to feel freer about using lies in their poems and wrote the poem to show how believable an invented story can be.

The term **verbal irony** identifies a discrepancy between what the speaker says and what the speaker means, as when wrestling with an umbrella in the rain you say, "What a lovely day." Nemerov's speaker in "Learning by Doing" (p. 81) uses the barb of irony to prick the mistaken experts who are about to kill a perfectly sound tree: "So what they do / They do, as usual, to do us good."

Dramatic irony is a discrepancy between what the author and reader know and what the speaker or characters know. Hamlet does not kill the king when he is at prayer, lest the king, repentant and thus in a state of grace, go straight to heaven. Hamlet does not know what the audience has seen: that the king, burdened with guilt because he cannot regret his crime, is unable to pray. Dramatic irony solidifies the relationship between audience and writer, letting readers in on what remains hidden to the characters. Irony torques a poem's tension as readers become caught up wondering if the characters will catch on or fall for the trap.

On a simple level we see dramatic irony in horror movies when someone in the audience yells at the bumbling teenager "Watch out!" as she reaches for the door that hides the maniac with his ax. On a more subtle level dramatic irony allows the audience to become the moral voice in a poem. The girl in "Kitten" does not protest the heartless choice her father gives her, allowing us, through dramatic irony, to judge his callousness more strongly.

Life itself may be ironic. Our expectations meet unexpected twists. The deserted church is turned into a liquor store. The "D" math student becomes a physics genius. This poem by T.S. Eliot (1888–1965) exemplifies such **situational irony:**

Aunt Helen

Miss Helen Slingsby was my maiden aunt,
And lived in a small house near a fashionable square
Cared for by servants to the number of four.
Now when she died there was silence in heaven
And silence at her end of the street. 5
The shutters were drawn and the undertaker wiped his feet—
He was aware that this sort of thing had occurred before.
The dogs were handsomely provided for,
But shortly afterwards the parrot died too.
The Dresden clock continued ticking on the mantel-piece, 10
And the footman sat upon the dining-table
Holding the second housemaid on his knees—
Who had always been so careful while her mistress lived.

Though kin, the speaker remains aloof though he clearly shows the aunt's character was defined by her concern for proprieties which now seem merely empty, whether observed (by the undertaker, who "wiped his feet") or flouted (by the footman and second housemaid). Though written in first person, the point of view has a wide angle of vision because it is emotionally distant from the scene; the nephew can report what goes on behind closed doors, even that "there was silence in heaven."

Questions and Suggestions

1. Try writing a poem using one of the following as the speaker:

> a turtle turned on its back by kids
> a major league outfielder who fears he'll be traded
> a surgical nurse on the late shift
> Marie Antoinette's wig maker
> one of your ancestors
> a dandelion
> a shoplifter

 What might you need to know or find out, or invent, in order to make the poem convincing and interesting? Or imagine another speaker who in some way will help you explore some part of yourself.

2. Write a poem about your mother, father, or another close relative, using an anecdote (real or imagined) before you were born. An old photograph

might help. Let the poem help you find out something you didn't know.

3. *For a group*. Form a circle. (1) On the top of a blank piece of paper each of you writes a brief description of a character (e.g., "A forty-eight-year-old produce manager . . ."). Pass the description to the person to your right and take the written description from the person on your left. (2) Now each of you should add a further detail about the character or the situation found on the piece of paper you receive (". . . cleaning up a load of spilled iceberg lettuce"). When you have added the detail, again pass the paper on to the person on your right. (3) Again each person adds another complication ("is thinking of her mother in the nursing home") and passes on the paper. (4) Then each person adds some detail that is occurring *while* the rest of this action is taking place—a moment of "writing off the subject" ("customers race in the door as a thunderstorm rolls through")—and passes the paper on. (5) Finally, out of the character and circumstances written on the paper in front of you, each of you tries to write a poem, using whatever point of view seems most effective.

4. Map out how the poets deliver the action through their verbs in Robert Frost's "The Witch of Coös" below and Louise Bogan's "Medusa" (p. 191).

5. In their poems Marilyn Nelson (p. 169) and Brooke Horvarth ("Arkansas Funeral," p. 191) treat the difficult subject of racism. Try handling it yourself, or try another thorny issue.

6. Both Frost's "The Witch of Coös" below and Kennedy's "In a Prominent Bar in Secaucus One Day" (p. 193) are frame narratives—they tell a story within a story. How do the outer frames help the poets present the outrageous inner stories?

7. Identify, in as much detail as you can, the point of view of these poems: Muriel Rukeyser's "A Simple Experiment" (p. 189), Allison Joseph's "Mary Poppins II" (p. 192), Sarah Gorham's, "Extra Extra" (p. 195), Louis Simpson's "American Classic" (p. 196) and Tricia Stuckey's "In the Mirror" (p. 196). What limitations, if any, does each narrator have? What effect does each poem's particular point of view have on how we read it?

Poems to Consider

Witch of Coös 1923

ROBERT FROST (1874–1963)

I stayed the night for shelter at a farm
Behind the mountain, with a mother and son,
Two old-believers. They did all the talking.

MOTHER. Folks think a witch who has familiar spirits
She could call up to pass a winter evening, 5

But won't, should be burned at the stake or something.
Summoning spirits isn't "Button, button,
Who's got the button," I would have them know.

SON. Mother can make a common table rear
And kick with two legs like an army mule. 10

MOTHER. And when I've done it, what good have I done?
Rather than tip a table for you, let me
Tell you what Ralle the Sioux Control once told me.
He said the dead had souls, but when I asked him
How could that be—I thought the dead were souls— 15
He broke my trance. Don't that make you suspicious
That there's something the dead are keeping back?
Yes, there's something the dead are keeping back.

SON. You wouldn't want to tell him what we have
Up attic, mother? 20

MOTHER. Bones—a skeleton.

SON. But the headboard of mother's bed is pushed
Against the attic door: the door is nailed.
It's harmless. Mother hears it in the night,
Halting perplexed behind the barrier 25
Of door and headboard. Where it wants to get
Is back into the cellar where it came from.

MOTHER. We'll never let them, will we, son? We'll never!

SON. It left the cellar forty years ago
And carried itself like a pile of dishes 30
Up one flight from the cellar to the kitchen,
Another from the kitchen to the bedroom,
Another from the bedroom to the attic,
Right past both father and mother, and neither stopped it.
Father had gone upstairs; mother was downstairs. 35
I was a baby: I don't know where I was.

MOTHER. The only fault my husband found with me—
I went to sleep before I went to bed,
Especially in winter when the bed
Might just as well be ice and the clothes snow. 40
The night the bones came up the cellar stairs
Toffile had gone to bed alone and left me,
But left an open door to cool the room off
So as to sort of turn me out of it.
I was just coming to myself enough 45
To wonder where the cold was coming from,

When I heard Toffile upstairs in the bedroom
And thought I heard him downstairs in the cellar.
The board we had laid down to walk dry-shod on
When there was water in the cellar in spring 50
Struck the hard cellar bottom. And then someone
Began the stairs, two footsteps for each step,
The way a man with one leg and a crutch,
Or a little child, comes up. It wasn't Toffile:
It wasn't anyone who could be there. 55
The bulkhead double doors were double-locked
And swollen tight and buried under snow.
The cellar windows were banked up with sawdust
And swollen tight and buried under snow.
It was the bones. I knew them—and good reason. 60
My first impulse was to get to the knob
And hold the door. But the bones didn't try
The door; they halted helpless on the landing,
Waiting for things to happen in their favor.
The faintest restless rustling ran all through them. 65
I never could have done the thing I did
If the wish hadn't been too strong in me
To see how they were mounted for this walk.
I had a vision of them put together
Not like a man, but like a chandelier. 70
So suddenly I flung the door wide on him.
A moment he stood balancing with emotion,
And all but lost himself. (A tongue of fire
Flashed out and licked along his upper teeth.
Smoke rolled inside the sockets of his eyes.) 75
Then he came at me with one hand outstretched,
The way he did in life once; but this time
I struck the hand off brittle on the floor,
And fell back from him on the floor myself.
The finger-pieces slid in all directions. 80
(Where did I see one of those pieces lately?
Hand me my button box—it must be there.)
I sat up on the floor and shouted, "Toffile,
It's coming up to you." It had its choice
Of the door to the cellar or the hall. 85
It took the hall door for the novelty,
And set off briskly for so slow a thing,
Still going every which way in the joints, though,
So that it looked like lightning or a scribble,
From the slap I had just now given its hand. 90
I listened till it almost climbed the stairs

From the hall to the only finished bedroom,
Before I got up to do anything;
Then ran and shouted, "Shut the bedroom door,
Toffile, for my sake!" "Company?" he said, 95
"Don't make me get up; I'm too warm in bed."
So lying forward weakly on the handrail
I pushed myself upstairs, and in the light
(The kitchen had been dark) I had to own
I could see nothing. "Toffile, I don't see it. 100
It's with us in the room, though. It's the bones."
"What bones?" "The cellar bones—out of the grave."
That made him throw his bare legs out of bed
And sit up by me and take hold of me.
I wanted to put out the light and see 105
If I could see it, or else mow the room,
With our arms at the level of our knees,
And bring the chalk-pile down. "I'll tell you what—
It's looking for another door to try.
The uncommonly deep snow has made him think 110
Of his old song, 'The Wild Colonial Boy,'
He always used to sing along the tote road.
He's after an open door to get outdoors.
Let's trap him with an open door up attic."
Toffile agreed to that, and sure enough, 115
Almost the moment he was given an opening,
The steps began to climb the attic stairs.
I heard them. Toffile didn't seem to hear them.
"Quick!" I slammed to the door and held the knob.
"Toffile, get nails." I made him nail the door shut 120
And push the headboard of the bed against it.
Then we asked was there anything
Up attic that we'd ever want again.
The attic was less to us than the cellar.
If the bones liked the attic, let them have it. 125
Let them stay in the attic. When they sometimes
Come down the stairs at night and stand perplexed
Behind the door and headboard of the bed,
Brushing their chalky skull with chalky fingers,
With sounds like the dry rattling of a shutter, 130
That's what I sit up in the dark to say—
To no one anymore since Toffile died.
Let them stay in the attic since they went there.
I promised Toffile to be cruel to them
For helping them be cruel once to him. 135

SON. We think they had a grave down in the cellar.

MOTHER. We know they had a grave down in the cellar.

SON. We never could find out whose bones they were.

MOTHER. Yes, we could too, son. Tell the truth for once.
They were a man's his father killed for me. 140
I mean a man he killed instead of me.
The least I could do was help dig their grave.
We were about it one night in the cellar.
Son knows the story: but 'twas not for him
To tell the truth, suppose the time had come. 145
Son looks surprised to see me end a lie
We'd kept up all these years between ourselves
So as to have it ready for outsiders.
But tonight I don't care enough to lie—
I don't remember why I ever cared. 150
Toffile, if he were here, I don't believe
Could tell you why he ever cared himself. . . .

She hadn't found the finger-bone she wanted
Among the buttons poured out in her lap.
I verified the name next morning: Toffile. 155
The rural letter box said Toffile Lajway.

A Simple Experiment 1973

MURIEL RUKEYSER (1913–1980)

When a magnet is
struck by a hammer
the magnetism spills out of
the iron.

The molecules 5
are jarred,
they are a mob going
in all directions

The magnet is
shocked back 10
it is no magnet but
simple iron.

There is no more
of its former

kind of accord 15
or force.

But if you take
another magnet
and stroke the iron
with this, 20

it can be
remagnetized
if you stroke it
and stroke it,

stroke it 25
stroke it,
the molecules
can be given
their tending grace

by a strong magnet 30
stroking stroking
always in the same direction,
of course.

The Rural Carrier Discovers
That Love Is Everywhere 1982

T. R. HUMMER (b. 1950)

A registered letter for the Jensens. I walk down their drive
Through the gate of their thick-hedged yard, and by God there they are,
On a blanket in the grass, asleep, buck-naked, honeymooners
Not married a month. I smile, turn to leave,
But can't help looking back. Lord, they're a pretty sight, 5
Both of them, tangled up in each other, easy in their skin—
It's their own front yard, after all, perfectly closed in
By privet hedge and country. Maybe they were here all night.

I want to believe they'd do that, not thinking of me
Or anyone but themselves, alone in the world 10
Of the yard with its clipped grass and fresh-picked fruit trees.
Whatever this letter says can wait. To hell with the mail.
I slip through the gate, silent as I came, and leave them
Alone. There's no one they need to hear from.

Medusa 1923

LOUISE BOGAN (1897–1970)

I had come to the house, in a cave of trees,
Facing a sheer sky.
Everything moved,—a bell hung ready to strike,
Sun and reflection wheeled by.

When the bare eyes were before me 5
And the hissing hair,
Held up at a window, seen through a door.
The stiff bald eyes, the serpents on the forehead
Formed in the air.

This is a dead scene forever now. 10
Nothing will ever stir.
The end will never brighten it more than this,
Nor the rain blur.

The water will always fall, and will not fall,
And the tipped bell make no sound. 15
The grass will always be growing for hay
Deep on the ground.

And I shall stand here like a shadow
Under the great balanced day,
My eyes on the yellow dust, that was lifting in the wind, 20
And does not drift away.

Arkansas Funeral 1997

BROOKE HORVATH (b. 1953)

As the cortege turned down another road to nowhere,
rolled with the cotton lint across fields like open ovens,
the six pall-bearers wadded into the dusty Buick Skylark
bitched above the local niggers, who after all these years
were still insisting on integrated schools. 5
 Or rather,
four bitched and one defended: give them, he said,
a job pays enough so they can afford a house,
they'll take care of that house almost as good
as we would. "We" meaning them, 10
these five friends and near relations
of the dead man, not one of them under sixty.

"We" did not mean me, a stranger dragooned
when, at the last minute, the sixth pall-bearer

failed to show. 15
 Not that six were required.
The old man even in his walnut box weighed little more
than a couple sacks of cotton, was now
what he always said he felt when ill: puny.
I was a fifth wheel, a silent partner, 20
one of those unnecessary people put up with
because even the dead have their needs:
a serge suit, revival hymns and scripture
in God's well-kept house, relatives teary-eyed
and sweaty from a night in Arkansas motels, 25
a full contingent of men to lift and tote.

So with the casualness of seeking a fourth for bridge
or hiring someone to help in the fields,
I was asked to lend a hand, who was what to the dead man?
The long-haired northerner who'd carpet-bagged his way 30
into the old man's granddaughter's bed,
who pronounced "Cairo" as though it were a city in Egypt
and forked through his greens as though he thought
his food was somewhere underneath.

As we made our way to where the car would finally stop 35
and we'd spill from its hot insides like cotton from a boll
to leave the old man in the ground he loved,
talk turned to other out-of-favor neighbors,
to why the Amish were such shits.
 No, I said, 40
if they won't wear buttons, they're German Baptists.
They're German Baptists, I said,
while in the roadside fields our passing dusted,
where men, black and white, bent hoeing cotton,
each, as he saw us coming, 45
laid down his hoe, took off his hat,
and stood at attention as we passed.

Mary Poppins II: That's Ms. Poppins to You 1997

ALLISON JOSEPH (b. 1967)

I am here to tell you
a spoonful of sugar
won't help much these days—
have you seen the electric bill?
You kids run around here 5
like you ain't got no sense,
lights on all over the house,

and ol' Mary has to come
up behind you, turning them off
when you hellions forget 10
you left 'em on, 'cause it all
comes out of my salary
in the end. Supercalifragilistic,
my ass—you kids are the messiest
rugrats I ever had the displeasure 15
to know: wooden ducks on the stairs
just ripe for me to trip on,
hair ribbons all over the sink,
jump ropes, silver jacks, slingshots
in every cranny and nook 20
of the parlor—hidden in the sofas,
shoved under the chaise.
Who do you think has to find that stuff
when you go crying to mama and daddy
about what you've lost? 25
I have to go down
on my creaky hand and knees
to find your spinning tops,
your toy drums, marionettes,
while you little weasels play 30
hide-and-seek in the garden.
The only thing they're hiding
and I'm seeking is a raise,
not a holiday bonus or a little
something extra for my birthday, 35
a real raise a woman can live on
and still send something
to her kids, her grandkids.
Lord knows my grands are smarter
than these future bottom-of-the-class 40
boarding school numbskulls.
Little do they know
next time I take to flying,
I ain't waving as those pale faces
get smaller and smaller, 45
I ain't coming back.

In a Prominent Bar in Secaucus One Day 1985

X. J. KENNEDY (b. 1929)

> *To the tune of "The Old Orange Flute"*
> *or the tune of "Sweet Betsy from Pike"*

In a prominent bar in Secaucus° one day
Rose a lady in skunk with a topheavy sway,
Raised a knobby red finger—all turned from their beer—
While with eyes bright as snowcrust she sang high and clear:

"Now who of you'd think from an eyeload of me 5
That I once was a lady as proud as could be?
Oh I'd never sit down by a tumbledown drunk
If it wasn't, my dears, for the high cost of junk.

"All the gents used to swear that the white of my calf
Beat the down of the swan by a length and a half. 10
In the kerchief of linen I caught to my nose
Ah, there never fell snot, but a little gold rose.

"I had seven gold teeth and a toothpick of gold,
My Virginia cheroot was a leaf of it rolled
And I'd light it each time with a thousand in cash— 15
Why the bums used to fight if I flicked them an ash.

"Once the toast of the Biltmore,° the belle of the Taft,°
I would drink bottle beer at the Drake,° never draft,
And dine at the Astor° on Salisbury steak
With a clean tablecloth for each bite I did take. 20

"In a car like the Roxy° I'd roll to the track,
A steel-guitar trio, a bar in the back,
And the wheels made no noise, they turned over so fast,
Still it took you ten minutes to see me go past.

"When the horses bowed down to me that I might choose, 25
I bet on them all, for I hated to lose.
Now I'm saddled each night for my butter and eggs
And the broken threads race down the backs of my legs.

"Let you hold in mind, girls, that your beauty must pass
Like a lovely white clover that rusts with its grass. 30
Keep your bottoms off barstools and marry you young
Or be left—an old barrel with many a bung.

"For when time takes you out for a spin in his car
You'll be hard-pressed to stop him from going too far
And be left by the roadside, for all your good deeds, 35
Two toadstools for tits and a face full of weeds."

All the house raised a cheer, but the man at the bar
Made a phonecall and up pulled a red patrol car
And she blew us a kiss as they copped her away
From that prominent bar in Secaucus, N.J. 40

1 *Secaucus:* New Jersey town near New York City; 17, 18, 19, *Biltmore, Taft, Drake, Astor:* once-fashionable hotels in New York; 21 *Roxy:* a movie palace.

Extra Extra 1996

SARAH GORHAM (b. 1954)

She's dressed to kill,
scarlet off-the-shoulder
minidress, matching sheers
and bangs moussed
like a spray of river 5
backed up behind a rock.
Her bag's hooked on a pinky
and she swings it,
tight little orbit,
parachuting 10
maple key. You flash back
to a fall morning
by sheer luck catching
the sudden sexual rain—
a thousand seeds 15
from one overripe tree.
It had to be
overkill, all that action
for a single coupling
into succulent, condition-red 20
soil. But now that you
think of it, there's
something extra here too,
an endearing messiness
as she flips her bag 25
once too often
and it flies smack
into her best
friend's abdomen.
She's blown her cool 30
but there's wisdom
in losing it too.
Call it instinct?
—this woman knows
in the beginning 35
life exploded:
a universe, a home
from all that swirling

powder and shadow
and gloss. 40

American Classic 1981

LOUIS SIMPSON (b. 1923)

It's a classic American scene—
a car stopped off the road
and a man trying to repair it.

The woman who stays in the car
in the classic American scene 5
stares back at the freeway traffic.

They look surprised, and ashamed
to be so helpless . . .
let down in the middle of the road!

To think that their car would do this! 10
They look like mountain people
whose son has gone against the law.

But every night they set out food
and the robber goes skulking back to the trees.
That's how it is with the car . . . 15

it's theirs, they're stuck with it.
Now they know what it's like to sit
and see the world go whizzing by.

In the fume of carbon monoxide and dust
they are not such good Americans 20
as they thought they were.

The feeling of being left out
through no fault of your own, is common.
That's why I say, an American classic.

In the Mirror 1995

TRICIA STUCKEY*

Come here,
he said
reaching an arm out
across the rusty-colored
red vinyl of the long bench seat. 5
Come here,
sit next to me.

Sliding over,
she watched him
watch the road. 10
Come closer,
he said
and the crazy grin spread
across his tanned face.
The teeth of his smile 15
shone in the sunlight
and his hair
sprung from his head
like a mane.
Closer, 20
he said,
and slung an arm
around her shoulder
pulling her to his side.
The dust flew up 25
from the road
and the big red truck
bounced and flung itself
down the old dirt road.
Look here, 30
he said
glancing toward the glare
of the side-view mirror.
She sang along, off key,
not knowing the words, 35
and leaned in closer still.
There,
he said,
in the mirror.
She tilted her head 40
and caught a glimpse
of her face next to his,
slightly sunburned,
eyes bright, teeth shining
from a crazy grin, 45
hair twisted into ropes
by the wind.
Look closely,
he said.
This is the way 50
I will always think of you.

8

METAPHOR

Metaphor is the magical spring of poetry. Aristotle declared that "the greatest thing by far is to be a master of metaphor. It is the one thing that cannot be learned from others; and it is also a sign of genius, since a good metaphor implies an intuitive perception of the similarity in dissimilars." Inextricably entwined both with the ways we think and with the origin and nature of language itself, metaphor in theory seems a knot of complexity. Luckily, just as we needn't know much about human musculature to run, we needn't have a theory of metaphor to use it.

Robert Frost's definition suffices: "saying one thing in terms of another." **Metaphor** means (literally, from the Greek) *transference:* We transfer the qualities of one thing to another, something normally not considered related to the first thing, as in "The sun hangs like a bauble in the trees." Qualities of a bauble transfer to the sun. The center of our solar system, our source of heat, light, and food has been dethroned, has become weak, trivial, gaudy, and, perhaps, silly. Notice how much the particular choice of words contributes. An earring is also a bauble, but a sun that is an earring touches a very different emotional register.

We call the subject, the thing that undergoes transference, the **tenor** (sun) and the source of transferred qualities the **vehicle** (bauble). When the metaphor is stated directly, made explicit, we use the term **simile,** syntactically announced by *like* or *as* (or *as though, as if, the way that*). Simile denotes *similarity* between tenor and vehicle as in "The sun hangs like a bauble." The italicized phrases in the following lines are similes.

> She dreamed of melons *as a traveller sees*
> *False waves in desert drouth*
>
> Christina Rossetti

> Hollow of cheek *as though it drank the wind*
> *And took a mess of shadows for its meat*
>
> W. B. Yeats

It is *as if I float on a still pond,*
drowsing in the bottom of a rowboat,
curled like a leaf into myself.

Elizabeth Spires

their bedroom door halved
The dresser mirror *like a moon*
Held prisoner in the house

Yusef Komunyakaa

I eat men *like air.*

Sylvia Plath

Tom Andrews (b. 1961) makes lively use of similes in this poem as he plays with a great Victorian poet's struggle to discover one thing in terms of another. What is Andrews suggesting about the resemblances (or lack of them) between language and film, between artist and audience?

Cinema Vérité: The Death of Alfred, Lord Tennyson

The camera pans a gorgeous snow-filled landscape: rolling hills, large black trees,
a frozen river. The snow falls and falls. The camera stops to find Tennyson,
in an armchair, in the middle of a snowy field.

Tennyson:
　　It's snowing. The snow is like . . . the snow is like crushed aspirin,
　　like bits of paper . . . no, it's like gauze bandages, clean teeth, shoelaces,
　　　　headlights . . . no,
　　I'm getting too old for this, it's like a huge T-shirt that's been chewed on by
　　　　a dog,
　　it's like semen, confetti, chalk, sea shells, woodsmoke, ash, soap, trillium,
　　　　solitude, daydreaming . . . Oh hell,
　　you can see for yourself! That's what I hate about film!
He dies.

When the transference is implicit, we use the term **metaphor.** A *metaphor* so compresses its elements that we *identify* the tenor with the vehicle; the connection happens in a flash: "The gun barked." "The sun is a bauble hung in the trees." "The ship ploughs the sea." Often we see in the compression its various elements and can untangle them: "The gun made a noise like a dog's bark"; "The ship cuts the water as sharply as a plough cuts the soil." As you work on your poems, strive for the intensity that metaphoric compression creates, so that "Filled with elation, I quickly left the house" might become "I tangoed out the door." When metaphors flash before us, we can suddenly grasp new connections. Consider the sizzle of this little poem.

Watermelons
CHARLES SIMIC (b. 1938)

Green Buddhas
On the fruit stand.
We eat the smile
And spit out the teeth.

Metaphor often eludes exact translation; through its dense evocativeness, it not only compresses and compacts but also expresses the inexpressible—it tells it "like" it is. Metaphors are italicized in the following fragments.

[Rain] *scores a bulls-eye every time*

Craig Raine

When the first crocuses
pushed their *purple tongues*
through the *skin* of the earth,
it was *the striking of a match.*

Cathy Song

Out, out, brief candle!
Life's but *a walking shadow, a poor player*
That struts and frets his hour upon the stage
And then is heard no more. It is a tale
Told by an idiot, full of sound and fury,
Signifying nothing.

William Shakespeare

[a hummingbird] A *Route of Evanescence*
With a revolving Wheel—

Emily Dickinson

Whirl up, sea—
Whirl your *pointed pines*

H.D.

In this poem notice how the metaphors register the complex attitudes the poem expresses:

The White Dress
LYNN EMANUEL (b. 1948)

What does it feel like to be this shroud
on a hanger, this storm cloud hanging
in the closet? We itch to feel it, it itches
to be felt, it feels like an itch—

encrusted with beading, it's an eczema 5
of sequins, rough, gullied, riven,
puckered with stitchery, a frosted window
against which we long to put our tongues,

a vase for holding the long-stemmed
bouquet of a woman's body. 10
Or it's armor and it fits like a glove.
The buttons run like rivets down the front.

When we're in it we're machinery,
a cutter nosing the ocean of a town.
Right now it's lonely locked up 15
in the closet; while we're busy

fussing at our vanity, it hangs there
in the drooping waterfall of itself,
a road with no one on it, bathed
in moonlight, rehearsing its lines. 20

Together the metaphors (as well as the similes) create an ambivalent tone; the somewhat pretty metaphors (*frosted window, vase, waterfall, bathed / in moonlight*) are undermined by the negatives (*shroud, eczema, road with no one on it*). By playing the metaphors off each other, Emanuel goes beyond our received notions of tradition and of "whiteness" (we're reminded of Melville's "Whiteness of the Whale" chapter in *Moby Dick*) and urges us to consider a wedding dress as a kind of gorgeous trap.

For practical purposes, distinguishing between simile and metaphor is far less important than recognizing their similarities. Because they are explicit, similes may seem simpler and closer to the straightforward, logical uses of language. But the evocative quality of any metaphor or simile depends on context. The popular notion that metaphor is stronger than simile, more forceful or evocative, is not really true.

Look at these lines of Browning:

> The wild tulip, at the end of its tube, blows out its great red bell
> Like a thin clear bubble of blood

The simile "Like a thin clear bubble of blood" startles us more than either of the metaphors, "tube" for the stem and "great red bell" for the flower. The simile carries the main, somewhat unpleasant tone of the passage (the speaker is comparing the city and the country to the disadvantage of the latter). The vaguely clinical "tube"

(and "bell," which has laboratory overtones as in "belljar") set up the grimly lovely "Like a thin clear bubble of blood."

Figuratively Speaking

Metaphors and similes fall into a larger group called *figures of speech,* or sometimes *tropes.* Under this larger heading fall literary devices like *irony, hyperbole,* and *understatement* that we mention in chapter 7 and which are so common we might forget they are "figures." Another device is **personification,** in which an inanimate object behaves like a person, as Emanuel's white dress "itches / to be felt" and feels "lonely locked up." A similar figure of speech, **animism,** is assigning animal characteristics to humans: "He wolfed down his lunch"; "She swims like a snail." Consider the rollicking invective the figures of speech in this poem by Pamela Alexander (b. 1948) conjure up:

Look Here

Next time you walk by my place
in your bearcoat and mooseboots,
your hair all sticks and leaves
like an osprey's nest on a piling,
next time you walk across my shadow 5
with those swamp-stumping galoshes
below that grizzly coat and your own whiskers
that look rumpled as if something's
been in them already this morning
mussing and growling and kissing— 10
next time you pole the raft of you downriver
down River Street past my place
you could say hello, you canoe-footed fur-faced
musk ox, pockets full of cheese and acorns
and live fish and four-headed winds and sky, hello 15
is what human beings say when they meet each other
—if you can't say hello like a human don't
come down this street again and when you do don't
bring that she-bear, and if you do I'll know
even if I'm not on the steps putting my shadow 20
down like a welcome mat, I'll know.

What a ride this poem gives us. Is it about a woman who has been rejected by a man for another woman (a "she-bear") and now is delivering a tirade against him, calling him inhuman for his oafishness and boorishness? Such a reading is legitimate but narrow; it doesn't begin to appreciate the pleasure the poem gives us, seeing this "you" with hair "like an osprey's nest," a stinking "musk ox" with "pockets full of cheese" and "live fish." Such inventiveness seems soothing almost, as if the power of

metaphor can redeem the angry speaker. Though she may be incensed by this man, she hasn't lost her sense of fun.

Classical rhetoricians list scores of figures of speech with which we needn't concern ourselves; a few common ones, however, are worth particular attention. The first two, metonymy and synecdoche, involve substitution. In **metonymy** we substitute one thing for something *associated with* it: "The White House was in a panic"; "The alarm clock drags her from bed." In his poem "Out, Out" (p. 69) Robert Frost deftly expresses the boy's desperate attempt to save himself by describing his holding up his arm, "to keep the *life* from spilling"; by substituting "life" for "blood" Frost emphasizes what's at stake. In **synecdoche** we substitute *a part for the whole or a whole for the part:* "The hired hand dug the potatoes"; "I drove my mother's wheels to the beach"; "There wasn't a dry eye in the house."

Through synecdoche and metonymy in "I heard a Fly buzz," Emily Dickinson (1831–1886) suggests a family who has gathered around a deathbed but whose tears and cries offer little comfort for the person dying.

> I heard a Fly buzz—when I died—
> The Stillness in the Room
> Was like the Stillness in the Air—
> Between the Heaves of Storm—
>
> The Eyes around—had wrung them dry 5
> And Breaths were gathering firm
> For that last Onset—when the King
> Be witnessed—in the Room—
>
> I willed my Keepsakes—Signed away
> What portion of me be 10
> Assignable—and then it was
> There interposed a Fly—
>
> With Blue—uncertain stumbling Buzz—
> Between the light—and me—
> And then the Windows failed—and then 15
> I could not see to see—

The relatives in the room (lines 5–6) are only "Eyes around" (synecdoche) and "Breaths" (metonymy) as if the speaker cannot, or doesn't wish to, see the grievers individually. The family and speaker anticipate the moment of death, a moment of revelation, "when the King / Be witnessed—in the Room." Whether the "King" is God or simply death, they all expect a momentous apotheosis, but only a fly, that insect associated with carrion, appears.

We see an example of a third figure of speech in the speaker's conflating the visual with the aural as the fly knocks around the room "With Blue—uncertain stumbling Buzz." This is **synesthesia:** the perception, or description, of one sense mode in terms of another, as when we describe a voice as velvety or crusty. Other elements

suggest the speaker's failing senses. Though a tiny creature, the fly "interposes" "Between the light—and me." In line 15, as the speaker tries to account for her loss of sight, she psychologically transfers the cause outside herself, blaming the "Windows," reporting they, not her faculties, "failed."

The final line records the still flickering consciousness inside the already senseless body before it, too, goes out like the speck of afterlight on a television screen: "I could not see to see—." The final dash suggests the breaking off of awareness, without resolution. The grand expectation of "the King" has been cut off by the merely physical obliteration of consciousness. The dying speaker never understands—or at least can't voice what she sees, or does not see.

Within their context words fit somewhere on a scale between the purely literal and the purely figurative. If in a casual conversation, you say, "I need more light to read this report," you are speaking literally. If however you say, "After I read the report, I saw the light about world hunger," you mean *light* figuratively, as *comprehension*. In Dickinson's poem she uses "light" literally and symbolically. The light is the actual light in the room coming from the windows, as well as the light of understanding, and the light of spirituality and divinity. The interplay of meanings, together with associated images ("eyes" and "windows"—eyes have been called the "windows of the soul"), create a poem both direct and dense which explores fundamental issues of epistemology and metaphysics—all in sixteen lines.

Poems that are wholly literal, that operate only on a literal level, often seem thin. Reading a poem that merely describes a dress ("An empire waist with a mother-of-pearl bodice and a gathered train of Belgian lace . . ."), we're likely to shrug and say, "So what?" (What about the lost opportunity, the "empire," "mother," and "train" embedded in the description?) In the same way, poems that operate wholly on a symbolic level often seem overblown and trite. Reading a poem that declares a passionate love with tired formulas ("My heart is a dove soaring in clouds of happiness"), we're likely to flinch and say, "Give us a break."

Even in highly symbolic poems like "I heard a Fly buzz" the images let us respond to something real; we can *see* and *hear* a buzzing fly. Elements of Dickinson's poem—*light, fly, seeing, windows*—can operate as **symbols** (they represent something else), but these symbols are grounded in, are a natural part of, the scene. The common housefly might be said to be a symbol of death, but its presence is also perfectly fitting. How ludicrous—and obvious—the appearance of other death symbols would be: a turkey vulture perching on the windowsill or the branches outside the window forming a skull and crossbones. The one figure not grounded in the scene, "King," sticks out, emphasizing the speaker's and grievers' high-flown expectations.

Though it must be apt, a symbol can be generalized and still be powerful as is the jar in Wallace Stevens's "Anecdote of the Jar" (p. 73) and the masks in this poem by Paul Lawrence Dunbar (1872–1906).

We Wear the Mask

We wear the mask that grins and lies,
It hides our cheeks and shades our eyes,

This debt we pay to human guile;
With torn and bleeding hearts we smile,
And mouth with myriad subtleties. 5

Why should the world be overwise,
In counting all our tears and sighs?
Nay, let them only see us, while
 We wear the mask.

We smile, but, O great Christ, our cries 10
To thee from tortured souls arise.
We sing, but oh the clay is vile
Beneath our feet, and long the mile;
But let the world dream otherwise,
 We wear the mask! 15

Dunbar investigates the manifold nature of the mask: It deceives onlooker and wearer; it hides the true self beneath it and hinders the wearer's abilities—it "shades our eyes"—all the more critical to repeat "mask," to declare that the smiles and songs hide tears and sighs. Knowing that Dunbar, the son of slaves, lived during a time of lynchings and the intensification of Jim Crow laws, we may infer that the poem is about the African-American experience, but the symbol of a suffering group masking its pain is universal.

A poet will find plenty of symbols in the material at hand—like Dickinson's light and fly, the snow and ice in "First Death in Nova Scotia"(p.152), and the menace of cats to express the girl's rage in "Kitten" (p. 180). Just about any image can act as a symbol, but don't get carried away. As Freud said, sometimes a cigar is just a cigar.

A Name for Everything

Language itself is deeply metaphorical. We speak of *the eye* of a needle, *the spine* of a book, the *head* and *mouth* of a river (which are oddly at opposite ends), a flower *bed*, of *plunging* into a relationship, of *bouncing* a check, or of *going haywire*, without thinking of the buried metaphors—of faces, bodies, sleeping, swimming, or the tangly wire used for baling hay.

Dead metaphors (which include clichés) show a primary way language changes to accommodate new situations. Confronted with something new, for which we can find no word, we adapt an old word, and soon the new meaning seems perfectly literal. The part of a car that covers the engine, for instance, is a hood. On early cars, it was in fact rounded and looked very much like a hood; but the word survives, although now hoods are flat and look nothing like hoods. (They still cover the engines' heads.) Sometimes the perfectly literal becomes metaphorical. Actual trunks were strapped to the back of early automobiles, and the word survives, although now the trunks are built-in and we may forget their likeness to trunks in an attic. Such metaphors can be useful even after their sense has evaporated. We say someone is

"mad as a hatter" although there aren't many hatters around and the chemical which, in fact, often made them crazy is no longer used.

Without us, the world is wordless. Adam's naming the animals of Eden stands as archetype for one of humanity's greatest concerns: naming things so we can talk about them. We're not finished with our naming—and never will be. We still have no common words for many things, relationships, feelings, activities: a single filament of a spider's web, unmarried couples living together, the strange green light of a tornado, or the many appearances of the sea's surface. Reportedly, Eskimos have more than twenty words for snow; yet we make do with barely two or three. Translators often find no precise equivalent for the ways different languages notice and name the parts of the world. Whenever we invent something new, we find a new term or adapt an old one to express it—thus, the Internet, the World Wide Web, and surfing.

When a subject is abstract, such as the emotion in Emily Dickinson's "After great pain, a formal feeling comes" (p. 267), metaphor allows the poet to express in particular terms what would otherwise remain vague and generalized. Dickinson ends that poem with exacting metaphors to evoke a *particular* feeling:

> This is the Hour of Lead—
> Remembered, if outlived,
> As Freezing persons, recollect the Snow—
> First—Chill—then Stupor—then the letting go—

Feelings are especially inarticulate and require metaphor to be understood; through metaphor Dickinson expresses the feeling of deadness that follows "great pain." We get frustrated with the general words for emotions—love, hate, envy, awe, respect, rage—because they don't express our particular feeling, and it is precisely their particularity that makes emotions important to us. In our desire to say what we feel, we turn to metaphor, borrowing the vocabulary of other things—in Dickinson's case freezing to death—to say what there are no exact words for. With just a few elements in "Sir, Say No More," Trumbull Stickney (1874–1904) evokes a complex feeling of dread:

> Sir, say no more,
> Within me 'tis as if
> The green and climbing eyesight of a cat
> Crawled near my mind's poor birds.

The eerie sensation springs out at us, though a critic might work all day to untangle the threads the metaphor knots up so simply.

The classical Roman orator Quintillian praised metaphor for performing the supremely difficult task of "providing a name for everything." The more complex the issue, the more we need something else to explain it, as the double helix helps us understand DNA and the mobius strip relativity. Metaphors work in an amazing variety of ways (no catalog could be complete) and do an amazing variety of jobs. They may illustrate or explain, emphasize, heighten, or communicate information

or ideas; or carry a tone, feeling, or attitude. They may even work—Hart Crane's phrase is the "logic of metaphor"—as a mode of discourse, a sort of language of associations. In this poem, Molly Peacock (b. 1947) devises metaphors related to childhood to explore the relationship between anxiety, responsibility, and helplessness.

Things to Do

Planning and worrying and waking up
in the morning with items on the list
clanking like quarters in the brain's tin cup,
this and that and what you might have missed
or who pissed you off, suspends you in a state 5
that wishes and hopes for its goal like some
little one wiggling in a chair who can't wait
for when her legs will reach the floor. The numb
knockings of anxiety are like the heels
of sturdy little shoes steadily beating 10
on upholstery. It's how anyone feels
having been put into a chair, meeting
responsibilities from a padded perch
too big for anyone's ass. As monarchs
we make ourselves small and govern in search 15
of what we'll grow into. Except we are
as big as we'll ever get and have gone as far.

So accustomed are we to metaphor that we rarely appreciate how fully it serves. In Shakespeare's sonnet "That time of year thou mayst in me behold" (p. 34), for instance, metaphors provide almost the whole effect of the poem, translating emotions into sharp and dramatic particulars about winter trees, choirlofts, twilight, and embers. The metaphors virtually stand for or present the emotion. Like literal particulars, metaphors enrich the texture and color of a poem, as well as evoke a poem's complex of emotion.

Pattern and Motif

The distance between the two parts of a metaphor—between tenor and vehicle—between their connotations, gives metaphor its resonance. In the best metaphors the meeting of tenor and vehicle, like a small chemical reaction, creates a flash of recognition. Tenor and vehicle too closely related (the sun *is a star*) won't spark; metaphors too unrelated (the sun *is a tow truck*) may shimmer with their strangeness only to leave a reader in the dark. A metaphor must do more than flash and dazzle. It establishes a commitment that what follows the metaphor will be somehow connected with it. If the bauble metaphor continued, "The sun hung like a bauble stuck in the trees, its broken rockets / slippery as banana peels of the gods," the reader would begin to suspect the poet was only showing off; mere dazzle grows wearisome.

The unifying links, patterns, or motifs between and among the metaphors in a poem must be somewhat conscious on the poet's part. But it is probably a matter more of the poet recognizing and following along with possibilities than of cold-bloodedly inventing or imposing them. Often the poet need only perceive the potential pattern in the material, and as the poem develops, explore its possibilities. In this way metaphor can help a poet think. Consider this poem by Hart Crane (1899–1932):

My Grandmother's Love Letters

There are no stars tonight
But those of memory.
Yet how much room for memory there is
In the loose girdle° of soft rain.

There is even room enough 5
For the letters of my mother's mother,
Elizabeth,
That have been pressed so long
Into a corner of the roof
That they are brown and soft, 10
And liable to melt as snow.

Over the greatness of such space
Steps must be gentle.
It is all hung by an invisible white hair.
It trembles as birch limbs webbing the air. 15

And I ask myself:

"Are your fingers long enough to play
Old keys that are but echoes:
Is the silence strong enough
To carry back the music to its source 20
And back to you again
As though to her?"

Yet I would lead my grandmother by the hand
Through much of what she would not understand;
And so I stumble. And the rain continues on the roof 25
With such a sound of gently pitying laughter.

4 *girdle:* a sash or belt

On a rainy night in an attic the speaker has come upon his grandmother's love letters. Notice how many ways—through similes, metaphors, images, connotations—Crane echoes what is tenuous, delicate, and precarious. The speaker's tone, his

doubt about how he can cross the distance between his grandmother's intimate life and his own life, registers this delicacy.

The opening stanza creates a parallel between the stars that exist only in memory (for it is a rainy night) and the grandmother who lives on in the speaker's memory and in the love letters. Stars, of course, even on a clear night are themselves echoes, light that has traveled millions of light-years from its source; we know only what has reached us across great time and space.

Stanza 2 focuses the more general ruminations about memory to the care that entering the past requires. The closing phrase "liable to melt as snow," (line 11) makes the letters so frail that even touching them (body heat quickly melts snow) could destroy them, much less opening them up and reading them. "Frail," "delicate," "flimsy," "friable"—none of these adjectives satisfies as the simile does. Notice how much we lose if the line were to rely on the metaphor alone: "and liable to melt."

Picking up on the "room for memory" in the "loose girdle of soft rain" (rain also melts snow) of stanza 1 and linking it with the fragile letters of stanza 2, stanza 3 leads to the realization that "Over the greatness of such space / Steps must be gentle." These "steps" offer multiple resonances: They suggest the stairs to the attic; the speaker's footsteps in the quiet echoing space on top of the house, preparing for his stumbling in the last stanza; the stages in the process of remembering; and the tones and semitones—the steps—of the piano keys of stanza 5 (which, in turn, suggest keys that lock and unlock private spaces). The letters, themselves, serve as keys to the grandmother's intimate life.

Piano keys are also white, and images of whiteness underlie the poem, tying together its multiple strains. Starlight, of course, is white, and the comparison of the soft brown letters to snow evokes their original state as well—the white papers the grandmother once held in her hands. The "invisible white hair" that "trembles as birch limbs webbing the air" (lines 14–15) associates the delicacy of memory and the letters with the attic's fragile cobwebs, with birch branches (apparently glimpsed outside the window), with the quiet sounds in the attic, with the piano's remembered sounds (an "air" is also a tune), and with the color of the grandmother's hair—invisible now, except in memory. Through pattern and motif, Crane connects strength and delicacy, time and space, light and sound, distance and intimacy in a poem that itself subtly explores the nature of interconnections. At its best, metaphor not only creates connections but also celebrates them, as here Crane celebrates the fragile but persistent connection between himself and another generation, another era.

Metaphor says more in an instant than do pages of explication. Instantly, intuitively, the reader apprehends the pertinent elements and ignores the irrelevant. Our analysis of "My Grandmother's Love Letters" follows where intuition leads and enumerates the relevant qualities that Crane's metaphors suggest. But for any poem, the sum of the parts, however illuminating, rarely equals the effect of the metaphors as a whole.

In Sylvia Plath's famous simile "I eat men like air," we understand at once what the speaker, "Lady Lazarus," is claiming, but what goes into our understanding? Eating something suggests we have power over it, and perhaps that we have killed it (or

will when we eat it). Eating something "like air" further reduces it, making it incon-sequential, common, negligible. Air, as Plath uses it, takes on a different tone than "air" as Dickinson uses it in this stanza of "After great pain" (p. 267).

> The Feet, mechanical, go round—
> Of Ground, or Air, or Ought—
> A Wooden way Regardless grown,
> A Quartz contentment, like a stone—

The speaker's indecisiveness or indifference in settling on one metaphor—"Ground, or Air, or Ought— / A Wooden way"—dramatizes how "Regardless" intense pain makes its victim. Plath's speaker exudes boundless energy; Dickinson's is down for the count—her feet are earth or air or wood or obligation or nothing ("ought" is a variation of "aught")—she doesn't seem to know or care. Crane's phrase "webbing the air" can allude to music since he has woven musical metaphors into the poem's texture. In each occurrence of "air" we screen out qualities that might undermine the metaphor. We don't consider how eating air might make Lady Lazarus hiccup, or that Dickinson's "mechanical feet" might be musical (except as a dirge!), or that "air"—the space of the attic air—is unimportant or negligible.

As Crane's poem indicates, metaphors often exert subliminal power, creating a hidden network that holds a poem together. We see such threads in this poem by Dave Smith (b. 1942):

Parkersburg, W. Va.

> Along the river tin roofs
> the color of blood
> release little rivulets
> of greasy smoke,
>
> longjohns hang in the wind 5
> like loose-jointed ghosts.
> I can see the current
> herringbone
>
> against the blue slate rocks.
> I am told my grandfather 10
> used to come here.
> I toss someone's whiskey bottle
>
> to see it spread out like stars.
> No one notices this.
> I wonder if anyone remembers 15
> the day he fell.

The images—"tin roofs / the color of blood," "rivulets / of greasy smoke," long johns hanging "like loose-jointed ghosts," "I can see the current / herringbone," the break-

ing bottle that spreads out "like stars"—all function separately in meaning, but subliminal connections link them. That the scene literally includes the river makes the "rivulets" of smoke appropriate. The sense of linear connection of river and rivulets with the color of the also liquid "blood" points subtly toward the speaker's felt interest in his grandfather—who used to come to Parkersburg, where the speaker now finds himself. The grandfather's belonging to an earlier time somehow faintly links him to the present old-fashioned long johns on the laundry lines; and of course he is the particular "ghost" that haunts the speaker's awareness as he now views the place.

The cloth of the long johns and the "herringbone" pattern of the river's current seem related. And the falling whiskey bottle seems mysteriously to connect with the time the grandfather "fell" (line 16). The word "fell" itself may be either literal or metaphorical: perhaps literal in the sense of "fell down" (part of some undisclosed anecdote?), perhaps metaphorical in the sense of "fell in death." Thematic importance makes the latter seem likelier, given the poem's elegiac mood; and if so, the grandfather's dissolution in death and into eternity is picked up by and gives the emotional significance to the bottle crashing "like stars." We may not be wrong if we go so far as to think of the grandfather as a man who wore long johns and drank a drop in his day. These links or resonances among the metaphors give the poem its haunting unity. The speaker's feeling is equally unprovable, unresolved; the poem ends with questioning: "I wonder if anyone remembers . . .".

Conceits

When metaphors dominate or organize a passage or even a whole poem, we call them extended metaphors or **conceits.** Secondary metaphors and images spring from the first, controlling metaphor, as do metaphors of pioneers crossing the Rockies in Kate Gleason's "After Fighting for Hours" (p. 217) or the whole scene of a harbor at dawn in Robert Bly's "Waking from Sleep" (p. 220). In this poem by Mary Oliver (b. 1935) the extended metaphor controlling the whole poem identifies music with a brother "Who has arrived from a long journey," whose reassuring presence makes the flux and danger of the world—"the maelstrom / Lashing"—seem, for the moment, tamed.

Music at Night

Especially at night
It is the best kind of company—
A brother whose dark happiness fills the room,
Who has arrived from a long journey,
Who stands with his back to the windows 5
Beyond which the branches full of leaves
Are not trees only, but the maelstrom
Lashing, attentive and held in thrall
By the brawn in the rippling octaves,
And the teeth in the smile of the strings. 10

So compelling is the fantasy of the metaphor that it is impossible to say whether the trees outside the windows are part of the metaphorical description of the brother or part of the literal scene. The real and the imagined weave into one picture.

In this poem John Donne (1572–1631) urges his wife not to mourn their upcoming parting. Drawing from the most recent ideas in theology, geology, astronomy, and metallurgy, Donne describes how a calm leave-taking will prove the greatness of their love.

A Valediction: Forbidding Mourning

As virtuous men pass mildly away,
 And whisper to their souls to go,
Whilst some of their sad friends do say
 The breath goes now, and some say, No;

So let us melt, and make no noise, 5
 No tear-floods, nor sigh-tempests move,
'Twere profanation of our joys
 To tell the laity our love.

Moving of th' earth° brings harms and fears,
 Men reckon what it did and meant; 10
But trepidation of the spheres°
 Though greater far, is innocent.

Dull sublunary° lovers' love
 (Whose soul is sense) cannot admit
Absence, because it doth remove 15
 Those things which elemented° it.

But we by a love so much refined
 That our selves know not what it is,
Inter-assured of the mind,
 Care less, eyes, lips, and hands to miss. 20

Our two souls therefore, which are one,
 Though I must go, endure not yet
A breach, but an expansion,
 Like gold to airy thinness beat.

If they be two, they are two so 25
 As stiff twin compasses are two;
Thy soul, the fixed foot, makes no show
 To move, but doth, if th' other do.

And though it in the center sit,
 Yet when the other far doth roam, 30

it leans and hearkens after it,
　　And grows erect, as that comes home.

Such wilt thou be to me, who must
　　Like th' other foot, obliquely run;
Thy firmness makes my circle just, 35
　　And makes me end where I begun.

9 *Moving of th' earth:* earthquakes; 11 *trepidation of the spheres:* irregular movements in the heavens; 13 *sublunary:* below the moon; hence, subject to change, weak; 16 *elemented:* composed.

He compares their parting to the peaceful deaths of virtuous men, to the unharmful movements of the heavens ("trepidation of the spheres") in contrast to earthquakes, and to the fineness of gold leaf which, even when hammered to "airy thinness," never breaks. The poem's final image, a conceit, is yet more startling: He likens the lovers to a drawing compass! The whole world seems ransacked and brought to bear, to center, on these lovers, whose parting comes to seem as momentous as the metaphors that express it.

Part of Donne's accomplishment stems from how he manages to keep many subjects spinning at once without letting any drop at his feet. Not controlling or focusing the nuances of a metaphor can lead to a **mixed metaphor,** a metaphor that combines unrelated, even contradictory, elements as in this sentence's mixing of military, baseball, and artistic metaphors: "If we're to marshall our forces, we'd better swing at every pitch and try to etch our cause into their consciousness." Mixed metaphors often occur when the poet has not shielded the tenor-vehicle connection from qualities that are irrelevant or unintentionally off-key. "Your eyes are lakes, along whose edge a velvet green scum sparkles with insects like a jeweler's tray," for instance, is a howler. Too many things are happening at once; and though the jeweler's tray is a colorful image, the reader is all too likely to be misdirected into responding to the scum around the eyes. Or the trouble comes when elements of a metaphor are incongruent, as in "The feather of smoke above the cabin slowly flapped its wings and disappeared across the winter sky." A feather doesn't have wings, and we can't imagine the flapping of what does not exist. Eliminating the individual feather and making the first part of the image less distinct, however, might make it work: "The feathery smoke above the cabin slowly flapped and disappeared across the winter sky."

Metaphoric Implication

The simplest metaphors may work with an almost inexhaustible subtlety and often do much more than either poet or reader may be aware. Even metaphors that are essentially nonimages—muted echoes, vague, shadowy partial shots, soft superimposition, or momentary flashes to a different scene—can work on our imaginations. Consider Shakespeare's Sonnet 30:

When to the sessions of sweet silent thought
I summon up remembrance of things past,
I sigh the lack of many a thing I sought,
And with old woes new wail my dear time's waste:
Then can I drown an eye, unused to flow, 5
For precious friends hid in death's dateless night,
And weep afresh love's long since cancelled woe,
And moan the expense of many a vanished sight:
Then can I grieve at grievances foregone,
And heavily from woe to woe tell o'er 10
The sad account of fore-bemoaned moan,
Which I new pay as if not paid before.
But if the while I think on thee, dear friend,
All losses are restored and sorrows end.

Through connotation the main pattern of images presents a series of legal and quasi-legal terms: "sessions," "summon," "dateless," "cancelled," "expense," "grievances," "account," "pay," "losses," and "restored," which together suggest a court proceeding over some financial matter—keep in mind that in Shakespeare's time debts were jailable offenses. The implicit metaphors make for a complex tone: a certain judicial solemnity, an irrecoverable loss, some technical injustice, which the miraculous appearance of the "dear friend" overturns. This shadowy story exists more as a quality of the sonnet's diction than as overt metaphor, and yet accrues through a number of passing implications. The sonnet so delicately handles the argument that we are hardly aware of the source of the poem's legal mood. We see no definite courtroom and yet we feel the speaker's sense of relief—as though he'd been sprung from jail—when he thinks about his "dear friend."

When the speaker is someone other than the poet, metaphoric implication can allow the poet to explore the complexity of another consciousness without making the character seem overly self-conscious. Through her metaphors, the speaker in this poem suggests—rather than reports—the depth of her feelings and scope of her insight.

The House Slave
RITA DOVE (b. 1952)

The first horn lifts its arm over the dew-lit grass
and in the slave quarters there is a rustling—
children are bundled into aprons, cornbread

and water gourds grabbed, a salt pork breakfast taken.
I watch them driven into the vague before-dawn 5
while their mistress sleeps like an ivory toothpick

and Massa dreams of asses, rum and slave-funk.
I cannot fall asleep again. At the second horn,
the whip curls across the backs of the laggards—

sometimes my sister's voice, unmistaken, among them. 10
"Oh! pray," she cries. "Oh! pray!" Those days
I lie on my cot, shivering in the early heat,

and as the fields unfold to whiteness,
and they spill like bees among the fat flowers,
I weep. It is not yet daylight. 15

The metaphors depict the disparity between the powerful and the powerless while
folding in the implication that those in control have forfeited their humanity. The
opening metaphor—"The first horn lifts its arm"—reverses the normal order;
the horn controls the arm rather than vice versa, suggesting the bugler who calls
the slaves to work has submerged his identity in his job. At the second horn, "the
whip curls across the backs of the laggards"; violence so dominates this world that
this weapon has a life of its own.

While she presents the masters as destructive and static, Dove presents the slaves
as dynamic and productive. The sensual images associated with the slaves ("dew-lit
grass," "children . . . bundled into aprons," "cornbread," "water gourds," "salt pork")
put in relief the parasitic nature of the masters. The slaves rush about their cabins,
gathering their babies and provisions for the day, "while their mistress sleeps like an
ivory toothpick" and the "Massa dreams of asses, rum and slave-funk."

Look how much the toothpick simile implies. The mistress appears frail and brit-
tle and aligned with death, for though ivory is precious and white, it is also the prod-
uct of another massive exploitation of Africa. Also, by likening her to the negligible
luxury of an ivory toothpick, Dove equates the mistress with an ornament; her role
in the household pales against the active and vital slaves who "spill like bees among
the fat flowers."

The imagery helps articulate the sadness of the speaker's isolation and helpless-
ness. Though her position in the house seems to protect her from the toil in the
fields and suffering from the whip, it also shuts her off from human contact, shut in
the house associated with death. She cannot assuage her sister's or the others' pain,
nor can she ask for—nor would she ask for—comfort from them. She can only lie on
her cot, "shivering in the early heat," and listen to their cries. Dove closes the poem
with the speaker's quiet desperation, "I weep. It is not yet daylight." The lonely day
is still to come.

Questions and Suggestions

1. Make up as many metaphors or similes as you can for a common object
 (light bulb, fireplug, telephone pole, dandelion leaves, mailbox, shoe, cat's
 eyes, end of a leaf's stem where it connects to the twig, stars, or others).
 Develop the best in a poem.

2. A metaphor or simile has been omitted from these passages. What vehicles would you choose? (The poems in which these figures appear are in Poems to Consider.)

(a) [an icicle] Slender _____ of light.
(b) A drop of [my milk] is like a _____.
(c) [Sparrows'] tails like _____.
(d) the clock, a _____ nailed to the wall.
(e) Inside the veins there are _____ setting forth.

3. As a group or on your own, list about twenty concrete but common nouns in one column and about twenty active, present-tense verbs in another; for example: ladle, saunter, seed corn, crank, swim, cop, glaze, chain, truck tire, bloom, moon, hail, belittle, petunia, snare, flit, cup, trunk, score, swing, sewing machine, towel, clover. (Notice how many words can be either nouns or verbs.) Now, almost arbitrarily, draw lines to connect them, so that the petunia belittles the . . . , or the moon glazes the . . . , or hail blooms. What metaphors can you make? "Hail blooms like clover"? Try exploring the richest through a poem.

4. After reading a couple times Robert Burns's "A Red, Red Rose" (p. 221) and William Wordsworth's "She Dwelt among the Untrodden Ways" (p. 221), consider what their metaphors imply about the young woman each poem depicts. Try to answer these questions:

• Is she from the country or city?
• Does she prefer the indoors or the outdoors?
• Is she shy or outgoing? Quiet or fun-loving?
• What is her complexion? The color of her hair? Is she slight or robust?
• What kind of activities does she enjoy?
• In "A Red, Red Rose" are the musicians amateurs or professionals?

5. Study the qualities that link the tenors and vehicles in the poems that follow in Poems to Consider (p. 216–221). For instance, what about the sea does H. D. suggest by linking it with a pine forest? What about sparrows helps Christopher Buckley explore the poor and humble? What about relationships does the pioneer metaphor help Kate Gleason uncover?

Poems to Consider

Icicles

1978

MARK IRWIN*

Slender beards of light
hang from the railing.
My son shows me
their array of sizes:

one oddly shaped, 5
its queer curve,
a clear walrus tooth,
illumined, tinseled.
We watch crystal cones
against blue sky; 10
suddenly some break loose:
an echo of piano notes.
The sun argues
ice to liquid.
Tiny buds of water, 15
pendent on dropper tips,
push to pear shapes:
prisms that shiver silver
in a slight wind
before falling. 20
Look, he says laughing,
a pinocchio nose,
and grabs one
in his tiny hand,
touching the clear carrot, 25
cold to his lips.

Oread 1924

H.D. (1886–1961)

Whirl up, sea—
whirl your pointed pines,
splash your great pines
on our rocks,
hurl your green over us, 5
cover us with your pools of fir.

After Fighting for Hours 1995

KATE GLEASON (b. 1956)

When all else fails
we fall to making love,
our bodies like the pioneers
in rough covered wagons
whose oxen strained to cross the Rockies 5
until their hearts gave out trying,
those pioneers who had out-survived
fever, hunger, a run of broken luck,
those able-bodied men and women

who simply unlocked the animals 10
from their yokes, and taking
the hitches in their own hands, pulled
by the sheer desire of their bodies
their earthly goods over the divide.

◈ Suddenly I Realized I Was Sitting 1996

ELIZABETH KOSTOVA (b. 1954)

I was entirely—let me start again. I was entirely unsure how the situation. I
was entirely unsure how the situation arose out of nothing. As situations do.
First, you think you know people: Rose, Phil, that other acquaintance who
knows both of them. Then you're looking through them, through their
quirks—like handling a pen badly, complaining about minor illnesses, tip-
ping too little at restaurants because they can't do arithmetic. You're not
only seeing through them, but hearing through them, almost not hearing
them, almost not hearing what you're listening to. One is telling a story,
already too long a story for a short lunch. One is telling a story you've heard
before from another friend. Listening, looking, seeing through them as if
they are becoming transparent around the table, you are there but not pres-
ent to them, you are watching. Suddenly I realized I was sitting on a vol-
cano. First, the friends around me, then the situation looming up large and
solid, bulky under or beyond their insubstantial forms. And what is it? Rose
loves. No. Phil hates Rose from way back. No. You can't name it but it's
there, the volcano, the unloving or too-loving mass of situation. You'd make
a plot of it. Frightening, maybe, or dull or worth trying to describe, but
always something. Not always volcano. Not always. In this case, however, I
realized suddenly that I was sitting on.

◈ Sparrows 1986

CHRISTOPHER BUCKLEY (b. 1948)

Like the poor, they are with us always . . .
what they lack in beauty is theirs
in good cheer—tails like pump handles
lifting them first among songsters, chiding
citylight or roadside to evening's praise. 5
Gristmills, hardy gleaners, but for them
the weeds and thorns would find us wanting.
Ragmen to the wind, Sophists of the twig,
they pause to bathe in the ample dust
and accept the insect as relish to the seed. 10
So it is becoming to not be too fastidious
when you are rapidly inheriting the earth.

Those Men at Redbones° 1990

THYLIAS MOSS (b. 1954)

Those men at Redbones who call me Mama don't
want milk.

They are lucky. A drop of mine
is like a bullet. You can tell
when a boy has been raised on ammunition, 5
his head sprouts wire. All
those barbed afros.

Those men at Redbones who call me Mama want
to repossess.

One after the other they try 10
to go back where they came from.
Only the snake
has not outgrown the garden.

Redbones: a bar and poolroom

Children of Sacaton 1992

GREG PAPE (b. 1947)

I came to Sacaton to teach the children
metaphor—look at the clock, a moon
nailed to the wall, a madman's eye.
What I said was good for a laugh,
a puzzled look, or a *so what*. 5
I learned many ways to call the roll.
I fell in love with many faces.
Because I was a kind stranger
they told me their secrets, their fears,
their fathers. They showed me 10
the sleeping chief in the mountains.
See? There's his head, and there's his feet.
They explained Mul-Cha-Tha, the place
of happenings. Their mothers
made baskets, sang the old songs, 15
worked in Phoenix, or drank beer all day.
They already knew metaphor. They said
the wind is the long hair of the horse
I ride in the mountains. They said
the saguaros are the old people dancing. 20
If the sun gets hungry, one of them said,
you better look out.

Waking from Sleep

1962

ROBERT BLY (b. 1926)

Inside the veins there are navies setting forth,
Tiny explosions at the water lines,
And seagulls weaving in the wind of the salty blood.

It is the morning. The country has slept the whole winter.
Window seats were covered with fur skins, the yard was full 5
Of stiff dogs, and hands that clumsily held heavy books.

Now we wake, and rise from bed, and eat breakfast!—
Shouts rise from the harbor of the blood,
Mist, and masts rising, the knock of wooden tackle in the sunlight.

Now we sing, and do tiny dances on the kitchen floor. 10
Our whole body is like a harbor at dawn;
We know that our master has left us for the day.

The Release

1979

JOSEPH BRUCHAC (b. 1942)

At sunset
the shadows of all the trees
break free and go running
across the edge of the world.

Fireflies

1994

TED KOOSER (b. 1939)

The cricket's pocket knife is bent
from prying up the lid of a can
of new moons. It skips on the grindstone,
chattering, showering sparks
that float away over the darkened yard. 5

This is the Fourth of July
for the weary ants, who have no union,
who come home black with coal dust.
Deep in the grass you can hear them
unfolding their canvas chairs. 10

There is a pier that arches out
into the evening, its pilings of shadow,
its planking of breeze, and on it
a woman stands snapping the shade
of a lantern, signaling someone. 15

 ## A Red, Red Rose 1796

ROBERT BURNS (1759–1796)

O, my luve's like a red, red rose
That's newly sprung in June.
O, my luve's like the melodie
That's sweetly played in tune.

As fair art thou, my bonnie lass, 5
So deep in luve am I;
And I will luve thee still, my dear,
Till a'° the seas gang° dry.

Till a' the seas gang dry, my dear,
And the rocks melt wi' the sun; 10
And I will luve thee still, my dear,
While the sands o' life shall run.

And fare thee weel, my only luve,
And fare thee weel a while!
And I will come again, my luve, 15
Though it were ten thousand mile!

8 *a'*: all; *gang:* go

She Dwelt among the Untrodden Ways 1799

WILLIAM WORDSWORTH (1770–1850)

She dwelt among the untrodden ways
 Beside the springs of Dove,
A maid whom there were none to praise
 And very few to love:

A violet by a mossy stone 5
 Half hidden from the eye!
—Fair as a star, when only one
 Is shining in the sky.

She lived unknown, and few could know
 When Lucy ceased to be; 10
But she is in her grave, and, oh,
 The difference to me!

9

BEYOND THE RATIONAL

All the arts, poetry among them, are mysterious. Something essential to their power always remains elusive, beyond craft. Labor at it as the artist may, the best usually just comes, like the gushing up of the sacred river in Coleridge's "Kubla Khan."

The Greeks explained the magic through the Muses, nine goddesses who aid and inspire writers and musicians. The frustrations of writing and composing, of getting it right, led artists to consider these Muses fickle, difficult to please—they had to be courted and seduced. The Christian and Renaissance explanation of this magic was similar: inspiration (from Latin, "to be breathed into"). The divine wind blows where it will. The Romantic explanation was genius, some freak of nature or of the soul. Followers of Freud explain the magic through the subconscious, a bubbling up from hidden parts of the mind. The Spanish poet Federico García Lorca calls the magic the *duende*, a word common in his native Andalusia, but impossible to translate into English. Duende "furnishes us with whatever is sustaining in art." It comes to the artist, an old musician told Lorca, not from the artist's conscious control or native talents but "from inside, up from the very soles of the feet." Researchers into creativity have figured out that people who tend toward the arts free-associate more easily than those in science and technology, but these psychologists have still not figured out what qualities of the mind, or the brain, engender this ability.

The creative person, C. G. Jung says, "is a riddle that we may try to answer in various ways, but always in vain." The power remains unexpected and mysterious, even frightening. Randall Jarrell likens the magic of poetry to being struck by lightning. The poet may stand ready on high ground in a thunderstorm, but nothing guarantees the poet will be struck.

In their origins the arts were primitive and no doubt occult. Julian Jaynes, in *The Origin of Consciousness in the Breakdown of the Bicameral Mind* (1976), argues that poetry was originally the "divine knowledge" or "divine hallucinations" of primitive peoples. "The god-side of our ancient mentality . . . usually, or perhaps always, spoke in verse. . . . Poetry then" he adds, "was the language of the gods."

Word Magic

On the walls of their caves, Stone-Age people drew the beasts they hunted and the plants they harvested as if to gain some ineffable, ceremonial mastery over them. The oldest poems we have are the charms, prayers, spells, curses, and incantations that accompanied the magical rites of ancient cultures. For almost any human experience—from the sacred to the mundane—we can find a corresponding chant, dirge, prayer, or ditty. The words bless apple trees or warriors' weapons, clear up a boil, cast out demons, and drive off a swarm of bees. There are chants to sanctify the newly-weds' first bed, celebrate a birth, curse the rich and powerful, strengthen medicinal herbs, or send the dead safely to the next life.

Like the best poems, these magic-poems are precise. Cut from the particular world of the speaker, they fit the speaker's specific needs and longings. This chant, a shaman's address to the spirits, comes from Siberia; the original is in Yukaghir, a language of which only a few hundred speakers are left.

> You, owners of the green and trees, help me,
> Sea mother, who has as cover seven snow mounds,
> As bed, eight ice layers,
> As collar, black foxes,
> As foam, arctic foxes, 5
> As waves, cub foxes.
> Help me, sea-mother-owner.

The chant begins by invoking the spirits of "the green and trees," then turns to a specific power, the sea mother, honoring her by calling up images of the land she rules, the bitter but alluring cold, the foxes scurrying through forests. The chant's repetition and parallelism, probably memory aids, register its rising urgency, leading to the simple plea, "Help me."

The following literary example of a magic spell, from Shakespeare's *A Midsummer Night's Dream*, also conjures up a magic world. After a quarrel, the fairy king, Oberon, enchants his sleeping queen, Titania, so that she will fall for the first oaf she spots after waking.

> What thou seest when thou dost wake,
> Do it for thy true-love take;
> Love and languish for his sake.
> Be it ounce° or cat or bear,
> Pard,° or boar with bristled hair 5
> In thy eye that shall appear
> When thou wak'st, it is thy dear.
> Wake when some vile thing is near.

4 *ounce:* lynx; 5 *Pard:* leopard.

Oberon's spell prompts us to anticipate, to our great delight, what isn't on the stage, but will be shortly, in the person of Bottom, wearing the head of an ass. Though Oberon normally speaks in blank verse, befitting the dignity of his noble position, when he casts the spell he speaks in rhyme. The resonance of repeated sounds heightens the magic as with the words of the witches Macbeth encounters:

> Eye of newt, and toe of frog,
> Wool of bat, and tongue of dog,
> Adder's fork, and blindworm's sting,
> Lizard's leg, and howlet's wing—
> For a charm of pow'rful trouble. 5
> Like a hell-broth boil and bubble.
> Double, double, toil and trouble,
> Fire burn and cauldron bubble.

The word "spell" itself suggests how powerful words are. As part of the curative, ancient peoples often literally spelled out the charm—something like a physician's prescription. An old charm in England against rabies called for writing down the spell on a piece of paper and feeding it to the mad dog. As part of a magic formula, soothsayers often spelled out in a triangle the occult word "abracadabra," and so evoked the essential power of language, of the ABCs.

As with all kinds of magic, the first criterion of word magic is that those who wield it and those likely to be helped or harmed must believe in its power. On plantations in the antebellum South, according to John W. Blassingame in *The Slave Community* (1972), overseers and masters dealt very cautiously with the slaves they believed possessed magical powers. Shrewd men and women who convinced the masters of their power might avoid getting sold or whipped, or intercede for others threatened with punishment. Against the conjurer's magic even the strength of the oppressor could seem feeble.

In the 1930s the Federal Writers' Project, collecting narratives of former slaves, recorded this love-spell:

> Little pinch o' pepper,
> Little bunch o' wool.
>
> Mumbledy—mumbledy.
>
> Two, three Pammy Christy beans,
> Little piece o' rusty iron. 5
> Mumbledy—mumbledy.
>
> Wrop it in a rag and tie it with hair,
> Two from a hoss and one from a mare.
>
> Mumbledy, mumbledy, mumbledy.

Wet it in whiskey 10
Boughten with silver;
That make you wash so hard your sweat pop out,
And he come to pass, sure!

Apparently a former slave helped sustain himself during the lean times after the
Civil War by selling such spells. Oddly, the charm's ending seems off-rhythm, sug-
gesting perhaps either an error in transcription or in memory, or maybe that the man
deliberately gave the transcriber the wrong verse.

We resort to magic and prayer when science and human effort fail us. We have
better treatment now for rabies, but are at as much a loss as anyone who lived in Re-
construction Tennessee or Elizabethan England to understand why someone falls in
love with one person instead of another, and so we may still count off on the petals
of a daisy, loves me, loves me not. Rational and sophisticated as we like to consider
ourselves, at our most intense and puzzling moments—moments at the heart of po-
etry—words often remain our greatest solace.

Our most familiar believers in word magic are children. From the toddler chirp-
ing out "Pat-a-cake," to the older parodist sneering at authority, "Glory, glory, hal-
lelujah, Teacher hit me with a ruler," children love language. From generation to
generation, songs and charms are passed along because children believe in their
power. Children govern their groups with rhyme ("One potato, two potato, three
potato, four"); wish with it ("Star light, star bright, first star I see tonight"); threaten
with it ("See this finger, see this thumb? / See this fist, you better run"); and accuse
with it ("Liar, liar, pants on fire"). And when cornered, they make their defense,
"I'm rubber, you're glue / What you say bounces off me and sticks to you." Like all
preliterate peoples, children delight in words, find them powerful, fear and respect
them.

Though most don't like to admit it, adults aren't much different. Certain words
remain taboo, and though we all know them, we avoid them in public, and they
can't be printed in this paragraph. We use magical words in church, in court, and
when we quarrel. With pledges, oaths, and vows people become wives and husbands,
nuns, physicians, presidents, witnesses, and citizens. In uttering the words we cross a
threshold; we are not exactly the same person as before we pronounced them.

Good poems recognize the potency of words and draw upon it. Read again and
again over the years, the best poems seem magically fresh. Passing centuries often do
not dim this mysteriously self-renewing energy. Such poetry comes from, and keeps
us in touch with, a fundamental power deep within the human psyche, where dark
rivers from time beyond memory carve the stone. One source of this power is sound,
"the musical qualities of verse," what T. S. Eliot (1888–1965) calls the "auditory
imagination." It is, he says,

> the feeling for syllable and rhythm, penetrating far below the conscious levels of
> thought and feeling, invigorating every word; sinking to the most primitive and
> forgotten, returning to the origin and bringing something back, seeking the

beginning and the end. It works through meanings, certainly, or not without meanings in the ordinary sense, and fuses the old and obliterated and the trite, the current, and the new and surprising, the most ancient and the most civilized mentality.

The age-old forms of language itself, its glacial mass and electrical flash, give shape to every new thought and discovery in our consciousness.

Like sound, images tap into this power. They can reach beyond the rational to some magical apprehension deep in our personal and collective memories. Freudian symbols and Jungian archetypes, magic talismans, superstitions, and dreams seem outcroppings of this subterranean granite of human experience. So, too, is metaphor, with its inexplicable leaps, uncanny logic, and magical rightness. In "The Red Ant," transcribed about 1873 from the Paiute in Arizona, the anonymous poet's whole world view crystallizes in seeing the ant, with its one sting, as an exceptionally brave warrior:

> The little red ant
> Descended the hill
> With one arrow only.

Metaphors are often nonrational, though the best make a superior kind of sense; operating through analogical rather than through logical processes, they give us a way beyond linear thinking to apprehend.

Poets need not, perhaps should not, concern themselves too directly with the sources of poetry's magic. It is enough to know that when writing well we may tap into this energy as we flip on a light without considering how trees and animals eons ago drew energy from the sun, then dissolved into the black lakes and the frozen black rivers, which we now drill and mine, and from which, through dynamos and copper wires, ancient light arrives in the lamp on our desk.

The Sense of Nonsense

At times we may get so bogged down in pondering the imponderabilities of language that we forget what any nursery rhyme, like this one, reminds us.

> Bat, bat,
> Come under my hat,
> And I'll give you a slice of bacon;
> And when I bake,
> I'll give you a cake
> If I am not mistaken.

5

Nonsense is fun. Part of word magic stems from how often and how easily words give us pleasure without asking us to pay dues. A killjoy might ask why such incongruous images as "bat" and "bacon" appear in this verse. We're not irresponsible if we an-

swer simply: because the words *sound good* together. What a delight to be led along by the string of bat-hat-bacon-bake-cake-mistaken. All the more fun because the elements are incongruous. In a post-Freudian, post-Marxist era, theorists might reckon some hidden political and sexual agenda in phrases such as "the cow jumped over the moon" and "the dish ran away with the spoon." To such talk we're inclined to say, "Fiddle-de-dee." Here is a famous example of nonsense poetry by Lewis Carroll (1832–1898).

Jabberwocky

'Twas brillig, and the slithy toves
 Did gyre and gimble in the wabe;
All mimsy were the borogoves,
 And the mome raths outgrabe.

"Beware the Jabberwock, my son! 5
 The jaws that bite, the claws that catch!
Beware the Jubjub bird, and shun
 The frumious Bandersnatch!"

He took his vorpal sword in hand:
 Long time the manxome foe he sought— 10
So rested he by the Tumtum tree,
 And stood awhile in thought.

And as in uffish thought he stood,
 The Jabberwock, with eyes of flame,
Came whiffling through the tulgey wood, 15
 And burbled as it came!

One, two! One, two! And through and through
 The vorpal blade went snicker-snack!
He left it dead, and with its head
 He went galumphing back. 20

"And hast thou slain the Jabberwock?
 Come to my arms, my beamish boy!
O frabjous day! Callooh! Callay!"
 He chortled in his joy.

'Twas brillig, and the slithy toves 25
 Did gyre and gimble in the wabe;
All mimsy were the borogoves,
 And the mome raths outgrabe.

In *Through the Looking Glass* Humpty Dumpty tells Alice that "slithy" means "lithe and slimy," "mimsy" means "flimsy and miserable." And "toves" are "something like badgers . . . something like lizards—and . . . something like corkscrews" that "make

their nests under sundials" and "live on cheese." These definitions only heighten the absurdity.

Yet the story of "Jabberwocky" seems clear enough: A boy quests after the dreaded Jabberwock, slays it with his sword, and is hailed for his deeds. The story is archetypal, like the story of David and Goliath. An **archetype** is a general or universal story, setting, character-type, or symbol that recurs in many cultures and eras. Because the archetypal pattern comes across, we don't much concern ourselves with who the "beamish boy" is or that the "Jubjub bird" and "frumious Bandersnatch" still lurk out there. The reader recognizes the poem as a joyous celebration of, among other things, language: its inventiveness, its whimsical sounds, its Jabberwock that "Came whiffling" and "burbled as it came."

Nursery rhymes and poems like "Jabberwocky" are related to riddles, jokes, and other word games, reminding us of the deep roots that join poetry—and all of the arts—to play. After all, the more common word for a dramatic composition is a *play;* we *play* musical instruments, and literary devices like metaphors and puns *play* on words. The play of language allows the juxtaposition of all sorts of things from the palpably untrue to the delectably outrageous. The impossible happens. Grammatically, one noun can substitute for another so that "The cow jumps over the fence" becomes "The cow jumps over the moon." The cow can also "jump to conclusions" or "jump a jogger in the park." And if we're so inclined, the cow might "jump ship in Argentina on a silvery mission to choke the articulated artichokes of criminal post(age) stamps." The syntax of a sentence may seem to be clear while its meaning remains murky; the linguist Noam Chomsky once offered this example, "Colorless green ideas sleep furiously." Nonsense can undermine our confidence in language, and many other patterns we normally take for granted, and help us appreciate its inventiveness and mystery.

While creating art certainly requires work and we speak of the finished product as a work of art, we must also keep in mind that art grows out of play—goofing around, free-associating, seeing what happens next and next. If we read the following poem by James Tate (b. 1943) as a kind of game, we can avoid troubling ourselves too much about what it means and appreciate what it does—how it plays with patterns of words and phrases, shuffling them to create new patterns.

A Guide to the Stone Age
for Charles Simic

A heart that resembles a cave,
a throat of shavings,
an arm with no end and no beginning:

How about the telephone?
—Not yet. 5

The cave in your skull,
a throat with a crack in it,
a heart that still resembles a cave:

How about the knife?
—Later. 10

The fire in the cave of your skull,
a beast who died shaving,
a cave with no end and no beginning:

A big ship!
—Shut up. 15

Instructions which ask you to burn other instructions,
a circle with a crack in it,
a stone with an arm:

A hat?
—Not the hat. 20

A ship with a knife in it,
a telephone with a hat over it,
a cave with a heart:

The Stone Age?
—There is no end to it. 25

Notice, despite the strangeness of the poem, how shrewdly Tate manages its surface: twenty-five lines of alternating three- and two-line stanzas. Each stanza type serves a different function. The tercets offer a kind of list; the couplets a question and an answer. Each element in the first stanza reappears at least once in combinations with new items in the following tercets; for instance the parts of line 1, "A heart that resembles a cave," reappear in "The cave in your skull" (line 6), "a heart that still resembles a cave" (line 8), "The fire in the cave of your skull" (line 11), and then in the final tercet stanza, "a cave with a heart" (line 23). The last line reverses the order of the first line.

A colon closes each tercet and introduces the couplet which apparently proposes some item to be included (e.g., line 4: "How about the telephone?"); at first, each possibility (telephone, knife, ship, hat) is rejected; then in the final tercet all the rejected items are included in the first two lines while its last line rearranges the items of line 1. This stanza, unlike the others, uses only one method of creating the noun phrase: *Noun + with + noun + preposition + noun* in the first two lines, and in the last line, a simplification, *noun + with + noun*.

In the final couplet, the first line echoes the title, and the last line seems to comment on the poem: "There is no end to it" implies—among other things—that the process of combining and recombining could go on endlessly. This ending, of course, is part of the poem's playfulness, for the poem *does end* just at the point where it claims, "There is no end to it."

Throughout the poem, Tate takes care that we sense the poem's jocularity. The Abbott and Costello bantering in the couplets seems to come to a head with the central couplet (ll. 14–15). "A big ship!" the interjector proposes. And the respon-

dent, as if out of exasperation, rejoins, with a half-rhyme, "Shut up!" The deflation of the tone alerts us that we are not meant to take the whole poem seriously, despite its often grim imagery of warfare and brutality.

Perhaps besides word games Tate has intended other games. The poem also contains five three-line and five two-line stanzas; 5 is the sum of 3 + 2. The twenty-five lines of the poem is the product of 5 times 5, five fives; each five lines can read as a separate group. Five lines end with the word "it." The numbers 2, 3, and 5 form a sequence of prime numbers, the list of which is infinite.

The poem's meaning may be unclear but Tate's intentions aren't. The poem is a game. When a poem indicates we should approach it primarily as a puzzle, we begin to ask ourselves where the game begins and ends, if our sense of its rules are really its rules. Tate questions rules themselves. The "Guide" doesn't so much guide us as jab at the efficacy of any guide (much less one to a prelinguistic era). The poem seems to be an instance of "Instructions which ask you to burn other instructions," an unending cycle. By dedicating the poem to the poet Charles Simic, a surrealist realist or realistic surrealist, Tate ups the ante of the game.

Poems such as Tate's have an ancestor in the work of Gertrude Stein (1874–1946), an expatriate American who has been called the "Mama of Dada." Stein spent most of her adult life in Paris as a central part of that city's great artistic and intellecutal community; her circle included Pablo Picasso, Henri Matisse, Ernest Hemingway, Mina Loy, Djuna Barnes, and Alfred North Whitehead. She described her writing as a "disembodied way of disconnecting something from anything and anything from something." Here is a short poem that makes up a part of her larger "A Valentine for Sherwood Anderson."

What Do I See

A very little snail.
A medium sized turkey.
A small band of sheep.
A fair orange tree.
All nice wives are like that 5
Listen to them from here.
Oh.
You did not have an answer.
Here.
Yes. 10

Later in the "Valentine" Stein asks "Why do you feel differently about a very little snail and a big one?" emphasizing her concern with how words affect readers. In writing such as Stein's and Tate's, and in many more poems (consider Stevens's "Gubbinal" and Williams's "Red Wheelbarrow") words, phrases, images, and whole passages are used as objects for their tone and color, rather than for their representation or for their "meaning." They are analogous to abstract art where, for instance, a

streak of red seems to confront a field of green paint. Such paintings aren't about the realistic rendering of reality but about form, shape, color, perception, and paint itself. The poet John Ashbery (b. 1927), a proponent of experimental poetry, looks to music for an analogy of his purposes:

> I feel I could express myself best in music. What I like about music is its ability of being convincing, of carrying an argument through successfully to the finish, though the terms of this argument remain unknown quantities. What remains is the structure, the architecture of the argument, scene or story. I would like to do this in poetry.

In a poem called "What Is Poetry," Ashbery speaks of "Trying to avoid / Ideas, as in this poem." Just as we can string together a perfectly regular syntactic sequence with nonsense parts ("the cow crawled to conclusions"), so, too, poets like Tate and Ashbery can use the framework of argument without its logical components. As Paul Carroll suggests in an essay on Ashbery, "multiple combinations of words and images (islands of significance) continually form, dissolve, and reform." Since meaning is not fixed, such poems invite the reader to take center stage, to help create the poem.

Since the nineteenth century, the avant-garde has constantly scrutinized notions of "meaning" and "reality." One wave of experimentation has followed another, challenging the notions of some generations while adopting and adapting techniques of others to create their own innovations. (Some of the movements in poetry include Symbolism, Imagism, Modernism, Surrealism, Dadaism, Futurism, Objectivism, Projectivism, Post-Modernism, Beat poetry, the New York School, and Language poetry.) By tapping into the potential of language, poets can suppress the ordinary conscious workings of the mind and allow the profound, subliminal effects of sound, images, and metaphor to confront the reader directly—without a concern for a poem's explicit "meaning." Eliot describes the assumptions behind such poems:

> The chief use of the "meaning" of a poem, in the ordinary sense, may be (for here . . . I am speaking of some kinds of poetry and not all) to satisfy one habit of the reader, to keep his mind diverted and quiet, while the poem does its work upon him: much as the imaginary burglar is always provided with a bit of nice meat for the house-dog. This is a normal situation of which I approve. But the minds of all poets do not work that way; some of them, assuming that there are other minds like their own, become impatient of this "meaning" which seems superfluous, and perceive possibilities of intensity through its elimination.

Eliot's *The Waste Land* is an early example of experimental poetry; it challenges meaning by suppressing the "habits" of narrative and logical argument in favor of a succession of characters, voices, scenes, fragments of scenes, images, quotations, allusions, and snippets; it is as much about itself as an object as about some other "subject."

Metaphors of Experience

Among its more ordinary—even traditional—functions, the nonrational in litera-
ture breaks down the barriers we usually erect between the normal and abnormal,
the logicial and illogical, the real and imaginary. By exploring what lies outside our
normal experience we can more closely examine what lies within it.

In the following poem, Dara Wier (b. 1949), uses the archetype of the journey to
play with the nature of contradiction:

Daytrip to Paradox

Just as you'd expect
my preparations were painstaking
 and exact. I took two

butane lighters and a cooler
 of ice. I knew the route 5
had been so well-traveled

 there'd be a store for necessities
and tobacco and liquor and axes.
 And near the Utopian village of Nucla

 three Golden Eagles watched me 10
from a salt cedar tree. One of them
 held its third talon hard in the eye

of a white Northern Hare. Audubon
 couldn't have pictured it better.
 Everything was perfect. Naturally 15

 it made me think of Siberia,
the bright inspirational star
 that's handed down the generations,

and the long, terrible nights
 of the pioneers' journey to paradise. 20
The valley on the way to Paradox

 was flat, there would be no choice,
nothing to get me lost.
 Cattleguards, gates and fencing

bordered the open range. Of course 25
 I crossed a narrow bridge
 to get into Paradox proper.

 In the store that doubled
as town hall and post office
 there was an account book for everybody 30

laid square on the counter.
 No one was expected to pay
 hard cold cash in Paradox apparently.

As we might expect, much in Dara Wier's poem makes sense in reference to **para-dox,** a contradictory—but true—statement. We recognize that the poem's journey is metaphorical; in order to arrive at Paradox we must be able to get past contradic-tions that seem to trip us up. Akin to the logical qualities of a paradox, the speaker's preparations are "painstaking / and exact," and yet they seem to consist of taking only "two / butane lighters and a cooler / of ice." But perhaps she needs them for the "tobacco and liquor" she will apparently pick up at the store, which strangely doesn't consider lighters or ice "necessities." She declares that the journey's scenery (which includes a Golden Eagle with its "third talon hard in the eye / of a white Northern Hare") "was perfect" then tells us it made her think of Siberia. Of course, eagles and hares fit *perfectly* in Siberia. The valley is, oddly, flat; and, paradoxically, "Cattle-guards, gates and fencing" define "open range." A "narrow bridge" leads to "Paradox proper," *proper* as if it were a large town, and *proper* as if narrowness were the correct approach to such an odd place.

The speaker seems appropriately skeptical. It's only a "daytrip." Nor does she seem persuaded by what she finds: "No one was expected to pay / hard cold cash in Para-dox apparently." By connecting the sounds of the final two words, "*Paradox appar-ently,*" she registers skepticism. What seems to be *apparent* is that Paradox deceives.

Wier presents the poem in three-line stanzas, but of four differing shapes. The pattern of indentations of stanza 1 is repeated in stanzas 6, 8, and 10; that of stanza 2, in stanza 7; that of stanza 3, in stanza 4; and that of stanza 5, in stanzas 9 and 11. The appearance is of logical order, exactness, but the differing stanza patterns fall in place more or less randomly. They seem to point now right (stanzas 2, 7), now left (stanzas 3, 4, 6, 8, 10), and often both ways or neither (stanzas 1, 5, 9, 11). The shift-ing pattern is never resolved; the impression seems finally to be, if logical, of a jan-gled logic, going every which way at once—suggesting the poem's judgment on paradox.

While Wier's poem shows us how the imaginary can help explore logical issues, in the following poem we see the imaginary used to explore the emotions.

Ministering Angels
SUSAN PROSPERE (b. 1946)

When I saw the pony in June, she was dressed
for a different climate—something nearer
her ancestral beginnings (she was Welsh)—
for she had rounded the great climacteric turn
that left her hormones delicately imbalanced
and her eyes were misted over
as if the Atlantic Ocean had raised its tide
over the Welsh coast until it took her.

5

She would drink from the porcelain bathtub
in the pasture long drafts of invisible water, 10
then would stand for hours in the kudzu,
enveloped in its dark contagion,
while the horseflies drilled,
until they were dizzy, after her.

All one day I worked to remove the coat 15
she no longer discarded in the ardent weather.
I sheared her, lacking shears, with scissors,
operating them with blistered fingers
until they moved automatically, flashing
over her body like bright, clacking stars. 20
The tufts of hair falling around her
accumulated into a dark, furred shadow
that repeated her strange predicament
and would stay on the ground to remind us,
when she left, of the way 25
we collapse downward before rising.

So I willed her alive,
at least for one more evening,
the ministering angels walking all night
beside her through the orchard, 30
explaining the lie of the next strata,
while occasionally pulling down for her,
from the trees, the phosphorescent pears.
Before morning, having earned their rest honestly
through good works, they draw a bath 35
in the outdoor tub and bathe in the open,
relishing the high, post-Victorian moment,
having stayed on earth long enough to remember.

Prospere reports that the angels appeared in her poem not because she believes in the actual existence of these supernatural beings; rather, they grew out of the poem's metaphoric matrix—metaphors of the incongruous. The angels are as out of place as the bathtub (an image of the domestic and private) which serves as a drinking trough in the pasture, and as out of place as the aging Welsh pony, no longer able to shed her heavy coat, living out her last days on the family farm in sweltering Mississippi. As she was writing the poem, Prospere says she asked herself what would "bathe in the open" in such a bathtub, and concluded angels would. Such angels seem fitting ministers to the aging pony whose furred shadow recalls "the way / we collapse downward before rising."

The grandeur of Prospere's diction allows this celestial visitation to seem possible. Phrases like "the great climacteric turn," "dark contagion," and "the high, post-

Victorian moment" support an attitude of ceremony and solemnity that underlies the poem. Metaphors that liken the pony's cataracted eyes to the Atlantic raising "its tide / over the Welsh coast" and the scissors to "clacking stars" help imagine a universe where massive forces are played out on the local level of the farm, where a minor creature might be attended by angelic ministers.

The angels themselves act like "metaphors" for the speaker's feelings; they figure her desire for a kind of heaven-on-earth for the aging pony: she wills the pony alive "at least for one more evening," when the ministering angels will feed her the also-dying "phosphorescent pears" dropping in the orchard.

Mind Dreams and Body Dreams

Our most everyday—or "everynight"—experience of the nonrational is dreams. In dreaming we seem to translate our conscious experiences and obsessions into a host of symbols and situations. While immersed in a dream, we find these symbols highly charged, but when we wake and our conscious mind tries to sort through them, we often are baffled by them while still feeling their deep relevance. The simple acts of falling asleep or waking up remind us that at times we exist simultaneously on more than one plane of consciousness. Look back to Frost's "After Apple-Picking" (p. 125) and notice how in "drowsing off" the speaker loses the distinction between the day-world of the fruit harvest and the coming dream-world where the "magnified apples" loom in his mind; reality becomes dreamy and the dream becomes real.

Usually we use our senses to test whether what we are experiencing is really happening. "Pinch me," we say when something seems too marvelous to believe. But our senses don't always tell the truth. Optical illusions prove that. In our dreams we can experience sensations of waking life without them really happening. A dream experience can be so convincing and a waking experience so strange that we might ask, as Keats does at the end of "Ode to a Nightingale," "Do I wake or sleep?"

In this passage from his 1855 *Leaves of Grass*, Whitman captures the frantic energy and the wild confusion of dreams where the divisions between the real and unreal break down, and weird, often erotic, images erupt in our heads:

> O hotcheeked and blushing! O foolish hectic!
> O for pity's sake, no one must see me now! my clothes were stolen
> while I was abed,
> Now I am thrust forth, where shall I run?
>
> Pier that I saw dimly last night when I looked from the windows,
> Pier out from the main, let me catch myself with you and stay
> I will not chafe you; 5
> I feel ashamed to go naked about the world,
> And am curious to know where my feet stand and what is
> this flooding me, childhood or manhood and the hunger
> that crosses the bridge between.

The cloth laps a first sweet eating and drinking,
Laps life-swelling yolks. . . . laps ear of rose-corn, milky and just ripened:
The white teeth stay, and the boss-tooth advances in darkness, 10
And liquor is spilled on lips and bosoms by touching glasses, and the best
 liquor afterward.

Asleep and dreaming, we hardly question our fantastic experiences. Images and events blend seamlessly into one another. Poems like Whitman's operate through such a self-breeding series of associations: One image suggests another and the images in their sequence replace rational and discursive ways of saying something. When the method fails and the poet has not arranged the images so that a reader's responses follow them naturally, impenetrable obscurity results. When association succeeds, it produces poems of great compressive power.

We would be foolish to approach Whitman's dream-vision with only our rational minds, to look simply for its "meaning," for its meaning lies beyond interpretation; it lies within our response to the sensual, frenetic images piling atop one another and within the frenzied pace of its sentences. It recalls to us our own befuddling, even embarrassing, dreams where each element harbors a powerful significance, often a significance beyond our powers to define it. The force of Whitman's images seems primitive. The landscape is biological, perhaps even bio-"logical"; the self is alone, thrust out naked (how many of us have had similar dreams?) to contend with the mysterious pier, with slippery footing, and with the orgiastic imagery of yolks, milky rose-corn, teeth, and liquor.

In both our waking and dreaming lives our bodies act and react without our conscious control; this is perfectly normal. Our lungs expand and contract, our heart beats, our blood circulates, and our synapses fire. We're not aware of these autonomic responses until something out of the ordinary happens, and even then our bodies do most of their work outside our consciousness. After narrowly avoiding a head-on collision, you pull the car over to compose yourself: You realize your heart is pounding, your lungs are straining, your skin is sticky with sweat. However, you still aren't aware of the minute explosions at your nerve endings, for instance, or how your pancreas is operating. This immense nonconscious activity of our bodies—which constitutes what "being alive" literally means—forms the basis of this poem by Nina Cassian (b. 1924):

Ordeal
 Translated from the Romanian by Michael Impey and Brian Swann

I promise to make you more alive than you've ever been.
For the first time you'll see your pores opening
like the gills of fish and you'll hear
the noise of blood in galleries
and feel light gliding on your corneas 5
like the dragging of a dress across the floor.

For the first time, you'll note gravity's prick
like a thorn in your heel,
and your shoulder blades will hurt from the imperative of wings.
I promise to make you so alive that 10
the fall of dust on furniture will deafen you,
and you'll feel your eyebrows like two wounds forming
and your memories will seem to begin
with the creation of the world.

This poem's eerie power recalls primitive spells. On one level the poem seems to address someone in particular, for the intimacy of the tone implies that the speaker—whoever she is—in some way knows the person she addresses. The speaker promises to "make you more alive than you have ever been," a promise suggestive of the expansive claims a lover makes. On another level, of course, the poem addresses us.

Through metaphor and a form of synesthesia (a mixing of the senses), Cassian creates the ordeal, carrying us into a world so minute that the senses seem to merge, and we arrive at our very creation, as individuals and as a species. The speaker promises that the "you" will be able to see pores opening "like the gills of fish," hear the noise of blood, and feel—not see—the light as it glides across the cornea "like the dragging of a dress across the floor." By magnifying autonomic responses, the speaker seems to imply that the "you" will not only become acutely aware of the microscopic processes of the body but also feel a latent spirituality and realize that within our bodies we harbor the processes of creation itself. Line 9, ". . . your shoulder blades will hurt from the imperative of wings," implies that the aching is caused by one's need to be more than human, to be divine perhaps.

Surreality

A movement that began in France in the 1920s, **surrealism** often uses the dream as an analogy for the nonrational. Through the **surreal** (the artistic application of the unconscious) the unconscious free-associative, nonrational modes of thought (intuition, feeling, fantasy, imagination) put us in touch with a surreality, literally, a super reality. Surrealistic poetry merges the inner and the outer world, dream and reality, the flux of sensations or feelings and the hard, daylight facts of experience.

Surrealism has often been misunderstood as poetry and art where anything goes; one just puts down whatever pops into one's head. A careful look at the work of the great French Surrealists like André Breton and Paul Éluard tells us otherwise. Paul Auster notes that poems which stick to surrealism's ostensible principle of "pure psychic automatism" rarely resonate. Even poems like Breton's, which employ the most radical shifts and oddest associations, use "an undercurrent of consistent rhetoric that makes the poems cohere as densely reasoned objects of thought." In this poem notice how Paul Éluard (1895–1952) creates a nonrational poem that nevertheless employs familiar modes of logical argument. The first stanza poses a question, and the rest of the poem sets out to answer it.

The Deaf and Blind
Translated from the French by Paul Auster

Do we reach the sea with clocks
In our pockets, with the noise of the sea
In the sea, or are we the carriers
Of a purer and more silent water?

The water rubbing against our hands sharpens knives. 5
The warriors have found their weapons in the waves
And the sound of their blows is like
The rocks that smash the boats at night.

It is the storm and the thunder. Why not the silence
Of the flood, for we have dreamt within us 10
Space for the greatest silence and we breathe
Like the wind over terrible seas, like the wind

That creeps slowly over every horizon.

The phrase which Auster translates as "with clocks / In our pockets" (ll. 1–2) in the original poem is "*avec des cloches / Dans nos poches*," literally: "with bells in our pockets." "Cloche" means the large bell found, for instance, in a belfry; the French words for smaller bells are *clochette* and *sonnette*. We derived our English word *clock* from *cloche*; the earliest clocks—often placed on the town hall—rang out the hour. Sailors still use "bells" to measure time, and when we're "saved by the bell," we're saved by time running out (itself a phrase from the hourglass and its sands).

In trying to keep the sense, spirit, and sound of an original, translators of poetry must weigh literal meanings against considerations of connotation, idiom, form, sound, and rhythm. The translator's choice of "clocks" is shrewd. To the surrealists a poem's sounds often matter more than one particular meaning. "Clocks" permits an internal rhyme with "pockets," registering Éluard's internal rhyme ("cloches," "poches"), while retaining the absurdity and lucidity of Éluard's first image. Our pockets can't hold something as huge as a town bell (or a clock—we carry watches in our pockets), but on a metaphoric level we might carry along to the sea the weight of regulation and social order, which both town bells and clocks imply. As the scholar Richard Stroik points out, the French have a phrase for parochialism which makes this point: *esprit de clocher*, literally, "spirit of the bell tower." Part of the surrealist agenda is to strip away the layers of received social attitudes to create a fresh realization of language, self, and reality.

Éluard's poem doesn't so much dismiss the rational as transcend or absorb it. The question-answer structure suggests a rational approach toward understanding while the terms of Éluard's argument shift and change. For instance, the sea, the exterior and interior silences, and the flood seem simultaneously to refer to reality and to act as metaphors for our complex experience of that reality. In effect, Éluard makes us question the divisions between our rational and nonrational experiences of reality,

and between the reality that exists independently of our senses and the reality we know through our senses. The title helps posit these questions. We know the sea primarily through sight and sound, but how do the deaf and blind experience the sea? Isn't the sea to them different from the sea known by the sighted and hearing? When they touch it and feel its sharpness and coldness, might they think of knives? Yet, no matter who observes it, the sea is still itself; it exists apart.

The poem also suggests that we may be deaf and blind in a metaphoric sense—blinded and deafened by *a priori* knowledge, by preconceptions. Simultaneously the poem may imply a parallel, though inverse, reading: Is the knowledge we carry in ourselves "purer and more silent," perhaps more "real" than the reality we experience around us?

Our experience of reading the poem imitates what it seems to be about: the multiplicity, fluidity, and ultimate mysteriousness of physical and metaphysical existence.

Since the origination of surrealism in France, poets have widely adapted its strategies, allowing them to break free of the literal and rational so as to handle experience in fresh and surprising ways. Consider this metaphorical fantasy by Susan Mitchell (b. 1944):

Blackbirds

Because it is windy, a woman
finds her clothesline bare, and without rancor
unpins the light, folding it into her basket.
The light is still wet. So she irons it.
The iron hisses and hums. It knows how to make the best of things. 5
The woman's hands smell clean. When she shakes them out,
they are voluminous, white.

All night my hands weep in gratitude
for little things. That feet are not shoes.
That blackbirds are eating the raspberries. That parsley 10
does not taste like bread.

From now on I want to live
only by grace. In other words, not to deserve things.
Without rancor, the light dives down
among the turnips. I eat it with my stew. 15

Today the woman's hands smell like roots. When she
shakes them out, they are voluminous, green.
All day they shade me
from the sun. The blackbirds have come to sit in them.
Since this morning, the wind has been enough. 20

Instead of finding nothing on the clothesline, the woman discovers the something that does remain: the sunlight that dries laundry. "Without rancor" she seems

to decide to accept this light in terms of the laundry; she unpins it, folds it, feels its dampness, irons it. These actions, both simple and impossible, suggest a kind of mysterious truth to be gained from acquiescence.

The speaker, in telling the story of the woman (who perhaps represents a version of herself), also comes to a decision: "to live / only by grace. In other words, not to deserve things." Through juxtaposition, she likens this state of grace to the light that generously does its work, "dives down / among the turnips," gives us food, without resenting that it gets nothing in return. In the final stanza Mitchell extends the metaphors to offer a picture of peaceful acceptance: The woman's hands become the sheltering shade trees, resting places for the birds.

By blurring the lines between reality and the imagination, the nonrational poem can register that edge of consciousness where the mind creates its own truth. Sunlight is ironed and angels draw baths. Eyebrows are wounds, and hands weep. Like talking to ourselves, fantasy may express the deepest and most serious feeling; we reveal ourselves in daydreams no less than in sleeping dreams.

From the hypnotic power of magic spells and the enigmatic playfulness of nursery rhymes and experimental poems like Tate's "A Guide to the Stone Age" to the mysterious reasoning of "Blackbirds," poetry has always cast its buckets deep into the human imagination, below the strata of rationality and logic. The subliminal powers of rhythm, image, metaphor, and structure remain as ancient as language itself; the poet-shaman, the bard, is an ancient figure who still lives among us. Poems that bare themselves to the magic of the mind help us resee the ordinary work-a-day world we live in as the extraordinary place it is.

Questions and Suggestions

1. Imagine that you are a blade of grass, a thistle in a parking lot, a zipper, a brick in a chimney, a mountain, a basketball, or another inanimate object that occurs to you. What might you feel as that thing (consider sensations like the touch of air, ground, a hand)? What have been your experiences? What might you be aware of? Write a poem in the first person, speaking as that object. In this poem a potato speaks:

 ### Potato
 MICHELLE BOISSEAU (b. 1955)

 I don't want trouble, but the rutabagas
 and the turnips, especially the turnips,
 are muttering Ingrate, Upstart, and throwing
 me looks. Sheez, Louise. I'm hardly escarole.
 So I got lots of friends? I'm adaptable, 5
 a hard worker, and I don't ask favors.
 Put them in a basket and they're bitter,

put them in a pan, better be copper.
The butter's too pale, the pepper's too coarse.
On and on. With me if I'm forgotten 10
I turn extra-spective and gregarious.
I'm not called the Dirt Apple for nothing.
I stick my necks out at any warm chink
and grope for the garden on leafy legs.

2. Try your hand at a prayer, curse, blessing, spell, chant, or the like. Make it lively and vivid. Some of our students have had fun with "A Bride's Prayer," "A Spell against Geography," and "Gremlin's Hymn."

3. For a group. Each person takes a piece of paper and writes down a noun or verb—something concrete, sensual, resonant, like "plummet" or "biscuit." Pass your word on to the next person who writes down a word that rhymes or off-rhymes with the word, for instance "plunder" with "plummet" and "fist" with "biscuit." Next, fold the paper down so only the second word shows, and pass the paper on to the next person who writes a rhyme or an off-rhyme for it, folds the paper to allow only the last word to show, and passes it on. Continue until every person has written on every piece of paper. Now, using the words on one of the pieces of paper, each of you writes a poem. Don't try to make sense, but make it sound good. Read over your poem. Does it have anything to do with whatever else you've had on your mind? Take turns reading the poems aloud. Don't be surprised if the group falls into uncontrollable laughter.

4. Write a wild nonsense poem. Coin a few words, and see if a reader can gather a sense of what they mean.

5. For several nights try recording your dreams. Write down as much as you remember, paying particular attention to the imagery, but without question-ing it. Now in a sonnet or a sonnetlike poem (of roughly fourteen lines which includes a turn—a redirection—somewhere past the midpoint), work the images into a poem in which you are going about your normal life, walking through the supermarket, perhaps, or swimming laps at the pool.

6. Don Kunz at the University of Rhode Island informs us that the town of Paradox really exists; it lies in Colorado near the village Nucla. Its name comes from the Paradox Valley, a geologic oddity that was not formed by a river, but by a combination of rising and later collapsing salts. If you stew over the reality of Wier's poem again, does this information change the poem for you?

7. In Poems to Consider take into account the ways Wallace Stevens in "The Snow Man" and Rodney Jones in "Nihilist Time" play with the notion of negation, making something out of "nothing." Do you see echoes from Stevens's final line, "Nothing that is not there and the nothing that is," somewhere in Jones's poem? How has Jones explored "nothing"?

8. Look at the poems in Poems to Consider and consider what each poem's appearance emphasizes or de-emphasizes in its use of the nonrational. For instance, how does the orderly shape of the poems by Stevens, Jones, Phillips, Whitmore, Stewart, and Derricotte manage the material within the poems? What effect does the more ragged shape of "La Muerte, Patron Saint of Writers" and "My Dream of the Empty Zoo" have on their pacing? What does the blocky appearance suggest about "Goat" (p. 244) and "In the Madness of Love" (p. 248)?

Poems to Consider

The Snow Man 1921

WALLACE STEVENS (1879–1955)

One must have a mind of winter
To regard the frost and the boughs
Of the pine-trees crusted with snow;

And have been cold a long time
To behold the junipers shagged with ice, 5
The spruces rough in the distant glitter

Of the January sun; and not to think
Of any misery in the sound of the wind,
In the sound of a few leaves,

Which is the sound of the land 10
Full of the same wind
That is blowing in the same bare place

For the listener, who listens in the snow,
And, nothing himself, beholds
Nothing that is not there and the nothing that is. 15

Nihilist Time 1998

RODNEY JONES (b. 1950)

How stark that life of slouchy avoidance,
Thinking all day and all night of nothing,
Alone in my room with Nietzsche and Sartre.
Nothing is what I'd come from, nowhere
Is where I'd been, and I was nothing's man. 5

Nothing was the matter, I'd not answer
If no one asked, for nothing was the point,
And nothing the view I'd take on faith.

When I died, I'd not be as I had not been
Before I was born, with nothing for a name. 10

Meanwhile I'd cuddle in a vacuum with my abyss,
Whispering endearing stuff: "My darling
Emptiness, my almost electron, my blank pet."
Later with no one, I'd not celebrate
No event, for nothing was what I loved. 15

What I hated were people doing things:
Bouncing balls, counting, squirming into jeans
When oblivion waited in every ditch.
I could hear black motors not starting up,
And zeros going nowhere, nothing's gang. 20

My Dream of the Empty Zoo 1999

JANET RENO (b. 1946)

The empty zoo has done better than expected:
once the numbered gazelles had died,
we could serve lunch by the camel granges,
sell weekends in the caves where monkeys mated,
put shops in the eagle cages, 5
where the fatted feed-mice,
red at the throat,
once folded like neglected gloves.

Now tourists wade the turtle streams,
and, harps in the air, the iron cages 10
comb whatever winds may come to them
into sleek skeins of quiet.
Long, silent giraffe ghosts glide over
everything—the long thick grass,
the gates, the bus stop outside. 15

Vast cloud shapes, Hannibal's elephants,
park in the lots. No one is leaving
and no one arrives at the quarantine cages
for hoofed stock. But the old Europe clock
is a tourist attraction: 20
every hour, in circles,
an iron quartet of heron flies.

Goat 1998

ANDREW HUDGINS (b. 1950)

You who eat milled grain
may mock the acorn scroungers, mock
the acorn grinders, acorn eaters.
"See how their thin lips twist from chewing
the bitter fruit?" you say, you who've never seen 5
even the milled grain, even the soft
hot loaves shovelled from the oven.
You rip them apart and devour them
without a thought to where they come from,
your sustenance, your pure delight 10
arriving every morning with the dew.

You may mock, deride, despise those
who harvest acorns, shell them, pound them, eat
rough crumbling acorn bread. Mock us,
but not our god, the goat god. Ignore him, 15
pass by his shrines, neglect the gods
with secret names and bestial shapes,
and hunters stumble, horses pull up lame,
the scent hounds fight among themselves,
and your swollen daughters bleed obscenely. 20
Crops wither and collapse into the furrows.
Your woven garments rot and fall
from your white shoulders, which will burn
or shiver according to the season,
and soon you eaters of honied oat cakes 25
will once more, as we do, drape sheepskin
across your shoulders, and roam the farthest woods.
You'll offer in appeasement to the god
your death—thin, unacceptable children,
and you yourselves will eat the scorned offering 30
and with every bitter mouthful you will wish
you were eating at the sufferance of the oak,
wish you were gnawing harsh dry acorn bread,
wish you were choking on it, and not your own blood.

La Muerte, Patron Saint of Writers 1993

CLARISSA PINKOLA ESTÉS

Here buses rattle like buckets
of bolts; brake drums made stronger
by prayers to Santiago. The paint of these buses

regalo blue, cielo red, tierra y sanguine.
Up front Old Virgin Mother rides lookout, 5
and it is the law: all bus tires must be square,
all drivers must be certifiably blind,
all riders must have springs in their necks
and their ass cheeks.
The men wear their hats extra jammed on. 10
The women tie the live chickens together loosely
on purpose, just to make trouble. And the old
toothless one sags next to me. She has always
just eaten a tub of garlic, she has always just rubbed
her armpits and genitals with vinegar and goat cheese. 15
She is always leaning toward me, never away.
And I am always her seat mate, or that of her older sister
or her aged father. Always I am sitting thigh to thigh
with La Muerte. Now this La Muerte, this old one, laughs
maniacally at absolutely nothing, and over and over, 20
and always right in my face. Her breath fogs my vision, wilts
my hat brim, makes my nose cry. I work hard to stay by her,
to love her, love her cackle, love her odor, to love the pain
that I feel. If I can love her, if I can stand this pain,
of being near what others flee, 25
I will be able to write tonight,
and maybe for as long as a month.

Ah La Muerte, patron of las chupatintas, the pen-pushers,
you who only travel by bursting bus or teeming train or
broken car or bombed-out lorry, you who run 30
all over my page, screeching, "Catch me if you can,"
you who hide between the lines as though they are hedges,
peering over like some old baby in a macabre peek-a-boo.
Ah La Muerte, my love, my lover, pray for us, your writer children.
Give us all those acrid, sour, dour, and sickeningly sweet 35
smirks and smells, exactly the ones we need to write right.
Please, I beg you in all my authorial insanity, sit beside us
now and forever, fertilize our writing for ever and always
with the holy compost of your smiles.

Carry-On 1997

ROBERT STEWART (b. 1946)

> Men and women are two locked caskets,
> each of which contains the key to the other.
> —Isak Dinesen

My love's feet inside this suitcase
poke at my leg like bird beaks,
or bones with not enough meat.

No matter where I turn
she puts her feet at night; 5
and forgetful after goodbye

left them in my Alamo rental car.
At Baltimore Airport they were
nested between my own

soft-sides, rubbing their soles 10
in that long conversation
in which nothing is said.

The question is not do I have
her feet, but can I carry them.
A couple of wings and lighted toes. 15

Conception 1998

SUSAN WHITMORE (b. 1962)

There's pasta carbonara in bed
long after the lights go out in the rooms of the house:
we eat bacon, egg, fettucine sweaty and sexy,

sucking on the rind of the grated lemon, aged Parmesan,
and suddenly there's hunger again for that white 5
Cape Cod house seen from the other side

of Beaver Lake, its windows lit at dusk like golden eyes,
sight sprinkled into ribbons across the water
more yellow than the bright trail of moonlight,

and I'm sitting there with my brothers at the table 10
in summer night heat in the screened-in porch by lantern
playing gin rummy and drinking Black Label

as the eels begin to surface on the water with their
scaled and pointed heads and again my first lover
lays me down in Yundt's lily field, saying, 15

Don't expect music or violins, and I'm raising the flute
to my lips as the space in Franck's *Symphonie en D*
falls open for me and the whole orchestra waits

while my little sister holds her baby Andrea, swinging
the rag doll by its worn thin neck like a pendulum 20
in the sleepy grandfather clock in Dr. N.'s waiting room

where I wait until finally my unborn Robert runs me
through Amsterdam rain before breaking me in two
and gluing me back together as I lie on the white,

red, white Venray hospital bed: He comes to me 25
with open mouth and closed fists, fighting,
powerless and angry, bloody and not to blame.

X 1992

CARL PHILLIPS (b. 1959)

Several hours past that
of knife and fork

laid across one another
to say done, X

is still for the loose 5
stitch of beginners,

the newlywed
grinding next door

that says no one
but you, the pucker 10

of lips only, not yet
the wounds those lips

may be drawn to. X,
as in variable,

anyone's body, any set 15
of conditions, your

body scaling whatever
fence of chain-metal Xs

desire throws up, what
your spreadeagled limbs 20

suggest, falling, and
now, after. X, not

just for where in my
life you've landed,

but here too, where 25
your ass begins its

half-shy, half-weary
dividing, where I

sometimes lay my head
like a flower, and 30

think I mean something
by it. X is all I keep

meaning to cross out.

In the Madness of Love 1985

GARY SOTO (b. 1952)

Richard on the cold roof screams, I'm the eye
Of Omar, and a friend and I, with crumbs
Falling from our mouths, shout for him to get
Down, to remember that the rent is due
And it's no time to act silly. 5
Look, he says, and we look: a burst
Of sparrows. No, the clouds, he says,
They are coming. We plead with raisins,
Watery plums, but he's distant as the sky—
Dark with kites crossing over to rain. 10
We plead with a sandwich, car keys, albums;
Threaten him with a hose, our black neighbor
The drummer. No use. I climb on all fours
Over the roof, unsteady as a wobbly chair,
And when I touch him he shivers 15
Like a kicked dog. I take hold and rock him
In my arms, his jaw stiff with rage
And his eyes so wet we could drink from them
And be free. What is it? I ask.
There, he points. And the clouds begin to move. 20

In the Mountains 1997

TOI DERRICOTTE (b. 1941)

My beloved was afraid. There was nothing
to be afraid of. But my beloved would not
come out.

The mountains were the same, shivering
down their dirt bones. The sky
was the same, cloudless, and of such a
blue intensity.
 In the evening on the sill 5
there was a long bug that whipped its
body like a lash when my beloved closed
the window. Besides that, there
was nothing.
 There had been a word 10
that broke off in her like the slow
falling of an avalanche. There had been
a look that held up its hands.

I tried to comfort her, but my
beloved lay down in the 15
darkness and turned her head
from me, and she would not speak.

PROCESS
Making the Poem Happen

There is a pleasure in poetic pains
Which only poets know. The shifts and turns,
Th' expedients and inventions, multiform. . . .

WILLIAM COWPER, FROM "THE TASK"

10

FINDING THE POEM

How do you start a poem? Where does it come from? Like the confluence of streams into the headwaters of a river, many sources flow together to create a poem. Often these sources are hidden, subterranean, so difficult to trace that the poem seems to have sprung from nowhere. Wade into a river and try to pinpoint where its waters originated. Large concerns of form and content, and their specific applications in sound, rhythm, image, and metaphor, along with your memories and imagination come together to begin a poem and create a common momentum. Writing a poem involves finding something to say, and also finding a way to say it.

Many beginning poets start a poem out of a burning desire to express something in particular, to write about hot love's sudden coolness or global warming. The urge to write *about* something often gives the poet the first impulse. But poetry isn't primarily "about" something. If it were, a prose summary could fire us up as much as the poem. Though some subjects may seem worthier of a poem than others, it's not so much the *subject* that makes a poem a poem; it's the way the poet uses *language* and *form* to express the subject. Yes, it feels great to get off our chests what we truly care about. But to make someone else care, a poem has to move others through language. You might, for instance, get others to nod in agreement with you if you say a certain American writer's style annoys you, but you won't capture their attention as this poem does:

Reading the Late Henry James
NATASHA SAJÉ (b. 1955)

is like having sex, tied to the bed.
Spread-eagled, you take whatever comes,
trusting him enough to expect
he'll be generous, take his time. Still
it's not exactly entertainment: 5
Page-long sentences strap
your ankles and chafe your wrists.

Phrases itch like swollen bee stings
or suspend you in the pause
between throbs of a migraine, 10
the pulsing blue haze
relieved. You writhe and twist—
if you were split in half,
could he get all the way in?
When you urge him to move faster, 15
skim a little,
get to the good parts, he scolds,
"It's all good parts."
Then you realize you're bound
for disappointment, and you begin 20
to extricate yourself,
reaching past his fleshy white fingers
for a pen of your own.

Part of the fun of Sajé's poem, of course, stems from its irreverence for a master writer; another part stems from her playful language. She connects James's congested syntax with bondage and dashes off the puns that surface ("you realize you're bound / for disappointment"). Her poem also incites parallel questions. Then what is reading Gertrude Stein like? Or Ernest Hemingway? Or Jane Austen? Like the "you" of Sajé's poem, we can imagine reaching for a pen of our own.

As painters work with paint, and filmmakers with film, poets work with language— lucky for us our medium is plentiful and free. We feel our way into poems word by word, groping for the right sentence, the magic metaphor, and then the next—step by step, into the stream. But how do we get into language to begin a poem?

Imitation, Mentors, and Models

The best advice to a beginning poet is unquestionably: READ. No matter how much you've read, you probably haven't read enough. Often, most of the poems beginning poets have read are tame ones that passed muster with school boards or predictable lyrics of pop music that are supported by driving rhythms of drums, guitars, keyboards. But poetry isn't tame or predictable or dependent on an amplifier. Poetry is what disturbs, what disturbs through language. Not necessarily a wild disturbance, it may be subtle as a gust that sweeps over a pond and rattles the cattails. Your work as a poet includes knowing how other poets have used language; reading their works shows you new ways to use it. Nothing we or anyone else can tell you about poetry will mean as much to you as what you discover for yourself. We want to write poems in the first place because we have read poems that captivate us. Your notions of what poetry is, or what poems can do, come from the poems you know and admire. The more you know, the more you'll feel poetry's potential. There is, after all, no disgrace in having learned something from somebody. Without your being aware, you have

been influenced already by the multitude of voices you have read or heard. These may include an intoxicatingly strange line by Emily Dickinson as well as the entire jingling theme song to some sitcom you loved when you were a kid. The great danger is not in being too much influenced by powerful poems but in being too little influenced—fixing early or fanatically on a single mentor and clinging to that one voice, or finding the whole truth in one theory or another. Beware especially of theories: It is *poems* you want.

Get under your skin poems of all kinds, old and new, fashionable and unfashionable. Read Shakespeare, Keats, and Dickinson. Read Goëthe, Baudelaire, and Lorca. Read poems published this week. Poets experiencing the same world you do—with its X-games, children with tattoos, and gene coding—are just as essential as poets firmly situated in the literary canon. Don't read *just* what everyone else is reading. Search out poems of other ages and cultures too. Try the hidden corners and odd nooks. Browse. Sniff out.

What you are looking for are the poems and the poets that really speak to you, who as Emily Dickinson said, make you feel physically as if the top of your head were taken off. Find one poet you love, find another. Look their books up in the library, the bookstore, in *Books in Print*, on the Internet. Use the money you'd spend on a CD to buy their books. Memorize their poems, learn them *by heart*—with all that phrase's connotations. Make them part of your inner being, and you will gain what Robert Pinsky calls the "pleasure of possession—possession of and possession by" another poet's words. These poems will be your models, after which you'll fashion your own poems. Poets' secrets hide in the open, in the poems, and you needn't clean her brushes or tune his strings to apprentice yourself to the finest artists in poetry.

"Imitation, conscious imitation," advises Theodore Roethke, "is one of the great methods, perhaps *the* method of learning to write." Rather than being a problem, *imitation* is the inescapable route toward becoming a poet. College basketball players study the reverse layups of the pros. Medical residents stand at the elbows of surgeons. Architecture students crane their necks to take in the cornices of buildings around them. Apprentice poets read. As a student, you may write Dickinson poems, Yeats poems, Frost poems, Bishop poems, any number of other poets' poems. As you discover and absorb admiration after admiration, the influences begin to neutralize each other and naturally disappear. The poems you write will begin to be in your own voice, not in Ginsberg's or Plath's. Don't worry about finding your own voice. Like puberty, it will just happen.

A poet's deep admiration for other poems often takes the form of new poems; Homer inspired Virgil who inspired Dante who inspired Petrach who inspired Sidney who inspired Herbert who inspired Dickinson who herself inspired a couple generations of poets. Maura Stanton has taken up a song from one of Shakespeare's plays and written a similar song in contemporary terms (p. 130). William Logan's "Song" uses contemporary imagery for a new take on such songs (p. 129). Here, Donald Justice (b. 1925) pays his respects to "Piedra negra sobre una piedra blanca," a poem by the Peruvian poet César Vallejo (1892–1938):

Variations on a Text by Vallejo

Me moriré en Paris con aguacero . . .

I will die in Miami in the sun,
On a day when the sun is very bright,
A day like the days I remember, a day like other days,
A day that nobody knows or remembers yet,
And the sun will be bright then on the dark glasses of strangers 5
And in the eyes of a few friends from my childhood
And of the surviving cousins by the graveside,
While the diggers, standing apart, in the still shade of the palms,
Rest on their shovels, and smoke,
Speaking in Spanish softly, out of respect. 10

I think it will be on a Sunday like today,
Except that the sun will be out, the rain will have stopped,
And the wind that today made all the little shrubs kneel down;
And I think it will be a Sunday because today,
When I took out this paper and began to write, 15
Never before had anything looked so blank,
My life, these words, the paper, the gray Sunday;
And my dog, quivering under a table because of the storm,
Looked up at me, not understanding,
And my son read on without speaking, and my wife slept. 20

Donald Justice is dead. One Sunday the sun came out,
It shone on the bay, it shone on the white buildings,
The cars moved down the street slowly as always, so many,
Some with their headlights on in spite of the sun,
And after a while the diggers with their shovels 25
Walked back to the graveside through the sunlight,
And one of them put his blade into the earth
To lift a few clods of dirt, the black marl of Miami,
And scattered the dirt, and spat,
Turning away abruptly, out of respect. 30

Justice plays variations on Vallejo's composition—repeating phrases, syntax, images, and words—to create a reconciliation between a man and his death. Take a look at Vallejo's poem, considering how the poems are similar:

Piedra negra sobre una piedra blanca

Me moriré en Paris con aguacero,
un día del cual tengo ya el recuerdo.
Me moriré en Paris—y no me corro—
tal vez un jueves, como es hoy, de otoño.

Jueves será, porque hoy, jueves, que proso 5
estos versos, los húmeros me he puesto
a la mala y, jamás como hoy, me he vuelto,
con todo mi camino, a verme solo.

César Vallejo ha muerto, le pegaban
todos sin que él les haga nada; 10
le daban duro con un palo y duro

también con una soga; son testigos
los días jueves y los huesos húmeros,
la soledad, la lluvia, los caminos . . .

Justice's epigraph comes from Vallejo's first line, which can be translated, "I will die in Paris in a downpour"; Justice adapts the line to fit the circumstances of his imagination: "I will die in Miami in the sun, . . . A day like the days I remember." He imagines his death as a returning to his hometown, where the sun shines "on the bay" and "on the white buildings" whereas Vallejo imagines his death far from his native land; he will die a stranger. Eerily, Vallejo did die in Paris on a rainy day.

Vallejo's is a spare sonnet-length poem of two four-line and two three-line stanzas. Justice's is longer, denser in detail—three ten-line stanzas. Justice and Vallejo may not have written their poems all on a stormy day (or in Justice's case with his dog quivering under his feet), but it sounds as though they both came to a revelation about the day they would die after looking at a blank page. Both poems begin with the future tense and shift to the past tense about two-thirds into the poems, after the equivalent phrases, "César Vallejo ha muerto" and "Donald Justice is dead." Both poems repeat phrases that include the anticipated death day ("jueves" means "Thursday,") and the words *day* and *today* ("día" and "hoy").

Justice tells us that the grave diggers, who wait for the funeral party to be on its way, will speak the tongue of the Peruvian poet. Vallejo's spirit seems to preside over Justice's poem, and the repetitions help create the tone of an incantation—apropos for someone imagining his own, albeit sun-drenched, funeral. "Variations on a Text by Vallejo" illustrates how many streams flow together in a poem—one's imagination, intuition, ear for language, technical mastery, and knowledge of other poems.

Because reading other poets is such a powerful source of poems, many poets begin writing sessions by reading for an hour or so, or until some line, some image, some rhythm launches them into the mood of a poem's beginning.

We should make a distinction between imitations like Justice's "Variations" and **parody,** a deliberate, exaggerated imitation of another work or style. More loosely, parodies act as criticism which exposes weaknesses in the original; as Anthony Hecht's "The Dover Bitch" (p. 274) skewers Matthew Arnold's "Dover Beach" (p. 273). Writing a serious parody or an admiring imitation, following mannerisms of style (like Whitman's catalogues or Dickinson's breathless dashes) or of subject matter (like Frost's country matters), can let you explore another poet's technique or style. What, after all, makes Dickinson sound like Dickinson, or Frost sound like Frost? What makes an Elizabeth Bishop poem a Bishop poem?

Be careful of self-parody, the impulse when writing a poem to mock it, turn it against itself. Under the stress of trying to get your poem right, you may subconsciously feel tempted to deflate it, make it into a joke, annul your commitment to it. Be aware of this impulse; ask yourself what issues in the poem are making you uncomfortable and confront them in the poem.

Sources, Currents

You may begin with a firm sense of what you want to write about, where you want to go with your poem, but don't hold too tightly to these notions. Stay open to opportunities; allow early impulses to shift and meander. Maxine Kumin says, "You write a poem to discover what you're thinking, feeling, where the truth is. You don't begin by saying, now this is the truth" and then start writing about it. Often your first notions aren't the richest. They're merely the first. If you stick stubbornly to them, you may miss discovering a more tantalizing direction. Maybe you first thought of writing about falling out of a treehouse when you were ten. Don't let the treehouse keep you from bringing in the smell of honeysuckle or your aunt's red Mustang which you bled all over on the way to the emergency room. Perhaps you suddenly remember that your aunt pinched packages of saltines from restaurants to pass out to panhandlers in lieu of quarters.

Keeping yourself open to sources means also keeping your imagination open. We'll risk the obvious and say Justice doesn't *know* he'll die in Miami. He's not a clairvoyant, and Vallejo probably wasn't either. And unlike the reporter whose first loyalty is to the facts—accurately recording the details of an event—the poet's first loyalty is toward making the richest possible poem. Just because something happened a particular way in life doesn't mean it should happen that way in a poem. If your poem ultimately ends up celebrating the prosaic saltine cracker in crisp little rhymes, so be it. If falling from the treehouse keeps nudging you, you can bring it into another poem.

The power of this poem by Yusef Komunyakaa (b. 1947) may stem from the vitality of its sources, its openness toward many, even contradictory, ones:

Sunday Afternoons

They'd latch the screendoors
& pull venetian blinds,
Telling us not to leave the yard.
But we always got lost
Among mayhaw & crabapple. 5

Juice spilled from our mouths,
& soon we were drunk & brave
As birds diving through saw vines.
Each nest held three or four
Speckled eggs, blue as rage. 10

Where did we learn to be unkind,
There in the power of holding each egg
While watching dogs in June
Dust & heat, or when we followed
The hawk's slow, deliberate arc? 15

In the yard, we heard cries
Fused with gospel on the radio,
Loud as shattered glass
In a Saturday-night argument
About trust & money. 20

We were born between Oh Yeah
& Goddammit. I knew life
Began where I stood in the dark,
Looking out into the light,
& that sometimes I could see 25

Everything through nothing.
The backyard trees breathed
Like a man running from himself
As my brothers backed away
From the screendoor. I knew 30

If I held my right hand above my eyes
Like a gambler's visor, I could see
How their bedroom door halved
The dresser mirror like a moon
Held prisoner in the house. 35

Inexperienced, impressionable, time heavy on their hands, the boys can't sort out their emotions about their parents. They're shut out of the house and shut in the yard, stuck in the middle, between the intimate world inside the house and the dangerous world beyond the yard. They are powerless to enter either, though what holds them is flimsy: only a latched screen door and an admonishment to stay in the yard. And who has locked them out? Komunyakaa intensifies the power the parents hold over the children by identifying them only as "they": the others, the adults, the enemy.

Perhaps every detail here did not occur in Komunyakaa's childhood precisely as the poem lays it out. That's hardly the point. The details help to evoke the boys' pain and confusion. The image of the blue robin's eggs may have flowed into the poem from another day, another experience, and seemed relevant after he came up with the lines "We were born between O Yeah / & Goddammit"; the vandalism of the bird nests implies the boys' anger and confusion over their parents' vacillating intimacy and fights. In this emotional universe, feelings of entrapment spread; Komunyakaa ends the poem with the normally innocuous mirror becoming an impris-

oned moon. The simile implies that the boys—blinded by anger and confusion—can't comprehend what is really happening in the house.

In the early stages of a poem you naturally won't tap into all its potential sources, especially those hidden beneath the surface. The important thing is to cultivate a fluidity of vision, to remain receptive to everything. Let impressions, ideas, metaphors, half-forgotten memories, the rhythms of a well-loved poem flood into your poem to enrich your first notions and to surprise you—and your readers. As Frost put it, no surprise for the poet, no surprise for the reader.

When something you hadn't been expecting enters your poem, allow it to register, to grow and deepen. Don't be quick to judge it. The analytical mode is essential to making poems, but don't turn that part of your thinking on too early, lest it dry up your sources. The analytical breaks things down into parts. At this stage you want to pull things together. You want to turn on the part of your brain that says, "Why not try it?" In the earliest stages you want to synthesize, bring things together, not analyze.

Getting into Words

Whatever the sources, wherever it originates, the poem begins with a *given* in which the poet becomes aware of the possibility of a poem. Like the speck of dust that water molecules cling to in order to form a rain droplet, a poem needs a given, a speck around which impulses, words, memories can cohere. Sometimes the seed can be another poem—as with "Variations on a Text by Vallejo."

In looking for the "given" of a poem, many poets begin by writing randomly, setting down in a notebook (or on a computer or typewriter) whatever swims into their heads: phrases, rhymes, ideas, images, lists, weird words. Random writing can serve as a writer's practice work, just as the baseball player slugs away in the batting cage, or the pianist plays scales, or the painter sketches. In the free-play of the notebook, you can experiment with sentence rhythms, explore images, recollect scenes for future poems, try out new voices. Such open-ended writing can steer you toward more, and then more possibilities. Tracing out a particular image can lead you to details you had forgotten, to a new direction, or to a metaphor, perhaps, that sparks an explosion. Drawing a connection between two or more unrelated passages in your notebook might ignite the elements of a poem. In this poem, we might suspect, the poet seems to have arrived at his given when he connected a statement by another poet with the image of a wet dog:

To a Stranger Born in Some Distant Country Hundreds of Years from Now
BILLY COLLINS (b. 1941)

> *"I write poems for a stranger who will be born in some*
> *distant country hundreds of years from now."*
> —Mary Oliver

Nobody here likes a wet dog.
No one wants anything to do with a dog

that is wet from being out in the rain
or retrieving a stick from a lake.
Look how she wanders around the crowded pub tonight 5
going from one person to another
hoping for a pat on the head, a rub behind the ears,
something that could be given with one hand
without even wrinkling the conversation.

But everyone pushes her away, 10
some with a knee, others with the sole of a boot.
Even the children, who don't realize she is wet
until they go to pet her,
push her away
then wipe their hands on their clothes. 15
And whenever she heads toward me,
I show her my palm, and she turns aside.

O stranger of the future!
O inconceivable being!
whatever the shape of your house, 20
however you scoot from place to place,
no matter how strange and colorless the clothes you may wear,
I bet nobody there likes a wet dog either.
I bet everybody in your pub,
even the children, pushes her away. 25

The epigraph serves as the poem's motivating incident; combined with the wet dog in the pub it provides the poem's seed and part of the poem's good-natured fun. As we read the title, the epigraph, and then the first lines of the poem, we are momentarily suspended as we try to figure out how these elements are related. Part of our pleasure in the poem comes from our "Aha!", from our appreciation when the connection flashes before us: Even strangers in some unimaginable future will still shun a mundane wet dog. Drawing associations between seemingly unrelated notions can give you the controlling metaphor—the seed of the poem—which you can explore as you create the poem.

Consistent writing in a notebook—which Billy Collins calls "keeping a log of the self"—can get you in the habit of thinking in words and let you keep track of the streams that feed your work. Your notebook can be your resource collection where during busy times you can stash your ruminations until you have time to take a look at them. Then later, you'll have something to begin with instead of having that oppressive blank page staring back at you.

If you're hooked on a word processor and can't fathom going back to pen and paper, regularly print out hard copies of your jottings to ensure you won't lose them. Be generous. If you only print out what you deem worthy, you're letting your analytical mind have too much say too early. For the earliest, sloppiest stages of writing,

the notebook has many advantages: It's portable, quiet, always accessible, and no problem during a thunderstorm. Also, unlike the computer that obliterates deletions, the notebook allows you to reconstruct what you've crossed out.

In his book on poetry and writing, *The Triggering Town,* the poet Richard Hugo advises student poets to use number 2 pencils, to cross out instead of erase, and "to write in a hard-covered notebook with green lined pages. Green is easy on the eyes. . . . The best notebooks I've found are National 48-81." That's what worked for him, and every poet will find a particular system that feels right and swear by it—notebook, computer, index cards with a felt-tip pen. The beginning poet will want to experiment, drafting poems on the computer, with paper and pencil, with different colors of ink, with script or printing, with lined and unlined pages, single sheets, tablets, and notebooks. Such things may not be important, or they may. Poets have written with a nursing baby cradled in one arm, by flashlight on an army footlocker after lights-out, and under odder conditions. But the poet is entitled to prefer working wherever it feels right—at a desk or (like Frost) with a lapboard in an easy chair. We know one young poet who feels best writing in the bustling anonymity of airport terminals.

Whatever system you develop, when it no longer works, try something else. Write a lot and write often, whether you feel inspired or not. A carpenter who picks up a hammer every day will strike the nails truer than someone who picks up a hammer once a month. Better to write for an hour a day than write only when the feeling grabs you. The feeling may never grab you or, more likely, once you've got off your chest whatever sparked the desire to write, you'll have little interest in going back to what you wrote, crafting it, making it into a finished poem. Poets who don't revise are as rare as batters who hit every pitch.

Try to set up a work schedule and stick with it. Writing at about the same time of day can give you a psychological edge—when you sit down at your scheduled time, your mind will be ready, tuned in to the sources of your poems. Also, be protective of your writing schedule. Unplug the phone, draw the curtains, wake up before anyone else or stay up when they've turned in. Discipline may not be a substitute for talent (however one defines that), but talent will evaporate without it.

Almost every writer goes through dry spells. Even the most disciplined come to a point where the wells seem empty and the blank page stares back. This can be particularly frustrating when you have a poem due Monday and don't have a clue where to begin. It sometimes helps to push yourself away from your desk for a while and put your mind on something else. Go for a drive, wander around a museum, get a haircut, page through a book of photographs, skim a field guide, and you may find a new way to get started. If that doesn't help, try looking through this text's Questions and Suggestions and Appendix I for a possibility, or if all else fails, maybe just set out to write a lousy poem. And make it as awful as you can. Really work at that. Revise, expand, make it worse. At least you'll have fun, and maybe end up with something more appealing than you thought you would.

Keeping a Poem Going

When the poem is coming, when the wind is in the sail, go with it. "And the secret of it all," Whitman says, "is to write in the gush, the throb, the flood, of the moment—to put things down without deliberation—without worrying about their style." Writing the first draft all in one sitting, filling up the page, or pages, from top to bottom, pushing onward when you feel the growing poem resistant, can give a poem coherence and clarity, for you are writing under the influence of a single mood, following the notions of a particular time. Getting a whole first draft early, even if sketchy and sloppy and wordy, will give you something seemingly complete to work on and puzzle over.

Sometimes, however, the inspiration slackens and your poem drifts in the doldrums. Then you must turn to craft to keep the poem going. Being lucky is often knowing how to be lucky, how to coax more and then more of the poem out of the shadows. It is often like the skills of fishing—knowing where to look for a fish, when to jerk the line and set the hook, when to let it run, and when to reel it in.

Once you have what feels like the *given* of a poem, a number of strategies can help you encourage its growth. One is simply to be very delicate about the moment you commit a line to paper. Poems often begin in the head and continue to develop there in the relatively free-floating mixture of thought, memory, and emotion. Putting something down on paper tends to fix it; and in the very earliest stages of a poem, the shoots of the poem may be too tender for transplanting. Words that feel full and grand in the mind may look spindly and naked on the page. All that blankness can be intimidating, swallowing up the handful of words that try to break the silence. Some poets compose scores of lines in their heads before taking up the pen—using meter and rhyme can help in the process. Other poets need to get words down early, when a sentence, line, or just a phrase seems strong enough to withstand the scrutiny of the page.

Talking to yourself, *literally*, may also help a poem along. We usually talk to ourselves when we are upset. Worried by some complex choice or problem—like whether to move to a distant city—the talking takes the form of "If I do this, then . . . But . . . Or . . . Then" Such brainstorming evaluates and projects uncertainties. Often, more significantly, talking to oneself is highly charged. Upset by an injustice, rejection, or unexpected flout—by an infuriating bureaucrat or an unfaithful friend—we go off by ourselves, talking *to* that person. Angry and hurt, we rehearse a speech, over and over, until we get just the sharp, cutting "logic" that our frustration calls for. The fantasy speech usually doesn't get said, of course. But we end up with a kind of resolution; we've defined, focused, and refocused the situation and our (just) response to satisfy ourselves. Similarly, as your poem develops, talk through your alternatives; verbalize; try out possible approaches to your "speech." In the early stages you don't know what the point of your poem will be (unlike, say, the writer of an editorial); by literally talking through your options, testing and probing your choices, you can focus them toward a solution.

Early or later, at some stage in the process, seeing the words on the page can prompt fresh ideas and directions. A poem's appearance on a page adds to its total ef-

fect. Early enough for a poem not to have jelled too much, type it up or print it out. Since we read poems in print, seeing a young poem on the page can help you see clearly how it *looks*. Lines will be longer or shorter than you imagined, for instance, and the poem skinnier or chunkier or more graceful.

Sometimes while coaxing out the poem, considering its form, even if tentative and provisional, can help. The very first line you write (which need not survive into a final version) may *feel* right for the poem and provide a norm to build the poem from. You will be looking to discover what sort of poem will develop, what visual form it will have. Will it be a narrow ribbon? A squat, solid poem? Tight? Loose? Long? Short? A line that confirms the first shadowy choices can become a standard by which to measure fresh possibilities, blanks into which you may fit newly arriving inspirations. Determining line and form may open up a stuck poem, allowing it to spread and fill like water into a design.

Often the first words on the page are jottings, and the poem will seem at first like random jigsaw pieces. Consider these sketchy impressions Yeats recorded after a visit in 1929 with Olivia Shakespeare (with whom he had been in love as a younger man):

> Your hair is white
> My hair is white
> Come let us talk of love
> What other theme do we know
> When we were young
> We were in love with one another
> And then were ignorant

The lines and phrases he began trying out were equally sketchy (and thin). Here are bits of them over several drafts:

> Your other lovers being dead and gone
> Those other lovers being dead and gone
>
> friendly light
> hair is white
>
> Upon the sole theme of art and song
> Upon the supreme theme of art and song
> Upon the theme so fitting for the aged; young
> We loved each other and were ignorant
>
> Once more I have kissed your hand and it is right
> All other lovers estranged or dead
>
> The heavy curtains drawn—the candle light
> Waging a doubtful battle with the shade

Gradually he began to find the poem in his phrases and arrived at eight lines of iambic pentameter, rhyming abba cddc. The image of the white hair didn't last, but

it lead to a rhyme (*right, night*) which became the opening argument of the final poem:

After Long Silence

Speech after long silence; it is right,
All other lovers being estranged or dead,
Unfriendly lamplight hid under its shade,
The curtains drawn upon unfriendly night,
That we descant and yet again descant 5
Upon the supreme theme of Art and Song:
Bodily decrepitude is wisdom: young
We loved each other and were ignorant.

In the earliest stages of making a poem—when you put down whatever comes into your head—you are still working your critical faculties, if often unconsciously. The writing of even a few lines may be a mingling of a hundred creative and critical acts in rapid-fire, usually invisible, succession. You will find it useful to list several alternatives to a sentence or a word in the margin. Is the tulip *red, streaked, dangerous, smiling, barbed, bloody, sanguine, fisted, squalid, gulping, a striped canopy?* At this stage the standard against which you test possibilities can hardly be more than a sketchy idea of the poem. But as your tentative choices accumulate, as the ideas of the poem clarify, as the poem seems to materialize on the page, it imposes more and more its own demands and necessities. Listen to the poem; follow where it wants to lead you.

As the look of a developing poem matters, so does its sound. When you can't seem to keep a poem going, try saying what you have so far aloud, over and over. Through repetition you can reveal both the awkward and graceful parts. Typing and retyping helps too; don't just use the "copy" and "paste" modes of your word processing program. Repeating the poem from the beginning will improve the continuity of the rhythm as well as the sense. This going back to the poem's first sounds can give you the momentum to get across the hard spot, just as coming upon a ditch you back up and get a running start to leap over. You'll find that hearing the sound of your own voice, saying the poem, sculpting, relishing, caressing the unfinished poem is part of the job, one of your tools.

To clarify the poem's intentions, acting belligerent with your words can pay off. Turn negative phrases into positives, positives into negatives. For instance, you've written, "I loved him the first night." Why not try: "I couldn't love him the first night." Or "I almost loved him." If the peacock's feathers were "beaten metal" try them out as "dragging paper." By challenging your initial intentions, you will test your commitment to your words and may find that making the opposite assertion is more productive or accurate. At least you will stir up the soup pot.

When a poem is a stubborn knot that doesn't unravel, another strategy is to consider that you may have before you two (or more) poems. A poem can go in almost any direction, and in many directions at once; ask yourself if the poem's directions support each other or crowd each other out. "Kill your darlings," Faulkner advised.

You must often get rid of those parts that feel most precious to you in order to let the whole flourish. Good writing is like good gardening; not only do you yank out the weeds, you thin out perfectly healthy plants to make room for the rest. When a poem is an intertwining of possibilities, you may need to unwind them and and put some aside before you can proceed coherently.

Look for the central thrust of the poem and prune out the rest. Find its central time and place, its key voice. Ask yourself, who is speaking? To whom? Why? When? Where? Bring the possibilities into focus. As Yeats drafted "After Long Silence," he sketched out the scene with Olivia Shakespeare—the lamplight, the drawn curtains—and a context ("other loves being dead and gone") and gradually arrived at the final poem.

Just as each poem comes into its own from a unique set of sources, so too does each develop from a unique application of tools. If it comes in a rush, a waterfall down the page, it may then need you to go through it slowly, weighing each word, each sound. If the poem comes slowly, nail by nail and board by board, then try working out a new draft in one swift torrent. A strategy that works to get one poem going may not work for another. Try out several strategies in a different order, at different times. See what works for you, but be elastic in the methods you try. Writing from formulas will give you formulaic poems.

At times, after hours of hard, focused work, the poem just doesn't come alive. Put it aside then; you may resuscitate it next week or next month. Or maybe not. Let it go then; fold your hand. You have other poems to write. The adventure—and the frustration—is that with each poem you begin all over again. But with each poem you'll have more options to choose from, more experience, and more skills to apply to your poem.

Emotion

Every poem has a speaker and therefore a voice. Every human voice (even when seemingly unmodulated, level, "emotionless") expresses a tone, an attitude toward the subject. Therefore all poems express some emotion, even if muted, unstated, or matter-of-fact. Handling emotion is a tricky aspect of bringing a poem to the page and can make an apprentice poet—or any poet—stumble. In the earliest stages of some poems, particularly those caught in an emotional storm, achieving some emotional detachment may be the first step. Give yourself some time to gain control before trying to write about some bottomless grief or soaring joy. Staying too close to a poem's material can keep you from putting it into perspective, giving it shape in a poem.

When the sharpness of your emotions has dulled a bit, you'll be capable of stepping back and taking a look; as Wordsworth notes, poetry

> takes its origin from emotion recollected in tranquillity; the emotion is contemplated till, by a species of re-action, the tranquillity gradually disappears, and an emotion, kindred to that which was before the subject of contemplation, is gradually produced, and does itself actually exist in the mind. In this mood successful composition generally begins.

"Emotion *recollected* in tranquillity": We regather the emotion and refeel it, in a new way. The more emotional the sources of a poem, the longer you many need to channel them into a poem. You don't stop feeling what's driving you to write the poem; your relationship to your emotions changes. You are then able to do more than feel—you can explore, project, discover, discriminate—talk it out. Strong emotions are rarely pure. Grief gets mixed up with guilt and anger; bliss with hope and doubt.

Sorting out the multiplicity of our feelings, understanding them, editing them, coming to terms with them (whether in action or in art) is as much a moral process as an aesthetic one. How we come to terms with them stems from what kind of person we decide to be. For the poet, as later for the right reader, the poem (in Frost's words) "ends in a clarification of life—not necessarily a great clarification, such as sects and cults are founded on, but in a momentary stay against confusion."

In the earliest drafts of bringing a strong emotion to the page, get down in words the emotional nexus that urges you to write. Write images randomly, play out metaphors that occur to you. At first you will likely put down only flat assertions and clichés: "You make me so happy"; "My heart is heavy as lead." Such generalities are a kind of shorthand to our feelings; we use them automatically without considering what they really mean or what our *particular* feeling is.

To render an emotion your first impulse may be to describe the speaker or character's emotional *response* to a situation—someone weeping or giggling or moaning. But keep in mind that creating a response in the reader is what you're after. Sure, laughter and tears can be contagious, but consider that novels and films which deeply move us, bring us to tears—or crack us up—don't so much show someone crying or laughing but show someone trying *not* to cry or laugh despite the dire or ridiculous circumstances. The grand comedy, and sadness, of Charlie Chaplin's Tramp was his dignity when feasting on a boiled boot or receiving the scorn of the wealthy.

Don't be too dismayed if your early drafts are full of generalities and clichés; try getting them on the page and then exploring them. If there wasn't a kernel of truth inside them, we wouldn't use clichés at all. At some time every cliché was such an insightful metaphor, so sharp and memorable, that those who heard it began using it themselves. Eventually through overuse the metaphor became a dead metaphor, weak and meaningless. If you find yourself drawn to a particular cliché, if you feel you just can't get past it, try delving into it; examine its nuances. You may find a way of bringing the metaphor inside back to life, as Emily Dickinson does in this poem:

> After great pain, a formal feeling comes—
> The Nerves sit ceremonious, like Tombs—
> The stiff Heart questions was it He, that bore,
> And Yesterday, or Centuries before?
>
> The Feet, mechanical, go round— 5
> Of Ground, or Air, or Ought—
> A Wooden way
> Regardless grown,
> A Quartz contentment, like a stone—

> This is the Hour of Lead— 10
> Remembered, if outlived,
> As Freezing persons, recollect the Snow—
> First—Chill—then Stupor—then the letting go—

Out of frustration to describe the pain we suffer, we talk about our heavy hearts, how we can't breathe or feel anything, how we feel dead. We do feel made of stone. But all these feelings remain abstract to someone else and won't affect an objective reader. It doesn't count if your reader is a close friend and already knows what you've gone through.

Dickinson's poem makes the emotions of great pain vivid; she saves the metaphors. Lead, that deadly and heavy element, aptly describes the weight which grief and pain bear down on us. But "heavy as lead" means next to nothing. Dickinson revives the cliché by *not* emphasizing its weight—heaviness is a connotation of "lead" anyway. Instead she uses it to explore the eerie sense of time that pain creates. We feel locked in an eternity where we can't tell yesterday from the distant past; we exist in an "Hour of Lead." Dickinson's image of lead also excites our senses; we almost taste the dull metal on our tongues.

Another way of achieving emotional detachment from a subject: Keep in mind that the speaker of a poem isn't precisely you, the living poet, but a version of you, a created self, a *persona*. When we begin a poem, by putting on the poet's mask that Yeats talks about, we can see past the emotional muddle we find ourselves in and gain insight. The stoic tone of Dickinson's "After great pain" speaks from such insight. In the space of their poems, poets become noble, brave, brilliant, tolerant—better people than they normally are. And they can become worse—bitter, jealous, greedy, or vindictive. It's okay not to be "nice" in a poem. Sometimes you must forget good manners and get vicious to be true to the poem.

Besides the mask of the self, try the fiction writer's technique: Focus the poem around another character in the situation. William Carlos Williams (1883–1963) expresses his concern for his newly widowed mother by writing in her voice:

The Widow's Lament in Springtime

> Sorrow is my own yard
> where the new grass
> flames as it has flamed
> often before but not
> with the cold fire 5
> that closes round me this year.
> Thirtyfive years
> I lived with my husband.
> The plumtree is white today
> with masses of flowers. 10
> Masses of flowers
> load the cherry branches

and color some bushes
yellow and some red
but the grief in my heart 15
is stronger than they
for though they were my joy
formerly, today I notice them
and turn away forgetting.
Today my son told me 20
that in the meadows,
at the edge of the heavy woods
in the distance, he saw
trees of white flowers.
I feel that I would like 25
to go there
and fall into those flowers
and sink into the marsh near them.

Taking her perspective, Williams seems to realize how deep his mother's grief is and how small a part he plays in it. Through her eyes the gorgeous spring day loses its luster. The blades of new grass, the masses of plum and cherry blossoms, the forest trees don't touch her; she wants to leave it all. His efforts to cheer her up are futile. He tells her of the flowering trees he's seen, but she wants only to drown herself in them. By allowing her to express what she does feel—instead of how she ought to feel—Williams permits his mother the dignity of her grief.

Inventing a character to speak for you can also give you emotional distance. What might it feel like for another person to feel what you're feeling? Invent a situation, emotionally similar to yours, and speak through that situation. Or become another character entirely. Amy Gerstler speaks in the voice of a mermaid (p. 167), Browning as the Duke of Ferrara (p. 176), Louise Glück as a field of daisies (p. 174). These poets use their understanding of human emotion to create new characters and find the source of a poem.

Using raw emotions risks **sentimentality**: writing that indulges emotion in excess of what caused it or that doesn't earn—through imagery, metaphor, detail—the emotion it asks a reader to feel; writing burdened with clichés; writing more interested in crude self-expression than in moving a reader. Most often sentimentality is merely simplistic, cheap, easy: the schmaltz of saucer-eyed urchins in rags and cuddly sad puppies. At its worst, sentimentality is dishonest. It masks the truth: If a writer depicts a ragged child as cute, how much of the child's actual situation has the writer really imagined? Will we be likely to see that child with all the subtleties and edges of a real human being?

At times we all enjoy letting our emotions run away with us. Who hasn't stood alone, late on a rainy night, looking out the window at the deserted street; then, feeling desolate, written a poem about the dark tragedy of everything? In the morning, however, with the sun out and the birds chittering, these gloomy pronouncements seem silly and empty.

Attendant with sentimentality is **overstatement.** Like the child who cries wolf, a poet who claims more than seems justified risks having readers tune out everything. On the other hand, the calm of **understatement** carries a reassuring air of conviction and control, like Dickinson's deft touch in depicting death by exposure: "First—Chill—then Stupor—then the letting go—." Your best reader won't miss anything. In the small violence of this poem, notice how the quietness of the scene makes it all the more affecting:

The Hawk
MARIANNE BORUCH (b. 1950)

He was halfway through the grackle
when I got home. From the kitchen I saw
blood, the black feathers scattered
on snow. How the bird bent
to each skein of flesh, his muscles 5
tacking to the strain and tear.
The fierceness of it, the nonchalance.
Silence took the yard, so usually
restless with every call or quarrel—
titmouse, chickadee, drab 10
and gorgeous finch, and the sparrow haunted
by her small complete surrender
to a fear of anything. I didn't know
how to look at it. How to stand
or take a breath in the hawk's bite 15
and pull, his pleasure
so efficient, so *of course, of course,*
the throat triumphant,
rising up. Not
the violence, poor grackle. But the 20
sparrow, high above us, who
knew exactly.

The speaker says she "didn't know / how to look" at the hawk eating the grackle and doesn't compel us to feel more about this scene than it merits. Nature doesn't sentimentalize its creatures; people do. One task of Boruch's poem includes seeing the predator and prey "exactly," with respect for the precision of the predator, sympathy for the "poor grackle," and acknowledgement that, for once at least, the sparrow's fears were accurate.

Brash, deliberate overstatement—**hyperbole**—has its uses. In Louise Glück's "The Racer's Widow" (p. 39), for instance, it reveals and measures the violence of the speaker's distress—"Spasms of violets," she says, or "I can hear . . . the crowd coagulate on asphalt." Williams's widow claims "Sorrow is my own yard," and then shows how the circumstance justifies her claim.

A word of caution—or of abandon. A poem that risks nothing is probably not worth writing. A poem that aims only at *not* being sentimental will be flat. The lines can be fine between overstatement and emotional accuracy, between sentimentality and sentiment, between understatement and obscurity. One person's proper outrage over a racist act may seem overblown to someone else. Dickinson's spare style baffled the first editor who published her. Walt Whitman's exhortations shocked some nineteenth-century readers, delighted others. Handling emotions in poems involves a trade-off between the poet's fires and the reader's wish not to get scorched by wild rhetoric. A poem that convinces readers that its feelings are warranted and genuine—even if extreme and unpleasant—is not sentimental. Dancing on the fine line is often the highest art.

Questions and Suggestions

1. Get up two hours before you usually do—best if it's still dark. Find a comfortable vantage point (window, back steps, bus stop bench) and make *sentences* for everything you notice. Welcome the metaphors ("First light slides a blue flame . . .").

2. Take a poem that you wish you had written and type it up several times. Memorize it. See if you can discover its secrets. Then try your hand at a version of the poem. Either attempt a "variation" along the lines of Justice's poem, or an updating like Stanton's "Song" (p. 130) of Shakespeare's "When Icicles Hang by the Wall" (p. 130).

3. Below are the opening sentences from some short stories and novels. Pick one that interests you and see what kind of poem it generates. The sources are in Appendix II:

 (a) There was a woman who loved her husband but could not live with him.
 (b) Through the fence, between the curling flower spaces, I could see them hitting.
 (c) Summers, even the dew is hot.
 (d) Come into my cell. Make yourself at home.
 (e) The grandmother didn't want to go to Florida.
 (f) Night fell. The darkness was thin, like some sleazy dress that has been worn and worn
 (g) It was a bright cold day in April, and the clocks were striking thirteen.
 (h) There is an evil moment on awakening when all things seem to pause.

4. Have you ever been boiling mad at someone? Try to recollect the emotion, then write an *understated* poem about that person using details from a con-

text. How would this person seem buying a car? Feeding a dog? Stranded in an oarless rowboat? Remember: *understated*.

5. In an essay, "Critical Disobedience: Nine Ways of Looking at a Poem," David Baker describes the circumstances of his poem "Still-Hildreth Sanatorium, 1936"; he wanted to write a poem like "a photographer's error, a double exposure of story. Or triple. An overlay of times, actions, images, impulses. . . . a poem that resists the tyranny of order, of easy clarity, of single-mindedness." Of the sources for the poem he notes the following: (1) his maternal grandmother's job in a sanitorium whose patients included Hollywood addicts and indigent Missouri farmers and her job in a J.C. Penney's store. (2) An episode with Chronic Fatigue Syndrome. (3) A dream in which his grandmother visited him during his illness. (4) His wife's help during his illness. (5) His mother's care for her mother. Examine Baker's poem (p. 277) for the ways he weaves multiple sources into a many-layered poem. Baker's essay appears in *Introspections: American Poets on One of Their Own Poems*, eds. Pack and Parini.

6. See if you can determine "the motivating incident" and guess at the "given" that propelled the poems which appear in this chapter's Poems to Consider. What ideas, emotions, situations seem to have come together to give the poet an apparent reason to write the poem? What ideas, images, metaphors come together to give the poem its "given"? For example, consider how Mark Jarman's "Ground Swell" (p. 275) brings together adolescence, surfing, the Vietnam War, and the exploration of one's subject matter. Or consider how Deborah Kroman's "Late Night Drive" (p. 279) draws on driving, lightning, an eye exam, and writing poems. The title "A *Nisei* Picnic: From an Album" (p. 279) tells us the poem was inspired by photographs; consider David Mura's choices in organizing the poem from the photograph. For instance why does the uncle appear first in the poem?

7. Translate Cesar Vallejo's "Piedra negra sobre una piedra blanca" (p. 256). If your Spanish isn't strong, ask a friend to do a literal translation, then try to work the poem into idiomatic English, keeping with Vallejo's tone.

8. In Poems to Consider look at how Anthony Hecht's "The Dover Bitch" plays with Matthew Arnold's "Dover Beach" (p. 273). How would you describe Hecht's point? Is it insightful? Fair? How does each poem stand up to time? What might the woman say if she spoke for herself? Try playing with Hecht's poem—or another poem you'd like to comment on—as he does with Arnold's?

Poems to Consider

Dover Beach 1851

MATTHEW ARNOLD (1822–1888)

The sea is calm tonight.
The tide is full, the moon lies fair
Upon the straits;—on the French coast the light
Gleams and is gone; the cliffs of England stand,
Glimmering and vast, out in the tranquil bay. 5
Come to the window, sweet is the night-air!
Only, from the long line of spray
Where the sea meets the moon-blanched land,
Listen! you hear the grating roar
Of pebbles which the waves draw back, and fling, 10
At their return, up the high strand,
Begin, and cease, and then again begin,
With tremulous cadence slow, and bring
The eternal note of sadness in.

Sophocles long ago 15
Heard it on the Aegean, and it brought
Into his mind the turbid ebb and flow
Of human misery; we
Find also in the sound a thought,
Hearing it by this distant northern sea. 20

The Sea of Faith
Was once, too, at the full, and round earth's shore
Lay like the folds of a bright girdle furled.

But now I only hear
Its melancholy, long, withdrawing roar, 25
Retreating, to the breath
Of the night-wind, down the vast edges drear
And naked shingles° of the world.

Ah, love, let us be true
To one another! for the world, which seems 30
To lie before us like a land of dreams,
So various, so beautiful, so new,
Hath really neither joy, nor love, nor light,
Nor certitude, nor peace, nor help for pain;
And we are here as on a darkling plain 35
Swept with confused alarms of struggle and flight,
Where ignorant armies clash by night.

28 *naked shingles*: gravel beaches

The Dover Bitch
(*A Criticism of Life*)

1959

ANTHONY HECHT (b. 1923)

So there stood Matthew Arnold and this girl
With the cliffs of England crumbling away behind them,
And he said to her, "Try to be true to me,
And I'll do the same for you, for things are bad
All over, etc., etc." 5
Well now, I knew this girl. It's true she had read
Sophocles in a fairly good translation
And caught that bitter allusion to the sea,
But all the time he was talking she had in mind
The notion of what his whiskers would feel like 10
On the back of her neck. She told me later on
That after a while she got to looking out
At the lights across the channel, and really felt sad,
Thinking of all the wine and enormous beds
And blandishments in French and the perfumes. 15
And then she really got angry. To have been brought
All the way down from London, and then be addressed
As a sort of mournful cosmic last resort
Is really tough on a girl, and she was pretty.
Anyway, she watched him pace the room 20
And finger his watch-chain and seem to sweat a bit,
And then she said one or two unprintable things.
But you mustn't judge her by that. What I mean to say is,
She's really all right. I still see her once in a while
And she always treats me right. We have a drink 25
And I give her a good time, and perhaps it's a year
Before I see her again, but there she is,
Running to fat, but dependable as they come.
And sometimes I bring her a bottle of *Nuit d'Amour*.

Bread and Water

1990

SHIRLEY KAUFMAN (b. 1923)

After the Leningrad trials, after solitary confinement
most of eleven years in a Siberian *gulag*, he told us
this story. One slice of sour black bread a day.
He trimmed off the crust and saved it for the last
since it was the best part. Crunchy, even a little sweet. 5
Then he crumbled the slice into tiny pieces. And ate
them, one crumb at a time. So they lasted all day. Not

the cup of hot water. First he warmed his hands around it.
Then he rubbed the cup up and down his chest to warm his
body. And drank it fast. Why, we asked him, why not 10
like the bread? Sometimes, he said, there was more hot
water in the jug the guard wheeled around to the prisoners.
Sometimes a guard would ladle a second cup. It helped
to believe in such kindness.

Ground Swell 1988

MARK JARMAN (b. 1952)

Is nothing real but when I was fifteen
going on sixteen, like a corny song?
I see myself so clearly then, and painfully—
knees bleeding through my usher's uniform
behind the candy counter in the theater 5
after a morning's surfing; paddling frantically
to top the brisk outsiders coming to wreck me,
trundle me gawkily along the beach floor's
gravel and sand; my knees ached with salt.
Is that all that I have to write about? 10
You write about the life that's vividest,
and if that is your own, that is your subject,
and if the years before and after sixteen
are colorless as salt and taste like sand—
return to those remembered chilly mornings, 15
the light spreading like a great skin on the water,
and the blue water scalloped with wind-ridges
and—what was it exactly?—that slow waiting
when, to invigorate yourself you peed
inside your bathing suit and felt the warmth 20
crawl all around your hips and thighs,
and the first set rolled in and the water level
rose in expectancy, and the sun struck
the water surface like a brassy palm,
flat and gonglike, and the wave face formed. 25
Yes. But that was a summer so removed
in time, so specially peculiar to my life,
why would I want to write about it again?
There was a day or two when, paddling out,
an older boy who had just graduated 30
and grown a great blond moustache, like a walrus,
skimmed past me like a smooth machine on the water,
and said my name. I was so much younger,
to be identified by one like him—

the easy deference of a kind of god 35
who also went to church where I did—made me
reconsider my worth. I had been noticed.
He soon was a small figure crossing waves,
the shawling crest surrounding him with spray,
whiter than gull feathers. He had said my name 40
without scorn, but just a bit surprised
to notice me among those trying the big waves
of the morning break. His name is carved now
on the black wall in Washington, the frozen wave
that grievers cross to find a name or names. 45
I knew him as I say I knew him, then,
which wasn't very well. My father preached
his funeral. He came home in a bag
that may have mixed in pieces of his squad.
Yes, I can write about a lot of things 50
besides the summer that I turned sixteen.
But that's my ground swell. I must start
where things began to happen and I knew it.

At Saint Placid's 1996

LUCIA PERILLO (b. 1958)

She wears a habit the unlikely blue color
of a swimming pool, the skin of her face
smooth where it shows beneath a wimple
from which one blond strand escapes.
While she squints at the sun, her hands 5
knit themselves in the folds of her skirts.
The man she's speaking to, the monk,
is also young, his shoulders broad
from shooting baskets in the gym.
I have seen him running across the fields 10
in his nylon shorts, big muscles like roasts
sheathing the bones in his thighs.
They are standing on the monastery's walkway
and I am at the window watching
this moment when their voices fall away, 15
nothing left but the sound of water dripping
off the trees, a fuchsia brooding in a basket
over her left shoulder. Silent now,
they are thinking. But not
about that. The fine weather, yes, 20
the church bells, the cross, an old woman
who used to come to mass who's dying.

All this they think of. But surely
not about that, no. Not that other thing.

Still-Hildreth Sanatorium, 1936 1996

DAVID BAKER (b. 1954)

When she wasn't on rounds she was counting
the silver and bedpans, the pills in white cups,
heads in their beds, or she was scrubbing down

walls streaked with feces and food on a white-
wash of hours past midnight and morning, down 5
corridors quickened with shadows, with screaming,

the laminate of cheap disinfectant . . .
and what madness to seal them together, infirm
and insane, whom the state had deemed mad.

The first time I saw them strapped in those beds, 10
caked with sores, some of them crying
or coughing up coal, some held in place

with cast-iron weights . . . I would waken again.
Her hands fluttered blue by my digital clock,
and I lay shaking, exhausted, soaked cold 15

in soiled bedclothes or draft. I choked on my pulse.
I ached from the weight of her stairstep quilt.
Each night was a door slipping open in the dark.

Imagine, a white suit for gimlets at noon.
This was my Hollywood star, come to be lost 20
among dirt farmers and tubercular poor.

He'd been forgotten when the talkies took hold.
He saw toads in webs drooping over his bed.
O noiseless, patient, *his voice would quake.*

He took to sawing his cuticles with butter knives 25
down to the bone and raw blood in the dark.
Then, he would lie back and wait for more drug.

And this was my illness, constant, insomnolent,
a burning of nerve-hairs just under the eyelids,
corneal, limbic, under the skin, arterial, 30

osteal, scrotal, until each node of the 400
was a pinpoint of lymphic fire and anguish
as she rocked beside me in the family dark.

In another year she would unspool fabrics
and match threads at Penney's, handling finery 35
among friends just a few blocks from the mansion-

turned-sickhouse. She would sing through the war
a nickel back a greenback a sawbuck a penny
and, forty years later, die with only her daughter,

my mother, to hold her, who washed her face, 40
who changed her bedgowns and suffers to this day
over the dementia of the old woman weeping

mama mama, curled like cut hair from the pain
of her own cells birthing in splinters of glass.
What madness to be driven so deep into self. . . . 45

I would waken and find her there, waiting
with me through the bad nights when my heart
trembled clear through my skin, when my fat gut

shivered and wouldn't stop, when my liver swelled,
when piss burned through me like rope against rock. 50
She never knew it was me, my mother still says.

Yet what did I know in the chronic room where I died
each night and didn't die, where the evening news
and simple sitcoms set me weeping and broken?

I never got used to it. I think of it often, 55
down on my knees in the dark, cleaning up blood
or trying to feed them—who lost 8 children to the Flu,

who murdered her sisters, who was broken in two
by a rogue tractor, who cast off his name. . . .
Sometimes there was nothing the doctor could do. 60

What more can we know in our madness than this?
Someone slipped through my door to be there
—though I knew she was a decade gone—

whispering stories and cooling my forehead,
and all I could do in the heritable darkness was 65
lift like a good child my face to be kissed.

◈ **In Marin Again** 1982

AL YOUNG (b. 1939)

for Arl

Again we drift back to these mountains, these
divine inclines our son could scale now.
Your loose blouse blows as you lean in worn jeans,
making it easy, a breeze to picture your breasts
underneath, your long legs: time's salty hello 5
still freely flowing after years of rainfall.
Smoothly we slip into this renewable night of
jagged crossings over dark peaks, fitful, fruitful.

Like mountains and rivers that go on and on,
love growing wild is wondrous, isn't it, with 10
its crazy horse catch-as-catch-can way of proving
that happiness, after all, is mostly remembered?

Love on the move encircles itself, boomerangs,
rounding out meaning the way water smooths stone.

◈ **Late Night Drive** 1998

DEBORAH KROMAN*

The road unscrolls between flat black fields.
A bolt of lightning backlights a thundercloud

like a memory uncovered by a song on the radio.
In the fissures of the brain the neurons

never touch each other. Filaments 5
with forked tips, they wait for the shock

to leap across, trigger the unstable ions,
illuminate what is hidden. During the eye exam

it startled me to see the veins on my retina
like golden branches. That's why I cast lines 10

across the page—look how the headlights find
the steam ghosts rising from the wet pavement.

◈ **A *Nisei* Picnic: From an Album** 1989

DAVID MURA (b. 1952)

Here is my uncle, a rice ball in his mouth,
a picnic basket (ants crawl in the slats) at his side.
Eventually he ballooned like Buddha,

over three hundred pounds. I used to stroke
his immense belly, which was scarred by shrapnel. 5
It made me feel patriotic.
Once, all night, he lay in a ditch near the Danube,
shoved in his intestines with his hands.
When he came back, he couldn't rent an apartment.
"*Shikatta ga nai*," he said. *Can't be helped*. 10

Turning from her boyfriend, a glint of giggle
caught in the shadows, my aunt never married.
On the day of her wedding, sitting in the bath,
she felt her knees lock; she couldn't get up.
For years I wanted to be her son. 15
She took me to zoos, movies, bought me candy.
When I grew up, she started raising minks
in her basement—"To make money," she said—
Most of them died of chills. She folded each one
in a shoebox and buried it in her yard. 20

My father's the one pumping his bicep.
(Sleek, untarnished, he still swims two miles a day.)
I can't claim that his gambling like his father
lost a garage, greenhouse or grocery,
or that, stumbling drunk, he tumbled in 25
the bushes with Mrs. Hoshizaki, staining
his tuxedo with mulberries and mud. He
worked too hard to be white. He beat his son.

Shown here, my head like a moon dwarfing my body
as I struggle to rise. Who are these grown-ups? 30
Why are they laughing? How can I tear
the bewilderment from their eyes?

A narrow Fellow in the Grass 1866

EMILY DICKINSON (1830–1886)

A narrow Fellow in the Grass
Occasionally rides—
You may have met Him—did you not
His notice sudden is—

The Grass divides as with a Comb— 5
A spotted shaft is seen—
And then it closes at your feet
and opens further on—

He likes a Boggy Acre
A Floor too cool for Corn— 10
Yet when a Boy, and Barefoot—
I more than once at Noon
Have passed, I thought, a Whip lash
Unbraiding in the Sun
When stooping to secure it 15
It wrinkled, and it was gone—

Several of Nature's People
I know, and they know me—
I feel for them a transport
Of cordiality— 20

But never met this Fellow
Attended, or alone
Without a tighter breathing
And Zero at the Bone—

11

DEVISING AND REVISING

Craft completes magic; technique carries out inspiration. Despite all kinds of helpful (and not-so-helpful) technology, new computer hard- and software, the Internet, and countless venues of support and instruction, the secret to writing remains rewriting. To paraphrase W. H. Auden, literary composition in the beginning of the twenty-first century A.D. remains pretty much what it was in the early twenty-first century B.C.: "nearly everything has still to be done by hand." Word by word and page by page, we plunge across known and unknown oceans, revising and tinkering, with each draft trying to get a little closer to landfall. Like simplicity, spontaneity and naturalness often spring from hard work.

Elizabeth Bishop's "The Moose" took twenty-six years from first draft to finished poem. Carolyn Kizer's "Shalimar Gardens" (p. 19) comes from a group of poems on which she has been working for about thirty years. Richard Wilbur reports that he waited fourteen years, occasionally jotting down a phrase "that might belong to a poem," before he started to write "The Mind-Reader"; he took another three years to finish the poem. Asked how long he was likely to work on a poem, he said, "Long enough."

Exploring

First drafts often mean exploration. The poet holds up a map that's mostly blank, with maybe a few ideas, like the rumor of rivers, sketched in. How can the poem grow out of these notions? How should it begin? Hopeless blunders usually mix with useful clues, and in letting them begin to sort themselves out, the poet becomes an explorer charting uncharted territories.

Let's take a look at an early draft of the poem that became "A Noiseless Patient Spider" (which we talked about back in chapter 2). Here Whitman is sorting out the poem's (sometimes muddled) impulses. He is exploring:

The Soul, Reaching, Throwing Out for Love

The Soul, reaching, throwing out for love,
As the spider, from some little promontory, throwing out filament after
 filament, tirelessly out of itself, that one at least may catch and form
 a link, a bridge, a connection
O I saw one passing along, saying hardly a word—yet full of love I detected
 him, by certain signs
O eyes wishfully turning! O silent eyes!
For then I thought of you o'er the world, 5
O latent oceans, fathomless oceans of love!
O waiting oceans of love! yearning and fervid! and of you sweet souls perhaps
 in the future, delicious and long:
But Death, unknown on the earth—ungiven, dark here, unspoken, never
 born:
You fathomless latent souls of love—you pent and unknown oceans of love!

Now look how Whitman transforms this material into an entirely new poem:

A Noiseless Patient Spider

A noiseless patient spider,
I marked where on a little promontory it stood isolated,
Marked how to explore the vacant vast surrounding,
It launched forth filament, filament, filament, out of itself,
Ever unreeling them, ever tirelessly speeding them 5

And you O my soul where you stand,
Surrounded, detached, in measureless oceans of space,
Ceaselessly musing, venturing, throwing, seeking the spheres to connect
 them,
Till the bridge you will need be formed, till the ductile anchor hold,
Till the gossamer thread you fling catch somewhere, O my soul. 10

 Try to ignore that "The Soul, Reaching, Throwing Out for Love" is weak; instead notice how many clues it offers Whitman to his final poem. First of all in the opening lines of the draft Whitman seems to have stumbled upon the *given* of the poem, making the connection between the spider's flinging out of filaments and the soul's groping. The earlier draft doesn't yet recognize the simile's potential, but in coming back to this draft Whitman must have begun to see—to have "re-visioned"—the possibilities of the spider-soul analogy.

 In "The Noiseless Patient Spider," Whitman recasts this analogy to make it the poem's motivating incident, creating a little fiction that suggests one day the speaker came upon a spider at work. He "marked where on a little promontory it stood isolated," began carefully observing it, then realized how his own soul acted similarly, "ceaselessly musing, venturing, throwing, seeking."

Notice how in the early draft the motivating incident seems to be something entirely different. The speaker says that he first saw "one passing along, saying hardly a word—yet full of love I detected him"; then the speaker goes on to describe this person's eyes, thinks of "you o'er the world" (whoever that "you" is), then drifts through references to "oceans of love" and "souls of love."

Both poems have about the same number of lines, though the first weighs in at 125 words and the final poem at a slim 87 words. While Whitman jettisons "eyes," "sweet," "delicious," "future," "Death," and "love," he holds on to "oceans of" along with a few other words and phrases—"little promontory," "filament," "tirelessly," "bridge," and "catch"—which lead him to the poem's final discoveries. For instance "filament" is echoed in "ductile anchor" and "gossamer thread"; the phrases "latent oceans," "fathomless oceans of love," and "waiting oceans" develop into the philosophic "measureless oceans of space," akin to the "vacant, vast surrounding" in which the spider finds itself. Whitman further develops this water motif with "launched" and "unreeling," words which help ground the sketchy acts of "musing, venturing, throwing, seeking." These progressive participles (words ending in "-ing"), by the way, stem from the original draft, although in it Whitman does not yet recognize the gerunds' deeper implications, how they celebrate process, trying, *exploration* itself.

In terms of the form of the poem, appreciating the richness of the spider-soul analogy also helps Whitman refine the shape the poem should take on the page. The two five-line stanzas of "A Noiseless Patient Spider" create a parallel structure that subtly affirms the connection between spider and soul. By pursuing the spider-soul connection, Whitman allows it to resonate fully. The poem itself comes to be about *the struggle for connection*—to be connected and to make connections—about venturing, reaching out, till we connect with something in the "measureless oceans of space" around us—which is very like the process of writing: We try and try and try again.

Trying Out

In the early stages, your job may be looking for clues. Before a passage can come right and words click into place, your own dissatisfaction—that something remains inaccurate or weak or flat—can spur your revision.

We can watch such dissatisfaction at work as John Keats (1795–1821) tries out four successive versions of the opening of "Hyperion," his long poem about the Olympic gods conquering the Titans. Hyperion, the titan of the sun, was displaced by Apollo, god of poetry; Saturn, the father of the Titans, by Zeus. Through trial and error Keats searches for the right image for lines 8–9. Here is the passage, with the first attempt in italics:

> Deep in the shady sadness of a vale
> Far sunken from the healthy breath of morn,
> Far from the fiery noon, and eve's one star,
> Sat gray-haired Saturn, quiet as a stone,

Still as the silence round about his lair; 5
Forest on forest hung about his head
Like cloud on cloud. No stir of air was there,
Not so much life as what an eagle's wing
Would spread upon a field of green eared corn,
But where the dead leaf fell, there did it rest. 10
A stream went voiceless by, still deadened more
By reason of his fallen divinity
Spreading a shade

Keats sets out a melancholy scene of Saturn in the dark, still forest. The first phrase that precedes the italicized passage with its static internal off-rhyme ("stir-air-there") sharply enough depicts the hush, but Keats was bothered by the simile of the eagle. He discarded the clumsy and unnecessary "what" that merely kept the meter, but instead of taking the easy solution of adding a syllable to describe the eagle (e.g., "Not so much life as a young eagle's wing"), he opted to change the image. Probably he sensed it as too vital for an image of vanquished divinity.

In his next version he tries out a bird with more apt connotations:

No stir of air was there,
Not so much life as a young vulture's wing
Would spread upon a field of green eared corn

Keats apparently intends us to see a large, powerful bird of prey gliding, causing absolutely *no motion* in the field of easily swayed grain far below. (In British usage *corn* indicates any grain, not American corn.) Perhaps Keats has in mind the shadow of the bird's wing passing over, but not moving, the limber stalks. Perhaps he wants a "young" vulture to highlight Saturn's age and weakness.

In the third version, however, Keats scraps the entire image. Carrion or no, the strong, vital bird spoils the mournful tone. And the sunny, spacious "field of green eared corn" undermines the brooding airless forest scene of defeated Saturn. Keats gives it another try:

No stir of air was there,
Not so much life as on a summer's day
Robs not at all the dandelion's fleece

The image now has a literal rightness and rich overtones. Dandelion gone to seed strikes a clearer note than "green eared corn"; and dandelion seeds—so easily wafted away—demonstrate how dead the air is and imply, in their color and implicit ruin, "gray-haired Saturn." The word "rob" subtly suggests the Olympians robbing the Titans of their domain. Following "No stir of air was there," the double negatives, "Not . . . not . . . ," emphasize the scene's absolute negation, and even their awkwardness seems, rhythmically, right for air so still it cannot dislodge one wispy seed. For some months Keats let the lines stand this way.

Several problems must have bothered him into another, final, revision. Possibly the lowly dandelion seemed inappropriate to a poem on a classical subject; also the line must awkwardly emphasize its *seeds* since we often associate dandelions with their bloom, with bright yellow. More significantly, Keats must have recognized that "fleece," though fluffy like a head of dandelion seeds, doesn't work in this context. For one thing, fleece is oily and heavy. For another, a fleece is not easily robbed (that would require pinning the sheep and shearing it). Pieces of wool might be snagged from a fleece, but not by a light breeze. Keats may have also been irked by the image's perspective, of the single dandelion seen up close, and so tried a longer shot:

> No stir of air was there,
> Not so much life as on a summer's day
> Robs not one light seed from the feathered grass

Like the dead leaf in the next line, Keats keeps the "seed from the feathered grass" abstract and generic. Visually, nothing competes with the main presentation of Saturn. The rhythm of the revised line is masterful: "Robs not one light seed from the feathered grass." The five even, accented syllables at the beginning of the line suggest a light, precarious balance. After this, the slightest quickening of "from the feathered grass" seems to pass like the looked-for, but nonexistent, breath of air. Not the least of Keats's mastery is using spondees for an impression of lightness.

Focusing

As when we look at slides, when we read poems, we want them brought into clear focus. Sharpening fuzzy spots—unintentional ambiguity, exaggerations, private meanings, confusing omissions, and especially purple passages—is part of the poet's job in revising. Since to the poet the words may seem perfectly sharp, noticing the blur is the first step. Look at the following version of a poem by Michael Burns (b. 1953) which appeared in *The Laurel Review* in 1992.

The First Time

She slapped him. She screamed, Tell me why, why?
And maybe he knew she didn't want an answer,
only the lie that would keep them together,
so he got out of the car and lay down in a dry ditch.

There was sobbing, the quiet headlights in the fog, 5
the motor running. He held his head in his hands
and thought of the other woman's voice, full
of rough pleasure, and the stain
shaped like a ballerina on the motel's ceiling.

Listening to his own weeping, he felt something 10
in him was cast loose, adrift like the wooden boats

of children, or scorched and coasting, falling
like the spent phase of a rocket launched for the moon.

A man has just told a woman, maybe his wife, that he has betrayed her sexually. She
hits him and asks him why; since he can't come up with an answer—with a lie that
will save their relationship—he lies down in the ditch, and he remembers the other
woman during sex. As he hears himself cry, he feels something "cast loose" in him
like a spent rocket phase. Burns titles the poem "The First Time," implying that this
was the first of perhaps many infidelities.

Consider the situation, then ask yourself if any elements of the poem seem gratu-
itous. Unnecessary? Do any images seem unrelated to the rest of the poem? Does the
tone falter somewhere?

Now take a look at the poem as the poet revised it for his book, *The Secret Names*
(1994).

The First Time

She slapped him. She screamed, Tell me why, why?
And maybe he knew she didn't want an answer,
only the lie that would keep them together,
so he left the car and lay down in a ditch.

There was sobbing, the headlights in the fog, 5
the motor running.
He thought of the other woman
As she rode him under the stained motel ceiling.

Listening to his own weeping,
he felt something to him was cast loose, 10
adrift like the wooden boats of children,
or scorched and coasting,
falling like the spent phase of a rocket.

The—sometimes dramatic—cuts that Burns made focus and therefore intensify the
poem. His dropping of fussy modifiers (*dry* ditch, *quiet* headlights, rocket *launched for
the moon*) sharpens the poem. In the revised poem, no longer do we have an implica-
tion that the man had been ambitious, capable of greatness; no longer is the rocket
launched for the moon. Instead the revised poem implies failure, focusing on the
falling "spent phase of a rocket." The deep cuts Burns makes in the second stanza
make the tone harsher, greatly complicating our view of the man. In the earlier ver-
sion, Burns tells us that in the ditch the man "held his head in his hands," suggesting
he is suffering, perhaps feeling remorse, for his behavior. In the revision such impli-
cation is gone. Also in the earlier version he remembers the other woman as having
enjoyed the act; her voice was "full / of rough pleasure," a depiction further softened
by the image of the ballerina. In the final version these somewhat tender details be-
come the starker, bestial "she rode him under the stained motel ceiling." In the revi-

sion Burns's tone and point of view —a distant third person from the start—become even more remote and cool. The revised character is less thoughtful than the first, making him all the more a person likely to drift, at the mercy of his impulses.

In terms of form, Burns appears to have made a trade-off. In the earlier version he established a symmetrical stanzaic pattern of 4-5-4 lines, but his deletions in the second stanza have broken the symmetry. His final version is asymmetrical, putting the greater weight on the longer, closing five-line last stanza. This slightly off-balance form appropriately emphasizes the man's sense of being "cast loose," "scorched and coasting."

At times the smallest tinkerings with a poem become the opportunity for a brilliant stroke that might never have come to the poet otherwise, as it does in the fourth stanza of this 1924 revision of Marianne Moore's "My Apish Cousins," which she retitled in 1935.

The Monkeys

winked too much and were afraid of snakes. The zebras, supreme in
their abnormality; the elephants with their fog-colored skin
 and strictly practical appendages
 were there, the small cats; and the parakeet
 trivial and humdrum on examination, destroying 5
 bark and portions of the food it could not eat.

I recall their magnificence, now not more magnificent
than it is dim. It is difficult to recall the ornament,
 speech, and precise manner of what one might
 call the minor acquaintances twenty 10
 years back; but I shall not forget him—that Gilgamesh among
 the hairy carnivora—that cat with the

wedge-shaped, slate-gray marks on its forelegs and the resolute tail,
astringently remarking, "They have imposed on us with their pale
 half-fledged protestations, trembling about 15
 in inarticulate frenzy, saying
 it is not for us to understand art; finding it
 all so difficult, examining the thing

as if it were inconceivably arcanic, as symmet-
rically frigid as if it had been carved out of chrysoprase 20
 or marble—strict with tension, malignant
 in its power over us and deeper
 than the sea when it proffers flattery in exchange for hemp,
 rye, flax, horses, platinum, timber, and fur."

The poem affectionately treats the zoo animals, the ordinary and the odd and the grand. The admired big cat seems a Gilgamesh—that is, like the Babylonian epic hero.

The poem takes a stunning leap at line 14, for the remark attributed to the cat turns out to be a vicious denunciation of the high-flown literary critic. Moore's admiration for the cat aligns her with its angry statement, and with the common readers whose portraits she has been amusedly sketching in the guise of zoo-creatures who turn out to be not so ordinary after all. The poem argues against the notion that art is some "inconceivably arcanic" thing, "malignant / in its power over us," which like the sea can take our practical goods in exchange for mere prettiness that deceives us.

This poem first appeared in 1917 with this fourth stanza:

> As if it were something inconceivably arcanic, as
> Symmetrically frigid as something carved out of chrysophrase 20
> Or marble—strict with tension, malignant
> In its power over us and deeper
> Than the sea when it proffers flattery in exchange for hemp,
> Rye, flax, horses, platinum, timber and fur."

Besides the dropping of line-capitals, the only change occurred in lines 19–20. Especially after "thing" in line 18, the repetition of "something" in both lines no doubt seemed redundant. Since the poem is in syllabics, simply dropping "something" would mar its form by leaving the line two syllables short. And in line 20 inserting "if"—"frigid as if carved . . ."—would still leave the line a syllable short.

Moore's solution repairs the syllable-count of line 20 by inserting "if it had been" and moving the first two syllables of "symmetrically" up to restore the syllable count of line 19. In the move she trades off the off-rhyme of "as-chrysoprase," for the enactment of fussy rigidity itself, dividing the word "symet- / rically." A minor task leads to a fine discovery.

Shaping

Another essential part of composition is *shaping*. As the words of a poem come, they must be deployed in lines. Sometimes the earliest verbalization carries with it an intuitive sense of form—as Whitman's earlier draft was similar in length and number of lines to his final "A Noiseless Patient Spider." But often the first phrases are a scattering, fragments with no certainty even as to which should come first. As a poem grows, the poet opts for some possible form, however tentative, which can be tested and altered as draft leads to draft. Meter? Rhyme? Free verse? Longer lines? Stanzas? The initial preference may be habitual, as Dickinson or William Carlos Williams instinctively worked in very short lines, or Whitman in very long lines. But a given poem may want a different sort of form. In "Yachts," for instance, Williams elected to write in lines much longer than was his custom: "Today no race. Then the wind comes again. The yachts // move, jockeying for a start, the signal is set"

In choosing stanzaic forms, whether in free verse or in meter, the poet looks for a pattern that can be used fully, without slackening, in subsequent stanzas. Of "I Hoed and Trenched and Weeded," A. E. Housman commented: "Two of the stanzas, I do

not say which, came into my head. . . . A third stanza came with a little coaxing after tea. One more was needed, but it did not come: I had to turn to and compose it myself, and that was a laborious business. I wrote it thirteen times, and it was more than a twelvemonth before I got it right." Poems don't always unwind from the top. Robert Lowell recalled that his well-known "Skunk Hour" was "written backwards," the last two stanzas first, then the next-to-last two, and finally the first four in reverse order. Similarly, many poets don't come to a final title until they have finished the poem.

Along with a tentative choice of form, shaping involves the experimental sculpting or fitting of further parts to the developed design. In the published versions of Marianne Moore's "The Fish," we can trace her shaping, her discovery of a poem's final form. Here is the earliest version, which appeared in a magazine in 1918:

The Fish

Wade through black jade.
Of the crow-blue mussel-shells, one
Keeps adjusting the ash-heaps;
Opening and shutting itself like

An injured fan. 5
The barnacles undermine the
Side of the wave—trained to hide
There—but the submerged shafts of the

Sun, split like spun
Glass, move themselves with spotlight swift- 10
Ness, into the crevices—
In and out, illuminating

The turquoise sea
Of bodies. The water drives a
Wedge of iron into the edge 15
Of the cliff, whereupon the stars,

Pink rice grains, ink-
Bespattered jelly-fish, crabs like
Green lilies and submarine
Toadstools, slide each on the other. 20

All external
Marks of abuse are present on
This defiant edifice—
All physical features of

Accident—lack 25
Of cornice, dynamite grooves, burns

And hatchet strokes, these things stand
Out on it; the chasm side is

Dead. Repeated
Evidence has proved that it can 30
Live on what cannot revive
Its youth. The sea grows old in it.

Despite its normal appearance, the poem's form is novel. Unmistakable rhyme-pairs—wade-jade, keeps-heaps, an-fan, and so on—*begin* and end lines 1 and 3 of each stanza. Self-enclosed in sound, tightly laced, these lines seem to resist the otherwise fairly straightforward movement of the sentences, so that the poem alternates between rigidity of rhyme and fluidity of run-ons (even over stanza breaks), mimicking the unpliant surfaces within the water and pliant water itself. Perhaps the problem is only that a reader, unaccustomed to the rhyming device, finds the novelty more distracting than helpful. But the poem seems not to have its right form.

Whatever her reasons, Moore's own dissatisfaction with this 1918 version is clear from the appearance, in an anthology the next year and in her book *Observations* in 1924, of a quite different version of the poem:

The Fish

wade
through black jade.
 Of the crow-blue mussel shells, one
 keeps
 adjusting the ash heaps; 5
 opening and shutting itself like

an
injured fan.
 The barnacles which encrust the
 side 10
 of the wave, cannot hide
 there for the submerged shafts of the

sun,
split like spun
 glass, move themselves with spotlight swift- 15
 ness
 into the crevices—
 in and out, illuminating

the
turquoise sea 20
 of bodies. The water drives a

 wedge
 of iron through the iron edge
 of the cliff, whereupon the stars,

 pink 25
 rice grains, ink-
 bespattered jelly-fish, crabs like
 green
 lilies and submarine
 toadstools, slide each on the other. 30

 All
 external
 marks of abuse are present on
 this
 defiant edifice— 35
 all the physical features of

 ac-
 cident—lack
 of cornice, dynamite grooves, burns
 and 40
 hatchet strokes, these things stand
 out on it; the chasm side is

 dead.
 Repeated
 evidence has proved that it can 45
 live
 on what cannot revive
 its youth. The sea grows old in it.

Two verbal changes sharpen Moore's images: "The barnacles *undermine* the / Side of the wave—trained to hide / There—*but* . . ." becomes "The barnacles *which encrust* the / side / of the wave, *cannot* hide / there *for* . . ." The simpler physical image of encrusting replaces the ambiguous idea of undermining, and clearly focuses the wit of reversing the usual way of seeing barnacles as belonging to, being attached to, the rock surface. The change also makes moot the possible questions of "trained to hide" how, by whom?—a training which, in any case, doesn't prevent the shafts of sunlight from spotlighting them.

 In stanza 4, "Wedge of iron *into* the edge" becomes "wedge / of iron *through* the *iron* edge . . ." The repetition of "iron" makes the opposed forces—sea against cliff— equal; and the denser sound seems appropriate for these unyielding forces.

 As you saw immediately, the most dramatic change is visual: For the 1924 version Moore opens up the earlier boxy stanza and devises a pattern of indentation. The re- lining *in effect* moves each flush-left rhyme-syllable up to a line of its own. So,

An injured fan

becomes

an
injured fan

This simple change, technically making both words *end*-rhymes, relieves the odd pressure in the 1918 version of the rhymes' seeming to bind or frame each line too tightly with itself. The 1924 stanzas rhyme *a a b c c d.*

The result might have been merely:

an
injured fan.
The barnacles which encrust the
side
of the wave, cannot hide
there for the submerged shafts of the

Moore, variably indenting the rhymed and unrhymed line pairs, introduces a further flexibility into the stanza shape—a visual "in and out" that suggests the sea shifting against the shore. Also by dropping the line-capitals of the 1918 version, she makes the poem look more fluid. In 1924, "The Fish" exemplifies great fluidity and, in the unvaried syllabics and unremitting rhyming (which incorporates any word, however unimportant), great rigidity.

Reprinting the poem in 1935, with no verbal changes whatever, Moore made one further adjustment: moving the single-syllable lines 4 up to the end of lines 3, making a five-line stanza: *a a b b c.* Thus:

The Fish

wade
through black jade.
 Of the crow-blue mussel-shells, one keeps
 adjusting the ash-heaps;
 opening and shutting itself like 5

an
injured fan.
 The barnacles which encrust the side
 of the wave, cannot hide
 there for the submerged shafts of the 10

sun,
split like spun

glass, move themselves with spotlight swiftness
into the crevices—
 in and out, illuminating 15

the
turquoise sea
 of bodies. The water drives a wedge
 of iron through the iron edge
 of the cliff, whereupon the stars, 20

pink
rice grains, ink-
 bespattered jelly-fish, crabs like green
 lilies, and submarine
 toadstools, slide each on the other. 25

All
external
 marks of abuse are present on this
 defiant edifice—
 all the physical features of 30

He cuts the grass and pulls the ivy back
and ~~turns~~ to knock the wasp nest
out of the eaves.
He is imposing order, but he leaves
some high grass in a corner of the yard
where his dog turns intently clockwise
first and then reverses itself
and lies down.
Thus man and dog shape the world
to fit their individual ends.

ac-
cident—lack
 of cornice, dynamite grooves, burns and
 hatchet strokes, these things stand
 out on it; the chasm side is 35

dead.
Repeated
 evidence has proved that it can live
 on what cannot revive
 its youth. The sea grows old in it. 40

The poem becomes less fussy, by avoiding the *two* monosyllabic rhyming lines of the
1924 stanza, which—as in the unindented form of it printed above—makes the pat-
tern of lines 1–3 and 4–6 rhythmically duplicative. The 1924 stanza, by contrast,
seems perhaps more exacting, more brittle. In the 1935 version, stanzas cast in pro-
gressive indentations shape the most flexible and expressive of Moore's attempts,
and demonstrate how even small adjustments in a poem's shape can open up nu-
ances and give a poem resonance.

A Set of Drafts

So far we have been examining fair copies or transcriptions from poets' manuscripts,
not actual working drafts with their scribbles and scrawls, arrows, jottings, marginal
lists, doodles, and even coffee stains. For the poet's own use, often poured out in a
rush, actual manuscripts are usually a mess and often indecipherable—except to the
poet. The four drafts of "Politics" by Miller Williams, however, are fairly legible and
we can follow in them all the twists and turns in the writing of the poem.

DRAFT 1

He has discovered the *given* of the poem: a parallel between the man's chores—
mowing, restraining ivy, knocking down a wasp nest—and the dog's making a com-
fortable spot in the unmowed grass. Both man and dog "shape the world" to their
own purposes. The similarity registers in the use of the same verb for both. In line 2
the man "turns to knock the wasp nest / out of the eaves"; in line 6 the dog "turns
intently clockwise," mashing the grass.

The poem began in the past tense, but changed in line 4 to present; the only cor-
rections on the manuscript are to alter the tense in the early lines.

In form, the poem seems to have fallen out naturally enough: two stanzas, one for
the man, one for the dog. The short third line in each stanza, which gives them a
similar shape, may have seemed thematically relevant. The rhyme "eaves-leaves" in
lines 3–4 appears casual or accidental (we see no sign of a further effort to rhyme),
but perhaps the poet initially left line 3 short, with the ending "eaves," in anticipa-
tion of "leaves" coming just ahead. Present tense and potential rhyme may have sug-

gested the corrections in lines 1–2. The draft demonstrates that the poet is alert to various formal possibilities in the unfolding poem.

As Williams usually writes in meter, it seems natural that lines 1, 4, and 5 are distinct pentameters and several others tetrameters (or nearly). In this draft, however, he seems more to be listening to the poem than imposing formal choices.

DRAFT 2

The draft shows so many changes—and very few corrections written on the draft—that the poet must be doing much of the work in his head.

The most striking choices have been in the poem's form. The draft now blocks out three rhymed quatrains and a couplet, with little squiggles in lines 11, 12, and 13 to hold the form open for completion later. Except for a rhyme-word missing in line 11, a rhyme scheme is in place. Line 12 proposes somehow to end "please her" to rhyme with "Caesar." The poem is rapidly becoming a sonnet.

No less decisively, the draft exhibits a leap forward in exploring the subject matter. Drawing on the ideas of imposing order and shaping the world in Draft 1, the title "Politics" firmly asserts the theme. Though the word will disappear from the poem later, "civilize" offers rich implications; and the appearance in line 10 of Newton, Christ, and Caesar, in a poem about mowing the grass, makes a larger claim than one could have expected from Draft 1. Didn't these historical figures in their very different ways try to "reshape the world," just as the man and dog do, as everyone is bound to do? Caesar, of course, is a political figure, as is Christ if we consider his ethical teachings. William's change in line 13 from the flat "they are friends" to "help their friends" suggests those teachings. Newton seems problematical; perhaps Williams is considering Newton's discoveries of the laws of an orderly universe.

We can see another relevant change in line 2: "briar" for ivy in Draft 1. More aggressive than the ivy, the thorny plant suggests (as does the wasp nest) a world that is complex, tangled, and harsh, like the fallen world after Eden, requiring a politics of force—the destruction of the wasps—to protect the safety and comfort of the speaker's home. The insertion of "swarming" in line 7 extends the suggestion.

The draft resolves the tense in lines 1–3: "having done with . . ." Removing the briars and wasp nest involves completed action in the past. This change allows the opening sentence to flow smoothly into line 3 ("he imposes order . . ."), stressing the values implied in its main clause.

The development of the draft, however, pays a price in wordiness. In line 4 the aside "because he always does" seems unnecessary (the phrase will disappear in Draft 3). "To *take and* reshape the world" in line 11 sounds awkward, and the same idea recurs somewhat redundantly in "civilize / a part of the world" (lines 8–9) and in "to change the world they find" (line 14). No doubt the poet notices the redundancy but sees the draft as very tentative, as the squiggles and the continuing casualness about meter suggest. Although the sonnet form raises an expectation of pentameters, a number of lines remain tetrameters with no sign of metrical tinkering; and the pentameter of line 4 in Draft 1, which will reappear in all further drafts—"he is imposing order, but he leaves"—is made (and kept) tetrameter here. The poet is rough-

POLITICS

[handwritten draft with numerous deletions and insertions]

Cutting the grass, having done with a ~~mess~~ tangle
of briar, a wasp nest in the eaves,
he imposes order; ~~tho~~ still he leaves,
because he always ~~does~~ some high grass (fence/angle)

where his dog turns intently clockwise
~~once~~ ~~first and~~ then turns around the other way,
making a ~~bed~~ to spend the swarming day.
 place
Thus the man and dog each civilize

a part of the world. He knows they both are bound
as everyone is, Newton and Christ and Caesar,
to take and reshape the world
 please her
 help their
 to ~~they are friends~~
~~who~~ change the world they ~~just~~ to fit their ends.

ing the poem in, still trying out and staying open to new possibilities that may alter its direction.

He decides to forgo the not-very-convincing rhyme "mess-grass," scratching out "mess" for the richer "tangle." The poet jots down a possible rhyming phrase in a circle in the margin—"fence/angle"—but how to work out that change remains the work of the next draft.

DRAFT 3

With the deletion of "because he always does," line 4 runs fluently to the rhyme "angle." Switching "ragged" for "high" enriches and clarifies—high grass might easily be a foot or more—and not incidentally makes the pentameter regular. In copying line 2, Williams had omitted the nest from Draft 2, so the sense is simply "having done . . . with wasps in the eaves." A change to "yellow jackets"—the insects themselves now rather than their nest—generates a more colorful line and a more graceful pentameter. Except for small adjustments, stanza 1 is now in its final form.

Since Draft 1, the dog's circling one way, then the other to mat the grass has taken up a lot of space for the little work the description does. Even the omission of "around" in copying from Draft 2 doesn't get it right. The marginal queries—"shade?

shadow?"—indicate the poet's dissatisfaction with that stanza, but he leaves tinkering with it for later.

In Draft 3, Williams fleshes out stanza 3. He discovers the missing rhyme: "hound," a choice just light enough in tone to keep the poem's heavy theme from weighing it down. Along with the verbal cleverness in the ultimate version of line 10 ("A square yard of his yard . . ."), the comic "hound" prepares for the pun that has all along been lurking in the last line: "to fit their ends": the dog's backside. Though serious, the poem maintains an amused detachment about its claims.

The choice "hound" fits into line 9—they "civilize / the world to suit a human and a hound," with its tempting alliteration—thus requiring the pushing down of the two lines in Draft 2 about being "bound / as everyone is, Newton and Christ and Caesar."

Fortunately, the space marked by squiggles and wasted by the redundancy "to take and reshape the world" can absorb these displaced lines. Although the projected rhyme "Caesar-please her" helped to personalize the dog as a she ("itself" in Draft 1), the rhyme might have been problematic anyway, and so becomes "her-were," set up by the new line 10: "This little piece of the yard belongs to her. . . ." Having shifted "as everybody is" to line 13, Williams easily replaces Newton with the more appro-

priate Jefferson. Further, the modification to "Jesus" is apt. As well as alliterating with "Jefferson" (which helps the line sound inevitable), "Jesus" makes the line regularly metrical without the rather ponderous rhythm of "Christ and Jefferson and Caesar were." The three historical figures are not arranged chronologically, as might seem natural, but the order interestingly suggests a spectrum from most altruistic to least. Jefferson, thus, with the ideals of democracy and equality, seems a balancing figure between Jesus and Caesar. The change to "Jesus" also emphasizes his human, rather than his divine, nature; and so reminds us of the radicalism of his teachings as well as of his own confrontations with political authority. The thorns of the "briar" perhaps hint at his crown of thorns.

DRAFT 4

Developing the marginal query of Draft 3 ("shade? shadow?"), a new line 5 provides a sense of the coziness of the dog's fence-corner, "trapping a small shadow most of the day." The new stanza turns the rhyme scheme inside out—"day" moves from

POLITICS

Mowing the lawn, having done with a tangle
of briar, with yellow jackets in the eaves,
he is imposing order, but he leaves
some ragged grass where the fence makes an angle
 small
trapping a shadow there most of the day.
On the swarming morning, circling clockwise twice
his dog turns herself intently clockwise
then ~~lies~~ on the flattened grass. This is the way
 drops
she reshapes the world to suit a hound.
He always leaves a square yard to her
because he knows that both of them are bound
as Jesus, Jefferson, and Caesar were
too.
(as all people are, and some small friends)
to change the stubborn world to fit their ends.

the second to the first line of the stanza, freeing "way" to serve as the connective from line 8 to line 9: "This is the way // she reshapes the world to suit a hound." Choosing between "civilize" and "reshape" from Draft 2 (dropped in Draft 3), Williams opts to reinsert the simpler. The redundancy in line 9 in both Drafts 2 and 3 ended up including both man and dog in the statement and so preempted the conclusion in line 14 that properly brings them together. Note how the summarizing "Thus" of the last sentence of Draft 1 had moved up to line 8 in Draft 2 ("Thus the man and dog each civilize . . .") and persisted there in Draft 3. Line 9 now focuses on the dog only, preventing an early summary that would short-circuit the poem's ending.

The idea of "because he always does" in Draft 2 reemerges here to fill out line 10: "He always leaves a square yard to her . . ." The draft drops the idea of the dog's possession ("belongs to her" in Draft 3) as possibly problematic. In the final poem, a witty repetition of "yard" will displace the irrelevant "always"—it needn't matter that the concession is habitual—giving the line a fresh rhetorical snappiness: "A square yard of his yard he leaves to her"

With the rhyme "civilize" out of the way, the right formulation occurs to the poet in recopying line 6. He strikes out "clockwise" in favor of "circling twice," and lets "clockwise" end line 7. Now he has room to recast line 8 to close the sentence: "then ~~lies~~ drops on the flattened grass." Finally the reason for her painstaking circling comes clear in the phrase "flattened grass."

In line 13, "everybody is" gives way to "all people are," and allows the phrase "and some small friends" (which includes the dog) a more logical completion of the line. As he had edged away from "belongs to her" (in Draft 3), the poet here also keeps the human perspective at the center. If "some small friends" reminds readers that others are enemies and must be excluded (the yellow jackets), they're also reminded how tricky the world can be. Politics is essential to the continual readjustments the world requires. The plainer, matter-of-fact "world they find" of Draft 3 gives way to "the stubborn world" (and in the finished poem to "a stubborn world"), which provides a fitting emphasis.

Several other small but meaningful changes from Draft 4 to the published poem deserve comment. In line 2, yellow jackets (which nest in the ground) will become "hornets"—leaving space for the alliterating "buzzing." In line 11, "because he knows that both of them" will become "because he sees that both of them" "Knows," which survived since Draft 2, is static, whereas "sees" suggests a realization. Drafting the poem has led him to create a motivating incident for the poem: As he cuts the grass, he thinks about his chores and arrives at a freshened sense of the world and what we make it.

The somewhat plodding "This is the way" of line 8 will become, simply, "In this way / she reshapes" Often we have observed the poet, in making some change, also clicking the pentameter into regularity. But through this good though minor change in line 8 the poet roughs up the rhythm of a line—the poet cares most that the line sound natural. Williams is listening to the poem, not following the cookbook. Similarly, he has been untroubled throughout that stanzas 1 and 2 rhyme *a b*

b a, while stanza 3 rhymes *a b a b,* thus mingling qualities of Italian and Shakespearean sonnets.

In copying line 13 into Draft 4, Williams began it without a stanza space, realized the mistake and scratched it out, then restarted the line a space below. But the "mistake" was actually a poet's keen instinct. In publishing the poem he closed up the stanza breaks, pleased, as he commented, for the poem "to be secretly a sonnet, and not ostentatiously a sonnet."

Politics

Mowing the lawn, having done with a tangle
of briar, with hornets buzzing in the eaves,
he is imposing order, but he leaves
some ragged grass where fences make an angle,
trapping a small shadow most of the day. 5
There, in the swarming morning, circling twice,
his dog turns herself intently clockwise
then drops on the flattened grass. In this way
she reshapes the world to suit a hound.
A square yard of his yard he leaves to her 10
because he sees that both of them are bound
as Jesus, Jefferson, and Caesar were
(as all people are, and some small friends)
to change a stubborn world to fit their ends.

The impulse for a poem is often sudden, a luminous notion, a glimpse, and, like Whitman, the poet's "gossamer thread" catches somewhere. As with "Politics," the poet intuits the richness or complexities implied in that glimpse. Writing the poem becomes, as Philip Larkin noted in a letter, "like trying to remember a tune you've forgotten. All corrections are attempts to get nearer the forgotten tune."

Questions and Suggestions

1. Take a completed but somehow still unsatisfactory poem of yours and take another stab at revising it. Read it aloud several times. Does something make you wince? Does something thud? That might be the trouble spot. Take out the phrase. Recast the sentence in another syntax. Or rethink the metaphor. If the poem is metered, try taking a foot out of each line; does that open it up? Look back through the drafts for a lost word, image, or detail that might start the poem over again.

2. After looking over Appendix I, p. 331, write a sonnet, selecting all the rhyme words first and arranging them on the page. Then fill it in, keeping the meter. Write *anything*; don't worry too much about it making sense.

3. Sometimes ruthlessness helps. If you have a poem that seems to take a long time but gets nowhere, try crossing our *every other line*. Even if they're good lines, cross them out (but don't erase). Now try to join together the lines that are left. Let the ideas/images in one line leap to the next. Can you find a more dynamic poem in the lines that remain? Add back the *essential* parts you crossed out, but go easy. Often less is more.

4. Try your hand at an **abecedarian,** a variant of an acrostic, in which each line begins, in order, with a letter of the alphabet. Copy the letters of the alphabet down the left side of a blank page, and begin filling in the lines, using each next letter as a clue for what might come next. Robert Pinsky in his "ABC" (p. 305) set himself the extra challenge of writing an abecedarian which the *words* of the poem are alphabetical: "Any body can die, evidently," the poem opens.

5. Here are the first six drafts of the opening lines of Richard Wilbur's "Love Calls Us to the Things of This World." Examine how they show the poet exploring, trying out, focusing, and shaping ways to begin the poem. What losses and gains does he make as he drafts the stanza?

DRAFT 1

My eyes came open to the squeak of pulleys
My spirit, shocked from the brothel of itself

DRAFT 2

My eyes came open to the shriek of pulleys,
And the soul, spirited from its proper wallow,
Hung in the air as bodiless and hollow

DRAFT 3

My eyes came open to the pulleys' cry.
The soul, spirited from its proper wallow,
Hung in the air as bodiless and hollow
As light that frothed upon the wall opposing;
But what most caught my eyes at their unclosing 5
Was two gray ropes that yanked across the sky.
One after one into the window frame
. . . the hosts of laundry came

DRAFT 4

> The eyes open to a cry of pulleys,
> And the soul, so suddenly spirited from sleep,
> Hangs in the air as bodiless and simple
> As morning sunlight frothing on the floor,
> While just outside the window 5
> The air is solid with a dance of angels.

DRAFT 5

> The eyes open to a cry of pulleys,
> And spirited from sleep, the astounded soul
> Hangs for a moment bodiless and simple
> As dawn light in the moment of its breaking:
> Outside the open window 5
> The air is crowded with a

DRAFT 6

> The eyes open to a cry of pulleys,
> And spirited from sleep, the astounded soul
> Hangs for a moment bodiless and simple
> As false dawn.
> Outside the open window, 5
> The air is leaping with a rout of angels.
> Some are in bedsheets, some are in dresses,
> it does not seem to matter

Poems to Consider

Love Calls Us to the Things of This World 1956

RICHARD WILBUR (b. 1921)

> The eyes open to a cry of pulleys,
> And spirited from sleep, the astounded soul
> Hangs for a moment bodiless and simple
> As false dawn.
> Outside the open window
> The morning air is all awash with angels. 5
>
> Some are in bed-sheets, some are in blouses,
> Some are in smocks: but truly there they are.
> Now they are rising together in calm swells

Of halcyon feeling, filling whatever they wear
With the deep joy of their impersonal breathing; 10

 Now they are flying in place, conveying
The terrible speed of their omnipresence, moving
And staying like white water; and now of a sudden
They swoon down into so rapt a quiet
That nobody seems to be there.
 The soul shrinks 15
 From all that it is about to remember,
From the punctual rape of every blessed day,
And cries,
 "Oh, let there be nothing on earth but laundry,
Nothing but rosy hands in the rising steam
And clear dances done in the sight of heaven." 20

 Yet, as the sun acknowledges
With a warm look the world's hunks and colors,
The soul descends once more in bitter love
To accept the waking body, saying now
In a changed voice as the man yawns and rises, 25

 "Bring them down from their ruddy gallows;
Let there be clean linen for the backs of the thieves;
Let lovers go fresh and sweet to be undone,
And the heaviest nuns walk in a pure floating
Of dark habits,
 keeping their difficult balance." 30

◈ An Onondaga Trades with a Woman Who Sings with a Mayan Tongue 1994

GAIL TREMBLAY (b. 1945)

We trade in Spanish, but you with the rich
cloth, tell your son how to behave in Mayan,
a language so beautiful it sings in my ears.
I watch him sit straight on the sofa in the hotel
lobby; your words giving dignity to his face. 5
I long to speak to someone in Onondaga, wondering
if you would recognize it as an indigenous tongue
since your world is so full of foreign languages,
and my people live so far north, our sounds
cannot be familiar to your ears. Attracted 10
by my braids, you unwrap the fingerbraided,
tasseled band from your own and offer it for sale.
I feel hesitant because it is so outside

my own tradition, but in the end your insistence
and its beauty make it mine. I wish my Spanish 15
were better, so I could make you understand
why I may never wear it, but will always treasure
it because you were proud enough to keep the old ways
alive and to want to see my hair properly bound
according to your custom making me less a stranger 20
in this, your sacred and most magic place.

ABC 1998

ROBERT PINSKY (b. 1940)

Any body can die, evidently. Few
Go happily, irradiating joy,

Knowledge, love. Many
Need oblivion, painkillers,
Quickest respite. 5

Sweet time unafflicted,
Various world:

X=your zenith.

Interim Report 1984

ELTON GLASER (b. 1945)

You could check out like the dandelion's
tatterdemalion, or like a fuel-injected starlet
wrecked in her Eldorado, blown away
with a choir of accountants piped in and
dismal wings squalling around the brain. 5

Might as well lie face down in the frogweed
and go peacefully. Let others drag their claws
across the blue back of the sky—it's all you can do
to keep your bowels out of a bowknot. Already
your heart is kicking the blood through with a curse. 10

And nothing now can save you, neither
the doctors nor the doctrines. Your bones rattle
like the spiel of an auctioneer, each sense
foreclosed and on the block, the creditors lining up
to claim what the beetle and the blowfly can salvage. 15

Woman on Twenty-Second Eating Berries 1990

STANLEY PLUMLY (b. 1939)

She's not angry exactly but all business,
eating them right off the tree, with confidence,
the kind that lets her spit out the bad ones
clear of the sidewalk into the street. It's
sunny, though who can tell what she's tasting, 5
rowan or one of the service-berries—
the animal at work, so everybody,
save the traffic, keeps a distance. She's picking
clean what the birds have left, and even,
in her hurry, a few dark leaves. In the air 10
the dusting of exhaust that still turns pennies
green, the way the cloudy surfaces
of things obscure their differences,
like the mock-orange or the apple-rose that
cracks the paving stone, rooted in the plaza. 15
No one will say your name, and when you come to
the door no one will know you, a parable
of the afterlife on earth. Poor grapes, poor crabs,
wild black cherry trees, on which some forty-six
or so species of birds have fed, some boy's dead 20
weight or the tragic summer lightning killing
the seed, how boyish now that hunger
to bring those branches down to scale,
to eat of that which otherwise was waste,
how natural this woman eating berries, how alone. 25

Two Poems of Advice 1998

WAYNE DODD (b. 1930)

A fence separates, it joins.
Always keep your hands

to yourself. Every night of summer
insects rush toward you, their hidden

eyes, the ones inside 5
their chests, are red, they glow

with desire. They want to
touch your face and lick

your crevices, reach in,
with their long tongues, 10

to where your wings,
in darkness,

sleep—the irresistible
taste of salt . . .

Always keep your mouth shut 15
when you speak

of desire. What if you have fallen asleep
unawares, the counterpane of evening

now falling across your face,
your shoulders? *Oh lilacs dark* 20

beneath the window! Think of the consequences,
the implications . . .

❖ Tuna 1998

MICHAEL WATERS (b. 1949)

Crete

Icy with sea-surge, only three
 green flies excavating
 the vitreous humor
 of its yellow eye, God-flung
galaxies perishing down the scales, 5
 the tuna overhung the warped
 wooden plank like Christ's
 body, ribboned & bloody,
pried from the cross to be dressed
 for its brief burial. But 10
 must every fish in seven
 oceans = Christian symbol?
Lemon leaves concealed the taverna
 till the crone brandishing
 her cleaver—*tono*— 15
 waved us beyond the trellis.
Then two seared slabs rinsed in oil.
 Imagine how long the soul
 must navigate the celestial
 passages before its formal 20
dispersal, how long this creature
 had tunnelled the arctic

channels before delivering
　　its torn shoulder to our table,
before each flake of flesh 25
　　　hesitated along the tongue,
　　　　then plunged the whole
　　body into blue-black mystery.

Jittery Clouds on Memorial Day 1998

MICHAEL NELSON*

As the poppies fade
no more rancor for the double pink
"Sara Bernhardt" peonies that take over.
Glee explores, in particular, the prairie strip
rim, friends have named Godspeed— 5
A lushness of grasses, that helps us avoid
hypocrisy, arouses us as long as no
snow lies on the ground. From the sea
of buttercups she rises, pulling seedlings
of Onopordum Acathium, (donkey fart in Greek), 10
the insistent silver thistle.
Tending to stiffness she honors high sonority,
rests on the roof of the abandoned play house,
happy to watch the desert marigold
from the poorest soil emerge, 15
and the fireweed that colonized
London after the blitz.
She eats with sticks a dark heartwood
from cartons, Cantonese,
gives way to pussy toes 20
and small elegies for the quick light
that skips across the ground of this day.

Landscape 1998

DEBORAH TALL (b. 1951)

The eye is aimed at.
Hounds give chase in the throat.
Oh island, oh man.
The underbrush is ripping
my ankles though we kiss 5
and kiss. I have climbed the cliffs
where the wives wait,
quicksand and crazy currents

beneath. The children
never learned to swim. 10
We knit their names into mist.

Buzzards huddle.
Headlights drift the hills
remote as stars. The sun
is only a star 15
(you knew that) but once
upon a time we
drank it neat.
The tense is passing.
The path to your ear 20
is cemented, fenced.

In the suburbs of the heart is
where we live now.

Fruit Flies to the Too Ripe Fruit 1997

MICHELE GLAZER

Fruit flies are useful in studies of heredity
because they multiply readily and are easy to keep.

From a bowl, deeply between green apples some things stir

like inklings of a long secret.

When the boy asks *where do they come from*, say *never*. 5

Not to exist until the fruit rots and then be

ubiquitous is the secret to a long memory.

Some are drawn to the spoiling.

Some sweat out of the smooth-skinned fruit

the way buried in a question is another question. 10

When the boy asks *how do you know*

toss out the hollowed cantaloupe to loosen the flies.

When the boy asks *where do they disappear to* whisper

always

Not to exist long but to metamorphose with each 15
individual extinction is the secret to a long shadow.

In this version of the story the father moves out.

12

BECOMING A POET

Becoming a poet is almost always a sort of accident. Liking poems turns into writing poems; writing poems leads to reading more poets and, influenced by them, the beginning poet continues to experiment, struggling to get each new poem right, learning, draft to draft, poem to poem. And in working on poems and reworking poems, one becomes a poet.

Sooner or later the beginner shows some work to a friend or a teacher, enrolls in a writing class, perhaps has a few poems published in the school or college literary magazine. Then one day, with some encouragement and determination, the poet takes a chance and sends some poems off to one of the literary magazines he or she has been reading. And probably the editor sends the poems back because they aren't quite good enough—yet. And sometimes—only sometimes—despite all the discouragements. . . .

What drives poets to write? Is it a love of words, of ideas, of discovery through language? Is it because nothing else is quite as challenging and fulfilling? Or are poets driven by less noble motives like power and fame? Poets are often hard put to say for themselves, and surely every poet writes for a unique combination of motives. For some writers the issue may be as simple as Flannery O'Conner's response to a student who asked, "Why do you write?" "Because I'm good at it," she answered.

The growth of a poet usually takes years, and if the poet is lucky and determined that growth continues. Reading the early writing of poets like Dickinson and Whitman can be tremendously reassuring. One of Dickinson's earliest poems, written when she was about nineteen, is an unremarkable valentine. Here are a couple of lines:

> Oh the Earth was *made* for lovers, for damsel, and hopeless swain,
> For sighing, and gentle whispering, and unity made of twain.

Fuzzy, sentimental images, slack lines, wooden rhythms, pedestrian or inflated diction—no arresting noun or verb in either line—make it typical of the drawing-room poems of its time and in many ways typical of most poets' early work. It merely makes pretty a commonplace notion. It doesn't grapple. It certainly doesn't make a

reader, as Dickinson later defined poetry, "feel physically as if the top of my head were taken off." Reading it, one could not predict that in her early thirties she would be writing some of the most powerful and distinctive poems in our language.

Whitman's early poems are as slight as Dickinson's valentine. Here is a stanza of "Our Future Lot," published in a newspaper in 1838 when Whitman was nineteen:

> O, powerless is this struggling brain
> To pierce the mighty mystery;
> In dark, uncertain awe it waits,
> The common doom—to die!

Egads! This doggerel hardly anticipates the poet who would pierce the mystery in poems like his elegy for Lincoln, "When Lilacs Last in the Dooryard Bloom'd" (even the title tells us how far Whitman had come from his "Our Future Lot"). Dickinson's and Whitman's early work share at least one problem: The poems aim to decorate a fact or a feeling rather than to discover or explore. They don't take chances. They are unadventurous. Language appears to act as a servant to a preordained "meaning." The poems are written from the outside in, instead of from the inside out: through exploration, trusting in the poem.

Obviously both beginning poets grew dissatisfied with their early efforts; they wrote more poems and read more poems. They read the journals of their age and immersed themselves in the world around them—even if that world, in Dickinson's case, was centered in a house and garden in Amherst, Massachusetts. Dickinson found guides in Shakespeare, George Herbert, and her older contemporary, Elizabeth Barrett Browning. Whitman found guides in the Bible, Shakespeare, and his older contemporary, Ralph Waldo Emerson. They grew up and became, in the great mystery of such things, our great foremother and forefather of American poetry.

The Growth of a Poet

Don't be too hard on yourself when a poem fails—failed poems can teach you much. And don't be embarrassed to be a beginner. Had there been creative writing classes in the sixteenth century, who knows, the student scribbling in the back of the room might have been a sophomore named Will Shakespeare.

Poets grow in the struggle, draft to draft, to make each poem fulfill itself. But "fixing" poems may not be the most important thing. Often, as Marvin Bell remarked, "revision means writing the next poem." For it is in the zigzag progress from poem to poem that the beginning poet develops. In this section we will follow the development of a student, C. Lynn Shaffer, through several poems over time.

Here is one of the first poems Shaffer wrote:

A Baglady's Plea

Another stretch of city street—
I turn to you but your eyes don't meet

Mine.
Can you not feel?

My heart beats, 5
With love,
With grief,
As yours does; do you see me in the rain?

My clothes are tatters; my shoes are worn,
But flesh and blood are things with which we both were born. 10
It's useless,
I won't lay blame.

If you would but try
Looking into my eyes you would see
Yourself in disguise— 15
Our souls are exactly the same.

A clear strength of this poem is that instead of talking generally about homelessness, Shaffer has created a dramatic situation to embody the problem, with a character (though a generalized one) as speaker. A phrase, ("Another stretch of city street") succinctly draws the scene. The poem also generalizes the "you"; we learn nothing specific about the age, sex, or class of the person whom the speaker encounters and who apparently ignores her. We see only the gesture of this person's refusal to meet the speaker's eyes.

The appearance of the poem on the page—free verse in four end-stopped quatrains—shows Shaffer's trying to give it a distinct shape. But several lines fit awkwardly. Several seem needlessly abrupt (like line 3) or gangly (particularly line 10), forced to obey the quatrain form. Only in stanza 4, as if with practice, do the lines begin to move with poise and precision. Elsewhere the poem seems off-balance, as in line 8, where the end of the stanza's first main clause seems jammed in with its second main clause, "do you see me in the rain?" Shaffer manages beautifully the line break after line 14 ("Looking into my eyes you would see"), demonstrating that she knows how line breaks can give sentences multiple meanings. Perhaps in line 3 she intended the isolated "Mine" to highlight the speaker's loneliness. As the only one-word line in the poem, however, the line seems an obvious contrivance; and it creates an awkward line break in line 2 ("your eyes don't meet") that offers the odd reading that the addressee has an eye problem of some sort.

The couplet rhymes *street-meet* and *worn-born* (lines 1–2, 9–10) are perhaps too pronounced for free verse or, at any rate, create an expectation of a pattern that seems abandoned, erratically resumed, then abandoned again. A reader may not even notice *blame-same* (lines 12, 16) or, worse, will conclude that the poem's rhymes are merely opportunistic. But the poem skillfully handles the inexact and internal rhymes in stanza 4 *try-[eyes]-disguise*, stressing the similarity between the addressee and the homeless speaker. These inexact and internal rhymes seem appropriate to the poem's free verse as the couplet rhymes do not. In emphasizing the

eyes in the opening and closing stanzas, Shaffer brings the poem full circle and helps it cohere. We sense a whole work before us, not just bits and pieces thrown together.

Admirably, the poem takes risks, dealing with a weighty theme: that if we look beyond appearances the homeless are like the rest of us and deserve the same respect. Decent people would agree with this statement. But does the poem do more than merely appeal to our sense of decency? Does it make the character interesting so the theme awakens in us a fresh response? Does the poem resist easy paraphrasing? If we summarize it, do we hazard leaving out some essential nuance?

The problem may lie in the poem's approach. Labeling the speaker a "baglady" undermines the attempt to show the speaker's essential dignity. The generic (even scornful) term and her tattered clothes are all we know of her. Whom she loves or for whom she grieves remains unknown. Nothing suggests even how it might feel to be forced to carry all one's belongings around in shopping bags. The poem doesn't delve deeply. The speaker asks, "do you see me in the rain?" If we're honest, we must answer, "No." We see only a blurry figure and one apparently ready to assign blame. Might not the passerby's averted eyes mean, not indifference or repugnance, but an all too vivid awareness of how human, and painful, an exchange of looks would be when one can do nothing meaningful to change the situation? Perhaps even the poem's momentary drama is too simplistic, undeveloped.

Now look at a poem Shaffer wrote for her first creative writing class a few months later.

A Butterfly Lands on the Grave of My Friend

Two pieces of translucent blue silk,
the same blue as pieces of her car on Route 7,
stir its own little breeze
in the somber sunlight.
It seems to hang in front of me 5
like a waterfall in air.
I reach out to grasp it.
It feels alive, an unreal blue powder
lingers on my fingertips.

I think life is like the wispy wings of the Wood Nymph 10
(Giant Swallowtail or Long-dash Skipper)
delicate, memorable.

The missionary disappears beyond the tombstones.
Its distinct colors
(like her intentional unfeminine stagger and cackle-snort laugh) 15
remain in my mind, vivid, permanent
as water flowing over stone.

Finding consolation in nature is typical of elegies, but Shaffer's developing craft allows her to treat the subject with some originality and to make it fresh. We might

first notice that Shaffer has grown as a poet in her attention to details: "translucent blue silk," "Route 7," "Wood Nymph," and "cackle-snort laugh." These details help clarify the implicit narrative and, equally important, offer her avenues to explore the situation. For example, in drawing the connection between the color of the butterfly and the color of the wrecked car, the speaker can also indicate how the friend died, and through her exploration of the image of the butterfly, she can give us a secondary impression that the friend was a young and energetic person. Notice, too, her sharper use of verbs, like "stir" and "grasp," which makes the scene feel immediate and dynamic.

Not all the details, however, appear significant. The "Giant Swallowtail" and "Long-dash Skipper" seem to enter the poem only because the poet likes the names. The heavily modified details of line 15 ("her intentional unfeminine stagger and cackle-snort laugh") seem more personally important than crucial to the poem; and the line's length makes it clumsy. The word "missionary" in line 13 is confusing. Is this a literal missionary (where did he or she come from?) or—as we gather after being momentarily distracted—is this the butterfly? Yet what is the butterfly a *missionary* of? Death? But that would seem to contradict the simile that likens the butterfly to life. Also, the word "missionary" prompts a religious reading which nothing else in the poem clearly supports.

But the quality of attention Shaffer pays to the subject shows her growing skills. The speaker carefully examines the butterfly—noticing it "stirs its own little breeze," likening it to "a waterfall in the air," and feeling its "unreal blue powder"—and then she makes this examination central to the poem; it means something. In trying to clearly perceive the butterfly, the speaker gropes for a new understanding of her friend's short life and of how she remembers her: "I think that life is like . . ." Here Shaffer borrows a move from a Mary Oliver poem that she admired, "White Owl Flying Into and Out of a Field" ("so I thought: / maybe death"), and she tries to push the implications of her metaphors. That pushing is what is important for a beginning poet. The result may seem a bit forced and contrived, a bit too easy (for example, the complicated nature of a survivor's memory, which she describes as "vivid, permanent," is glossed over), but the result isn't very critical; more crucial here is that Shaffer is trying to make the images work, do the work of the imagination. In the final line her pushing pays off; she arrives at the fitting simile, "as water flowing over stone." This metaphor doesn't feel strained; it seems to have grown out of the imagery of waterfall (line 6) and tombstones (line 11). Further, it suggests that the speaker contemplates the relationship between the permanent and the mutable: Water often implies life and life forces; stone often implies permanence and death. Yet flowing water erodes stone. The images aren't easy to sort out, yet their complexity makes possible an emotionally complex poem which resists easy paraphrasing.

Rhythmically the final line sounds right, too. As a line of iambic tetrameter in a free-verse poem, it lends authority to the speaker's final words; it sounds measured and thoughtful, giving us a sense that some truth has been won. Line 16 begins to be metrical while line 17 is exact:

rĕmáin | ĭn mў | mínd, vílvĭd, pérlmănént

as wáltĕr flówlĭng ólvĕr stónel.

Even the run-on, "*permanent* / as water flowing," has the air of a graceful paradox. As the last sound in the line, the word "stone" receives extra emphasis and touches a dark note which is slightly undercut by the lulling assonance of the *o*'s in "flowing," "over," and "stone." Throughout the poem, Shaffer's use of internal rhyme, alliteration, and assonance gives the poem cohesion and a rich texture. In the first line, the *u* sounds in "two," "translucent," and "blue" offer musical unity. The counterpointed *r*'s, light *i*'s, and long *i*'s in lines 8 and 9, along with the internal rhyme of "lingers" and "fingertips," help to underline the delicate, ephemeral qualities of the butterfly and set up the coming exploration of life in terms of the butterfly. Sometimes, however, Shaffer's alliteration seems to go too far. The phrase "wispy wings of the Wood Nymph" (nearly impossible to say aloud) sounds overwrought and self-conscious, as though—to use a pun—she were gilding the butterfly.

Notice other small ways, too (like the less formal choice of not using line-capitals) that indicate the poet's development. Especially remarkable is Shaffer's confidence that the *plural* "Two pieces of translucent blue silk" in line 1 can take the *singular* pronoun of "stir *its* own little breeze" in line 2 without confusion—of course, she's using her title to good advantage.

Like Shaffer's earlier poem, this one also has some trouble getting the pace of the lines right. The awkward line 15 may echo the friend's lovable gawky manner, but its seventeen syllables throw the stanza, even the poem, off-balance. We sense that the poet is suddenly trying to stretch the line out to fit in everything.

As Shaffer continued writing and reading, she grew more aware of how to consider and control her lines' inner structure. That attention shows in a poem she wrote the next year.

To Dust

The earth sucks the life right out of you,
Dad told me once, because it has to.
He had to make the dirt bleed rich
in his fields, and the dust stirred
to cling to him for spite. When he ripped 5
the onions from the ground, their roots
hung pale like bloodless veins.

We found him sitting against a sycamore.
He died while the corn stalks waved
in the distance, to the wailing of the pregnant 10
cow, her hooves stomping up poofs of dust.
He must have been watching to make sure

> she made it, must have sat to rest
> while the nose of the calf squeezed
> out towards the light, heart twitching in its chest. 15
>
> They carried him up from the field on a stretcher.
> I held the newborn Black Angus, hot birth stink
> rubbing into my clothes, and I buried my face
> in the slick black squirming flesh.
> Its spindly legs hung over my arms like grass. 20

What a leap! The suppleness of this poem reveals Shaffer's maturing skills. Shaffer's deft handling of balance and imbalance in the lines helps her emphasize a farmer's struggle and quiet acceptance of fate. An impression of alternating force and release pervades the poem and supports its two major themes of birth and death and the congruent images of farming.

The poem opens with a harsh assertion, "The earth sucks the life right out of you," but the next line moderates the assertion: The laws of nature may seem personally malevolent, but are only necessary. The end-stop of line 1 sharpens the emphatic opening line—six stressed and three unstressed syllables—but the sentence runs on to the relatively balanced and more lightly stressed line 2 which closes the sentence as if getting in the last word. Line 3 begins evenly, with a regular pattern of unstressed and stressed syllables, then ends with two stressed syllables. This strong beat is somewhat modulated by the enjambment into the fourth—more lightly accented—line. The first phrase of line 3 echoes the end of line 2 ("because it has to. / He had to . . ."), suggesting the interconnection between the earth and the father, between birth and death, plowing and harvesting, grass and dust.

Shaffer's images and metaphors also draw this connection. The first stanza's closing image of the onions' "bloodless veins," which the father ripped from the ground, recalls how "The earth sucks the life right out of you." Closing her poem, Shaffer touches on this image through the calf to create a subtle resolution: "Its spindly legs hung over my arms like grass." Visually the long leaves of spring onions are akin to the grass. Like the poem's first line, the last line uses six accented syllables but is more rhythmically balanced. We might say it scans as beginning and closing with two iambs with a rhythmic glitch in the middle; therefore, the rhythm suggests a pattern of order-disturbance-order, corresponding perhaps to the thematic cycle life-death-life.

Somewhere along the way the reader may realize with surprise that the poem is in meter. (The little arrhythmia in line 20 scans as a spondee and anapest—"hung over my arms. . . .") Yet the poem so flexibly deploys the meter—with frequent anapests and pyrrhic-spondees—that it may pass unnoticed; its pace underlies the assured, measured flow of the poem's sentences. Lines 8, 10, 15–18, and 20 are pentameters; lines 1–3, 5–6, and 11–13, tetrameters; and lines 4, 7, 9, 14, and 19, trimeters. Only the bacchic foot in line 1 focusing the harsh verb—

The earth | sucks the life | right out | of you,

—is irregular; and perhaps that anomaly, along with the quick variation of line length in lines 1–4 works to conceal the poem's formal undercurrent.

Although a striking poem, "To Dust" might still profit from some fiddling. In writing about death—or any other intense subject—one risks sentimentality and melodrama. Some readers might find the title an example of such heavy-handedness, even though Shaffer has indirectly called up the too-familiar "dust to dust" and has made dust integral to the poem by weaving it into the first two stanzas. Is a similar risky allusion ("all flesh is grass") meant in "flesh" and "grass" in lines 19–20? The danger is perhaps greater as the somewhat mechanical reference may seem decorative and undercut the daring of the final simile. Is "flesh" exactly the right word anyway?

Some refocusing might help lines 9–10. The phrase "the corn stalks waved" in context permits the image that the corn is waving good-bye to the father. Even it unintentional, the **pathetic fallacy** (sentimentally crediting nature with human feelings or behavior) hazards undercutting the tone of somber acceptance and trivializing the farmer's death.

And in lines 10–11 the breaking of the phrase "the pregnant / cow," which jams the flow against the caesura, seems awkward and puts undue emphasis on "pregnant." The point is not that the cow is pregnant—she is giving birth. Shaffer tried moving "cow" back to the end of line 10—

> in the distance, to the wailing of the pregnant cow,
> her hooves stomping up poofs of dust.

—but was dissatisfied. End-stopped, the lines seem flat and passive. Without the strong emphasis the run-on creates, the cow is merely pregnant, uncomfortable, not in labor. The solution may be in recasting the syntax of the passage so that the muscular enjambment carries the meaning with a truer emphasis, something like ". . . in the distance and the pregnant cow / wailed, her hooves. . . ."

These are niggling imperfections in a fine poem. Shaffer has created a vividly imagined world and peopled it. Shaffer herself isn't the speaker, and the father in the poem bears very little resemblance to her own father, who is still alive. In her growth as a poet, Shaffer has come far from the thinly imagined character in "A Baglady's Plea."

Going Public

Professional Poet

Someone the other day called me a professional poet to my face.

"Don't call me that," I cried. "Don't call anyone that. As well talk about a professional friend."

"Oh!" he said.

"Or a professional lover."

"Oh!"

Most poets and readers share Robert Francis's reverence for poetry's intimacy and its often lonely devotion to truth: Trust the poem.

But there is a practical side. For one thing, as we have been saying all along, respect for the poem means getting it right. To make it new, as Pound urges, you must learn not only the trade or craft, but also the traditions that gave birth to the poets who preceded you. Dickinson and Whitman became the poets they became partly

Ox Cart Man

In October of the year,
he counts potatoes dug from the brown field,
counting the seed, counting
the cellar's portion out,
and bags the rest on the cart's floor.

He packs wool sheared in April, honey
in combs, linen, leather
tanned from deerhide,
and vinegar in a barrel
hooped by hand at the forge's fire.

He walks by ox head, ten days
to Portsmouth Market, and sells potatoes,
and the bag that carried potatoes,
flaxseed, birch brooms, maple sugar, goose
feathers, yarn.

> An odd phrase.
> Is it better than
> "by the ox's head"?

When the cart is empty he sells the cart.
When the cart is sold he sells the ox,
harness and yoke, and walks
home, his pockets heavy
with the year's coin for salt and taxes,

and at home by fire's light in November cold
stitches new harness
for next year's ox in the barn,
and carves the yoke, and saws planks
to build the cart again

> This strikes me as
> the place to stop.

and in March taps sugar trees,
and in April shears wool
from sheep that grew it all over again,
and in May plants potatoes
as bees wake, roused by the cry of lilac.

> omit

> Very well finished. No big cracks that I can see.
> I'm pretty sure about omitting the last stanza—
> it's fidgety. And redundant.

because they knew earlier traditions so well that they could challenge them, change them, and bring other traditions to them to create new traditions. Poets such as Joy Harjo, Derek Walcott, Garrett Hongo, M. Scott Momaday, and Rita Dove have found new ways to marry the European traditions of poetry to the oral and musical traditions of their ancestral cultures—to line singing, jazz rhythms, ceremonial chants—to the multifarious aspects of the world's traditions, past and present. Knowing the great (and even the not-so-great) work of other poets both humbles and thrills any poet. John Dryden scolds poets who, rashly deciding they know all about poetry before they have immersed themselves in it, conclude that "Virgil, compared to them, is flat and dry; / And Homer understood not poetry." Don't be too quick to grab a theory about poetry; theories—like the knowledge of craft—must be earned through practice.

And remember not to be in a rush, either, to finish a poem and judge it. As William Stafford remarks, "Writing is a reckless encounter with whatever comes along. . . . A writer must write bad poems, as they come, amongst the better—and not scorn the "bad" ones. Finicky ways can dry up the sources." If you write enough poems, good ones will happen. Try having several poems going at once; then, as a class due date approaches, you'll have choices. Pounding out a poem the night before will usually produce something misshapen or frail, likely to wither under the strong light of public scrutiny.

Respect for the poem also includes finding for it the readers who complete the equation. Later, as you grow as a poet, you will think of submitting to magazines and journals, perhaps eventually of gathering your poems in a book. For now, though, your audience is your class. Put your best foot forward, as they say. Type or print out the poems neatly. Proofread—carefully—to prevent mistakes creeping in and to check for oversights. Anything that distracts for even the tiniest flicker of a second—a grammatical error, mispunctuation, cloudy bit of syntax, misspelling, typo—costs your poem a momentary loss of your reader's attention. Do a surgical job. Don't leave clamps in the patient.

When you discuss another poet's work in class, be fair. Give the poem and the discussion your full attention. You will learn much, almost by osmosis, by listening to others talk about a fellow poet's work. Read the poem on its own terms. What is the poem trying to do? What are the ways it is trying to do it? How are they working? Be honest, but never cruel or patronizing. Your responsibility as a poet-reader means you respect and trust the poet's effort. By the same measure, when your poem comes up for discussion, do hear what people are saying. Some of it won't be helpful, but you can think that through later. And don't rush to explain or defend. A poem that needs explaining isn't doing its job.

Writing Communities

Because the poem that seems great today can seem dumb tomorrow and wonderful again the day after, poets need friends, other members of a writing class, other poets, and eventually editors: honest, thoughtful readers. What may be obvious to someone else, though not to the poet, may very well start the poet going again on the poem, or provide the clue to patching a thin spot or avoiding a clunker.

On page 318 is a facsimile of Draft 15 of Donald Hall's "Ox Cart Man." The comments, originally in longhand, are those of poet Louis Simpson, to whom Hall had sent the draft. Both of Simpson's insightful suggestions prompted good revisions by Hall. The awkward "He walks by ox head," perhaps natural enough in earlier versions where the poem was cast in first person as spoken by the character, becomes "He walks by his ox's head." (Why might Hall have preferred this to "by the ox's head"?)

When Hall saw that the activities that would complete the cycle in stanza 6 (back to potatoes, where the poem began) are already implied, he dropped the stanza. Dissatisfied with the rhythm of "to build the cart again" for concluding the poem, however, he tried out several alternatives: "to make the new cart," then "building another cart," "building the cart again," and "building the new cart." He finally settled on "building the cart again," a quiet iambic trimeter line whose initial reversed foot (building) emphasizes the farmer's steadfast work.

Good readers for your poems aren't those who love everything you write, nor those who slash it to ribbons. Praise, however, can be more ruinous than keen criticism. If a reader showers your poem with praise, you will feel reluctant to change it, to hold under the microscope just those places which deserve the most scrutiny and which will lead you to a better poem. You want a sharp disinterested eye. On the other hand, ignore readers who make personal attacks or who come after a poem with a bulldozer. Good readers help you find the gold seam in the rock—they don't blow up the mountain. And if a reader seems uninterested in a poem, take that response into consideration—what in your poem might spark the interest of someone outside your poem, outside the intricacies of your own life?

Your class will likely act as one of your earliest groups of readers. As the term finishes, you may want to trade phone numbers and e-mail addresses to continue exchanging poems with members of your class. You may also find fellow poets in the community around you. Check your local and regional papers and Web sites for writing groups and literary readings—you'll find them everywhere from bars and coffeeshops to museums and bookstores. Regularly attending poetry readings—by those with many published books and by those just starting out—will get you in contact with the variety of poetry and poets out there. Besides the writing programs in colleges and universities, many towns have literary centers and libraries that hold workshops, sponsor readings, publish literary calendars/newsletters, and provide space for poets to meet. These centers often rely on the help of volunteers—check them out. You may also find helpful the writing conferences throughout the United States and abroad that for a couple days or weeks generally offer workshops, readings, lectures, receptions, and individual conferences with poets. With some careful homework you can find one within your budget (some offer scholarships or work opportunities) that will give you the kind of help you're seeking. National organizations devoted to supporting poets and poetry include the Associated Writing Programs (AWP, to which your school may belong), Poets and Writers, The Poetry Society of America (PSA), The Academy of American Poets, and PEN (Poets, Essayists, and Novelists). Many organizations have Web sites.

Since the development of the Internet, someone with access to the Web can have readers all over the globe. You can find poetry chatrooms at many sites, from

small groups that started in a college writing class to groups allied with large literary organizations. Like the rest of the Web, these sites are very fluid, but a little surfing, particularly starting with the links from large reputable sites like PSA and Poets and Writers will lead to a variety of helpful—and not-so-helpful—sites. As with all parts of the Web, the user should be cautious about sharing personal information and remain skeptical about the expertise (or sincerity) of anyone you happen to meet.

Getting Organized

Keep the drafts of your poems; you never know what will be useful. Clip the sheets together, latest version on top. Always keep a copy when you submit poems for class (or to a magazine).

As poems multiply, a system of manila folders will keep things straight: a folder labeled NEW for poems you are currently working on, one marked FINISHED, and maybe one for NOTES—ideas, stray lines or images, interesting words, clippings, and so on. Soon an OLD MSS folder will be useful to collect fragments and poems that seem no longer promising; it may turn up a treasure on a rainy Saturday morning when you are looking for ideas. And soon, too, perhaps a folder marked PUBLISHED. Some poets find it useful to think of their work as an assembly line with poems moving along it in all the varying stages of the process.

When should a beginning poet begin sending poems out to magazines? If your school has a literary magazine, start readying a group of poems now—apply the finishing touches, check the journal's deadlines—and away they go!

For larger journals, as soon as you have three or four good, really finished poems and know several magazines or journals that would be appropriate for the poems, send them out. A rule of thumb: Stick to magazines you have read. If you like the poems in a magazine, odds are that you and the editors are on a similar wavelength. If you don't like the poems in a magazine, you would probably be wasting stamps to send a manuscript there. So the first thing is to get acquainted with magazines that publish poetry: literary quarterlies, poetry journals, little magazines, as well as *The New Yorker*, *The Atlantic*, and *The Nation*. Start browsing at the library, pick up some literary journals in bookstores, surf the Net, and subscribe to a few that feature work you like. Literary magazines are some of the great bargains on the planet, and your support can help them stay around.

Writer's Digest Books publishes *Poet's Market*, as annual, which lists some 1,800 periodicals and presses that print poems, specifying the kind of poetry each wants, what they pay, and how to submit manuscripts. Dustbooks' *The International Directory of Little Magazines and Small Presses* lists more than 5,000 markets. In the journals *Poets & Writers* and *The AWP Chronicle* and at their Web sites you'll find announcements from editors wanting poems. If you can't find a magazine, write for a sample copy (enclosing the single copy price). You may want to rank magazines that pay higher among your possibilities.

When you are ready, send three or four poems to the first magazine on your list. Check the magazine for submission guidelines; if it doesn't offer any follow these as a rule of thumb. Each poem should appear cleanly printed or typed, single-spaced, in

the center of a sheet of regular 8½-by-11-inch bond paper, with your name and address in the upper left corner. You needn't include a cover letter—although some poets like to drop a note to editors thanking them for their consideration—but *always* enclose a self-addressed, stamped envelope (SASE) for a response from the editors. If you want your copies back, include enough postage for their return; otherwise, ask the editors to recycle them. Some journals read only at certain times in the year; look the magazine over carefully to find out when you should submit your work. Address the packet to the editor by name if you know it, or to Poetry Editor. Keep a log: poems, date sent, and, later, the response. Be patient. Editors of small journals receive thousands of submissions a year. Expect to wait a few months before you hear anything.

The probability, of course, is rejection. Even very good poets get enough rejection slips to wallpaper a den. But don't be discouraged easily. If the poems still look pretty good to you, put them in another envelope and ship them off to the next magazine on your list. Sooner or later, a rejection slip will carry a scribbled note: "Sorry" or "Fine work" or "Liked 'Mushroom Morning.'" Sooner or later, there will appear a letter of acceptance and perhaps a small check. (Checks for poems are usually small checks.)

Sending poems around may be exciting as well as part of learning the trade. And it can be a stimulus to finishing poems. So never mind Horace's classical advice to wait nine years before publishing. Learning from mistakes may be more useful in the long run than trying not to make them.

If anyone wants money to publish or consider your poems, beware. Odds are, unless you know the journal or press to be reputable, it is a scam.

The copyright law (Title 17, USC) that went into effect in 1978 gives copyright protection to a work for the author's lifetime plus fifty years. That protection begins with its creation, so the penciled poem on your desk is included. You may register unpublished work (Form TX, one copy of the work, and the fee), but you needn't go to the trouble. The publisher of any reputable periodical or book will register the work on publication. Even though the registration is made in the publisher or magazine's name, the copyright belongs to the author—unless there is a written agreement to the contrary. In the absence of such a written agreement, a magazine acquires only the right to initial publication in one of its issues. The author retains copyright and full control. So don't sign anything, except a check. If in doubt, consult someone who knows about such things. (For information or forms: Copyright Office, Library of Congress, Washington, DC 20559.)

Very few poets earn a living through poetry. Williams was a doctor, Moore a librarian and editor, Stevens an attorney for an insurance company, and Frost did a lot of teaching (he also tried his hand as a poultry farmer and failed). Today many poets teach, and many others are researchers, attorneys, physicians, managers, ranchers, nurses, web-site managers, therapists, journalists, union organizers—and just about anything else you might think of. Money for poetry (like honors, if they come) is likely to come too late to do much good. Get a job.

More important than money, though, is freedom. Since in our society poetry doesn't pay much, poets are free to write pretty much as they wish. And more impor-

tant still is the art of poetry. All of us, while we're writing, join the company of Shakespeare, Milton, Whitman, and Dickinson.

Questions and Suggestions

1. In the library browse among the poetry in magazines like *Poetry, Hudson Review, Paris Review, Callaloo, Poetry Northwest, Hanging Loose, Agni, Ploughshares, Field, American Poetry Review, North American Review, New Republic, Cream City Review, Iowa Review, Ohio Review, Georgia Review, Gettysburg Review, Black Warrior Review, Green Mountains Review, Prairie Schooner, Poet Lore, Missouri Review, New letters, Tar River Poetry, Southern Review, Crazyhorse, Boulevard, Three Penny Review, Quarterly West, Laurel Review, DoubleTake, Five Points, Salamagundi, Crab Orchard Review,* or *Zzyzyva.*

2. Buy a book of poems. Buy another.

3. Here are two poems by students. If you were an editorial assistant for a poetry magazine, would you recommend either for publication? (See Appendix II).

 a) **Howard**
 GLENN BROOKE*

 A fisherman, Howard goes down to the Ohio River
 every day; there is nothing else.
 He cuts a fresh willow rod, and settles himself
 by the same muddy pool below the B&O tracks,
 on his usual knob of damp slate. 5

 Howard never baits his hook. He waits
 He looks at the dimple where his twill line
 disappears into the brown water,
 hardly looking up or down or away
 "Tis enough," he says. 10

 My mother says Howard is crazy;
 our preacher, who has prayed earnestly,
 says Howard is the greatest fisherman in the world.
 We accept Howard with the patience of farmers,
 with the faith of great depths in rivers. 15

 Howard has never caught a fish.
 There, in his cord coat and patch cap,
 he endures season upon season, the comings and goings
 of barges and children, and the backwater fogs
 drifting in and out, like doubts, like legends. 20

b) **Mrs. Bradley's Dilemma**
AMY B. KESEGICH*

His underwear is the last thing
in the dryer—
the cotton folds stay damp
long after
the socks become electric, 5
the sheets hot.
What can I do with these—
loose and white as puppy skins?
No one I know is poor enough
for a dead man's underwear. 10
Our sons won't take them.
They have his watch
and ties, his belts and coins,
things with value to pass on.
And yet, I can't toss the cloth 15
that held him close
into the trash with chicken bones.
He's not in them anymore—
his egret legs don't poke
through these hemmed holes, 20
nor does this elastic loop
hug his wrinkled waist.
Maybe I'll tuck them in my drawer,
nuzzling against my socks.
Should I hide them from myself— 25
what if they surprise me?
I'm scared enough of ghosts
not to plant them
in my own house.

4. Write a poem about writing poems. Use metaphors and detailed images to
 realize it. Is it like planning, planting, tending, and harvesting a garden?
 Like manufacturing a machine tool? Baking bread? Playing a high-stakes
 poker game? Making a kite? Perhaps focus on a single detail in the process of
 writing: the miles of words stored in the tiny cylinder of a pencil lead? The
 little fox trot your fingers do on the keyboard?

5. For a group. Each of you makes photocopies of at least three poems you
 really love. Next get scissors and cut each poem apart, cutting lines and
 phrases—don't leave more than a couple lines together. Put your pieces in
 an envelope. Meet other members of the group at your favorite pizza joint or
 coffeehouse. One or two of you should bring scissors, tape (in a dispenser to
 make it easier), and blank sheets of plain paper. In the center of a table

everyone spills out their poem pieces and uses them to assemble their own poems. When you have finished, read them aloud to each other.

6. Look over three or four poems you have written during the past few months. What has changed in your work? How have you grown as a poet? In what ways would you like to see your work develop further? Do any of the poems that follow in Poems to Consider reflect how you have come to feel about poetry? Are any the kind of poem you would like to write?

7. Prepare and send out a group of poems to the first magazine on your list.

Poems to Consider

Dancing with Poets 1987

ELLEN BRYANT VOIGT (b. 1943)

"The accident" is what he calls the time
he threw himself from a window four floors up,
breaking his back and both ankles, so that walking
became the direst labor for this man
who takes my hand, invites me to the empty strip of floor 5
that fronts the instruments, a length of polished wood
the shape of a grave. Unsuited for this world—
his body bears the marks of it, his hand
is tense with effort and with shame, and I shy away
from any audience, but I love to dance, and soon 10
we find a way to move, drifting apart as each
effects a different ripple across the floor,
a plaid and a stripe to match the solid navy of the band.
And suddenly the band is getting better, so pleased
to have this pair of dancers, since we make evident 15
the music in the noise—and the dull pulse
leaps with unexpected riffs and turns, we can hear
how good the keyboard really is, the bright cresting
of another major key as others join us: a strict
block of a man, a formidable cliff of mind, dancing 20
as if melted, as if unhinged; his partner a gift of brave
elegance to those who watch her dance; and at her elbow,
Berryman back from the bridge, and Frost, relieved
of grievances, Dickinson waltzing there with lavish Keats,
who coughs into a borrowed handkerchief—all the poets of exile 25
and despair, unfit for this life, all those who cannot speak
but only sing, all those who cannot walk
who strut and spin until the waiting citizens at the bar,
aloof, judgmental, begin to sway or drum their straws

or hum, leave their seats to crowd the narrow floor　　　　30
and now we are one body, sweating and foolish,
one body with its clear pathetic grace, not
lifted out of grief but dancing it, transforming
for one night this local bar, before we're turned back out
to our separate selves, to the dangerous streets and houses,　　35
to the overwhelming drone of the living world.

Stepping Out of Poetry　　　　　　　　　　1977

GERALD STERN (b. 1925)

What would you give for one of the old yellow streetcars
rocking toward you again through the thick snow?

What would you give for the feeling of joy as you climbed
up the three iron steps and took your place by the cold window?

Oh, what would you give to pick up your stack of books　　5
and walk down the icy path in front of the library?

What would you give for your dream
to be as clear and simple as it was then
in the dark afternoons, at the old scarred tables?

Diversion　　　　　　　　　　　　　　　1997

ROSANNA WARREN (b. 1953)

Go, I say to myself, tired of my notebooks and my reluctant pen,
go water the newly transplanted sorrel and dill,
spriggy yet in their new humus and larger clay pots;
water artemisia, salvia, centaurea
which are classical, perennial, and have promised to spread their nimbus　5
of violet and silver through our patchy backyard
for summers to come, from poor soil.
Then I'll return indoors to the words copied
on the yellow legal pad,

her words　　　　　　　　　　　　　　　　　10
　　which I cannot shape,
　　　　which sentence me:

"There are things I prefer
to forget—"
　　(what things?) "Just,　　　　　　　　　　15

things—" "Darling, I can't
　　locate myself—" "Where
　　　　are *you?*"

and if she, in her compassion, forgets
or doesn't know, I will perennially remember, 20
how I erase these messages
I later transcribe: one punch
of one button on the answering machine—

and how, with cruel
helpfulness 25
I have asked:

"Don't you remember?"

restoring to her a garden of incident
which she cannot keep, water, or tend,
and which will die, soon, from her ministrations. 30

◈ Like Miles Said 1994

ALVIN AUBERT (b. 1930)

my memory aint too good
i trouble the past, like, crazy
maybe i'm crazy like they say miles was
maybe i don't half know what i'm doing
like miles said if you don't know what you're 5
doing chances are you ain't doing nothin'

quoting the old drummer he played with
when he first started playin'
who was dead when miles said that about him

now miles is dead and i'm sure every mf 10
and his mama is going to be lyin'
about stuff miles said like maybe i'm doin'
right now but miles won't mind
miles was hip to all that shit

like every time you put a mouthpiece 15
to your lips you bound to lie some.

◈ Rain 1997

SIDNEY WADE (b.1951)

It so happens I'm tired of desire,
of the mouths of the thousand things endlessly calling,
of the tongues of lemons, the voices of men,
the taste of iron and salty linen.
It so happens I'm tired of the pulling, 5

the vigorous dance of the charming ego,
the songs of the kitchen, the boiling sonata,
bite of the tweezers, the plumbing's whine.
I'm tired of passion, counterfeit or otherwise,
tired of prices, of heft and of gain, 10
of the towering columns, the whole archipelago
of plummeting bridgework and dangerous vines.
I want to lie down and transmogrify sentences,
I want to dissolve on a cool, gray cloud.
When the sky bends down to pleasure the ground, 15
the rain is cool; it's dark and it rains.

The Bad Snorkler 1998

RONALD WALLACE (b. 1945)

Stands on the anemones as his fins
advance their bad ideas among these animals
that live so slowly their thoughts grow only an inch
or so a year. He cuts them off midsentence
as he spins his clumsy, unforgettable tales 5
of land and air. If he barks his shin on brain coral,
burns his hand on fire coral, ignores the fan
coral waving him off, he's happy, He shouts at us

to follow him in deeper, where he knows nothing
by name but the eels and octopi that try 10
to lie their way out of the corner he's got them in.
He's a wet suit full of damage, a trip mine
of enthusiasm, the good-will ambassador from a land
so far off nothing translates that he can understand.

A Live Dog Being Better Than a Dead Lion 1995

BRIGIT PEGEEN KELLY (b. 1951)

Rain. Rain from Baltimore. The ballroom floor
Is lit. See the gold sheen on the over-
Whelmed grasses? See the starched ruff of the hedgerow?
And the dancers are dressing. They tease
Their toes into shoes. Tease their breath into stays: 5
Stay the moment. Stay the luck. Stay, stay, the fields
Are full of rain and baby's breath. These will
Fashion the heart, and the heart fastened to the sleeve
Will break fire as the redbird did this morning
Bursting his small buttons against the glass. The glass 10
Was not black-hearted. It was an innocent pretender.

It took to itself the idea of sky and the bird bought
It, played his brave swan dive into our palms.
So let us wear it. Let us wear the bird like
A boutonniere to remind us that caution snares 15
Nothing. O the cautious are caught in the net
Of their cares: *Stop, No Turn, Leave Your Shoes
At the Door. Please Don't Spit on the Statue* and
Tokens Go Here. But the bird rode his cheer up.
Rode the high wire of his cheer up. Left 20
Without counting the cost his spittle-bright snail
Trail for the rain to erase, for the wind to wash
Out. Booted his small body beyond the Beyond.
Now the wrecked grace of the morning trails
Its tattered clouds. But they are flowers. 25
The pink flowers of Maryland turn softly above us.

◈ Childhood 1996

ARTHUR SMITH (b. 1948)

That simply, that richly, the days were under way,
And I remember them, breezes

Wafting from the spice-islands of the past
Where even now the plums darken almost

Beyond desire. Almost? Well, then, beyond, 5
Though with what exhilaration we set sail—

Tail winds bullying the stitched canvas,
Our course determined by the stars.

Night and day we endured—the seawinds
Brackish, the repetitions tedious— 10

Until we anchored off an island
Never charted,

From which we expected much—
Not what we found: the bones

Of those before us, the earth disturbed, 15
A chest filled with nothing, the light of day.

◈ The Next Poem 1985

DANA GIOIA (b. 1950)

How much better it seems now
than when it is finally done—

the unforgettable first line,
the cunning way the stanzas run.

The rhymes (for, yes, it will have rhymes) 5
almost inaudible at first,
an appetite not yet acknowledged
like the inkling of a thirst.

while gradually the form appears
as each line is coaxed aloud— 10
the architecture of a room
seen from the middle of a crowd.

The music that of common speech
but slanted so that each detail
sounds unexpected as a sharp 15
inserted in a simple scale.

No jumble box of imagery
dumped glumly in the reader's lap
or elegantly packaged junk
the unsuspecting must unwrap. 20

But words that could direct a friend
precisely to an unknown place,
those few unshakeable details
no confusion can erase.

And the real subject left unspoken 25
but unmistakable to those
who don't expect a jungle parrot
in the black and white of prose.

How much better it seems now
than when it is finally written. 30
How hungrily one waits to feel
the bright lure seized, the old hook bitten.

APPENDIX I

A BRIEF GLOSSARY OF FORMS

See also the Index of Terms for additional forms.

Stanzaic and Other Generic Forms

couplet The most elementary stanza, two lines; when rhymed, *a a*. Flexible, it has served for narrative (Chaucer's *The Canterbury Tales*), but is also capable of succinctness and punch, as in this epigram by Anonymous:

> Seven wealthy towns contend for Homer dead
> Through which the living Homer begged his bread.

triplet (tercet) Stanza of three lines. Triple rhyming (*a a a*) is possible in shorter poems, such as "On Two Ministers of State" by Hilaire Belloc (1870–1953):

> Lump says that Caliban's of gutter breed,
> And Caliban says Lump's a fool indeed,
> And Caliban, and Lump and I are all agreed.

But *a b b* and *a b a* are alternatives. In "Nevertheless" Marianne Moore uses *a a b*. The Italian form **terza rima** follows the *a b a* scheme *and* uses the unrhymed line for the double rhymes of the next stanza: *a b a, b c b, c d c*, and so on. Shelly's "Ode to the West Wind" is the most familiar example in English.

quatrain Stanza of four lines:

> ### Cadence
> ROBERT FRANCIS (1901–1987)
>
> Puckered like an old apple she lies abed,
> Saying nothing and hearing nothing said,
> Not seeing the birthday flowers by her head
> To comfort her. She is not comforted.

331

The room is warm, too warm, but there is chill 5
Over her eyes and over her tired will.
Her hair is frost in the valley, snow on the hill.
Night is falling and the wind is still.

Although Francis succeeds with *a a a a*, the usual schemes are *a b c b* (often used in ballads, hymns, and popular songs), *a b a b*, *a a b b*, and *a b b a*. Rhyming on only two of the four lines, *a b c b* is of course the simplest; and when the lines alternate tetrameter and trimeter, as in "Western Wind" (p. 31) or Dickinson's "I heard a Fly buzz" (p. 203), it is sometimes called a **ballad stanza.**

Beyond the quatrain, stanzaic variation increases exponentially. Three longer stanzas have been employed with frequency: **rime royal** (seven lines of iambic pentameter, *a b a b b c c*), **ottava rima** (eight lines, *a b a b a b c c*), and the **Spenserian stanza** (nine lines: eight of iambic pentameter and the last iambic hexameter, *a b a b b c b c c*; used by Keats in "The Eve of St. Agnes"). With such patterns, the poet must be continually looking forward for possible rhymes in the sense that lies ahead, and backward to bring other rhyme words into place, as each stanza is laced together. A **nonce stanza** is one made up for a particular poem, like that invented by Marianne Moore for "The Fish" (p. 290) or by George Herbert for "Easter Wings" (p. 118). The challenge is to repeat the form naturally and effectively throughout the poem.

blank verse Unrhymed iambic pentameter. Since the seventeenth century, it has been a formal workhorse for longer poems—Shakespeare's tragedies, Milton's *Paradise Lost*, Wordsworth's *The Prelude*, Browning's and Frost's dramatic monologues, Stevens's "Sunday Morning" or "The Idea of Order at Key West."

stichomythia A convention of dialogue, from Greek drama, in which two characters speak in exactly alternating lines of verse. The device is useful for contrast or dispute or, as in this poem by Christina Rossetti (1830–1894), question and answer:

Up-Hill

Does the road wind up-hill all the way?
 Yes, to the very end.
Will the day's journey take the whole long day?
 From morn to night, my friend.

But is there for the night a resting-place? 5
 A roof for when the slow dark hours begin.
May not the darkness hide it from my face?
 You cannot miss that inn.

Shall I meet other wayfarers at night?
 Those who have gone before. 10
Then must I knock, or call when just in sight?
 They will not keep you standing at that door.

> Shall I find comfort, travel-sore and weak?
> Of labour you shall find the sum.
> Will there be beds for me and all who seek? 15
> Yea, beds for all who come.

Whole-Poem Forms

sonnet Both familiar and useful: fourteen lines of iambic pentameter. The **Shake-spearean** (or **Elizabethan**) **sonnet** is commonly rhymed in three quatrains and a couplet: *a b a b, c d c d, e f e f, g g*. Shakespeare's Sonnet 73 (p. 34) is a good example in which the sense corresponds to the four divisions. The **Italian** (or **Petrarchan**) **sonnet** is typically rhymed: *a b b a a b b a, c d e c d e* (or *c d c d c d*) in units of eight and six lines: **octave** and **sestet.** The sense, statement and resolution, usually conforms to this division. Although its "turn" does not come exactly between the octave and the sestet, this sonnet by Elizabeth Barrett Browning (1806–1861) typifies the form:

Grief

> I tell you, hopeless grief is passionless;
> That only men incredulous of despair,
> Half-taught in anguish, through the midnight air
> Beat upward to God's throne in loud access
> Of shrieking and reproach. Full desertness, 5
> In souls as countries, lieth silent-bare
> Under the blanching, vertical eye-glare
> Of the absolute Heavens. Deep-hearted man, express
> Grief for thy Dead in silence like to death:—
> Most like a monumental statue set 10
> In everlasting watch and moveless woe
> Till itself crumble to the dust beneath.
> Touch it; the marble eyelids are not wet;
> If it could weep, it could arise and go.

Poets have worked any number of successful variations on the rhyme schemes of both kinds of sonnet. Edmund Spenser used an interlocking *a b a b, b c b c, c d c d, e e*. Frost, who wrote more sonnets than might be supposed, tried numerous variations, including: *a a a b b b c c c d d d e e*. His "Acquainted with the Night" is a variation on terza rima, with the final couplet made by simply "omitting" the unrhymed line in the last "triplet": *a b a, b c b, c d c, d e d, e e*.

villanelle Borrowed from the French, a poem of six stanzas—five triplets and a quatrain. It employs only *two* rhymes throughout: *a b a, a b a, a b a, a b a, a b a a*. Moreover, the first and third lines are repeated entirely, three times, as a refrain. Line 1 appears again as lines 6, 12, and 18. Line 3 appears as lines 9, 15, and 19. This villanelle by Bruce Bennett (b. 1942) keeps the form exactly:

Spilled

It's not the liquid spreading on the floor,
A half a minute's labor with the mop;
It's everything you've ever spilled, and more.

The stupid broken spout that wouldn't pour;
The nasty little salesman in the shop. 5
It's not the liquid spreading on the floor,

A stain perhaps, a new, unwelcome chore,
But scarcely cause for sobs that will not stop.
It's everything you've ever spilled, and more.

It's the disease for which there is no cure, 10
The starving child, the taunting brutal cop.
It's not the liquid spreading on the floor

But through a planet, rotten to the core,
Where things grow old, get soiled, snap off, or drop.
It's everything you've ever spilled, and more: 15

This vision of yourself you can't ignore,
Poor wretched extra clinging to a prop!
It's not the liquid spreading on the floor.
It's everything you've ever spilled, and more.

sestina Even more complicated: six six-line stanzas and one three-line stanza. Instead of rhyme, the *six words* at the ends of lines in the first stanza are repeated in a specific, shifting order as line-end words in the other five six-line stanzas. Then all six words are used again in the final triplet, three of them at line ends, three of them in midline. The order of the line-end words in the stanzas may be transcribed this way: 1-2-3-4-5-6, 6-1-5-2-4-3, 3-6-4-1-2-5, 5-3-2-6-1-4, 4-5-1-3-6-2, 2-4-6-5-3-1; and in the triplet, (2)-5-(4)-3-(6)-1. Poets since Sir Philip Sidney have used the sestina successfully; recent poets, notably Marilyn Hacker, David Lehman, and James Cummins, have also used it. An exemplary sestina by Michael Heffernan appears on page 133.

pantoum A Malayan form: an indefinite number of *a b a b* quatrain stanzas, with this restriction: lines 2 and 4 of each stanza, *in their entirety*, become lines 1 and 3 of the following stanza, and so on. The carry-over lines are called *repetons*. The sequence is ended in a quatrain whose repetons are lines 1 and 3 of the *first* stanza *in reversed order*. This example by Vonna Adrian (1906–1987) will make it clearer:

A Plaguey Thing

If I were you I'd just forget it:
A pantoum is a plaguey thing.

It drives you crazy if you let it;
It haunts you, dawn and evening.

A pantoum is a plaguey thing. 5
My friend, can you define *pantoum*?
It haunts you, dawn and evening.
Does it belong in a drawing room?

My friend, can you define *pantoum*?
Do you strum it or pluck it or beat it? 10
Does it belong in a drawing room?
If fruit or veg, then you could eat it.

Do you strum it or pluck it or beat it?
Dare mail it to a little mag?
If fruit or veg, then you could eat it. 15
Producing it can be a drag.

Dare mail it to a little mag,
It drives you crazy if you let it.
Producing it can be a drag;
If I were you I'd just forget it. 20

haiku (hokku) A Japanese form, three lines of five, seven, and five syllables. The essence of the haiku, however, is not its syllabic form (which is virtually meaningless in English), but its tone or touch, influenced by Zen Buddhism. Haiku are, in general, very brief natural descriptions or observations that carry some implicit spiritual insight. The most famous is by Matsuo Basho (1644–1694), translated (without the syllabics) by Nobuyuki Yuasa:

Breaking the silence
Of an ancient pond.
A frog jumped into water—
A deep resonance.

Nearly as famous are these tender poems by Kobayashi Issa (1763–1827), translated by Robert Bly:

Cricket, be
careful! I'm rolling
over!

The old dog bends his head listening . . .
I guess the singing
of the earthworms gets to him.

limerick Five lines, of which the first, second, and fifth are trimeter; the (usually indented) third and fourth, dimeter. Rhymed *a a b b a*. The dominant rhythm is

anapestic. The first limericks, published in London in 1821 by John Harris in *The History of Sixteen Wonderful Old Women,* were not humorous:

> There was an old woman of Leeds
> Who spent all her life in good deeds;
> > She worked for the poor
> > Till her fingers were sore,
> This pious old woman of Leeds.

Edward Lear (1812–1888) saw the comic potential and in 1846 published his first *Book of Nonsense* (verses and drawings) which started the craze:

> There was an Old Man with a beard,
> Who said, "It is just as I feared—
> > Two Owls and a Hen,
> > Four Larks and a Wren,
> Have all built their nests in my beard!"

Lear kept the model's fifth line as a recycling of the first line, though other poets didn't, and by the end of the century an almost classical literature existed in the form—mostly by the versatile Anonymous:

> There was a young fellow named Hall,
> Who fell in the spring in the fall;
> > 'Twould have been a sad thing
> > If he'd died in the spring,
> But he didn't—he died in the fall.

The fun often is using a proper name, preferably polysyllabic, to end the first line and then getting the second and fifth lines to rhyme with it:

> There was an old man of Nantucket
> Who kept all his cash in a bucket;
> > But his daughter, named Nan,
> > Ran away with a man,
> And as for the bucket, Nantucket.

For the poet who enjoys the challenge of complicated forms, there are many more, like the French *rondeau* and *rondel,* the Welsh *cywydd llosgyrnog,* or the Arabic *rubaiyat,* all of which have been successfully adapted to English.

APPENDIX II

NOTES TO THE QUESTIONS
AND SUGGESTIONS

Chapter 2

1. *a)* **Theology**
PAUL LAURENCE DUNBAR (1872–1906)

There is a heaven, for ever, day by day,
The upward longing of my soul doth tell me so.
There is a hell, I'm quite as sure; for pray,
If there were not, where would my neighbors go?

b) **Liu Ch'e**
EZRA POUND (1885–1972)

The rustling of the silk is discontinued,
Dust drifts over the court-yard,
There is no sound of foot-fall, and the leaves
Scurry into heaps and lie still,
And she the rejoicer of the heart is beneath them: 5

A wet leaf that clings to the threshold.

Chapter 3

Box, p. 65: Here is a big, old wooden box
 Which needs, and has, no locks.
 Because it holds nothing inside,
 Its top is opened wide.

 The top is open wide;
 There are no locks.
 For nothing's kept inside
 This wooden box.

A box
Without locks,
Top wide—
Empty inside.

1. *a)* **Death of the Day**

My pic|tures black|en in | their frames

 As night | comes on,

And youth|ful maids | and wrink|led dames

 Are now | all one.

Death of | the day! | a stern|er Death

 Did worse | before;

The fair|est form, | the sweet|test breath,

 Away | he bore.

 b) **Riches**

The count|less gold | of a mer|ry heart,

The ru|bies and pearls | of a lov|ing eye,

The in|dolent nev|er can bring | to the mart,

Nor the se|cret hoard up | in his treas|ury.

 c) **Anecdote of the Jar**

I placed | a jar | in Ten|nessee

And round | it was, | upon | a hill.

It made | the slov|enly wil|derness

Surround | that hill.

The wil|derness | rose up | to it.

And sprawled | around, | no long|er wild.

The jar | was round | upon | the ground

And tall | and of | a port | in air.

It took | domin|ion ev|erywhere.

The jar | was gray | and bare.

It did | not give | of bird | or bush,

Like noth|ing else | in Ten|nessee.

d) ***If I should learn, in some quite casual way***

If I | should learn, | in some quite cas|ual way,

That you | were gone, | not to | return | again—

Read from | the back-|page of | a pap|er, say,

Held by | a neigh|bor in | a sub|way train,

How at | the corn|er of | this av|enue

And such | a street | (so are | the pap|ers filled)

A hur|rying man, | who hap|pened to | be you

At noon | today | had hap|pened to | be killed—

I should | not cry | aloud—| I could | not cry

Aloud, | or wring | my hands | in such | a place—

I should | but watch | the sta|tion lights | rush by

With a |more care|ful in|terest on | my face;

Ŏr ráise | mў éyes | ănd réad | wĭth gréatĕr cáre

Whére tŏ | stóre fúrs | ănd hów | tŏ tréat | thĕ háir.

e) **_A Bird came down the Walk_**

Ă Bírd | cáme dówn | thĕ Wálk—

Hĕ díd | nŏt knów | Ĭ sáw—

Hĕ bít | ăn Áng|lĕ wórm | ĭn hálves

Ănd áte | thĕ fél|lŏw, ráw,

Ănd thén | hĕ dránk | ă Déw

Frŏm ă | cŏnvén|ĭ ent Gráss—

Ănd thén | hópped síde | wĭse tŏ | thĕ Wáll

Tŏ lét | ă Bée|tlĕ páss—

Hĕ glánced | wĭth ráp|ĭd éyes

Thăt húr|rĭed áll | ărŏund—

Thĕy lóoked | lĭke fright|ĕned Béads, | Ĭ thóught—

Hĕ stírred | hĭs Vél|vĕt Héad

Lĭke óne | ĭn dán|gĕr, Cáu|tĭous,

Ĭ óf|fĕred hím | ă Crúmb

Ănd hĕ |ŭnrólled | hĭs féath|ĕrs

Ănd rówed | hĭm sóft|ĕr hóme—

Thăn Óars | dĭvíde | thĕ Ó|cĕan,

Tóo síl|vĕr fŏr | ă séam—

Ŏr Bút|tĕrflíes, | óff Bánks | ŏf Nóon

Léap, plásh|lĕss a͜ | thĕy swim

Chapter 4

5. ***In One Place***
 ROBERT WALLACE (b. 1932)

> —something
> holds up two or three leaves
> the first year,
>
> and climbs
> and branches, summer
> by summer,
>
> till birds
> in it don't remember
> it wasn't there.

5

Chapter 5

2. The rain it raineth every day,
 upon the just and unjust *fella,*
 but more upon the just, because
 the unjust hath the just's umbrella.
 Anonymous

 Leo
 BOB MCKENTY (b. 1935)

 Leo doesn't give a damn.
 He won't lie down beside the lamb.
 He's too preoccupied, my guess is,
 Lying with the lionesses.

Chapter 6

4. ***In Her Parachute Silk***
MICHELLE BOISSEAU (b. 1955)

She stands at the top of the aisle
as on a wing. The white paper
carpet is cloud
spilled out. The pillbox hats

turned to her are the rows 5
of suburbs she falls into.
She is our mother,
or will be, and any of us

stumbling upon this scene
from the next generation, would fail 10
to notice what makes even her
tremble, with her silver

screen notions of marriage—
where all husbands scold
to hide their good natures, and wives 15
are passionately loyal.

Her groom, after all, is just a boy
home from the war,
his only trophy, the parachute
she's made into her dress. It's a world 20

of appetites, she knows
all too well, waiting there
watching the flowers
bob in her hands, dizzying.

Despite herself, she's not thinking: 25
Go slowly, pace it,
a queen attended to court,
Bette Davis. Nor of the $20 bill

her mother safety-
pinned to her underpants. 30
But: My God,
a room full of men, looking,

each will ask me to dance—
your hand tingles
when you touch their close- 35
clipped heads. And the men,

nudged to turn around
and watch the bride descend,
see a fellow parachutist
as they all drift 40

behind enemy lines,
stomachs turning over as they fall
into the horizon, into the ring
of small brilliant explosions.

Chapter 10

3. The lines originally came from:
 a) D. H. Lawrence, "Two Blue Birds"
 b) William Faulkner, *The Sound and the Fury*
 c) Shirley Ann Grau, "Fever Flower"
 d) Walker Percy, *Lancelot*
 e) Flannery O'Conner, "A Good Man is Hard to Find"
 f) Eudora Welty, "The Whistle"
 g) George Orwell, *1984*
 h) Kay Boyle, "The Astronomer's Wife"

Chapter 12

3. Both poems were published.

APPENDIX III

A FEW SUGGESTIONS
FOR FURTHER READING

Anthologies

Marjorie Agosan, ed., *These Are Not Sweet Girls: Poetry by Latin American Women*, White Pine, 1994.

Aliki Barnstone and Willis Barnstone, eds., *Women Poets from Antiquity to Now*, Schocken, 1992.

Joseph Bruchac, ed., *Returning the Gift: Poetry and Prose from the First North American Native Writers' Festival*, University of Arizona Press, 1994.

Gerald Costanzo and Jim Daniels, eds., *The Carnegie Mellon Anthology of Poetry*, Carnegie Mellon University Press, 1993.

Philip Dacey and David Jauss, eds., *Strong Measures: Contemporary American Poetry in Traditional Forms*, Harper & Row, 1986.

Richard Ellmann and Robert O'Clair, eds., *The Norton Anthology of Modern Poetry*, 2nd ed., Norton, 1988.

Peter Fallon and Derek Mahon, eds., *The Penguin Book of Contemporary Irish Poetry*, Penguin, 1990.

Sascha Feinstein and Yusef Komunyakaa, *The Jazz Poetry Anthology; Second Set: The Jazz Poetry Anthology, Vol. 2*, Indiana University, 1991, 1996.

Edward Field, Gerald Locklin and Charles Stetler, eds., *A New Geography of Poets*, University of Arkansas Press, 1992.

Annie Finch, ed., *A Formal Feeling Comes: Poems in Form by Contemporary Women*, Story Line Press, 1994.

Carolyn Forché, ed., *Against Forgetting: Twentieth Century Poetry of Witness*, Norton, 1993.

Ray Gonzalez, ed., *After Aztlan: Latino Poets of the Nineties*, Godine, 1992.

Michael S. Harper and Anthony Walton, eds., *Every Shut Eye Ain't Asleep: Poetry by African Americans Since 1945*, Little, Brown, 1994.

Robert Hass, ed., *Poet's Choice: Poems for Everyday Life*, Ecco Press, 1998.

Jane Hirshfield, ed., *Women in Praise of the Sacred: 43 Centuries of Spiritual Poetry by Women*, HarperPerennial, 1994.

Garrett Hongo, ed., *The Open Boat: Poems from Asian America*, Anchor, 1993.

Paul Hoover, ed., *Postmodern American Poetry*, Norton, 1994.

Florence Howe, ed., *No More Masks! An Anthology of Twentieth-Century Women Poets*, rev., HarperPerennial, 1993.

Mark Jarman and David Mason, eds. *Rebel Angels: 25 Poets of the New Formalism*, Story Line Press, 1996.

David Lehman, series ed., *The Best American Poetry*, annual, Simon & Schuster, 1988 to present.

Czeslaw Milosz, ed., *A Book of Luminous Things: An International Anthology of Poetry*, Harcourt Brace, 1996.

Duane Niatum, ed., *Harper's Anthology of Twentieth-Century Native American Poetry*, Harper & Row, 1988.

Ed Ochester and Peter Oresick, eds., *The Pittsburgh Book of Contemporary Poetry*, University of Pittsburgh Press, 1993.

A. Poulin, Jr., ed., *Contemporary American Poetry*, 6th ed., Houghton Mifflin, 1996.

Dudley Randall, ed., *The Black Poets*, Bantam, 1971.

Kenneth Rosen, ed., *Voices of the Rainbow: Contemporary Poetry by Native Americans*, Arcade, 1993.

Jerome Rothenberg and Pierre Joris, eds., *Poems for the Millennium: The University of California Book of Modern & Postmodern Poetry*, Vol. I, 1995, Vol. II, 1998.

On Poetry, Writing Poetry, and Poets

W. H. Auden, *The Dyer's Hand and Other Essays*, Random House, 1962.

David Baker, ed., *Meter in English: A Critical Engagement*, University of Arkansas Press, 1996.

Bruce Bawer, *Prophets & Professors: Essays on the Lives and Words of Modern Poets*, Story Line Press, 1995.

Robin Behn and Chase Twichell, eds., *The Practice of Poetry*, HarperPerennial, 1992.

Sven Birkerts, *The Electric Life: Essays on Modern Poetry*, Morrow, 1989.

Eavan Boland, *Object Lessons: The Life of the Woman and the Poet in Our Time*, Norton, 1995.

Sharon Bryan, ed. *Where We Stand: Women Poets on Literary Tradition*, Norton, 1993.

Thomas W. Disch, *The Castle of Indolence: On Poetry, Poets and Poetasters*, Picador USA, 1995.

Frederick Feirstein, *Expansive Poetry: Essays on the New Narrative & The New Formalism*, rev. ed., Story Line Press, 1999.

Annie Finch, *The Ghost of Meter: Culture and Prosody in American Free Verse*, University of Michigan Press, 1993.

Robert Francis, *The Satirical Rogue on Poetry*, University of Massachusetts Press, 1968.

Stuart Friebert, David Walker and David Young, eds., *A Field Guide to Contemporary Poetry and Poetics*, 2nd ed., Oberlin College Press, 1997.

Paul Fussell, *Poetic Meter and Poetic Form*, rev. ed., Random House, 1979.

Tess Gallagher, *A Concert of Tenses: Essays on Poetry*, University of Michigan Press, 1986.

Dana Gioia, *Can Poetry Matter?* Graywolf, 1992.

Louise Glück, *Proofs & Theories: Essays on Poetry*, Ecco, 1994.

Thom Gunn, *Shelf Life: Essays, Memoirs, and an Interview*, University of Michigan Press, 1993.

Donald Hall, *Death to the Death of Poetry: Essays, Reviews, Notes, Interviews*, University of Michigan Press, 1994.

Robert Hass, *Twentieth Century Pleasures*, Ecco Press, 1984.

Seamus Heaney, *The Government of the Tongue: Selected Prose*, Farrar, Straus & Giroux, 1988.

Richard Hugo, *The Triggering Town*, Norton, 1982.

Randall Jarrell, *Poetry and the Age*, Knopf, 1953.

David Kalstone, *Becoming a Poet: Elizabeth Bishop with Marianne Moore and Robert Lowell*, Farrar, Straus & Giroux, 1989.

Mary Kinzie, *The Cure of Poetry in an Age of Prose*, University of Chicago Press, 1993.

Carolyn Kizer, *Proses: On Poems and Poets*, Copper Canyon Press, 1994.

Stephen Kuusisto, Deborah Tall, and David Weiss, eds., *The Poet's Notebook: Excerpts from the Notebooks of 26 American Poets*, Norton, 1995.

Martin Lammon, ed., *Written in Water, Written in Stone: Twenty Years of* Poets on Poetry, University of Michigan Press, 1996.

David Lehman, ed., *Ecstatic Occasions, Expedient Forms*, rev. ed., University of Michigan Press, 1996.

William Logan, *All the Rage*, University of Michigan Press, 1998.

Robert McDowell, ed., *Poetry after Modernism*, 2nd ed., Story Line Press, 1991.

Mary Oliver, *A Poetry Handbook*, Harcourt Brace, 1995.

Robert Pack and Jay Parini, eds., *Introspections: American Poets on One of Their Own Poems*, Middlebury College Press, 1997.

Robert Pinsky, *The Sounds of Poetry*, Farrar, Straus & Giroux, 1998.

Alex Preminger and T. V. F. Brogan, eds., *The New Princeton Encyclopedia of Poetry and Poetics*, Princeton University Press, 1993.

George Saintsbury, *A History of English Prosody*, Macmillan, 1910.

Barbara Herrnstein Smith, *Poetic Closure: A Study of How Poems End*, University of Chicago Press, 1968.

Timothy Steele, *Missing Measures: Modern Poetry and the Revolt Against Meter*, University of Arkansas Press, 1990.

Eileen Tabios, ed., *Black Lightning: Poetry in Progress*, Asian American Writers' Workshop, Temple University Press, 1998.

Lewis Turco, *The New Book of Forms: A Handbook of Poetics*, University of New England, 1986.

Alberta T. Turner, ed., *45 Contemporary Poems: The Creative Process*, Longman, 1985.

Miller Williams, *Patterns of Poetry*, Louisiana State University Press, 1986.

Clement Wood, *The Complete Rhyming Dictionary*, rev., Doubleday, 1992.

And bear in mind literary journals (some are listed on p. 323) and writing organizations (p. 320); these often have web sites. Stroll through a library or bookstore (physical or virtual), and you'll find books by many poets included in this text—and by many others.

ACKNOWLEDGMENTS

Adeyemon, Omoteji, "Savior." Copyright © 1995 by Omoteji Adeyemon. Reprinted by permission.

Adrian, Vonna, "A Plaguey Thing." From *A Gaggle of Verses*, Bits Press. Copyright © 1986, 1988 by Vonna Adrian. Reprinted by permission.

Alexander, Pamela, "Look Here." Copyright © 1994 by Pamela Alexander. First appeared in *The Atlantic*. Reprinted by permission.

Allbery, Debra, "Outings." From *Walking Distance*. Copyright © 1991 by Debra Allbery. Reprinted by permission of the University of Pittsburgh Press.

Andrews, Tom, "Cinema Vérité: The Death of Alfred, Lord Tennyson." Copyright © 1993 by Tom Andrews. First appeared in *Field*. Reprinted by permission of the author.

Aubert, Alvin, "Like Miles Said." From *If Winter Come*. Copyright © 1994 by Alvin Aubert. Reprinted by permission of Carnegie Mellon University Press.

Baker, David, "Still-Hildreth Sanitorium, 1936," *The Truth about Small Towns*. Copyright © 1998 by David Baker. Reprinted by permission of the University of Arkansas Press.

Barrax, Gerald, "The Guilt." Copyright © 1992 by Gerald Barrax. First appeared in *The Gettysburg Review*. Reprinted by permission of the author.

Basho, "Breaking the silence." From *The Narrow Road to the Deep North & Other Travel Sketches*, translated by Nobuyuki Yuasa. Copyright © 1966 by Nobuyuki Yuasa. Reprinted by permission of Penguin Books, Ltd.

Becker, Robin, "When Someone Dies Young." From *All-American Girl*. Copyright © 1996 by Robin Becker. Reprinted by permission of University of Pittsburgh Press.

Bennett, Bruce, "Smart." Copyright © 1978 by Bruce Bennett. From *Taking Off*, Orchises Press. Reprinted by permission of the author. "Spilled." Copyright © 1997 by Bruce Bennett. First published in *Tar River Poetry*. Reprinted in *It's Hard to Get the Angle Right*, Greentower Press.

Bishop, Elizabeth, "First Death in Nova Scotia." From *The Complete Poems 1927–1979* by Elizabeth Bishop. Copyright © 1979, 1983 by Alice Helen Methfessel. Reprinted by permission of Farrar, Straus & Giroux, Inc.

Bly, Robert, "Looking at a Dead Wren in My Hand." From *the Morning Glory* by Robert Bly. Copyright © 1970 by Robert Bly. Translations of two haiku by Issa. Copyright © 1969 by Robert Bly. "Waking from Sleep." From *Silence in the Snowy Fields*. Copyright © 1962 by Wesleyan University Press. All reprinted by permission of Robert Bly.

Boisseau, Michelle, "In Her Parachute-Silk Wedding Gown." From *No Private Life*, Vanderbilt University Press. Copyright © 1990 by Michelle Boisseau. "Potato," © 1998 by Michelle Boisseau. First appeared in *Tar River Poetry*. Reprinted by permission.

Boruch, Marianne, "The Hawk." From *A Stick That Breaks and Breaks*, copyright © 1997 by Marianne Boruch. Reprinted by permission of Oberlin College Press.

Brooke, Glenn, "Howard." Copyright © 1986 by Glenn Brooke. Reprinted by permission.

Brooks, Gwendolyn, "We Real Cool." From *Blacks*, The David Company, Chicago. Copyright © 1987 by Gwendolyn Brooks. Reprinted by permission.

Bruchac, Joseph, "The Release." Copyright © 1979 by Joseph Bruchac. Reprinted by permission.

Bryan, Sharon, "Sweater Weather: A Love Song to Language." From *Flying Blind*. Copyright © 1996 by Sharon Bryan. Reprinted by permission of Sarabande Books.

Buckley, Christopher, "Sparrows." From *Dust Light, Leaves*, Vanderbilt University Press. Copyright © 1986 by Christopher Buckley. Reprinted by permission of the author.

Burns, Michael, "The First Time." From *The Secret Names: Poems*. Copyright © 1994 by Michael Burns. Reprinted by permission of the University of Missouri Press and the author.

Campo, Rafael, "El Día de los Muertos." From *What the Body Told*. Copyright © 1996, Duke University Press. Reprinted with permission.

Cassian, Nina, "Ordeal." Translation copyright © by Michael Impey and Brian Swann. Originally published in *An Anthology of Contemporary Romanian Poetry*, London. Reprinted by permission of Michael Impey.

Collins, Billy, "To a Stranger Born in Some Distant Country Hundreds of Years from Now." From *Picnic, Lightning*. Copyright © 1998 by Billy Collins. Reprinted by permission of the University of Pittsburgh Press.

Cope, Wendy, "Strugnell's Bargain." Copyright © 1984 by Wendy Cope. Reprinted by permission.

Costanzo, Gerald, "The Sacred Cows of Los Angeles," copyright © 1992 by Gerald Costanzo. Reprinted from *Nobody Lives on Arthur Godfrey Boulevard* with the permission of BOA Editions Ltd., 260 East Avenue, Rochester, NY 14606.

Cummings, James, "Games," from *Portrait in a Spoon*. Copyright © 1997 by James Cummings. Reprinted by permission of University of South Carolina Press.

Cunningham, J.V., "For My Contemporaries." From *The Exclusions of a Rhyme*. Copyright © 1960 by J. V. Cunningham. Reprinted with the permission of the Ohio University Press, Athens.

Daniels, Jim, "Short-order Cook," from *Places/Everyone*. Copyright © 1985 by Jim Daniels. Reprinted by permission of the University of Wisconsin Press. "The Day After," from *Blessing the House*. Copyright © 1997 by Jim Daniels. Reprinted by permission of University of Pittsburgh Press.

Derricotte, Toi, "In the Mountains," from *Tender*. Copyright © 1997 by Toi Derricotte. Reprinted by permission of the University of Pittsburgh Press.

Dickinson, Emily, Poems #328, 341, 465, 986. Reprinted by permission of the publishers and the Trustees of Amherst College from *The Poems of Emily Dickinson*, Thomas H. Johnson, ed., Cambridge, Mass.: The Belknap Press of Harvard University Press, Copyright © 1951, 1955, 1979, 1983 by the President and Fellows of Harvard College.

Dodd, Wayne, "Two Poems of Advice." Reprinted from *Wayne Dodd: The Blue Salvages* by permission of Carnegie Mellon University Press © 1998 by Wayne Dodd.

Doty, Mark, "No." From *My Alexandria*. Copyright ©1993 by Mark Doty. Used with the permission of the poet and the University of Illinois Press.

Dove, Rita, "The House Slave." From *The Yellow House on the Corner* by Rita Dove. Copyright © 1980 by Rita Dove. "A Hill of Beans." From *Thomas and Beulah*. Copyright © 1986 by Rita Dove. Reprinted by permission of Carnegie Mellon University Press.

Dresch, Christine, "Holy Water." Copyright © 1998. Reprinted by permission of the author.

Dunn, Stephen, "Laws." From *Not Dancing*. Copyright © 1984 by Stephen Dunn. Reprinted by permission of Carnegie Mellon University Press.

Eady, Cornelius, "The Wrong Street." From *The Gathering of My Name*. Copyright © 1991 by Cornelius Eady. Reprinted by permission of Carnegie Mellon University Press.

Eimers, Nancy, "A Night without Stars," from *No Moon*, Purdue University Press. Copyright © 1997 by Nancy Eimers. Reprinted by permission.

Éluard, Paul, "The Deaf and Blind." Translation by Paul Auster in the *The Random House Book of Twentieth Century French Poetry*. Copyright © 1982 by Paul Auster. Reprinted by permission.

Emanuel, Lynn, "The White Dress." Copyright © 1998 by Lynn Emanuel. Reprinted by permission.

Estés, Clarissa Pinkola, "La Muerte, Patron Saint of Writers." Copyright © 1990 by Clarissa Pinkola Estés. First appeared in *Colorado Review*. Fall 1993. Reprinted by permission.

Fantauzzi, David A., "Moorings" and draft of same. Copyright © 1977 by David A. Fantauzzi. Reprinted by permission.

Flanders, Jane, "Shopping in Tuckahoe." From *Timepiece*. Copyright © 1988 by Jane Flanders. Reprinted by permission of the University of Pittsburgh Press.

Francis, Robert, "Cadence." From *Butter Hill*. Copyright © 1984 by Paul W. Carman. Reprinted by permission. "Professional Poet" and "The Indecipherable Poem." From *The Satirical Rogue on Poetry*. Copyright © 1965 by Robert Francis. Reprinted by permission of the University of Massachusetts Press. "Excellence" and "Glass." From *Robert Francis: Collected Poems, 1936-1976*. Copyright © 1976 by Robert Francis. Reprinted by permission of the University of Massachusetts Press.

Friman, Alice, "Diapers for My Father," first appeared in the *Ohio Review*. Copyright © 1998 by Alice Friman. Reprinted by permission.

Gerstler, Amy, "Siren." From *Bitter Angel*. Copyright © 1990 by Amy Gerstler. Reprinted by permission.

Gioia, Dana, "The Next Poem." Copyright © 1985 by Dana Gioia. First appeared in *Poetry*. Reprinted by permission.

Glaser, Elton, "Interim Report." From *Relics*. Copyright © 1984 by Elton Glaser. Wesleyan University Press. Reprinted by permission of the University Press of New England.

Glazer, Michele, "Fruit Flies to the Too Ripe Fruit," from *It Is Hard to Look at What We Came to Think We'd Come to See*, by Michele Glazer, © 1997. Reprinted by permission of the University of Pittsburgh Press.

Gleason, Kate, "After Fighting for Hours." Copyright © 1995 by Kate Gleason. First appeared in *Green Mountains Review*, Vol. 8 #2, Fall/Winter 1995–96. Reprinted by permission of the poet.

right © 1998 by Carolyn Kizer. First appeared in *New Letters*. Reprinted by permission of the poet.

Klappert, Peter, "Scattering Carl." Copyright © 1998 by Peter Klappert. Reprinted by permission of the poet.

Knight, Etheridge, "A Poem of Attrition." From *The Essential Etheridge Knight*. Copyright © 1986 by Etheridge Knight. Reprinted by permission of the University of Pittsburgh Press.

Komunyakaa, Yusef, "Sunday Afternoons." From *Magic City*. First appeared in *New American Poets of the 90s*. Copyright © 1991 by Yusef Komunyakaa. Reprinted by permission of the author.

Kooser, Ted, "Fireflies," from *Weather Central* by Ted Kooser. Copyright © 1994 by Ted Kooser. Reprinted by permission of the University of Pittsburgh Press.

Kostova, Elizabeth, "Suddenly I Realized I was Sitting," Copyright © 1996 by Elizabeth Kostova. Reprinted by permission of the poet.

Kroman, Deborah, "Late Night Drive," copyright © 1998 by Deborah Kroman. Reprinted by permission of the poet.

Kumin, Maxine, "The Long Marriage," copyright © 1997 by Maxine Kumin. First appeared in *The Georgia Review*. Reprinted by permission of the poet.

Lake, Paul, "Blue Jay." From *Catches*. Copyright © 1986 by Paul Lake. Reprinted by permission of the publisher, R. L. Barth.

Lattimore, Richmond, "Catania to Rome." From *Poems of Three Decades* by Richmond Lattimore. Copyright © 1972 by Richmond Lattimore. Reprinted by permission of The University of Chicago Press.

Levine, Philip, "The Return: Orihuela, 1965." Copyright © 1994 by Philip Levine. First appeared in *The Nation*. Reprinted by permission.

Logan, William, "Song," copyright © 1998 by William Logan. First appeared in *Gettysburg Review*. Reprinted by permission of the poet.

Lyons, Richard, "Lunch by the Grand Canal," copyright © 1998 by Richard Lyons. First appeared in *Paris Review*. Reprinted by permission of the poet.

Machan, Katharyn Howd, "Hazel Tells Laverne." Copyright © 1981 by Katharyn Howd Machan. Reprinted by permission.

Matthews, William, "Men at My Father's Funeral." Copyright © 1992 by William Matthews. First appeared in *The Ohio Review*. Reprinted by permission.

McKenty, Bob, "Leo." Copyright © 1994 by Bob McKenty. Reprinted from *Lighten Up*. Reprinted by permission.

Meek, Jay, "Swimmers." From *Windows*. Copyright © 1994 by Jay Meek. Reprinted by permission of Carnegie Mellon University Press.

Milosz, Czeslaw, "Realism." Copyright © 1994 by Czeslaw Milosz. First appeared in *The New Yorker*. Reprinted by permission of Robert Hass.

Mitcham, Judson, "An Introduction." Copyright © 1996 by Judson Mitcham. First appeared in *The Georgia Review*. Reprinted by permission of the poet.

Mitchell, Susan, "Blackbirds." From *The Water Inside the Water*. Copyright © 1983 by Susan Mitchell. Wesleyan University Press. Reprinted by permission of the University Press of New England.

Moss, Thylias, "Those Men at Redbones." From *At Redbones*. Copyright © 1990 by Thylias Moss. Reprinted by permission of Cleveland State University Poetry Center.

Mura, David, "A *Nisei* Picnic: From an Album." Copyright © 1989 by David Mura. From *After We Lost Our Way*, first printed by Dutton, reprinted by Carnegie Mellon University Press. Reprinted by permission.

Nelson, Marilyn, "Balance" and "Minor Miracle." From *The Fields of Praise*, copyright © 1997 by Marilyn Nelson. Reprinted by permission of Louisiana State University Press.

Nelson, Michael, "Jittery Clouds on Memorial Day." Copyright © 1998 by Michael Nelson. Reprinted by permission of the poet.

Nemerov, Howard, "Power to the People," "Learning by Doing," "The Fourth of July." Copyright © 1973 by Howard Nemerov. Reprinted by permission.

Nye, Naomi Shihab, "Famous." From *Hugging the Jukebox*. Copyright © 1982 by Naomi Shihab Nye. Reprinted by permission of Theodore W. Macri, agent for Breitenbush Books.

Ochester, Ed, "Poem for a New Cat." From *Changing the Name to Ochester*. Copyright © 1988 by Ed Ochester. Reprinted by permission of Carnegie Mellon University Press.

Olds, Sharon, "Quake Theory," from *Satan Says*. Copyright © 1980 by Sharon Olds. Reprinted by permission of the University of Pittsburgh Press.

Oliver, Mary, "Music at Night." From *The Night Traveler*. Copyright © 1978 by Mary Oliver. Reprinted by permission of Bits Press and the poet.

Olsen, William, "The Dead Monkey." From *The Hand of God and a Few Bright Flowers*. Copyright © 1988 by William Olsen. Reprinted by permission of the poet.

Ortiz Cofer, Judith, "Cold as Heaven." From *Reaching for the Mainland & Selected New Poems*. Copyright © 1995 by Judith Ortiz Cofer. Reprinted by permission of Bilingual Press/Editorial Bilingüe, Arizona State University, Tempe, AZ.

Pape, Greg, "Children of Sacaton." From *Storm Pattern*. Copyright © 1992 by Greg Pape.

Reprinted by permission of the University of Pittsburgh Press.

Pastan, Linda, "Jump Cabling." First appeared in *Light Year '85*. Copyright © 1984 by Linda Pastan. Reprinted by permission.

Peacock, Molly, "Afraid" and "Things to Do," from *Raw Heaven*. Copyright © 1984 by Molly Peacock. Reprinted by permission of the poet.

Perillo, Lucia, "At Saint Placid's," from *The Body Mutinees*. Copyright © 1996 by Lucia Perillo. Reprinted by permission of the poet.

Phillips, Carl, "X." From *In the Blood* by Carl Phillips. Copyright © 1992 by Carl Phillips. Reprinted with the permission of Northeastern University Press.

Plumly, Stanley, "Woman on Twenty-second Eating Berries." Copyright © 1990 by Stanley Plumly. First appeared in *Antaeus*. Reprinted by permission.

Pinsky, Robert, "ABC." Copyright © 1999 by Robert Pinsky. Reprinted by permission of the poet.

Powell, Lynn, "Promised Land." From *Old and New Testaments*. Winner of the 1995 Brittingham Prize in Poetry. Copyright © 1995 by Lynn Powell. Reprinted by permission of the University of Wisconsin Press.

Prospere, Susan, "Ministering Angels." From *Sub Rosa*. Reprinted with the permission of W. W. Norton & Company, Inc. Copyright © 1991 by Susan Prospere. Originally published in *Poetry*.

Rankine, Claudia, "The Man. His Bowl. His Raspberries." From *Nothing in Nature Is Private*, Cleveland State University Poetry Center. Copyright © 1994 by Claudia Rankine. Reprinted by permission of the poet.

Reno, Janet, "My Dream of the Empty Zoo." Copyright © 1998 by Janet Reno. Originally appeared in *Gettysburg Review*. Reprinted by permission of the poet.

Rich, Adrienne, "The Slides." Reprinted from *Time's Power, Poems 1985–1988*, by Adrienne Rich. Copyright © 1989 by Adrienne Rich. Reprinted by permission of the author and W. W. Norton & Company, Inc.

Roethke, Theodore, "My Papa's Waltz." Copyright © 1942 by Hearst Magazines, Inc. From *The Collected Poems of Theodore Roethke* by Theodore Roethke. Used by permission of Doubleday, a division of Random House, Inc.

Rosenberg, Liz, "The Silence of Women." From *Children of Paradise*. Copyright © 1994 by Liz Rosenberg. Reprinted by permission of the University of Pittsburgh Press.

Rukeyser, Muriel, "A Simple Experiment," from *Out of Silence*, TriQuarterly Books. Copyright © 1991 by William Rukeyser. Reprinted by permission of International Creative Management.

Sajé, Natasha, "Reading the Late Henry James," from *Red Under the Skin*. Copyright © 1994. Reprinted by permission of the University of Pittsburgh Press.

Shaffer, C. Lynn, "A Baglady's Plea," "A Butterfly Lands on the Grave of My Friend," and "To Dust." Copyright © 1995 by C. Lynn Shaffer. Reprinted by permission.

Shomer, Enid, "Among the Cows." From *This Close to Earth*. Copyright © 1992 by Enid Shomer. Reprinted by permission of The University of Arkansas Press.

Shumaker, Peggy, "Chinese Print: No Translation." From *Esperanza's Hair*. Copyright © 1985 by Peggy Shumaker. Reprinted by permission .

Simic, Charles, "Watermelons." From *Return to a Place Lit by a Glass of Milk*. Copyright © 1974 by Charles Simic. Reprinted by permission of George Braziller, Inc.

Simpson, Louis, "American Classic." From *Caviare at the Funeral*. Copyright © 1981 by Louis Simpson. Reprinted by permission of Grolier, Inc.

Smith, Arthur, "Childhood." Reprinted from *Arthur Smith: Orders of Affections* by permission of Carnegie Mellon University Press. Copyright © 1996 by Arthur Smith.

Smith, Dave, "Parkersburg, W. Va." From *The Fisherman's Whore*. Copyright © 1989 by Dave Smith. Reprinted by permission of Carnegie Mellon University Press.

Song, Cathy, "Primary Colors." From *Picture Bride*. Copyright © 1983 by Yale University Press. Reprinted by permission of Yale University Press.

Soto, Gary, "In the Madness of Love." Copyright © 1985 by Gary Soto. Used by permission of the poet.

Spires, Elizabeth, "Letter in July." Copyright © 1992 by Elizabeth Spires. First appeared in *Poetry*. Reprinted by permission.

Stafford, William, "Traveling Through the Dark." From *Stories that Could be True* by William Stafford. Copyright © 1960 by William Stafford. Reprinted by permission of Harper & Row, Publishers, Inc.

Stanton, Maura, "Song (After Shakespeare)." From *Cries of Swimmers*. Copyright © 1984 by Maura Stanton. Reprinted by permission of Carnegie Mellon University Press.

Steele, Timothy, "Epitaph." From *Uncertainties and Rest*. Copyright © 1979 by Timothy Steele. Reprinted by permission of the poet.

Stern, Gerald, "Stepping Out of Poetry." From *Lucky Life*. Copyright © 1977 by Gerald Stern. Reprinted by permission.

Stewart, Robert, "Carry-On." Copyright © 1998 by Robert Stewart. Reprinted by permission of the poet.

Stuckey, Tricia, "In the Mirror." Copyright © 1995 by Tricia Stuckey. Reprinted by permission.

Tall, Deborah, "Landscape." Copyright ©

1998 by Deborah Tall. First appeared in *Gettysburg Review*. Reprinted by permission of the poet.

Tate, James, "A Guide to the Stone Age." From *Absences*. Copyright © 1972 by James Tate. Reprinted by permission of Carnegie Mellon University Press.

Taylor, Henry, "Barbed Wire." Reprinted by permission of Louisiana State University Press from *The Flying Change* by Henry Taylor. Copyright © 1985 by Henry Taylor. "Understanding Fiction," from *Understanding Fiction*. Copyright © 1996 by Henry Taylor.

Tomes, Marta, "The Kiss." Copyright © 1995 by Marta Tomes. Reprinted by permission.

Townsend, Ann, "Day's End." Copyright © 1998 by Ann Townsend. From *Dime Store Erotics*. Reprinted by permission of Silverfish Review Press.

Tremblay, Gail, "An Onondaga Trades with a Woman Who Sings with a Mayan Tongue." From *Indian Singing*, copyright © 1998 by Gail Tremblay. Reprinted by permission of Calyx Press.

Trowbridge, William, "The Art of Vanishing." Copyright © 1997 by William Trowbridge. First printed in *Gettysburg Review*. Reprinted by permission of the poet. "Enter Dark Stranger." Copyright © 1985 by William Trowbridge. From *Enter Dark Stranger*, The University of Arkansas Press, 1989. Reprinted by permission.

Updike, John, "Player Piano." Copyright © 1958 by John Updike. Reprinted by permission.

Valentine, Jean, "Dearest." From *Pilgrims*, copyright © 1969 by Jean Valentine. Reprinted by permission of Carnegie Mellon University Press.

Vando, Gloria, "Ronda." Copyright © 1995 by Gloria Vando. First appeared in *Paper Dance: 55 Latino Poets*, 1995, eds. Virgil Suarez and Juan Felipe Herrera. Reprinted by permission of the poet.

Voigt, Ellen Bryant, "Dancing with Poets." From *The Lotus Flowers*. Copyright © 1987 by Ellen Bryant Voigt. Reprinted with the permission of W. W. Norton & Company, Inc.

Wade, Sidney, "Rain." From *Green*. Copyright © 1998 by Sidney Wade. Reprinted by permission of University of South Carolina Press.

Wallace, Robert, "In One Place." Copyright © 1979 by Robert Wallace. From *The Common Summer: New and Selected Poems*, Carnegie Mellon University Press, 1989. Reprinted by permission.

Wallace, Ronald, "The Bad Snorkler." Copyright © 1991 by Ronald Wallace. Reprinted by permission of the University of Pittsburgh Press.

Warren, Rosanna, "Diversion." First appeared in *The New Republic*. Copyright © 1996 by Rosanna Warren. Reprinted by permission.

Waters, Michael, "Tuna." Copyright © 1998 by Michael Waters. Reprinted by permission.

Watterson, Meggan, "For the Women of Ancient Greece." Copyright © 1995 by Meggan Watterson. Reprinted by permission.

Whitmore, Susan, "Conception." Copyright © 1998 by Susan Whitmore. First appeared in *The Georgia Review*. Reprinted by permission.

Wier, Dara, "Daytrip to Paradox." From *The Book of Knowledge*. Copyright © 1988 by Dara Wier. Reprinted by permission of Carnegie Mellon University Press.

Wilbur, Richard, "Hamlen Brook." First appeared in *The New Yorker*. Copyright © 1985 by Richard Wilbur. Reprinted by permission of the author. "Love Calls Us to the Things of This World." From *Things of This World* by Richard Wilbur. Copyright © 1956 and renewed 1984 by Richard Wilbur. Reprinted by permission of Harcourt Brace & Company. Six drafts of the opening lines of "Love Calls Us to the Things of This World." Copyright © 1964 by Richard Wilbur. Reprinted by permission.

Williams, Miller, "The Curator." From *Adjusting to the Light*. Copyright © 1992 by Miller Williams. Reprinted by permission of the University of Missouri Press. Drafts of "Politics." Copyright © 1995 by Miller Williams. Reprinted by permission of the author.

Williams, William Carlos, "Poem (As the cat)," From *Collected Poems Volume I 1909–1939*. Copyright © 1938 by New Directions Publishing Corporation. Reprinted by permission of New Directions Publishing Corporation.

Wojahn, David, "The Assassination of John Lennon." From *Mystery Train*. Copyright © 1990 by David Wojahn. Reprinted by permission of the University of Pittsburgh Press.

Young, Al, "In Marin Again." From *Heaven: Collected Poems*, Creative Arts Books. Copyright © 1992 by Al Young. Reprinted by permission of the author.

Index of Authors and Titles

Index of Terms